World of Worldly Gods

AMERICAN ACADEMY OF RELIGION

RELIGION, CULTURE, AND HISTORY

SERIES EDITOR
Kristian Petersen, Old Dominion University

A Publication Series of
The American Academy of Religion
and
Oxford University Press

FEMINIST POETICS OF THE SACRED
Creative Suspicions
Edited by Frances Devlin-Glass and Lyn McCredden

PARABLES FOR OUR TIME
Rereading New Testament Scholarship after the Holocaust
Tania Oldenhage

MOSES IN AMERICA
The Cultural Uses of Biblical Narrative
Melanie Jane Wright

INTERSECTING PATHWAYS
Modern Jewish Theologians in Conversation with Christianity
Marc A. Krell

ASCETICISM AND ITS CRITICS
Historical Accounts and Comparative Perspectives
Edited by Oliver Freiberger

VIRTUOUS BODIES
The Physical Dimensions of Morality in Buddhist Ethics
Susanne Mrozik

IMAGINING THE FETUS
The Unborn in Myth, Religion, and Culture
Edited by Vanessa R. Sasson and Jane Marie Law

VICTORIAN REFORMATION
The Fight over Idolatry in the Church of England, 1840-1860
Dominic Janes

SCHLEIERMACHER ON RELIGION AND THE NATURAL ORDER
Andrew C. Dole

MUSLIMS AND OTHERS IN SACRED SPACE
Edited by Margaret Cormack

REAL SADHUS SING TO GOD
Gender, Asceticism, and Vernacular Religion in Rajasthan
Antoinette Elizabeth DeNapoli

LITTLE BUDDHAS
Children and Childhoods in Buddhist Texts and Traditions
Edited by Vanessa R. Sasson

HINDU CHRISTIAN FAQIR
Modern Monks, Global Christianity, and Indian Sainthood
Timothy S. Dobe

MUSLIMS BEYOND THE ARAB WORLD
The Odyssey of ʿAjamī and the Murīdiyya
Fallou Ngom

MUSLIM CIVIL SOCIETY AND THE POLITICS OF RELIGIOUS FREEDOM IN TURKEY
Jeremy F. Walton

LATINO AND MUSLIM IN AMERICA
Race, Religion, and the Making of a New Minority
Harold D. Morales

THE MANY FACES OF A HIMALAYAN GODDESS
Haḍimbā, Her Devotees, and Religion in Rapid Change
Ehud Halperin

MISSIONARY CALCULUS
Americans in the Making of Sunday Schools in Victorian India
Anilkumar Belvadi

DEVOTIONAL SOVEREIGNTY
Kingship and Religion in India
Caleb Simmons

ECOLOGIES OF RESONANCE IN CHRISTIAN MUSICKING
Mark Porter

GLOBAL TANTRA
Julian Strube

LAUGHTER, CREATIVITY, AND PERSEVERANCE
Ute Hüsken

WORLD OF WORLDLY GODS
The Persistence and Transformation of Shamanic Bon in Buddhist Bhutan
Kelzang T. Tashi

AMERICAN ACADEMY OF RELIGION

World of Worldly Gods

The Persistence and Transformation of Shamanic Bon in Buddhist Bhutan

KELZANG T. TASHI

OXFORD
UNIVERSITY PRESS

Oxford University Press is a department of the University of Oxford. It furthers the University's objective of excellence in research, scholarship, and education by publishing worldwide. Oxford is a registered trade mark of Oxford University Press in the UK and certain other countries.

Published in the United States of America by Oxford University Press
198 Madison Avenue, New York, NY 10016, United States of America.

© Oxford University Press 2023

All rights reserved. No part of this publication may be reproduced, stored in a retrieval system, or transmitted, in any form or by any means, without the prior permission in writing of Oxford University Press, or as expressly permitted by law, by license, or under terms agreed with the appropriate reproduction rights organization. Inquiries concerning reproduction outside the scope of the above should be sent to the Rights Department, Oxford University Press, at the address above.

You must not circulate this work in any other form
and you must impose this same condition on any acquirer.

Library of Congress Cataloging-in-Publication Data
Names: Tashi, Kelzang T., author.
Title: World of worldly gods : the persistence and transformation of shamanic Bon in Buddhist Bhutan / Kelzang T. Tashi.
Other titles: Contested past, challenging future
Description: New York : Oxford University Press, 2023. |
Series: Religion, culture, and history |
Revision of the author's thesis (doctoral)—Australian National University, 2020, under the title: Contested past, challenging future : an ethnography of pre-Buddhist Bon religious practices in central Bhutan. |
Includes bibliographical references and index.
Identifiers: LCCN 2022044647 (print) | LCCN 2022044648 (ebook) |
ISBN 9780197669860 (hardback) | ISBN 9780197669884 (epub) |
ISBN 9780197669891
Subjects: LCSH: Bon (Tibetan religion)—Zhemgang (District) |
Shamanism—Zhemgang (District) | Buddhism—Zhemgang (District) |
Religion and culture—Bhutan—Zhemgang (District) |
Social change—Bhutan—Zhemgang (District) |
Zhemgang (Bhutan : District)—Religious life and customs.
Classification: LCC BQ7964.3.B47 T37 2023 (print) | LCC BQ7964.3.B47 (ebook) |
DDC 299.5/4—dc23/eng/20221013
LC record available at https://lccn.loc.gov/2022044647
LC ebook record available at https://lccn.loc.gov/2022044648

DOI: 10.1093/oso/9780197669860.001.0001

Printed by Integrated Books International, United States of America

In loving memory of my beloved Mother

Contents

List of Illustrations ix
Acknowledgments xi
Note on Orthography xv

1. Introduction 1
 Multiple Identities 4
 Bon in Bhutan 15
 Great and Little Traditions? 21
 Fieldwork and Methodology 24
 Structure of the Book 26

2. Goleng Village in Zhemgang District 29
 Three Ridges of Zhemgang 29
 Goleng Village 38
 Social Organization: Dung, Kudrung, Pirpön, and Mamai Lineage Houses 40
 The Goleng *Dung* Nobility and Lineage Deities 46
 The Founding of Buddhist Temples in Goleng 51

3. Soul Loss and Retrieval 58
 The Fluidity of Five Life Elements 58
 Common Rituals for Strengthening Declining Life Elements 61
 The Primordial Bon Ritual for Recapturing the Abducted Soul 65
 The Local Divinities of the Golengpa Bon Pantheon 67

4. Dealing with Threats to Health and Welfare 76
 Protective and Healing Rituals 76
 The Big *Gyalpo* Beings 81
 Gyalpo Shul Du: The Ritual of Dispatching the Big *Gyalpo* to His Palace 83
 The Small or Familial *Gyalpo* Spirits 86
 Autochthonous Demons 87
 Demonesses and Witches 89
 Discerning the *Sondre* Host 91
 Shartsen: The Eastern Mountain Deities 94
 Poison Givers: We Are Pure and Clean People 99
 Treating the Poison Attack 101
 Gyalpo, *Sondre*, and *Duk* Beings as Economy-Generating Spirits 103

5. Controlling the Bon Priests ... 106
 Lu'i Bonpo: Becoming a *Lu* Specialist ... 106
 The Ritual of Releasing Trapped Serpent Spirits ... 109
 Ways of Becoming a Bonpo Shaman ... 116
 The Shamanic Retrieval of Lost Souls ... 120
 The Official Bonpos of Zhemgang ... 125
 The Official Bonpo of Goleng ... 126
 Bonpos in Court ... 130
 The Politics of Black Magic Rituals ... 133

6. The Annual *Rup* Ritual ... 141
 The Significance of *Rup* to the *Dung* Nobility ... 141
 Rup Rules and Consequences ... 144
 Outline of the *Rup* Rite ... 146
 Dham Dham: *Rup* Divinities, Divinations, and Sealing Rites ... 150
 The Rites of the First, Second, and Third Days of *Rup* ... 156
 Rup and Its Future ... 159

7. Phallic Rituals and Pernicious Gossip ... 163
 Phallic Symbols ... 163
 The Antigossip Ritual ... 166
 The Phallic Rituals of the Annual *Chodpa* ... 175
 The Buddhist Phallic Ritual Cake ... 178
 The Phallic Rituals by the *Gadpo* ... 180

8. Buddhist Accommodation of Bon Rites and Practices ... 191
 The Annual Propitiatory Ritual of Local Deities and Demons ... 191
 Buddhist Versions of the Odé Gungyal Ritual ... 197
 Child Gods and Naming Patterns ... 203
 The Former Clerical Bon Temple ... 210

9. The Persistence and Transformation of Golengpa Religiosity ... 220
 Buddhism, Shamanic Bon, and Clerical Bon ... 220
 From Oral/Literary to Mundane/Supramundane Distinctions ... 225
 Syncretism and the Politics of Religion ... 229

10. Conclusion ... 236

Appendix: Phonetic Renderings of Local Terms ... 243
Notes ... 263
References ... 271
Index ... 279

Illustrations

Figures

1.1. Goleng and neighboring villages	25
2.1. A partial view of Goleng village	39
3.1. The abode of serpent beings	73
7.1. The phallic kharam structure	168
8.1. The ritual cakes depicting the four main local deities	194
8.2. The journey of god Odé Gungyal	201

Tables

3.1. The Five Classes of Local Gods and Spirit Beings	69
6.1. Consequences of Noncompliance with Ritual Rules	146
6.2. *Rup* Rites and Rituals	149

Acknowledgments

This book would not have come to fruition without the support and generosity of a number of people and institutions. It is first and foremost to the people of Goleng that I owe a deep and lasting debt of gratitude for their kindness and hospitality during a year of fieldwork. They treated me as if I were one of their family members and tolerated my intrusion into their annual rites and everyday rituals, which often took place in the face of difficult and serious situations. My sincere thanks to the village headman, Ugyen Penjore, who introduced me to Tsultrim Wangmo and her brilliant son Sangay Dorji. She was the first Golengpa to welcome me to her house and subsequently became my generous host, while her son helped me as a long-term research assistant before resuming his studies.

Thanks are also due to Dechen Wangdi, Kinzang Wangchuck, Jambay Tshering, Ugyen Dema, Jambay Kelzang, Tshering Dorji, Kinley Wangdi, Kinley Yangzom, Kinely Namgyal, Dorji, Nima Tshering, and Kunley for their contributions to this project. My grateful thanks are extended to Tshultrim Dorji, who accompanied me to Shobleng village, introduced me to Bonpos there, and hosted me at his mother-in-law's house during their annual *rup* rite. The same goes for Yeshi Dorji, who took me to Ngangla in the southern part of Zhemgang, and Phuba—the janitor of Kumbum temple in Wangdiphodrang—who welcomed me despite odd hours.

I am especially indebted to Bonpo Chungla, Bonpo Pemala, and Bonpo Sangay of Goleng, Bonpo Tempala of Shobleng, *pamo* Karma of Berti, a Chungdu *pawo* from a nearby village in Nangkor county, and Bonpo Dophu of Bumthang, all of whom invited me to attend various rituals and provided invaluable insights by patiently answering my endless questions. Heartfelt thanks go to lay Buddhist *chöpas* in equal measure, particularly to Lopön Pema Wangchuk, who very kindly not only invited me to attend various Buddhist rites but also contributed many invaluable insights and provided advice. Besides Golengpas, I am grateful to the former district governor (Dzongdag) of Zhemgang, Harka Singh Tamang, and the county headman of Nangkor, Dorji Wangchuk, for allowing me to conduct research in Goleng, which is under their direct jurisdiction.

I owe a deepest and inestimable gratitude to my PhD supervisor at the Australian National University (ANU), Nicolas Peterson, without whose constant guidance, support, and generosity throughout this journey this project would have been impossible. During my doctoral research, he not only provided a detailed commentary on each chapter but also supported the final months of my fieldwork with additional funding from his research fund. Most importantly, he taught me how to think anthropologically and reminded me of the importance of clear and simple writing over an opaque style. Despite his retirement, he was generous with his precious time and continued to provide the most invaluable comments and suggestions on the revised draft of this book. Nic continues to be my constant source of inspiration and guidance.

I would like to offer my special thanks to my supervisory panel members, Patrick Guinness (ANU) and Dorji Penjore (Centre for Bhutan Studies). It was Dorji Penjore who not only introduced me to Nicolas Peterson but also recommended Goleng as an ideal study location. He was involved in the formulation of the thesis proposal, and during the fieldwork he provided me with crucial advice and support. Patrick Guinness read the earlier drafts of Chapters 5, 6, and 7 and provided valuable comments and suggestions in the Thesis Writing Group. Philip Taylor, Christine Helliwell, Caroline Schuster, and Simone Dennis introduced me to anthropology as a first-year PhD student, and without their support and guidance I would not have found a home in anthropology. I greatly appreciated the support that I received from Yasmine Musharbash and Chris Gregory during my studies. Thanks in particular go to Meera Ashar, Philip Taylor, and Assa Doron, all of whom served as my interim supervisors at different stages of my first-year PhD program.

My research was generously supported by Endeavour Scholarships and Fellowships (2016–2020) provided by the Australian Government's Department of Education and Training. Fieldwork was funded by an ANU Higher Degree Research Grant with the award of an additional Vice-Chancellor's Travel Grant (2017–2018). My sincere thanks to both the funding agencies, without which this work would not have been possible. This book has been greatly improved by the constructive comments and thoughtful suggestions from five anonymous reviewers. I am grateful to the three thesis examiners whom I know to be Geoffrey Samuel, David Holmberg, and Tsering Shakya. Unanimously recommending the award of the PhD, they provided generous and illuminating comments, inspiring me to push myself to think theoretically as well as transnationally in new ways.

At the American Academy of Religion, I am forever indebted to the erudite editor of the Religion, Culture, and History series, Robert Yelle, for his kind guidance, support, and encouragement right through the initial phase of the book proposal to the blind peer review process. I am grateful to two reviewers of the book manuscript, one of whom I know to be Daniel Berounský, for their valuable feedback and suggestions. Their crucial comments and critiques greatly improved the overall clarity of the manuscript. At Oxford University Press in New York, my deepest gratitude is due to Cynthia Read, Steve Wiggins, Theo Calderara, project editor Paloma Escovedo, project manager Suganya Elango (Newgen), book cover designer James Perales, and most importantly the judicious copyeditor Richard Isomaki for their kind assistance and guidance throughout the publication process.

At the University of Toronto, I am grateful to Christoph Emmrich and Michael Lambek for their generosity and support for my work during my affiliation with the Centre for South Asian Studies at Munk School of Global Affairs, where I was a research associate. At the London School of Economics and Political Science, I am equally grateful to Catherine Allerton and Katy Gardner for their interest in my work and the support given to me as a visiting fellow in the Department of Anthropology.

I gratefully acknowledge that a part of the final revision of this book was undertaken during my affiliation as a postdoctoral fellow with National University of Singapore (NUS). I must express my sincere gratitude to the Asia Research Institute for a postdoctoral fellowship, and to Jamie Davidson, who has been a gracious mentor and guide at NUS. I have been also extremely fortunate to have the support and guidance of William Sax at Heidelberg University as I embark upon a new research project.

My special thanks to the participants of the Department of Anthropology's Thesis Writing Group (2019) at ANU for stimulating discussions. Fay Styman, Ian Pollock, Meng Cao, Shamim Homayun, Shaun Gessler, Kirsty Wissing, Simon Theobald, Alexander D'Aloia, Shamim Homayun, and Stefanie Puszka all provided useful comments on the earlier drafts of Chapters 5, 6, and 7. Thanks are also due to the panel organizers and participants of the Australian Anthropological Society Annual Conference (2019), the American Anthropological Association / Canadian Anthropological Society Annual Meeting (2019), and the Association of Social Anthropologists of the UK and Commonwealth Annual Conference (2019), where I have presented some sections of Chapters 2, 3, and 5. I gave a talk on Chapter 9 at the University of Toronto as part of the Centre for South

Asian Studies Pathbreaker Series. Some information on social organization in Chapter 2 appeared in my article in the *Journal of Anthropological Research* (2022). The friendship and support of a group of Bhutanese academics in Canberra, particularly Dendup Chophel and Lhawang Ugyel, is greatly appreciated.

Lastly but most importantly, I would like to thank my family. My dearest mother Sherab Yangchen was a devout Buddhist born into a deeply religious family with a long line of hereditary lamas. She was my source of inspiration and primary refuge, without whose support and blessings I would not be where I am today. Her sudden demise in mid-2018 when I barely started writing my dissertation devastated and traumatized me for many months, rendering my life completely empty and meaningless. My father, Gyembo, is an equally devout Buddhist with great discipline and integrity. Despite his own enduring grief, my father kept encouraging me and constantly prayed for the successful completion of my studies. He is my guide and a role model that I look up to. My sincere thanks go to my siblings and relatives, who always support me. Thanks in particular go to my elder brother Khenpo Kencho Tenzin for helping me with the Wylie transliteration and for his unfailing encouragement and prayers. Most importantly, I want to thank my dearest son Norbu Yoedbar for his patience, as he had to separate from his mother to support his father's ambitions. Finally, I want to thank my amazing wife Dema Yangzom from the bottom of my heart for her love and constant support, and for everything else.

Note on Orthography

The dialects spoken by the people of central Bhutan have no formal written script. Except where necessary, I have not followed the Wylie convention of transliteration in the book, but romanized words based on how they are pronounced by people and how I heard them. The local words are italicized throughout the book, but their first appearance is shown in parenthesis. Where appropriate, non-English words have been pluralized. A list of the phonetic rendering of local terms with Wylie transliteration has been provided at the end of the book.

1
Introduction

> Without Buddhist priests, dharma protectors will be displeased; without Bon priests, local deities will be angered.
> —Local adage

Before the coming of Buddhism to Bhutan in the seventh century, Bon was the only prevalent religious practice, and it continues to survive down to the present day. This is surprising because Bon religiosity has been looked down on by Buddhists due to the practice of animal sacrifice and its alleged association with black magic rituals that are antithetical to core Buddhist values. Moreover, unlike Buddhism, Bon does not offer enlightenment to sentient beings and accordingly has no salvific function. Despite many centuries of Buddhist opposition, including ongoing censure today, Bon beliefs and practices continue to play a role in the lives of people in Bhutan through annual celebrations and everyday engagement in Bon healing and protective rituals.

This book is an exploration of the relationship between Bon and Buddhism through an ethnography of Goleng village (also spelled as Goling) and its neighbors in Zhemgang district in central Bhutan, which are a stronghold of Bon practices and beliefs. I am interested in why people, despite shifting contexts, continue to practice and engage with Bon rituals while recognizing that what they are doing is antithetical to the civilizing mission of the Buddhist masters from Tibet and, of course, against the religious prescription of the Bhutanese state, which made Drukpa Kagyu—a branch of the Kagyu school of Tibetan Buddhism—its state religion in the seventeenth century. Against the backdrop of long-standing tensions between Buddhism and Bon, which go back to the eighth century, this study investigates the failure to eliminate Bon, and why Buddhists felt it necessary to reach a rather awkward accommodation not only with some Bonpos but also with their own mission of illuminating the so-called uncultivated country with the universalizing light

of Buddhism. Zhemgang is particularly relevant to addressing this question as Buddhist institutions came very late to some areas of the district, indeed, only in the 1960s. Although the majority of Bhutanese people identify as Buddhists, Bon is widely practiced across Bhutan, with people taking part in a range of Bon practices through everyday rituals and annual rites. Some villages in western Bhutan, for instance Haa, have shared annual Bon rites, in which live-animal sacrifices were made until recently. Yet I have chosen Zhemgang in central Bhutan as my field site because it is the region where the surviving nobilities, despite officially not existing, thrive, and the annual Bon rite is the most intense.

What follows is not simply a study about the relationship between a local religious practice, Bon and Buddhism, a world religion; it is also a study of the ontological orientation of villagers in the contemporary Bhutanese society. At the heart of the book lies the question of cultural persistence and change: what explains the tenacity of pre-Buddhist Bon beliefs, as they are lived and contested, in the presence of the invalidating force—Buddhism. Framed in long-standing debates around practices unsystematically identified as "Bon" by Tibetologists and anthropologists, and how they relate to what anthropologists refer to as religious syncretism, my analysis lays bare deeper forces that operate under the veneer of Buddhism's civilizing mission.

The study reveals that the reasons for the tenacity of Bon practices and beliefs amid censures by the Buddhists are manifold and complex. One explanation for the persistence of pre-Buddhist religious beliefs in Goleng and Shobleng villages is their remoteness and small population so that no official Buddhist institutions were actually established in the area until the mid-twentieth century. Buddhism itself was never as strong as in other areas that are home to the major Buddhist centers of the country, and hence, Bon has managed, despite the odds, to be seen as more relevant to villagers' everyday concerns and local problems. Nevertheless, the villages of this area have been well aware of Buddhism for centuries through their contacts with Buddhist masters and practitioners from elsewhere whose religious traditions, though official, are unaffiliated with the state-sponsored school of Buddhism, which is mainly concentrated in the state-based institutions found in district (*dzongkhag*) and subdistrict headquarters (*drungkhag*).

Given the long history of Buddhist antagonism toward Bon, it was very surprising to learn that there has been an appointment of the first official Bon priest (hereafter Bonpo) of Zhemgang proper[1] by the district office in the 1990s in an effort to restrict and marshal Bon practices in the region.

Similarly, the appointment of a local Bonpo to the official Bonpo role in Goleng by the district office is another case in point. This was, however, against the will of the people of Goleng (Golengpa hereafter) and historically unprecedented not only in Goleng, or for that matter in Zhemgang, but in the country as a whole. While Bon in general and Bonpos in particular have been denigrated by the Buddhists for centuries, this particular scheme is aimed to crack down on the former by designating a specific Bon priest as the "official Bonpo" in the hope of discrediting the others.

Two Buddhist temples have recently been established in Goleng: the first temple construction was in the 1960s and antedated the appointment of the official Golengpa Bonpo, while the second temple was established in 1994. In addition to it, there have been several occasions in Zhemgang proper and Buli villages in which the local Bonpos were subject to religious validation. All the active Bonpos from the neighboring villages were summoned to the village centers, and their Bon practices were then systematically scrutinized, reviewed, contested, and judged by Buddhist clergies and high-ranking officials. It was on one such occasion that Bonpo Karma of Pam village was singled out from the pool of Bonpos for the newly created position of the official Bonpo of Zhemgang proper. Currently, a monthly honorarium of Nu 500 ($8) is provided by the district office for his religious services at the courtyard of the district office. Bonpo Karma, who boasts about his role by calling himself the state or official Bonpo (*zhung-gi bonpo*), emphasizes that the Buddhist clergies and high-ranking officials were affiliated with the state-funded school of Buddhism and came all the way from the capital, Thimphu, to organize the selection of the official Bonpo.

Slowly and methodically, the district office's interests in certifying Bonpos have extended beyond its headquarters, particularly to Bon stronghold villages such as Goleng. While their mission is guided by Buddhist logic, the designation of an official Bonpo of Goleng was the corollary of a lawsuit filed by three Golengpa plaintiffs against a Bon priest who was believed to be practicing a form of Black Bon[2] (*bon nag*) involving live-animal sacrifices and black magic rituals as opposed to White Bon (*bon kar*)—which by the same token is denuded of animal sacrifices and black magic rituals. It should be, however, noted *bon kar* and *bon nag* are both retrospective labels given by Buddhists, but they are now accepted and employed by the Bonpos themselves to refer to their specific forms of ritual. It was this legal process that culminated in Bonpo Chungla's appointment as the first official Golengpa Bonpo—the vocation that he embraced until he stepped down from his

formal role due to his age and medical condition in the early 2000s. However, except for Chungla, who embraces *bon kar*, the district court issued a written order in the early 1990s prohibiting more than six active Golengpa Bon priests, including the current de facto village Bonpo, from performing destructive rituals and engaging in Bon divinations and burnt offerings (*sur*). The surveillance of Bon by the district office is still in place, but it only becomes active when people complain about the Bonpos or their Bon rituals.

While the Bonpos who resort to black magic ritual and live-animal sacrifice were reprimanded and indefinitely banned from performing their rituals by the court, the handful of Bonpos who adhere to the Buddhist ethics and moral status of any sentient being have continued to be recognized by the Zhemgang district office. Chungla of Goleng and Karma of Zhemgang proper both belong to this latter category. On the other hand, Bonpo Pemala, who was originally banned by the district court from performing any forms of Bon rituals, was made a de facto "official" Golengpa Bonpo by the villagers themselves following his predecessor's retirement in the early 2000s. Although the appeal of the decision of the district court was made by a group of village elite[3] (*goshé nyenshé*) in 1993, Bonpo Pemala's candidature for the position of the second official Golengpa Bonpo was dismissed in line with the first court ruling. Nonetheless, Bonpo Pemala has been officiating at the annual Bon rituals, thereby contradicting the court ruling, and of course, it was against the wishes of lay Buddhists, including Lopön Pema Wangchuck, who is the head of Golengpa lay Buddhists. Despite the fact that the court can impose a penalty of up to Nu 1,000 ($16) and a six-month jail sentence for the breach of its orders, these unofficial Bonpos, while desisting from the acts of animal sacrifice and black magic rituals practice their art—from basic *sur* offerings to advanced shamanic ritual healings—and more than 99% of Golengpas continue to have recourse to Bon rituals to this day.

Multiple Identities

Before proceeding with the history of Bon in Bhutan, it is helpful to provide an overview of the long and complex history of Buddhism and Bon in Tibet, and their relationship over the course of many centuries. The pre-Buddhist Bon is portrayed in Buddhist sources as an anti-Buddhist religious practice that opposed and resisted the propagation of Buddhism in eighth-century Tibet[4] and as the religion that later inspired the anti-Buddhist campaign

during the reign of the pro-Bon Tibetan emperor Langdarma[5] (r. 838–42). During this troubled era, the believers of Bon were viewed by Buddhists as adepts at black magic rituals and animal sacrifices who like untamed and hostile autochthonous beings were in need of spiritual domestication and religious upgrading to Buddhism. For this reason, the thirty-eighth emperor of Tibet, Trisong Detsen, invited masters including the famed Tantric master Padmasambhava (also known as Guru Rinpoche) from India to assist him to firmly re-establish Buddhism in Tibet.

During this early diffusion of Buddhism (*tenpa ngadar*), Padmasambhava accomplished this mission by first employing Tantric means to subjugate the powerful local deities who obstructed the construction of Samye monastery in the eighth century, and then eventually converting and binding them by oath to become the protectors of Buddhist dharma (*chökyong*). Since then a plethora of Tantric deities, converted earthly gods, and subsequent Buddhist masters have been engaged in a civilizing mission of "taming, ordering and bringing under cultivation of the wild territory of Tibet and its various humans and non-human inhabitants" (Samuel 2013: 78). The believers of pre-Buddhist Bon were then largely persecuted by the state, and, according to Karmay (2009 [1997]: 118), the Bonpos of central Tibet were banished, while those unwilling to leave were converted to Buddhism.

This pre-Buddhist Bon, particularly in Tibet, is said to have undergone a series of religious transformations that, according to Buddhist sources,[6] had at least three distinct historical stages,[7] namely, wild or outbreak Bon (*rdol bon*), corrupted or erroneous Bon (*'khyar bon*), and reformed or plagiarized Bon (*bsgyur bon*) (cf. Van Schaik 2011, 2013b; Bjerken 2004; Martin 2001). While this narrative seems to reflect the Buddhist polemics against the transformation of Bon, the first, *rdol bon*, corresponds to the pre-Buddhist Bon that existed until the legendary King Drigum Tsenpo,[8] while *bsgyur bon* characterizes the contemporary Clerical or "eternal" Bon (hereafter Yungdrung Bon), which began reorganizing its religious beliefs and practices between the eleventh and fourteenth centuries under strong Buddhist influence (Samuel 2017: 123–124) of Nyingma and other postimperial Tibetan Buddhist schools during the later diffusion[9] (*tenpa chidar*). On the other hand, *'khyar bon* is more or less the later version of *rdol bon* but with renewed religious prominence due to the Bonpos ritualistic function at the royal court until the late eighth century.

After the 1960s, the studies in which "Bon" increasingly became the official label for the "organized, soteriological religion calling itself Yungdrung Bon"

proliferated, while the old manuscripts containing the word "Bon" and the local ritualists among the culturally Tibetan populations in pan-Himalayan societies designating themselves as Bonpo and their rituals as Bon along with its various vernacular appellations such as *lhaven, lhabon, bombo, phajo, nejum, pawo,* and so on, continue to appear (Huber 2015c: 271). The above rituals and priests, along with the other local ritualists without a Bon referent,[10] which are found in northern Nepal, Sikkim, Bhutan, Arunachal Pradesh, and southern Kham in Tibet, rather than isolated phenomena, share a "clear family resemblance" (Huber 2015c: 272; Samuel 2013: 80) and are characteristic of pre-Buddhist or unorganized Bon. However, since the translation of the "Nine Ways of Bon" by Snellgrove (1980 [1967]) in collaboration with contemporary Yungdrung Bonpo monks, views of pre-Buddhist Bon have completely transformed, from its being seen as shamanistic, unorganized, and animal-sacrificing religious practices to a clerical and organized religion with its own founder, canonical texts, and philosophies.

According to Kværne (1995), the pre-Buddhist Bon of Tibet concerns funerary rites involving animal sacrifices performed by priests known as Bonpos, particularly for the kings of the imperial period. The claims of continuity with this unorganized religion are therefore being made by the followers of Yungdrung Bon based on this priestly ritual tradition at the royal court, which was certainly shamanic in nature. The other important rituals of the period for the laity, such as the worship of local gods and deities, divinations, and so on, were, to a degree, not seen as the tasks of the ancient Bonpos, resulting in some scholars calling them "popular religion."[11] The most notable labels for these pre-Buddhist religious practices, excepting the death rituals of the kings, are "folk religion" (Tucci 1980), "nameless religion" (Stein 1972),[12] and recently, "pagan religion" (Ramble 1998, 2008). Although as Samuel (2017) rightly suggests, a term like "folk religion" tends to represent the non-Buddhist religious practices that are still present in Bhutan and other neighboring Himalayan regions, it does not embody the attributes of Bon in its entirety primarily because it fails to address the influence of Indian or even Persian religions (cf. Ramble 1998).[13]

The development of pre-Buddhist Bon into a self-conscious Yungdrung Bon under the influence of and in competition with the reinvigoration of Tibetan Buddhist schools is already known to scholars. Such modification and reconstruction of the so-called reformed Bon in response to the needs of that turbulent period is reflected in the following passage by Samuel (2013):

Studies of the Bon religion of Tibet underwent a dramatic change in the 1960s and 1970s when the voices of the Bonpo themselves began to be taken seriously. The writings of David Snellgrove (e.g. 1989 [1961], 1980 [1967]), Per Kvaerne (e.g. 1974) and Samten Karmay (e.g. 1972, 1975) opened up to us a very different Bon, a religious tradition which was comparable to, and indeed in many ways very similar to, Tibetan Buddhism, with its own monasteries, lamas and texts, its own sense of its history and lineage, and its own project of taming and civilizing the Tibetan people. "White Bon," "Black Bon," animal sacrifices, sorcery and shamanistic rituals were nowhere to be seen. (79–80)

Prior to publications on Yungdrung Bon by its proponents, the pre-Buddhist Bon in which animal sacrifices and shamanistic rituals—entailing interactions with the spirit world through morbid dreams, trances, and semitrances so as to heal the sick—were very much part of religious life was studied by several anthropologists in the Himalayan borderlands. Considering the centrality of ritual practices characterized by spirit possession, spirit mediumship, and shamanistic-animistic practices, such a form of Bon is often studied through the lens of shamanism (see Ortner 1978, 1995; Holmberg 1989, 2006, etc.). Although their focus was on the dichotomy and prevailing relations between Bonpo priests and Buddhist lamas rather than the etymological meaning of the term "Bon" or the Bon religion itself, these scholars continued to refer to the common Bon ritualists in the region as shamans not only because they share many characteristics constituting the phenomenon of shamanic practice but also to reflect the researchers' interlocuters' standpoint on local Bon practices. The terms "shaman" and "shamanic" were also applied by scholars like Samuel (1993) to study a form of Tibetan Buddhism beyond the shamanic complex originally found in Siberia, while other scholars restricted to Siberian roots their usage of the concept of shaman (e.g., Balikci 2008).

Gorer (1938), Fürer-Haimendorf (1955), Berglie (1976), and more recently Ramble (2008) and Balikci (2008) observed no opposition between Buddhist priests and Bonpo shamans among the Lepchas,[14] and Sherpas,[15] but the latter two scholars, who studied culturally similar societies in Nepal, found an active clash between these ritualists of two antagonistic religious beliefs. For instance, Ortner (1978, 1995) found Bonpo shamans among Sherpas in Nepal in decline, and she attributed it to the Buddhist campaign for religious upgrading to Buddhism primarily through the construction of

Buddhist temples and monasteries, which perpetuates the domestication and taming ideal of pre-Buddhist Bon in ancient Tibet. Her findings were later corroborated by Mumford (1989), who witnessed the shamanic layer of Gurung shamans being constantly challenged by their Buddhist counterparts (see also Paul 1976). Anthropologists like Desjarlais (1992, 2016), Holmberg (1989, 2006), Shneiderman (2015), Bellezza (2005), and Adams (1992) continue to employ terms like Bon and *lhabon*, call its ritualists Bonpo,[16] and use *pawo*[17] to refer to the religious practices of pre-Buddhist complex. As a means of taming and subjugation of the pre-Buddhist Bon, some Bonpo shamans were successively validated by Buddhist lamas (Day 1989, 1990) by relying on the nature of possessing gods, while at the same time incorporating the shamanic elements into their practices primarily through a reincarnation (*tulku*) system. This assimilation, of course, provoked Ortner (1995) and Samuel (1993) to label them as "upgraded shamans" and "civilized shamans" respectively.

As reflected in the comments by Samuel about changes in representations of the Bon, the old Bon, which involved animal sacrifices, sorcery, and shamanic rituals, seems to have metamorphized into a civilized and elite Bon. The seminal works by clerical Bonpo scholars (e.g., Snellgrove 1989 [1961], 1980 [1967], 1987; Kvaerne 1974, 1983, 1995; and Karmay 1972, 2005, 2009, 2014) presented a rather different form of Bon, not only with its own founder and lineage system but also with its own scheme of "taming and civilizing Tibetan people" (Samuel 2013: 80). Indeed, the reformed Bon can be seen as an "unorthodox form of Buddhism" (Kvaerne 1995: 10). According to *Zijid*, the longest version of Shenrab's biography, by the fourteenth-century Bonpo treasure revealer Loden Nyingpo, the systematized Bon religion originated in the land of Olmo Lungring in Tagzig, identified by scholars as Persia (Karmay 2009 [1997]: 104). While Shenrab's life reflects enormous Buddhist influence,[18] biographical sources maintain that he was born eighteen millennia ago, before Buddhism even began.

The Yungdrung Bonpo tradition holds that the legendary founder Tonpa Shenrab Miwo, whose name literally means "the best male *shen*[19] teacher," visited Tibet by way of Zhangzhung (cf. Blezer et al. 2013: 102) in western Tibet to propagate Bon teachings by translating them into Tibetan from Zhangzhung. However, this claim has been recently disputed by Blezer et al. (2013: 118), who found no evidence of the title *shen* in the Zhangzhung period—that is, before the seventh century. Similarly, according to Hoffman (1979), the term *shen* is a title for the best Bon priest rather than a name of

a person, and therefore "not a proper name" of the "mythical founder of the later systematized Bon religion" (25). This has been emphasized by Dotson (2008), who demonstrated that the opposition between Bonpo and *shen* is "based on a false dichotomy" (66), and by Blezer (2008), who regards *shen* as a generic reference to senior or the best Bon priests, who became not only the origin of the founder but also the archaization of Tonpa Shenrab legends (215). As the book progresses, it will be clear that my Bonpo interlocutors were uninformed about the existence of Yungdrung Bon, while still employing the name "Bonpo Tonpa Shenrab" in their rituals.

With these seminal publications by Yungdrung Bonpo scholars, prolongation of the life of Yungdrung Bon religious figures to maintain uninterrupted continuity with the pre-Buddhist Bon, promotion and demotion of Bon/Shen priests, appropriation and corruption of Buddhist narratives, and doctrines including Ati Yoga or Great Perfection (Dzogchen) from the Nyingma[20] school of Tibetan Buddhism and Vinaya became well known within wider Bon scholarship (cf. Huber 2013; Blezer 2008). According to Blezer (2008), a large part of the historicity of antecedents for Yungdrung Bon eludes verification, primarily because the available written sources are not datable before the tenth or eleventh century AD (see also Germano 2005). In other words, the reformed Yungdrung Bon only began to develop as a "self-conscious" Bon under the influence of and in reaction to the proliferation of new Buddhist schools (*chidar/sarma*) from the late tenth century onward (Powers 2007; Van Schaik 2011). Hence, Van Schaik (2011) concluded that Yungdrung Bon is "in truth a new religion" (99), a position that conflicts with the Yungdrung Bonpos' claim of antiquity. Claims about Yungdrung Bon's continuity with pre-Buddhist Bon were also debunked by Huber (2015d), who described it as an "aberrant development" rather than an instance of "unbroken continuity" (378). In this sense, it is ahistorical and devoid of deep religious history. Blezer (2008) makes the following comments on the antiquity of Yungdrung Bon:

> A fascinating aspect of Bon religion is its aura of antiquity, which reaches back into an obscure "pre-Buddhist" past, beyond the Neolithic even. Thus the legendary founder of Bon, Tonpa Shenrab Mibo, is said to have been born eighteen millennia ago.... Stein suggests the legend starts from this respectably remote but remembered past, a past of human proportions. Then, as legend evolves, dates move back in time, perhaps even out of time—to the supra-humane, eventually ending up in pre-history. (201)

Rolf Stein (1988), examining the manuscripts found in the Dunhuang cave in China, concluded that the word "Bon" designates a ritual or invocation rather than a philosophical principle or the name of the reformed religious doctrine (cited in Van Schaik 2013b: 227). However, this conclusion was disputed by Karmay (1998 [1983]), who demonstrated that the manuscripts actually attest to the ubiquity of the unorganized, pre-Buddhist religious practices designated as Bon in the imperial period. The existence of pre-Buddhist Bon practices and more precisely of ritualists with the appellation of Bonpo was recently attested to by Van Schaik (2013b), who examined the previously neglected wooden slips[21] discovered by Aurel Stein (1921) in the Tibetan military settlement in Miran. Yet as Blezer (2008) notes, the existence of Bon during the imperial period does not affect the historicity of the "conscious and organized" Yungdrung Bon that developed in reaction to new Buddhist schools.

The tradition of Yungdrung Bon was officially recognized by the Fourteenth Dalai Lama in 1987, thus giving it the same religious rights and status as other Buddhist schools (Kværne and Thargyal 1993: 45–46). The unorganized pre-Buddhist Bon, on the other hand, without a clear link with Yungdrung Bon continues to be widely practiced across the Himalayas despite the lack of systematized doctrine or formal recognition. Because of the ubiquity of pre-Buddhist or unreformed Bon beliefs, on the one hand, and the acceptance of Yungdrung or reformed Bon as the legitimate pre-Buddhist religion on the other, scholars have sallied forth to make sense of the conundrum of varying Bon identities. Among them the most recent is Samuel (2013), who has analyzed the existing literature on Bon ranging from Tibet to the Himalayan borderlands and postulated that the term "Bon" can variously denote the following, while cautioning us to consider its changing usage (89):

1. Bon and *gshen* known from Dunhuang documents
2. The organized religion of Bon (Yungdrung Bon)—with hereditary lineages, reincarnate lamas, monasteries, and so on, and the associated use of *bon* as equivalent to *chos* and to Sanskrit dharma
3. Bon or *lhabon* as invoker-priests of various kinds in Himalayas
4. Bombo shamans (Tamang)—with myths of competition with Milarepa and other Tibetan lamas
5. Buddhist negative stereotypes of Bon

In my view, the term "Bon" is misused and overused by the scholars of different disciplines to the extent that its original meaning is lost in an academic quest for its unified denotation. Before Western scholarship on Bon weighed in, the historical Buddhist sources[22] referred to Bon as a religion of animist-shamanistic rituals[23] involving propitiation of local deities, animal sacrifices, and spirit mediumship, and as the indigenous religious practices that resisted, opposed, and obstructed the re-establishment of Buddhism in the eighth century in Tibet. Despite the evidence from lived experience of religious praxis in which the term "Bon" is employed as a generic or umbrella designation for the multifarious animistic and shamanic practices of the pre-Buddhist era that fall outside the domain of so-called official religion, including Yungdrung Bon, different scholars have taken the liberty to interpret these pre-Buddhist Bon practices differently.

Due to non-Buddhist elements in Bon and Bon's indigeneity to Tibet, Bhutan, and other Himalayan regions, some scholars have referred to this form of religious life as pre-Buddhist or non-Buddhist (see Ardussi and Pommaret 2007), essentially discounting other non-Bon religions. This is particularly true in recent studies by researchers from the Centre for Bhutan Studies, who in an effort to find a faith-neutral alternative for "Bon" began labeling these pre-Buddhist Bon rituals as "non-Buddhist" practices. Further, it was claimed that this form of Bon practiced in Bhutan characterized by shamanic and animistic practices is fallaciously known as Bon (see Phuntsho 2013), despite the fact that Bhutanese people have been calling their non-Buddhist practices "Bon" for many centuries.

More recently, Huber (2013), in his extended ethnography in the eastern Himalayas, challenged the common notion of Yungdrung Bon as a single "Bon lineal descendant and inheritor" of Tibetan materials dating back before the eleventh century (288). He posited a Sid-pai lha Bon, in which the god Odé Gungyal and other *phywa* gods, who are considered to be the procreators of early Tibetan kings, form a unique system of worship distinct from locally Bon-identified and Yungdrung Bon:

> We can demonstrate the obvious integrity of Srid-pa'i lha Bon as a distinct, self-identified form of "priestly Bon" developed out of a combination of deep roots in ancient narratives and rites, some sharing of material with certain earlier stages in the development of Yungdrung Bon, and features in common with trans-Himalayan priestly cultures. (Huber 2013: 288)

While recognizing the existence of locally Bon-identified ritualists such as Bonpos and *lhami*, Huber (2013), investigating the worship of the specific Sid-pai lha Bon in eastern Bhutan and the Monyul corridor,[24] employed the term "autonomous" to refer to those hereditary Bonpos who, indeed, do not fall under formal Yungdrung Bon but are rather independent and community-specific ritual specialists sharing cognate roles with the ordinary village Bonpos (271). Nonetheless, a clear distinction between Bon and Sid-pai lha Bon is not made or felt by the people who have been worshipping in what Huber (2013) calls "a distinct, self-identified form of priestly Bon" (288) for centuries. Toni Huber's long-standing interest in the Bon shamans resulted in the publication of a two-volume study in 2020 documenting mainly the Sid-pai lha in the extended Himalayas spanning from eastern Bhutan to Arunachal Pradesh in north India. This voluminous book, entitled *Source of Life: Revitalisation Rites and Bon Shamans in Bhutan and the Eastern Himalayas*, was, unfortunately, not available to me while writing this book; hence his findings could not thoroughly be integrated into it.

Let me, however, point out Huber's postulate that directly concerns the labeling of the shamanic ritual complex in question. Based on the analysis of this specific ritual practice of Sid-pai lha, he proposed "mundane rites" as an alternative to what scholars before him variously called "folk religion," "nameless religion," and "pagan religion." These rites are the expressions of everyday concerns for a successful life and therefore are exclusively oriented toward achieving "mundane goals" rather than transcendental aspirations. Given the lack of metaphysical doctrines that are otherwise central to the rites of salvation religion and the inextricability of the Sid-pai lha rites and everyday realities of people in the region, Huber argues that the "mundane rites" in this context must be seen as nonreligious phenomena (2020: 2–14). Yet some of these mundane Bon rites have been long incorporated into village Buddhist practices (see Chapter 8).

As for my part, rather than treating it as improper to refer the pre-Buddhist religious practice as Bon (cf. Van Schaik 2011: 99–100), the problem of scholarship on Bon seems to lie in the legitimacy of the reformed Bonpos' claims over religious continuity with the pre-Buddhist Bon rather than the historicity and diversity of the pre-Buddhist Bon, and their local Bon deities and rituals. Due to the centrality of the worship of community-specific supernatural and ancestral beings in Goleng and their apparent anomalousness with respect to the ethos of institutionalized Buddhism, my understanding of Bon rituals is closest to Ramble's "pagan religion." Nonetheless, this book

does not follow any of these conventions, but rather treats unreformed Bon and reformed Bon as separate entities by clearly distinguishing them—that is, pre-Buddhist Bon, which constitutes an amorphous body of worship of divinities whose identities are linked to particular communities and the territory people share with them, versus Yungdrung Bon, which is known as the reformed or Buddhist-influenced Bon. In fact, I refer to soteriologically oriented Bon as Yungdrung Bon (and to Yungdrung Bonpos), while the other religious corpus that is pragmatically oriented and locally identified as Bon (or *Bon chö*) by both Buddhists and Bonpos themselves is what I mean when I refer to Bon.

As it is evident, Bon is concerned with divination, healing, protection, manipulation of local gods and spirits, and black magic and funerary rituals[25]— whether at the royal court or the houses of common people—without philosophical sophistication. Furthermore, it is characterized by shamanic healings and rituals, such as going into either trance or semitrance or séance and involves soul flight as well as ancestor worship, and as such is believed to have no particular human founder or scripture. In contrast, the centrality of focus in the Yungdrung Bon tradition has shifted from unorganized Bon to institutionalized Bon, with its own lineage system, monastic establishment, and most importantly, scriptural texts and complex philosophies. While one can still find shamanic elements inherent in its practices, they remain peripheral to the core of Yungdrung Bon religiosity.

Apropos of the Nine Ways of Yungdrung Bon (*thegpa gu*), the art and practice of sortileges, destructive and death rituals, and the worship of local gods and deities constitute the first four ways—Bon of cause[26]—and are central to the early Bon practices, while the last five ways—Bon of effect[27]—exclusively concern canonical texts such as sutras and tantras of the reformed Bon (Yungdrung Bon). Excepting the death rituals, there are, however, striking similarities between the ritual practices of the Bon of cause and the form of Bon practiced in Bhutan today. Further, Bonpos have an important ritual relationship with the local nobilities claiming royal ancestry to Tibetan kings, reflecting the associations between Bonpos and emperors of the Tibetan imperial period. The propitiation of the so-called untamed local gods and deities is not only a unique province of Bonpos but also central to the shamanic worldview—the underlying feature that is intrinsically part of Bon.

The idea of the shaman as a universal concept beyond Siberian cultures has attracted criticisms (Kehoe 2000), yet shamans are found in many cultures in the form of spirit mediums[28] and through spirit possessions (see, e.g., Asante

and Mazama 2009; Kendall 2009). In the face of the untidy boundary between shamans and spirit mediums, and for that matter shamanism and spirit possession, a sociological analysis of "ecstasy" as the ontology of spirit possession, spirit mediumship, and shamanism (Lewis 2003) provides avenues for uncovering the common social functions of magical religious practitioners variously known as shamans, mediums, or spirit mediums. Recently, a shamanic conceptual bundle has been proposed by scholars dealing with the anthropology of consciousness. It included having a special relationship with spirits and seeing things that nonshamans cannot see; possessing special knowledge or technique to harm others and to interact with spirits on behalf of ordinary people or the community; doing dramatic performances accompanied by a rhythmic dance; sharing an animistic belief system of the community; having more complex theoretical constructs; assuming a distinct social role with a specific name; undertaking rigorous training; and manifesting their power either in songs or in physical objects (Webb 2013: 62).

In this book, I adopt a broad understanding of shaman so as to incorporate a set of local religious phenomena, including spirit mediumship and spirit possession, all of which are characterized by strong elements that are not only oriented toward serving the community but also share a common modality and structure. Because of their emphasis on the nonshamanic components such as celibacy, monasticism, and scholasticism, the reformed Bon is treated as "Clerical Bon," while Bon is referred to as "Shamanic Bon." The terms "shamanic" and "clerical" as conceptual categories were first applied by Samuel (1993) to distinguish the forms of Clerical and Shamanic Buddhism in the context of Tibetan Buddhist societies. According to Samuel, Clerical Buddhism is embodied by celibate lamas who draw their powers from scholarships and monastic discipline, while Shamanic Buddhism is constituted by Tantric lamas whose powers stem from the quest for enlightenment. The goal of enlightenment and the idea of karma are central to both the Clerical and Shamanic Buddhism (6), yet certain rituals by Tantric masters were argued to be constituting a form of an advanced shamanic practice (11–12). While Shamanic Buddhism in Samuel's scheme is by no means subordinate to Clerical Buddhism, Shamanic Bon remains by and large a marginalized religious phenomenon that is often faced with invalidation from clerical traditions. This shamanic form of Bon (Bon or Shamanic Bon hereafter), which is widespread in Bhutan but still viewed negatively by Buddhist priests, is the main focus of this study.

Bon in Bhutan

The earliest historical documents of proto-Bhutan available are from Buddhist writings that portray proto-Bhutan as a wild territory in need of spiritual cultivation. As maintained by the later Buddhist historiographies written from the twelfth century onward, Buddhism initially arrived in the seventh century when two temples, which are historically ascribed to the Tibetan emperor Songtsen Gampo,[29] were built to vanquish autochthonous beings populating the areas in modern-day Paro and Bumthang. The region was then known as a "dark and barbaric country" (*Mon*) given that *Mon* was a loose exonym used by the early Tibetans to label the non-Indo-Aryan people in the vast Himalayan region to the south of Tibet, who are generally believed to be unexposed to Buddhism. Whether the founding of these two temples is historically verifiable or not, the country is said to have undergone a wave of domestication when the great Buddhist master Padmasambhava from India visited Bhutan in the middle of the eighth century.

The accounts of Padmasambhava's multiple visits were recorded only in the later Buddhist writings. According to one Buddhist source,[30] Padmasambhava arrived in proto-Bhutan (*Mon*) upon the invitation of a certain King Sindhu Raja, locally known as Chakhar Gyalpo (literally "Indian king"), who settled in the present-day Chamkhar in Bumthang following a feud with a certain Indian king Nawoche. As suggested by the local title, that is, Chakhar Gyalpo, it is highly likely that this legend was originally confined to present-day Chamkhar area rather than to the newly designated district of Bumthang, which gained popularity in the seventeenth century. The name of Chamkhar clearly appears to be a transformation of a dialectal word *Chakhar*, which in turn implies "India or Indian," rather than the "Iron Castle,"[31] as claimed by later Buddhist writers. Likewise, the Buddhist rendering of the name *Jakar*,[32] where the district's fortress is based, can also be considered a derivation of the term *Chakhar* and hence an example of Buddhist creolization to accommodate Buddhist ideas and fit the needs of the time.

Whatever the case, it is said that his defection to the north, however, did not bring about a truce until his only son, Tala Mebar, became the victim of the conflict. Disenchanted with Shalging Karpo, who is the chief local deity and also his main tutelary protector, King Sindhu terminated daily propitiation and desecrated the numen's abode. In retribution, Shalging Karpo captured the king's soul (*la*), rendering the latter ill and his future uncertain. But via Padmasambhava's esoteric Tantric means and techniques, the

king's soul (*la*) was restored in the form of a white spider, not only effectively subjugating Shalging Karpo and the other local Bon deities but also mending the two kings' fiery relationship by erecting an oath stone (*nädho*) at a site believed to be the present-day Nabji in Trongsa.[33] By touching it, the two kings accept the Buddhist practice of nonviolence and compassion.

While this narrative cannot be taken seriously as reflecting historical developments, particularly in relation to the claim that this area was then a border between "Mon" and "India," the ubiquity of Bon in proto-Bhutan is also clear from other religious hagiographies, particularly that of Prince Tsangma, who was banished to the southern country of Mon[34] (*Lho Mon*) by his brother Langdarma, the last emperor of Tibet. As the early exonym *Mon* suggests, proto-Bhutan was seen as a unfavorable place of exile inhabited by humans who were unexposed to the enlightened dharma and, of course, by a host of untamed nonhuman others. The idea of autochthonous beings as the primordial owners of different elements of nature is central to Bon. To some extent, even Buddhist monks accept the Bon notion of different facet of nature such as mountain peaks, valleys, lakes, cliffs, and the subterranean world as the real locus of guardian deities (*tsen*), lake deities (*tsomen*), cliff deities (*tsen*), serpent spirits (*lu* or *sadag*), demons (*düd*), and congeries of nonhuman entities. Sometimes, these local numina are benevolent; at other times they are largely punitive. In order to coexist harmoniously with the human neighbors who are considered their "guests" (*jonpo*), they must by placated with rituals by the faithful—propitiatory or petitionary as well as commemorative in nature.

The othering of Bon is obvious, as much of the scholarship on Bhutanese religiosity is devoted to the study of state-sponsored Buddhism. But it is important to understand how Buddhism became a "great tradition," the process of its ascendancy over Bon, and the key figures who played a central role in legitimizing Buddhism as the state religion. While some narratives hold that the Bonpos who resisted the reorganization of their beliefs in Tibet during the Buddhist king Trisong Detsen's campaign fled to Bhutan and other Himalayan regions, the Bon practices in Bhutan are many centuries old. Indeed, religious historiographies, and the nature and forms of various local Bon rituals in wide currency in villages today, suggest that Bon existed in Bhutan long before the arrival of Buddhism.

Following the reinvigoration of Tibetan Buddhist schools, many Tibetan Buddhist masters from different schools and subschools visited Bhutan for various secular and spiritual reasons. Among them, Zhabdrung Ngawang

Namgyal (1594–1651) of the Drukpa Kagyu school occupies a prominent place in modern Bhutanese history. He unified the various warring fiefdoms for the first time in the 1630s and promulgated the dharma by establishing Drukpa Kagyu—a subbranch of the Kagyu school of Tibetan Buddhism—as the state religion. The newly founded country was named "dragon country" (Druk) and introduced a dual system[35] of administration with a spiritual leader and a temporal leader as the head of the clergy and the state, respectively. Another Buddhist master who made remarkable contributions to the Buddhist civilization in pre-Zhabdrung Bhutan was the native treasure revealer Pema Lingpa (1450–1521). As one of five sovereign treasure revealers (*tertongi gyalpo*), he is the only non-Tibetan master to illuminate not only his native land with dharma but also the parts of Tibetan territories and its inhabitants, who, despite living in an equally isolated world (see Shakya 1999), were accustomed to referring to Pema Lingpa's native land as the "southern dark land" (*Mon Yul*).

Pragmatically oriented rituals that are publicly designated as Bon, and after the arrival of Buddhism as Bon religion (*Bon chö*),[36] and dedicated to local deities and spirit beings are widespread in Bhutan. They are meant to ward off evil beings and misfortunes, and concurrently bring about good fortune and healthy life. The term *chö* is apparently an adaptation of a Buddhist term *chö*, which roughly connotes "religion," and it is likely that it was Buddhists who added *chö* to designate Bon as a distinct form of religious practice. Pommaret (2014) preferred the term "Bon *chö*" to Stein's "nameless religion," but the *chö* referent is tautological unless one wishes to maintain a clear distinction between Bon and Bon *chö*. My ethnographic data attests that "Bon" and "Bon *chö*" identify the same thing—Shamanic Bon—rather than mutually exclusive concepts. Hence, in Bhutan, "Bon" is an all-embracing term for religious practices that fall outside the orbit of Buddhists or priests of other institutional religions. These specific rituals, of great local significance, are performed annually by the ritualists, who are neither Buddhist priests (i.e., monks [*gelong*]) nor lay Buddhist practitioners (*gomchen*[37] or *chöpas*) nor Hindu priests, that is, pandits and sadhus.

Bonpo is the formal and common title of Bon priests, some of whom have their own acolytes to assist them. They call themselves Bonpos and are known as such to Buddhist priests and villagers alike. This status is either inherited or obtained as a result of self-learning or divine election. Just as there are specific types of ritualists in Buddhism, local terms such as *lha bon* and *sid-pai lha bon, shenpo, phajo, pawo, nejum*, and the like are employed to

specify Bon ritualists or the regional variations in Bon rituals dedicated to specific local deities. The partial conversion of local deities by later Buddhist masters to Buddhism has not prevented their remaining Bon deities, including a motley crowd of untamed local deities. Rituals to propitiate local deities, which are categorized by Buddhists as "mundane beings," are in fact central to Bon worship.

Among the most common Bon ritualists in the Himalayan region are what anthropologists such as Sherry Ortner and David Holmberg have called Bonpo shamans. In Bhutan, the male and female shamans are commonly known as *pawo* and *pamo* respectively. The regionally distinct ritualists found across Bhutan, regardless of the type of rituals they perform or the class of divinities they propitiate, fall under the umbrella term "Bonpo," sharing features of the "shamanic conceptual bundle" (see Webb 2013: 61–62). Indeed, these shamans perform overlapping social functions, such as reconciling various "socionatural interests" (Viveiros de Castro 2014: 151) by helping community members in times of crisis, increasing harvests, healing the sick, or sometimes harming others at the request of their clients.

Interacting with spirits that cannot be seen or contacted by ordinary people, crossing the hierarchical cosmographies that cannot be crossed by ordinary people, and thereby transcending "ontological fragmentation" (Descola [2004] 2013: 372) involves dancing, whether ludic or stationary, trancing or semitrancing, assisted either by a drum or a bell. While there are overarching components to rituals performed by Bonpos regardless of their specific local names, Bonpos generally do not enter a trance, which is the special province of *pawos* and *pamos*, who have different training. There are some ritualists who function as both Bonpo priest and Bonpo shaman, depending on the ritual settings, however. Yet all the Bonpos possess some shamanic techniques to communicate with the supernatural beings through a semi-trancelike state. In this sense, all Bonpo shamans (*pawo* and *pamo*) are considered complete Bonpos, but not all Bonpos are considered complete shamans. There is distinctive regional usage of the terms *pawo* and *pamo*,[38] and these figures, unlike in Tibet, are not under Buddhist influence.

Although Bon has been studied by historians, theologians, Tibetologists, and anthropologists outside Bhutan, there are no substantive ethnographic publications on Bon in Bhutan, who lack any formal organization. Moreover, the paucity of written records concerning Bon practices makes it difficult to know their history. Until 2002, Shamanic Bon received scant scholarly attention because it was obscured by civilizing Buddhism. The Bhutanese

Bonpo shaman complex was studied by Chhoki (1994), but the most popular study is *Wayo, Wayo—Voices from the Past*, a monograph published by Centre for Bhutan Studies in 2004. Most of the authors of *Wayo, Wayo* were not anthropologists; nonetheless, it describes seven annual rituals in eastern and central Bhutan villages that illustrate the persistence of Bon beliefs and practices. In these rituals, specific divinities are propitiated by feast offering and libation: they range from Odé Gungyal,[39] the chief of the *phywa* gods (Penjore 2004; Dorji 2004; Pelgen 2004), to local deities (Choden 2004; Rapten 2004; Kinga 2004; Galay 2004), to Tonpa Shenrab, who is regarded as a Bonpo master rather than as the founder of Yungdrung Bon. A common feature among these Bon rituals was animal sacrifice, a practice that was abolished in the early twenty-first century by Buddhist masters from Bhutan and Tibet in their campaign to upgrade local people to Buddhism. Nonetheless, people continue to offer meat bought from a shop or obtained from animals that have died from age or disease or been killed by carnivores.

Dorji (2004), who studied *rup* (also spelled *roop*)—a major Bon rite held annually in Goleng and neighboring villages—argues that it is losing its relevance because smart-farming techniques are now applied to boost yields, but my own research seems to belie that conclusion. Similarly, *Wayo, Wayo* portrays Bon as in decline among the younger generation, which is less interested in taking up the Bonpo's role than in career opportunities in urban areas. Penjore (2004) and Dorji (2004), among others, articulated the precarity of the future of Bonpo and their religious practices, not because of the Buddhist antagonism, but because of modernity, which reduces the rituals' relevance. The theme of modern relevance and fewer candidates for the position of Bonpo, rather than Buddhist antagonism, was again the main concern in subsequent publications (e.g., Ardussi and Pommaret 2007; Dorji 2007; Pelgen 2007). However, these conclusions were drawn from the observation of certain annual rituals, with minimal focus on the everyday practices of Bon as a whole. In any case, only spotty anthropological attention has been paid to such community rituals as *kharpu, rup, lha bon*, and Goshing village's *chodpa* in central Bhutan; Brokpa village's *kharphud, lha bon*, and *kharam* rituals in eastern Bhutan; and *lha bod, Radap*, and Chungdu rituals in western Bhutan.

Huber (2013), who conducted an ethnographic study of Bon rite spanning several years, particularly in the eastern Himalayas, presents a rather different picture than the researchers cited in the preceding paragraph: Bon practices continue "unabated until today in the valleys of eastern Bhutan

and the Mon Yul corridor" (263). He employs the term "Sid-pai lha Bon" to refer to local Bon worship in which the *phywa* gods such as Odé Gungyal are invited from their heaven, located in the cosmos above the multilayered sky—specifically thirteen levels (*namrimpa chusum*). Huber indicates that Sid-pai lha Bon worship is widespread among the geographically contiguous communities who share a close linguistic background and genealogical distribution. The speakers of the East-Bodish language group, among them the people of my main field site, Zhemgang, and also the people of Trongsa, Bumthang, and Lhuntse, observe the annual rituals where Odé Gungyal and his retinues are invited by a Bonpo to descend from their celestial realm to their fumigated houses. As I witnessed, the gods always travel via Tibet to replenish the blessings associated with property: a bumper harvest, increasing livestock, and a healthy family.

Goleng and Shobleng have evaded the anthropological gaze since studies have been conducted either by anthropologists in eastern Bhutan or by nonanthropologists in central Bhutan. Two of the numerous healing rituals were recently studied by Taee (2017) and Schrempf (2015b, 2015c), again in eastern Bhutan. Nearly two decades after *Wayo, Wayo*, Shamanic Bon in the villages continues to exert its influence on people's everyday lives through its wide range of rituals and rites that involve worship of higher gods, volatile local deities, and amorphous numina (e.g., Huber 2013, 2020; Pommaret 2009) inhabiting different facets of nature and thus forming a unique pantheon.

Complexity has characterized Bhutanese religiosity since the seventh century, with the advent of Buddhism and the arrival of Padmasambhava in the eighth century. Slowly, the old pre-Buddhist Bon faith lost its supremacy, and pure Buddhism became more syncretic in the process of taming Shamanic Bon. While Buddhists tried to obliterate Bon beliefs and practices, they also incorporated some of them by converting local Bon gods and deities into protectors of Buddhist teachings (Samuel 2013: 77). These dharma protectors are still venerated and are propitiated with specific offerings at regular intervals, not to mention many people who have vast knowledge of Bon rituals and practices although they are Buddhist by faith or at least self-identify as Buddhists.

Bonpos attend Buddhist rituals and are Buddhists at the same time. Yet some exceptional Bonpo shamans refrain from receiving blessings from a Buddhist lama or eating Buddhist offerings (*tsog*) because they claim spiritual supremacy: their skills are the result of direct instruction from the gods

rather than from humans or canonical texts, as is the case with Buddhist monks. Currently, Bon believers have replaced animal sacrifices by making nonmeat offerings, allowing Buddhist to identify them as White Bon, while those who continue with animal sacrifice and black magic rituals carry the Buddhist stereotype of Black Bon. The live sacrifice of chickens, pigs, yaks, and sheep was abolished by decree of the religious heads and authorities, but some live-animal sacrifices, such as yearly yak sacrifice to Ap Chungdu, the protective deity of Haa in western Bhutan, only ceased in 2013. Bon rituals, whether calendric or quotidian, are pragmatically oriented, mainly toward the revitalization of vitality, fertility, and wealth, and take many forms.

Great and Little Traditions?

Through an analysis of the relationship between Bon and Buddhism and the contemporary dynamics of Bhutanese society, this book tackles a longstanding concern of anthropology: cultural persistence and change and religious syncretism. Redfield's idea of great and little traditions comes to the fore as my arguments unfold. His model holds that in any given society there are two traditions: great and little. The former is the tradition of the "reflective few," the urban, elite, and literate, and is universalistic, while the latter is particularistic and constitutes the local beliefs and practices of the "unreflective many," the rural, illiterate peasanty. The distinction between the two traditions has been elaborated in the Indian context by contrasting literary, Sanskritic Hinduism with village religion (Marriot 1955; Srinivas 1952; Singer 1972).

The concept of great and little traditions attracted criticism for its failure to see the village tradition as an integrated cultural system, in that culture cannot be separated into different elements (Dumont and Pocock 1957; Obeyesekere 1963). Among the critics are Dumont and Pocock, who nonetheless presented their own version of two levels: literary, Sanskritic civilization, which reflects the unity of India, and popular culture and religion, which represent diversity (Goody 1986), in effect reproducing the great-little distinction. Historical and contemporary religions have been proposed as ideal categories in preference to great and little, and the continuities and transformations between them as central to the understanding of cultural change (Tambiah 1970). Given that Hindu and Buddhist texts were written in different historical periods, a distinction between the two traditions is

ahistorical and prevents their being treated as a synchronic totality. Studies of Islam have also argued that the religious differences between formal Islam and local beliefs and practices are variants within a single unified tradition, and that neither orthodox nor nonorthodox Islam is "more real" or superior to the other (Asad 1986; see also Geertz 1976).

The distinction between great and little traditions, however, remains valid, as the ideas of a higher tradition permeate many modern village societies (see Stewart 1991). Furthermore, the multiplicity of belief systems and rituals in other Asian countries show that the local religion cannot be glossed as a single tradition with cultural unity. For example, the fact that Buddhism and the local folk practices constitute two heterogeneous belief systems in many historically Buddhist countries suggests that people continue to make distinctions. Buddhism's primacy as a great tradition is clear among the believers, but allegiance to both systems is found in the same society, as well as in the same person as, not a single, but two conflicting religions (Spiro 1982; Sangren 1984). In Southeast Asian societies, localization of features borrowed from Indian great traditions, as well as a universalization of the local beliefs and practices (Pain 2017) through refashioning and reinterpretation, reveals that belief in the existence of another, higher tradition is persistent.

Despite criticisms, the great and little traditions as conceptualized by Redfield remain the most useful way to understand the current relationship between Bon and Buddhism in Goleng. It actually reflects how Bonpos and *chöpas* and to some extent villagers themselves actually talk about of the relationship. Indeed Buddhism and Bon in Goleng are viewed in terms of great and little traditions; people often make the distinction between them explicit. Golengpas define Bon and Buddhism via indigenous conceptions, such as man's religion (*mi chö*) versus god's religion (*lha chö*), and mundane religion (*jigtenpai chö*) or worldly/worldly god's religion (*sid-pai lha chö*) versus supramundane/enlightened or Buddha's religion (*nangpa sangaypai chö*). However, I do not endorse the concept of great and little tradition in the Bhutanese context as it has been applied to the Indian society. Instead, I approach it through modified distinctions, as opposed to conventional contrast between rural and urban, local and translocal, and oral and literary.

Lha chö and *mi chö* are local and cultural idioms for the transcendental religion of the higher divinities and the local practices of the lesser gods. As a mundane religion (*jigtenpai chö*) of worldly gods, Bon is centered on the pragmatic concerns of everyday life, while Buddhism, as a supramundane

or enlightened religion (*nangpa sangaypai chö*), is oriented toward transcending samsara and attaining enlightenment. As the name suggests, Buddhism is higher and more prestigious than Bon, viewed as a religion of worldly concerns. In this sense, *lha chö* and *mi chö* correspond to *nangpa sangaypai chö* and *jigtenpai chö*, but the latter are most common expressions used by Golengpas to refer to Buddhism and Bon respectively. They thereby foreground the supramundanity and mundanity, reflecting the idea of great and little traditions.

Golengpas always identify themselves as Buddhists (*nangpa*), but, as in Southeast and Chinese societies (Spiro 1982; Maspero 1981), they are adherents of more than one religion at the same time. Their religious consciousness is characterized by belief in both Buddhism and Bon, and through participation in the religious activities conducted by lay *chöpas*, celibate monks, or Bonpos (see Chapters 3, 4, 5, 7, 8). Nonetheless, as I shall show, the chief lay *chöpas*, and, for that matter, high monks, and some Bonpo shamans do not participate in each other's rituals. The long-term efforts to replace textless Bon rites with scriptural Buddhist rituals (see Chapter 6) reify two religious systems, rather than create a single tradition.

As the book progresses, it will be clear that Golengpas consider their religious practices to be a composite of great and little traditions. Villagers, Bonpos, and the Buddhist hierarchy are all conscious of a distinction between Buddhist and Bon rituals. Buddhism with its corpus of doctrinal texts, an assembly of monks and lay practitioners, and temples is viewed as a great tradition, while Bon, without canonical texts and places of worship, is perceived as a little tradition. Correspondingly, it is Buddhist practitioners and shamanic Bonpos who constitute the great and little communities. The recognition of Buddhism as a high religion (see Ortner 1989) by people indicates that Golengpa religiosity is by no means a coherent whole, one-dimensional, or without a disjuncture between Buddhism and Bon, thus overshadowing the perceived unity of a single cultural system.

Access to great tradition by the villagers has been greatly improved by globalization in tandem with education and training in literary texts and acquirement of sophisticated knowledge (see Chapter 6), yet the boundary between the great and little traditions in Goleng remains intact, neither replacing the other. Today some Bonpos are educated and have texts for annual Bon rites (see Huber 2020), while lay *chöpas* and monks have not entirely rejected Bon beliefs. This boundary is maintained by the belief in the features of mundanity and supramundanity of the given religion than by the

conventional orality/literacy, peasant/elite, and urban/folk dichotomies. Given that the elements of little tradition are embraced by the elite, and the sacred texts of great tradition are accessed by nonelite others, that is, village literates, this book, through ethnographic evidence, sheds new light on the central distinguishing features of great and little traditions (see Chapter 9).

Fieldwork and Methodology

My main field sites, in general, are Nangkor and Trong counties (*gewog*) of Zhemgang district, although ethnographic accounts from wider central Bhutan,[40] including geographically contiguous districts such as Trongsa, Bumthang, and Wangdiphodrang, appear in the book. These counties are further divided into several subcounties (*chiwog*), but Goleng and Shobleng villages, which make up Goleng *chiwog*, constitute my core research location. Although Zhemgang lags the economic growth and development elsewhere in Bhutan, there is a vibrant religious and cultural life. Zhemgang is notable for villages celebrating unique annual Bon rituals: *rup* in Goleng, Dakpai, Buli, Kikhar, Tsaidhang, Nyakhar, and Shobleng, *shu* in Tali and Buli, and until a few decades ago, *mitsim* in Tagma, *gadhang* in Bjoka and Ngangla, and *kharphud* (also pronounced as *karipa*) in Wamleng and Shingkhar villages (also in parts of eastern Bhutan). In Goleng village, the annual Bon ritual is well known, and so are the performances of daily Bon rituals including, until recently, live-animal sacrifice and black magic ritual, undeterred by the civilizing Buddhism, which penetrated the isolated villages only recently. Furthermore, there exists a nobility (*dung*) characterized by patrilineality, on the one hand, and a matrilineal-based social arrangement in relation to the organization of households and land inheritance, on the other.

My interest in Bon in part emanated from the nature of my upbringing. I was born in a village also in Trong county, Zhemgang, but I come from a Buddhist family that has a long line of hereditary lamas. We are the only family in the village that does not resort to Bonpos and Bonpo shamans during the times of spiritual uncertainty, yet I was well aware of the Bon practices in the villages and have become interested in the construction of the Bon religious landscape as a result of my study. Although I am native to Zhemgang, much of the county and its localized culture, let alone the remote villages, was unfamiliar to me, due to the mountainous terrains

dissected by steep slopes, deep gorges, and narrow valleys. To navigate the villages, I had to find research assistants, who helped me obtain approval from the local administrators and establish contacts with villagers. Studying Goleng was by no means "studying home" for me. Nonetheless, when I first arrived in Goleng I was greatly advantaged due to the familiarity with the local language and customs, and also because of my own identity as a former civil servant, which enabled me to quickly become involved in the people's lives.

I spent twelve months living in Goleng, occasionally traveling to neighboring Shobleng village (Figure 1.1). On my first day in Goleng, I followed a local custom and consulted the village headman (*tsogpa*), who introduced me to a brilliant college student from the village. He subsequently became my primary research assistant for almost half of my research period there. For the first few months, I was fortunate enough to live at his home, but as the fieldwork progressed, I returned to the nearby town of Tingtibi in the evening, as Goleng lacked reliable power and internet connection. I insisted on the nominal monthly rental, but his mother only accepted my own subsistence in kind. Hence, unless there were important events such as rituals or

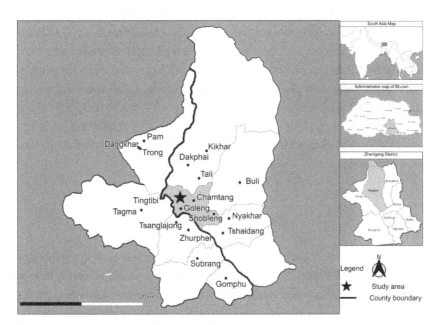

Figure 1.1 Goleng and neighboring villages

meetings in the evening, I wrote up my fieldnotes and transcribed recorded videos and audios more often in Tingtibi than in Goleng proper.

I initially planned to conduct a village census at a later stage of the fieldwork; however, I soon realized that a census would introduce me to each member of the community. Thus it is the demographic information of the village, including the records of family genealogies, that I first started collecting. The village census greatly facilitated building relationships across the village insofar as within the first week of living in the village, I quickly came to know the Bonpos and had witnessed protective and healing rituals. I made extensive use of semistructured interviews with key informants and had informal conversations with a range of people in the village.

When there was not much religious activity in Goleng, my collaborators took me to Wangdiphodrang and beyond to visit two temples that are connected with the Clerical Bon. To supplement my ethnographic data, I also collected several religious texts, interesting biographies, and hagiographies found in the religious establishments. My informants constituted people of different status, power, educational background, and beliefs, in that they were farmers, government employees, village elite (*goshé nyenshé*), housewives, students, and above all priests who had been living in their villages for many years. The Buddhist *chöpas* and a handful of monastic-educated *goshé nyenshés*, and Bonpos identify themselves as Buddhists and Bonpos, respectively. While the general populace self-identifies as Buddhists, they had no problem with performing or attending Bon rituals, which are seen by Buddhist priests as antagonistic to Buddhism. Although my primary informants were Bon priests and ordinary people, I also spent substantial time with the lay Buddhist *chöpas* and their chief—the lay Buddhist priest. Therefore, where possible, I present their contrastive perspectives on the dialectical relationship between Bon and Buddhism, and its persistence and transformation.

Structure of the Book

This book comprises ten chapters. The basic social organization of Goleng is adumbrated in Chapter 2. It introduces the residual feudal elements in local social structure that relate to the distinctions of four key patrilineal groups and the system of matrilineal inheritance practice and matrilocal pattern of

residence. This chapter then illustrates the backdrop to and the motivations for the founding of two Buddhist establishments in Goleng by taking a diachronic view of Bon and Buddhist history from the construction of the first Buddhist temple in the late 1960s down to the present day. Chapter 3 offers ethnographic insights into the complex local cosmology/pantheon and people's shamanic worldview. It looks at Golengpa's beliefs about soul loss and the centrality of five life elements—mana-like substances that inhabit Tibeto-Burman imaginations—which, as the foundation of a successful life, can be threatened by supernatural beings. How threats to Golengpa's health and welfare are warded off is the main concern of Chapter 4. It focuses on family and individual concerns, and addresses threats to Golengpa's everyday life, health, and welfare. Life elements are perceived to be always in a state of flux, and disturbed by meddlesome supernatural beings from the local Bon pantheon.

Chapter 5 looks into the tensions between local practice and missionizing Buddhism and state interventions in Bon practice, especially authorizations of official Bonpo in the villages of Zhemgang district. It centers on Bonpo practitioners, their recruitment and training, their ritual dancing and trance, whether in appeasing the untamed supernatural beings or retrieving lost souls. It also engages the political contexts and consequences of the anti-Bonpo sentiments of the state and key court cases that revolve around village resistance to state intrusion. Chapter 6 provides an exegesis of the biggest annual Bon rite, in which the primordial Bon god Odé Gungyal is invited from a sky realm to the village, primarily to gain the god's blessing for prosperity, including the fertility of crops and livestock and the vitality and fecundity of humans. It underlines the negative consequences of there being an official Bonpo and discusses complications the unofficial Bonpos face at the village level. The fear of pernicious gossip, which is an enormous concern in Goleng, is the focus of Chapter 7. It provides the most detailed ethnographic study of phallic propitiations that are central to avoiding the effects of widespread pernicious gossip in the village and ensuring prosperity. The chapter describes antigossip Bon rituals that emphasize fertility and draw on phallic symbolism.

In Chapter 8, the extent of accommodation of Bon beliefs by Buddhists in the context of naming traditions and syncretic rituals by the lay Buddhists is investigated. It focuses on the incorporation of Bon deities and rituals as a common method to suppress, if not eliminate, Bon priests. Chapter 9 reflects

on the relationship between Buddhism and Shamanic Bon, and Buddhism and Clerical Bon. It discusses religious syncretism in the context of the great and little traditions by relating the findings to the wider anthropological literature. The conclusion highlights the findings of this study on why and how Bon has survived despite more than a millennium of dominant Buddhist religious structure.

2
Goleng Village in Zhemgang District

This chapter introduces Goleng village in Zhemgang district, where I carried out my fieldwork, and its general circumstances. It provides an overview of the local religious landscape and the social organization within which Bon beliefs are embedded. Particular attention is given to the power and structure of the four lineage houses and their specific lineage deities, all of which provide a firm footing for Bon practices. One aim of this chapter is to indicate how the roles of the former *dung* (pronounced as *dhung*) nobility, which was the most powerful among the four lineage houses, have remained central to the annual Bon rite and to the former nobility's own status. The other aim is to foreground the recency of Buddhist arrival, as well as to reveal the weak Buddhist presence in Goleng. The chapter concludes that the existence of *dung* nobility, the recency of Buddhism, and most importantly, the scant Buddhist presence have created fertile grounds for Bon beliefs to continue to exist.

Three Ridges of Zhemgang

The use of "Monyul," "Lho Monyul," and so on by Tibetan Buddhist masters to refer to proto-Bhutan must have been a means to forge their own legitimacy among its non-Buddhist people, who were believed to be living in a "spiritual darkness." These terms were used quite extensively from the eighth century through the seventeenth century, until Zhabdrung unified the country. Zhabdrung was a Tibetan Buddhist master who was recognized as one of the reincarnations of Pema Karpo[1] of Drukpa Kagyu, a sub-branch of the Kagyu school of Tibetan Buddhism. Following opposition from the supporters of the rival claimant, who had the backing of the powerful ruler of Tsang, Zhabdrung fled to Bhutan in 1616 and subsequently unified the warring fiefdoms from his base in western Bhutan.

"Drukpa" is a general term for the modern Bhutanese people. It was applied by Zhabdrung to signify their distinct cultural and religious identity,

particularly distinguishing from the Tibetans. However, the diverse set of regional terms used to refer to people according to the language or dialect they spoke did not disappear but rather began to evolve into distinct regional appellations. Within Bhutan, ethnolinguistic groups are often explained through a politico-economic lens. Apart from the three dominant and popularized ethnolinguistic groups, that is, Western Bhutanese (Nubchogpa/Ngalongpa), Eastern Bhutanese (Sharchogpa), and Southern Bhutanese (Lhotshampa) and the marginal ethnic groups, namely, Monpa, Lhopa, and Brokpa, other groups such as the people of central Bhutan, which I refer to here as Üchogpa for convenience, have been grafted onto overarching Nubchogpa, and the speakers of minority languages remain free-floating without an official categorization. The Üchogpa occupy the four districts of central Bhutan, namely, Lhuntse (also known as Kurtoe), Bumthang, Trongsa, and Zhemgang (also known as Kheng), with a strong religious and cultural affiliation, and most importantly, with a fairly homogenous ethnolinguistic identity.

The vernaculars spoken by people, particularly in Zhemgang, Bumthang, and parts of Trongsa and Lhuntse districts, are mutually intelligible (see Dorji 2011); hence a dominant language of central Bhutan. They, along with the small groups of speakers of Nyenkha, that is, Mangdekha in Trongsa and Dzalakha in Lhuntse, are grouped under the East-Bodish phylum of the non-Tibetic Bodish languages (see van Driem 1994; Hyslop 2013). While the Eastern Bodish languages are closely related, the minority language groups, such as Nyenkha and Dzalakha, are, however, not mutually intelligible with the dominant language. The classification of these dialects by no means reflects "ethnic divisions," as there is no ethnic bond that sets the Üchogpa people or the speakers of the Eastern Bodish languages apart from the mainstream Bhutanese (van Driem 1994: 91).

There are indeed variations within the county itself, let alone in the region, in terms of accents and some vocabularies, but the regional variation is far less intense than the dialects of, for instance, English in England or Hindi in India. Similar variations also exist among the Nubchogpa and Sharchogpa people. Van Driem has demonstrated that these vernaculars can be considered dialects of a same language, as the slight variation in them neither inhibits interdistrict communication nor makes these dialects completely distinct languages. The Peling Buddhist tradition of the Nyingma school is widespread throughout the region in question.

Khengkha—the dialect of Kheng people (Khengpa hereafter)—is the most spoken language in central Bhutan.[2] The Khengpas are currently found all over Bhutan, but the primary settlements are in Zhemgang. According to the senior villagers, the lower half of Trongsa district, that is, from Kuenga Rabten to the south of Zhemgang, is traditionally Kheng, while the upper half is considered Mangde. Nonetheless, Mangdekha is spoken only in some villages of the upper parts of Trongsa. Interdistrict migration within central Bhutan, particularly between Khengpas and the people of Bumthang (Bumthangpas), is well known with the primary aim of evading extractive taxes or for some political reasons. Political conflicts, heavy taxes, and corvée levy forced some Khengpas to migrate further to Dagana in the west and to some parts of eastern Bhutan (Penjore 2009) as well as to Bumthang to the north. Currently, one can also find many Khengpas in Sarpang and Tsirang districts following the recent resettlement program (*zhisar*).

The term "Kheng" connotes several meanings. One popular interpretation is that the region is rich in the plant artemisia (*khempa*) used for fumigation rituals. It is also believed that the term "Kheng" was employed to refer to people who, by virtue of favorable local weather, were experts in paddy cultivation. It also suggests that Kheng is a part of the wider hidden land (Beyul Khempalung)—the term applied by Tibetans to uncharted regions. Interestingly, many parts of Zhemgang are still unmapped, be it by the high Buddhist masters or the state officials. On the other hand, in the book *Gyalrig*,[3] written by the monk scholar Ngawang in the late seventeenth century, the inhabitants of Zhemgang are portrayed as the descendants of Ongma, the youngest son of the Tibetan prince Tsangma (cited in Dorji 2005).

"Kheng-ri Nam-sum" is another ambiguous name for Zhemgang, chiefly used for administrative purposes during the feudal period. It literally means the three different ridges of Kheng, namely, the Outer Kheng (*Pyikor*), Inner Kheng (*Nangkor*), and Tagma-side (*Tagmachog*). In historical and government documents, the term "Kheng-ri Nam-sum" seems to be recorded as the "three regions" of Kheng. Except for the small villages of Berti—a former vassal of the Kheng nobility in Tagma and the only indigenous Monpa group in Zhemgang—and Bjoka in southern Zhemgang, the Khengkha dialect remains the lingua franca. There is, however, no strong evidence to suggest that "Kheng" or "Kheng-ri Nam-sum" was used to refer the people of Zhemgang (Zhemgangpa hereafter) prior to the unification of the country by the forces of Zhabdrung.

Although the present-day temple in Kikhar village in Nangkor county is said to have been built by the Tibetan emperor Songtsen Gampo in the seventh century, and many other villages blessed by Padmasambhava in the eighth century, they were not recorded in mainstream history. The inclusion of only a few temples as the ancient spiritual hub for Buddhism in the religious history is the main factor that decenters these regional establishments, lending greater attention to formally recognized institutions. Currently, the term "Kheng" applies not only to the people of Zhemgang but also to the groups of people in present-day Trongsa, Dagana, and some parts of eastern Bhutan. It is, then, incorrect to use "Kheng" to refer to the Zhemgangpas alone, for it isolates other diasporic communities that should be bracketed together. To avoid this ambiguity, I have limited the usage of this appellation and consistently used "Zhemgang" and "Zhemgangpa."

Zhemgang district comprises eight counties (*gewog*), and each *gewog* has five subcounties (*chiwog*). The county is run by a county headman (*gup*) along with an assistant county headman (*mangmi*) and a clerk (*drungyi*), who are democratically elected for five-year terms. These headmen report to the district governor (*dzongdag*), who is appointed by the state. For centuries, Zhemgang remained marginalized and geographically isolated. Today almost the whole of the district falls under the protected areas of various national parks and sanctuaries created in the 1960s. Many villagers were unaware of such conversions until they began to witness restrictions on their use of forest products, which are an important source of livelihood. Hence, fining villagers for violating the new law has now become quite common.

While conserving the area has enhanced biodiversity and ecosystem processes, it has also isolated the villages from development and economic benefits that parks are supposed to provide them. Under the slogan of "high value, low volume," recreation and tourism are encouraged but are often restricted to other economically advanced districts, and one sees almost no tourists in the Zhemgang district capital, never mind the villages, which are actually of global interest, given the rich ecosystem. Regulations protecting the environment led to the recent veto of a bill for the construction of a hydropower project and omission of Zhemgang from the so-called tourism flagship program run by the government in 2019. Although the region is connected by the Sarbang-Trongsa highway, road travel during the summer is literally impossible. Flooding and landslides are frequently triggered by the torrential rain of the long monsoon season, and Zhemgang can remain completely cut off for weeks. In the far-flung counties, some villages have not

received electrification yet, and mobile and internet connectivity is still in its infancy.

Essentially, Zhemgang is a topographical name given to a hilltop (*gang*) where a certain monk by the name of "Zhang" meditated. Lama Zhang is said to have had a toxic relationship with a chieftain whose identity is contested in historical sources and diabolized in local narratives with the likes of Langdarma of Tibet.[4] Whatever the identity, the villagers believe that collective fear of the chieftain led to the assassination of Lama by stuffing his throat with scarves. Hence as the name suggests, "Trong" village which is located close to the Zhemgang Dzong is blamed for the murder (*trong*) of the monk, although it is plausible that *trong* is a later deformation of *krong*, which also denotes village. Similarly, there is no authentic source explaining the identity of Lama, his date of his arrival, or the construction of his hermitage.

The local narratives claim that the monk was a prominent Drukpa Kagyu lama from Tibet, but there is no obvious evidence to support them. Other religious personalities claim that the person who meditated on the hilltop was a Tibetan lama by the name of Zhang Yudrakpa Tsondru Drakpa, of the Tsalpa Kagyu tradition, who visited western Bhutan, particularly Wangdiphodrang, in the twelfth century. If this version is correct, the lama does not belong to Drukpa Kagyu, nor did he die at the hands of locals, but rather returned to his homeland in Tibet. Thus we are left with one option—that is, to look for the answer within the locality that gave birth to the lore of Zhang but has been more or less neglected by previous studies. One way to trace the history of Zhang is to turn to the biography of Sakya Özer, which was written in the mid-1900s by Senge Dorji of Lamai Gonpa of Gomphu—the original seat (*dhensa*) where Sakya Özer was born and spent his early years. This is probably the only text that discusses the early religious history not only of Gomphu but of Zhemgang as a whole, and researchers have not had access to it. The biographic account that shares a common theme with the legends discussed elsewhere is summarized below:

> During the time of Lama Sakya Özer, dharma transmission in Gomphu was challenged by a powerful Bonpo shaman (*pawo*) who had the power to cross a mountain with a single bang on his drum. The lama subsequently lost hope of propagating dharma in the village and anointed his kindred-cum-heart-son[5] Ngawang Chogyal as his regent instead. The regent was then granted a prophecy to continue his teachings, which must perdure through time. Before long, the lama transformed into a peacock and

circumambulated the village three times and left it, never to return. Later, Ngawang established a *choje* line and initially propagated Mahamudra (*phyag chen*) tradition of the Kagyu school. His son Gompo Tingzin practiced Dorji Lingpa Terchö, while from Sithar Dondup onward, Peling became their main tradition. Later Dorji Tharchen, the sixth hereditary lama, married into another branch of nobility, namely Tsakaling Choje of Mongar.[6]

As seen in this summary, the last part of the life of Sakya Özer is undocumented, but what is clear from the text is that he never returned to his seat in Gomphu. Senge Dorji, who wrote this biography in the twentieth century, was the eighth hereditary lama and passed away in the late 1980s at the age of eighty-four. By genealogical reckoning, assuming that the seven hereditary lamas before him lived to seventy years, Sakya Özer would have been a contemporary of Pema Lingpa, who lived in the mid-fifteenth century. Senge distinguishes Zhang from Sakya Özer and considers the latter to be the second master to bless Zhemgang. However, in absence of the historicity of his later life at his birthplace on the one hand, and the narratives concerning the assassination of the unidentified Lama Zhang on the other, it is a tenable to argue that they might have been the same person rather than a reincarnate of another (cf. Phuntsho 2013). In other words, during his brief sojourn in Zhemgang proper, which ended in a fateful incident, the new locals probably took him for a Tibetan lama. Gomphu has, like many villages in Bhutan, the characteristics of *beyul* by all accounts. *Beyul* is described as a hidden, mountainous, and isolated land believed to be blessed by Guru Padmasambhava. As the name "Gomphu," which is equivalent to "retreat mountain," suggests, there is a sacred rock (*neygor*) in the village with the imprint of Guru Rinpoche's hat, resembling Pema *Khabi*.[7] The locals believe that their village was blessed by Guru after he meditated (*gom*) in this cave on the hill (*phu*).

As in many rural villages in Bhutan, the people of Zhemgang are religiously pluralistic, as some of the rural villagers until the twentieth century remained relatively backward in terms of core Buddhist teachings, that is, philosophical Buddhism. Apart from Lama Sakya Özer and his successors in Gomphu, it seems there were few or no major local Buddhist figures from Zhemgang. Currently, while Zhemgang has seen an increasing number of people ordained as monks at institutions within the country and in India since the late twentieth century, the vast majority of Buddhist masters in the country are believed to have reincarnated elsewhere, as though to reflect the

opposition by the Bonpo shaman to the lama and the anathema consequent on the assassination by the people of Trong. Many of the villages in Zhemgang are still isolated by geography to the extent that they are visited by these reincarnate lamas from other more developed districts only infrequently.

One popular adage that exalts Zhemgang is certainly the old aphorism: "Zhemgang is the sphere of nobilities; Bumthang is the sphere of dharma." In this expression, Zhemgang is analogous to the "land of nobility" (*dung-gi khorlo*), and it holds true even after the fall of nobilities in the twentieth century. These prominent nobilities were, in effect, feudal chieftains holding various titles of nobles such as *choje, dungje, khoche, ponpo, ponmo*, or even *gadpo*, and wielded overwhelming power within central Bhutan. Their control, however, varied greatly according to the size and power of their principalities. Except for *ponmo*, which is the title given to the wife of the *ponpo*, these are patrilineal titles reserved for men. *Choje* translates to "lords of dharma" and identifies the descendants of Buddhist luminaries who gave up the vow of celibacy to continue the line of a politico-religious title, either for spiritual or for political reasons. While *choje* are the inheritors of Buddhist religious titles who are obliged to perform religious activities for the community, *dungje* or simply *dung*, are generally secular in nature and associated with Bon. The *dung* ascribes their origin to certain Bon divinities, though both *choje* and *dungje* possess either religious or political status, or sometimes both. The *khoche* fall under the same rubric as *dungje* in the sense that they are concerned with the secular rather than Buddhist religious affairs. Finally, the *ponpo, ponmo,* and *gadpo* are also the successor to political titles, but it is highly unlikely that they have a direct religious ancestry.

The origin of *dung* nobilities in Bhutan predates the acquisition of written literature. Hence the paucity of written records explaining the origin of *dung* invites sweeping conjectures about their pedigrees. Michael Aris (1979), who is probably the first Western historian to examine the *dung* nobility, postulated that they were indigenous to central Bhutan and the Tawang[8] region of India, while Ardussi (2004) demonstrated that they belonged to "obstinate *dung*" (*dung reng*) of southern Tibet bordering Bhutan, who, to avoid subordination to Phagpa Pelzang (1320–1370) and his Sakya government, fled to Bhutan and the Tawang region in the late fourteenth century. The invincibility of these *dung* in the region provoked military intervention by the Sakya government, and the hypothesis is that instead of surrendering to Sakya government forces, they migrated southward. As described in Gyalrig, the traditional historians ascribe the origin of *dung* to a divine being who

is associated with the Bon divinity. This divine being is particularly of interest here, as he is no other than the god (*lha*) Odé Gungyal, who will be examined in detail in Chapter 6. Aligning themselves with the oral sources, traditional historians claimed that the *dung* of Ura village in Bumthang was the progenitor of the subsequent *dungs* of central Bhutan, including present-day Mongar (Zhongar). The mythical narrative about the Ura *dung* as cited in Phuntsho (2014: 428–447) is summarized below:

> The people of Ura prayed to the god Odé Gungyal to bless them with a leader after the death of Prince Khikha Ratho, who was, because of his grotesque mien and religious beliefs, banished by King Trisong Deutsen in the eighth century. Odé Gungyal dispatched his proxy, Guse Langling, from his celestial realm, who like early Tibetan kings descended to earth using a supernatural rope (*mu thag*) that connects heaven and earth. Once he landed on earth, he turned into a clear light and dissolved into a certain lady of Ura village. Their child was later named as Lhagon Palchen. However, the grandson of Lhagon died without an heir to succeed his father, Lhazang. But before he passed away, Drakpa Wangchuck advised them to look for his reincarnation in Yarlung, Tibet. They later found the boy in the family of Yarlung kings and later became *dung* Lhawang Drakpa. The Ura people abducted the boy to Bumthang, and he gave rise to several *dung* families in Bumthang. The grandson of Lhawang, Nima Wangchuck, started the next generation of *dungs* in Zhemgang and Mongar.

The above narratives suggest that the people of proto-Bhutan worshiped the powerful Bon god Odé Gungyal and, for that matter, practiced Bon. The use of the word "god" (*lha*) as part of their names by these *dung* nobilities not only foregrounds their divine associations but also undergirds the significance of the god Odé to the lives of ordinary people. While there are other versions on the origins of *dung*, the commonality between them is the claim that the Yarlung boy was the descendant of Tibetan emperor Trisong Deutsen and that he was abducted. Yet other versions claim that the *dung* and *khoche* nobilities trace their origin to Prince Tsangma of the Yarlung dynasty, who was banished by his brother Langdarma in the ninth century. Later, the reascription of the origins of the future generation of *dungs* to the same divine being of antiquity legitimized their dominance and power, given that the notion of divine association, noble origin, and prophetic birth shape the social, religious, and political lives of the faithful. Hence their local hegemony may

be attributable to their association with higher beings including the Yarlung kings, which not only provided the basis for their political legitimacy but also kept at bay any subversive campaigns within the principality.

The tradition holds that the prince whose body was never exposed to defilement at the court of his father became grossly polluted upon interaction with the local people, who unlike Tibetans were not illuminated by the Buddha dharma and by the same token did not attain spiritual realization. Local foods and village girls constituted "impurity" and led to a partial loss of his celestial consciousness. Further, the prince became intoxicated and fathered many children across central and eastern Bhutan, whose progenies became the *dung* nobilities. According to this theory, they are reckoned as the polluted *dung* (*nyedung*) which literally means the nobility procreated out of wedlock between the sullied divine prince and the local girls. There is another variant of *dung* that apparently ascribes nonroyal descent to them. It is associated with the three brothers[9] of Lhalung Palgyi Dorji[10] (Ardussi 2004: 69), who, following the assassination of King Langdarma, fled to Bumthang and started noble families. While the argument on the origin of *dung* made by John Ardussi is inferential, the narratives of pre-fourteenth-century *dung* were, as I shall show later, in wide circulation among the nobilities themselves and the villagers who were under their strong influence and domination. This leaves us in doubt about the apical ancestor or the single origin of nobilities who may have actually developed diachronically at different historical periods. Whatever the case may be, with the arrival of Buddhist masters from Tibet, the Buddhist *choje* prospered, while the Bon *dungje* gradually became marginalized in Bhutan as a whole.

In Zhemgang, history has recorded only nine prominent *dung* families, but there is evidence of existence of the several other nobilities ruling their territory independently until the unification by Zhabdrung. Given the bifurcation of nobilities over time, the exact number of *dung* nobilities is difficult to ascertain. Although their feudal powers are now reduced to nothing, some of their descendants can be traced to the present day through both patrilineal and matrilineal lines. The *dungs* mostly ruled from their bases at Shingkhar, Tunglabi, and Kuther in Pyikor in the north adjoining Bumthang; Tagma, Zurphel, and Subrang in Tagmachog; and Nyakhar in Nangkor. The two *khoche* nobilities controlled their principality from Ngangla and Bjoka in southern Zhemgang adjoining eastern Bhutan, while the *ponpo* nobilities controlled their fief from Buli, Tali, Kikhar, and Dakphai in Nagkor. Goshing, Kalamti, and Phangkar in southern Zhemgang had their own *dungs*, while

the prominent *gadpos* ruled their fiefdom from Gomphu in Tagmachog, and Wamleng, Bardo, and Khomshar in Pyikor. Among these nobilities, the Nyakhar *dung* was by far the most powerful.

There are several other *dungs* who were apparently not recorded in the political history of Bhutan. In Gomphu, *dung* families, namely Rakshong, Bindulung, and Gomphu *dungs*, once ruled their fief from lower Gomphu, and the structural ruins of their establishment can be still found. The rivalry between Nyakhar and Gomphu *dungs*, which led to a conflict in the pre-Zhabdrung era, is well remembered by both sides. As will be seen later, there is also a *dung* family in Goleng that still enjoys social prerogatives, especially during the annual Bon rites.

Goleng Village

There are several local narratives concerning the meaning of the name of the village. However, in the absence of historical evidence, the villagers, including the *goshé nyenshé*, concur that these meanings are attributable to its physical features. The most popular and hitherto the most favored rendering states that Goleng, which literally means "barley land," was once a field of abundant barley. Barley farming was perhaps the main agricultural activity of the Goleng, although one cannot find a single barley field today. After the introduction of rice in the 1960s, barley and buckwheat did not compare either in taste or in yield.

Another interpretation of the Goleng name is a Buddhist version. According to the chief lay *chöpa*, Lopön Pema Wangchuck, a male spirit (*nepo*) is believed to be dwelling in the hill where the present-day village temple was built. The spirit is manifested in the shape of a hill that is identical to the head (*go*) of a bull (*lang*). In other words, the present temple was built in order to subdue one of the many supernatural beings that inhabit parts of the village, echoing the prevailing idea of Buddhist subjugation of evil spirit beings and the widespread tendency of Bhutanese people to connect everything with Buddhism. Still others claim the two mountains above the village resemble the horns of a bull. Another interesting rendition of the word *go* is to "begin." Goleng village is supposedly the first village in the region to institutionalize festivals such as the annual *rup*, which is the major Bon rite. However, the significance of the second word in the village name, *leng*, in the last two interpretations is unknown.

The hillside on which the village is situated is studded with dwellings of varying sizes, and the green fields are enclosed with fences to keep out domestic animals (see Figure 2.1). With an elevation under six hundred meters, Goleng is a prosperous village in Nangkor county, facing Tsanglajong village in Trong county. It dominates the thundering Mangdechu River below that separates the two villages, both spatially and politically. The weather is generally unreliable, though strong heat dominates the peak summer. During the monsoon (June–September), Goleng receives heavy but irregular rainfall. Since 2009, the village has been connected by a farm road to the Tingtibi-Gomphu highway in the south and to Tali and Buli in the north. Nonetheless, fallen trees and landslides often obstruct travel by car in summer, while in winter, because of the poor roads, it takes at least forty-five minutes from either destination to arrive in Goleng.

The five subcounties, Dakphel-Tali, Buli, Goleng, Nyakhar, and Dunbang, constitute Nangkor county, whose office is permanently based in Buli to the northeast of Goleng. Each subcounty is headed by a subcounty headman (*tsogpa*) and multiple village headmen (*pirpön*) who, lacking formal office spaces, perform their duties from home. Goleng county is composed of

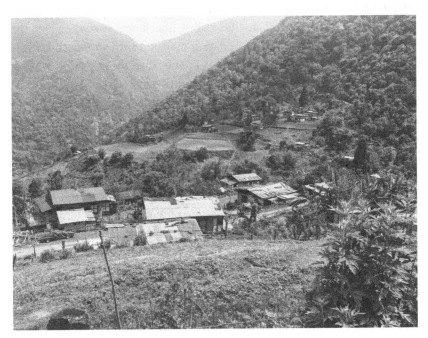

Figure 2.1 A partial view of Goleng village

Goleng, Chamtang, and Shobleng villages and falls under the county's direct jurisdiction. In 2017, Goleng county had a population of 331 in sixty-nine households, of which ten are in Shobleng and five in Chamtang villages respectively. There is a small Western-style school in Goleng with fewer than one hundred students. While this primary school was established in 2003, a basic health unit (BHU) is yet to be built in the village. The BHU located near the county office in Buli, and the small hospital in Yebilaptsa in Trong county, are the primary healthcare centers Golengpas visit in the case of minor illnesses. Golengpa patients with severe health conditions are referred to tertiary hospitals in either Gelephu or Thimphu.

Social Organization: Dung, Kudrung, Pirpön, and Mamai Lineage Houses

Before the proliferation of nobilities from the eighth century onward, most of whom associate their pedigree with the early Tibetan kings and Buddhist luminaries, the social organization seems to have been purely matrilineal. With the arrival of religious and aristocratic families from Tibet, patrilineality reinforced the religious and political hegemony they brought with them but did not eliminate the existing matrilineal system. In fact, the nobilities have ended up accommodating matrilineality, so that today it is only titles that are patrilineally inherited. For instance, the fissioning of noble families by migration to other areas from Bumthang to start a new family line can be in part ascribed to the strong matrilineal system, given that moving to the wife's estates at marriage is still prevalent. Politically, male descendants who inherit the title of "noble" are no longer revered, nor have they held a titular position since the abolition of serfdom in 1958. This amendment to the patrilineal rule has catapulted the family system back to matrilineal social arrangement—the system that has been widespread since proto-Bhutan.

Women in Goleng are the heads of many households. The term *gung* is used interchangeably with *thab*, which in turn is synonymous with "hearth," to refer to the household. A typical Golengpa family constitutes parents along with a married daughter, her husband, and their children and other members of the family of their parents, especially of the mother's (Barth and Wikan 2011: 14–17). However, there is no specific uniformity in defining the meaning of family. Villagers regard the family (*zatsang* or *nangtsang*) as the house of relatives who eat together at the common *thab* no matter how

distant or close they may be biologically. In this way *zatsang* is related to the kitchen (*thab tsang*), in terms of both meaning and function. Co-residents, whether they be close or distant relatives, who cook on a different *thab* are considered to be a distinct household. Although the majority of Golengpas live in an extended family, some have an intact nuclear family unit.

The house and the land are inherited by the eldest daughter, or sometimes by the youngest daughter. It is the inheritor of the natal house who takes up the position of head of household (*maipa*). The other daughters practice neolocal residence, generally in the same village and inherit only land (usually less than the new head) (see Wikan 2012; Tashi 2022), but they automatically become the heads of new households/houses built on their share of land, which is split up and scattered in separate blocks across the village. Adult men have in the past generally had no entitlements to any part of their matrilineal family estate. Community rituals are organized on the basis of matrilineal descent (*ru*) group. The eldest daughter assumes the role of a mother and is often regarded as her deputy (*amai tsab*). For assuming and performing the familial duties, the eldest daughter is given a larger share of the inheritance. In 1995, following amendments to the Marriage (1980) and Inheritance Acts (1980) that enshrine equal rights to inheritance, there has been a rise in the equal division of land between the daughters and sons. Nevertheless, Golengpas still favor daughters with an extra share of land that operates as an important asset for woman (cf. Pain and Pema 2004). On the other hand, among the nomads and the handful of villages in the lower part of Zhemgang, patrilineal primogeniture is still prevalent, whereby the eldest son is regarded as acting father (*apai tsab*).

Except for households without a daughter, husbands move to their wife's house, bringing nothing with them. First-cousin unions were permitted until the recent legislation. Male-headed households in the former nonnoble population are only found in families without daughters. In such cases, the son takes a wife (*nama*) either from the same or a different village. The in-marrying woman will have a portion of land inherited from her mother, and the landholdings and properties inherited by the husband are transmitted to his daughters rather than to his sons or his sister's sons and daughters. The same is the case with the matrilineal land. There are four lineage louses, namely Dung, Kudrung, Pirpön, and Mamai Houses, that carry political titles even today in Goleng, but the titles are only applied to the male line. It is the women who retain strong social and economic ties with the lineage house. That is to say that after the establishment of a new household

(*gungsar*) by moving out, and thus physically breaking free from their natal house—whether the lineage house or its collateral households—the daughters still belong to the same lineage house and play a significant role in performing corporate annual rituals and rites.

While Golengpas practice uxorilocal residence, there is no disjuncture between the role of a genitor and father in the sense that the latter assumes absolute authority over his children. In other words, this form of matrilineal system has little effect on spousal relations. A woman's brother has no right or control over his sister's land, nor any role in the upbringing of his sister's children. The wife's brother may, however, single-handedly build a house for the family, but he cannot inherit the house he built. Instead, he moves out of the house upon marriage. The relationship with his sister's children actually weakens thereafter, but nonetheless, children maintain a stronger kinship ties with maternal uncles than with paternal uncles. The males inherit family titles and statuses, but they sever their connection with their own by joining their wife's lineage house. Since the house and land are passed on matrilineally, the new households forming from the house of nobility, however, may be known by the title of the in-marrying husband, but not at the same rank as the four main lineage houses unless he branches off to other villages without nobilities. There seems to be no competition or conflict between the in-marrying husbands/fathers and their wife's brothers/brothers-in-law.

Another aspect of this matrilineal social system is the informality and instability of marriage. Customary courtship involves informal visits at night by a boy to a girl's room with the requirement he leave the house before dawn. In western Bhutan, this practice is labeled night-roaming (*phyiru shelni*), while in central Bhutan it is explicitly known as "going toward a girl" (*bomethna*) (see Penjore 2009: 1). The amorous song[11] below illustrates the currency of the nightly visits even in western Bhutan (see Yangdon 2015: 34):

BOY: Do not bolt the door at night, I will bring you betel nuts and leaves.
GIRL: I do not want them, but give me money. Shoes make noise, so put on your socks and come!

There is no formal marriage ceremony, and cohabitation is developed through such nightly visits, most of which are noncontractual relationships. The economic bond between the parties involved in the nightly visit only comes to the fore when they are seen "publicly together"—that is,

transitioning from "furtive" to "conspicuous" visits—"staying for breakfast" (Wikan 2012: 230). Getting caught in the nightly visit by the girl's parents brings unwanted trouble to the visiting boy—especially if he has no intention of marrying the girl—leading to the termination of night visits. One can come across a household setting wherein a mother lives with her children, often from different fathers and thus without a stable resident father. The children born out of wedlock as a result of the nightly visiting system are currently lightly stigmatized in most urban areas in that their father is referred to as "cock" (*khari*) upon the failure of mothers to identify the child's genitor. Yet the identification of the child's father does not always culminate in the contraction of marriage, nor a contribution to the child's upbringing by the genitor. "Fatherless" children are not a barrier to a woman remarrying. While there seems to be no ambiguity between the social roles of mother's brothers and fathers/husbands, there is no terminological distinction between wives and women.

In the absence of the caste system in Bhutan, social stratification up until the late 1950s was based on the taxation structure between the one who received payment and those who paid it. The state and the nobilities extracted taxes from the commoners (*miser*) annually both in kind and in labor. The commoners were stratified into two classes of taxpayers: *khraipa* and *tsungmapa*. The *khraipas* through their respective district headquarters had a heavy tax obligation to the state. The *tsungmapa* were also legitimate taxpayers, but, unlike *khraipa*, they paid lower taxes to the collateral descendants of the royals instead (Barth 2018: 51), particularly to the powerful Pelripa and Wanglingpa Houses in Bumthang. The taxpayers owned lands, and by virtue of paying higher taxes to the state, *khraipas* were of higher rank.

According to Penjore (2009), *khraipas* automatically became *tsungmapas* when they could not manage to pay the taxes imposed on them. Below the *tsungmapa* were the two nontaxpaying underclasses: serfs and slaves. The serfs (*drapa*) worked entirely for the nobility, but they had some rights and entitlements. The slaves (*zapa*) on the other hand were the de jure property of the nobles and as a result trapped on the lowest rung of the social ladder. This form of social stratum underwent a major change in the 1950s with the abolition of slavery, land redistribution, and nobility by the third king (r. 1952–1972) (see Ura 1994: 31). Golengpas were *khraipas* and paid taxes to the state until late 1950s. There are no traces of the presence of *tsungmapa*, although at one point in time some feudal taxpayers would have worked for

their *dung* family. Golengpas claim that Goleng *dung* neither paid taxes nor contributed labor to the state. During the theocracy (1651–1907) many of the nobilities actually extracted taxes from sizable commoner populations, but after their dramatic downfall, they acted as go-betweens whose task was to deliver taxes to the state.

For the rest of the Golengpas, taxes and corvées were two things that had far-reaching impact on their lives. Corvée labor for the nobles and other powerful houses was a frequent episode of their hard agriculture life. When it came to corvée, there was no exemption, and regardless of its size, each household had to surrender one or two adults depending on the nature and urgency of the work. They were obligated to perform exacting obligations such as building *dzongs*, herding the cattle of the nobility, and transporting government officials from one village to another. The main form of tax payment was in terms of goods and services. Common goods were cotton, *Rubia cordifolia* (*tsuth*), *Strobilanthes cusia* (*sangja*), dairy products, turmeric (*yongka*), different hand-woven fabrics, and so on (cf. Ura 1994). The tax contributions were carried to Dolepchen in Pangzur village, Trongsa, and from there the people of Trongsa took care of the package until their border with Bumthang district. Tax payments were finally delivered to the lords in Bumthang by the commoners of Bumthang. The same patterns followed within Zhemgang in that people of a particular *gewog* carried their taxes to the perimeter of the next county, from which the people of that county took them toward their destination. The corvée labor system has disappeared among urban societies though remnants persist in villages without motorable roads.

Goleng seems to be a fairly new settlement of the local diaspora who migrated from the nearby villages. According to Dawa Bidha, who is the oldest person in the village, Goleng had only six households in 1919. The most important lineage is certainly that of the former nobility—Dung House—which clearly predates the rest of the houses. The senior citizens, including the nonagenarians, agree that even their grandparents do not know when the main Dung House was built. As its design shares some aesthetic similarities with the temple, Golengpas often argue that it was once their community temple before offering it to *dung*. The factuality of this narrative is questionable since no history of Goleng is available before the rise of the nobility. Members of the nobility were highly respected, and the evidence suggests that the early Goleng *dung* enjoyed similar social privileges as nobilities elsewhere. A Golengpa elder recalls their situation:

In the olden days, we were so poor that we hardly had anything to eat. It was only the *dung* family who were quite well-off. They would send other members of the community to fetch water from the stream below the village, which nearly takes three hours to return from. In return for the labor, they were rewarded with a handful of maize grains.

The other three main houses are Mamai (also known as Zurpa), Kudrung, and Pirpön. Apart from the Mamai House, all of them were politically active. The Mamai House seems to have received its name from a certain Golengpa woman who evaded tax by "edging away" (*zur*) from the center of the village. Considering the number of new households it spawned over time, the term *mamai*, which means "natal house," has gained currency in recent times. Golengpas argue that the consanguinity between Kudrung and Mamai Houses is incontrovertible. A local narrative has it that a certain Golengpa man worked for the deputy governor (*drungpa*) of Shingkhar village as his attendant (*kudrung/kudrungpa*). He gave rise to a new lineage and became the sole progenitor of the future *kudrung* households. The Shingkhar *drungpa* himself worked for Pangtey *pön* of Bumthang by assisting the latter in collecting taxes in the region. The son of a Goleng *dung* whose name is unknown married a woman who was a sister to the *kudrung*. The *kudrung* is said to have sought tax exemption for his sister by taking advantage of his connection with the Pangtey *pön*. In this sense, the Mamai House claims a common descent with the Dung House. Such reckoning is indeed characteristic of people who share a common apical ancestor.

The *kudrung* was responsible for coordinating the timely tax payment by the *tsungmapas* of the nearby villages of Tsaidhang, Nyakhar, Dunbang, Singkhar, and so on, and as a result he must have been fairly powerful in the villages with the majority of *tsungmapas*. Similarly, like the *kudrung*, a certain Golengpa man worked as a subcounty headman (*pirpön*) and later he started a new house—Pirpön—in Goleng. He was also heavily involved in collecting taxes primarily from the *khraipas*. It was the *pirpön* who oversaw and liaised with external tax-collectors like the factotum (*garpa*) and other officials responsible for exacting taxes. Additional responsibilities of the *pirpön* included arranging boarding and lodging, identifying hosts for the *garpa*, and assigning corvée works. Since Golengpas were primarily *khraipa* taxpayers, the *pirpön* might have been more powerful than the *kudrung*, at least in Goleng.

The Pirpön House certainly came into being after the emergence of Mamai and Kudrung Houses, however, evidence suggests that these two politically active houses worked side by side. But it is difficult to ascertain if the primal *kudrung* and *pirpön* are related or if they descended from two separate ancestors, although neither family is considered to be nobility. In any case, these four main houses are considered the progenitors of present-day Golengpa households and the center for their collective religious activities. The political power of the Goleng *dung* has been already reduced to social powers that are only significant to the community rituals such as the annual Bon rite—*rup*. The Goleng nobility has lost its higher status and autonomy of the pre-1950s, and outside the annual Bon ritual setting, noble lineage is structurally of little significance to the populace. Such a dramatic fall in political power was the result of rising powers within the nobility's territory. For instance, the new *kudrung* and *pirpön* received the support of other political families who became more powerful than Goleng *dung*.

The Goleng *Dung* Nobility and Lineage Deities

In general, the power of the nobilities of Zhemgang varied greatly according to the era and region. While the political power of some nobilities extended to several villages, the power of many nobilities was limited to their own hamlets. Nonetheless, after the military campaign by the forces of Zhabdrung in the seventeenth century and the subsequent loss of ancestral wealth, their power today is whittled down almost to nothing. The impression is of their being a fairly dormant player in the arena of power struggle between rival nobilities of Zhemgang. Yet despite their dormant projection in the wider theocratic context, patrimonial treasures of the Goleng *dung* underlie their dominance, at least within the village. When the representative of the people (*chimi*) Kunzang from Tali village joined the Goleng *dung* family as an inmarrying husband (*magpa*) circa 1966, the *dung* family had no more male descendants. However, the family was still rich and owned its own estate including lands, rare pearls, ivory tusks, eight thousand verses (*Gedtongpa*) written in gold, an alcohol vase (*jandhom*) made from elephant bone, shields (*dali chamu*), and so on. As popular expression implies that one cannot be a man of power without being a man of wealth, they would have been fairly powerful in Goleng through 1960s.

As *magpa* and *chimi*, Kunzang became very powerful in the 1960s. His power was, however, exercised mostly to swindle his wife and the *dung* family by taking their antiques, allegedly for the "inspection" by dubious experts. With his support, his disrobed monk son purloined *Gedtongpa* and other antiquities from the Dung House. When the community discovered this theft, they filed a lawsuit at the district court. According to Golengpas, the legal proceedings, which concluded in 2006, declared Kunzang of guilty of larceny and sentenced him to a jail term of six months. The ownership of *Gedtongpa* has since then been transferred to the community, and they are housed inside the community temple. The other possessions could not be tracked down either by the *dung* family or by community members. Currently, except for the large statue of Zhabdrung, which they claim was gifted by Nyakhar *dung* in the seventeenth century, the Goleng *dung* possesses nothing that is of religious or political significance. The statue of Zhabdrung at the Dung House actually indicates their subordination to the center rule and by extension, the end of their local hegemony. Hence, they probably received it from Migyur Tempa rather than the Nyakhar *dung*, who was by far more powerful and resistant to the Zhabdrung's campaign, led by Migyur Tempa. Currently, compared to other households, the *dung* family owns less land, and Golengpas argue that if there is one person to blame, it is the outsider *magpa*.

The Goleng *dung* is believed to be the descendant of the Samkhar *dung* who was the feudal lord of Samkhar village in the Sarpang district. Some claim (see Dorji 2005) that the Goleng *dung* was started by Wugpa of the Tagma *dung* in an unspecified time. At any rate, the Goleng *dung* must be related to both Samkhar and Tagma *dungs*, as *dung* families in Zhemgang were believed to have arisen from the descendants of Ura *dung*. The first Goleng *dung* seem to have belonged to the first group of settlers in Goleng, as there are neither local narratives nor any historical records before him. Due to lack of evidence, such claims on the origin of Goleng *dung* may appear dubious, but another member of the Tagma *dung* who is remembered by many senior people, including Dawa Bidha (age ninety-eight) and Chungla (age ninety-four) did indeed settle down in Goleng as *magpa* to the daughter of Goleng *dung*. If the origin of early *dung* is correct, the affinal tie between Samkhar *dung* and Tagma *dung* was re-established in the early twentieth century, further legitimizing the existence of Goleng *dung*.

Chungla believes that the marriage between Tshewang Namgay of Tagma *dung* and Mutok, the descendant of Goleng *dung*, occurred before

1925—that was around the same year he was born. When he was a child, the marriage between them was said to be fully matured. While others still claim that Tshewang was the progenitor of Goleng *dung*, the Goleng *dung* seem to have been long active prior to his arrival. Soon after their marriage, Yeshe Peldron, who was the sister to Mutok, married a man by the name of Kencho. He was apparently from eastern Bhutan and thus was popularly known as Sharchogpa Kencho. Their relationship produced two daughters, but the sudden demise of Kencho and Mutok culminated in a marriage (as the old saying goes, "One gets the wife of his deceased brother") between the widower Tshewang and the widow Yeshe. Despite the sororate marriage with the widow, the marriage did not procreate his successor. Many people today believe that two children of Sharchogpa Kencho, as a husband to Yeshe, were the daughters of Tshewang. However, as it stands, Tshewang also later died childless. While the genitor of these daughters was not *dung*, their mother belongs to the legitimate Goleng *dung* family whose ancestry can be traced back to the first Goleng *dung*.

As seen already, the Golengpa society is organized around the four main houses, (*machim*) which were established by the politically active Golengpas of the past. The *machim* and its related households identify their ancestry with four different progenitors and divide themselves into four distinct sections: Dung, Kudrung, Pirpön, and Mamai people. Their progenitors worshiped different local deities who were concretized by serendipitous encounters with four disparate animals. Two of the four deities are females. Hence by way of section, each of the Golengpa household is connected only to one of the particularized deities who are worshiped in the form of a particular animal. The collectivity of the main lineage houses is designated by the four animals representing them and their deities. Hence, the particular animal operates as the collective double of the lineage house and its associated households. The titles of their four main lineage houses, as I shall show later, are fundamental to the operation of life in Goleng.

The power and spatial orientation of these local gods influence the power of these four mains houses. Each household is linked to different non-human others who are externalized in the form of animals, which in turn operate as the mount (*chibta*) of the local deities. As I shall show, the power of the four main houses actually depends on the power of the particular local deity they are associated with. I shall first describe the accounts of how and when Golengpas began to worship the four main lineage deities, which all occurred at the foundation of the village. The most important deity in the

local pantheon is the female mountain deity (*tsen*) Rematsen. Rematsen is the only terrestrial being who dwells in the high mountain overlooking the slopes where Goleng village is perched. Her mount is a horse, and Golengpas usually dream of a white horse, particularly when Rematsen is displeased with them.

The other three are subterranean beings mostly residing in underground spaces, such as beneath a specific pond, piece of land, or rock. Samdrup Gyalmo is another female supernatural being who is considered to be the owner of the land (*nepo*). She is believed to dwell in the small pond of Bundang just on the fringe of the village. When Golengpas' antecedents discovered the head of a gayal (*bamin*)—a kind of wild bull—in the pond, they took it as the mount of the deity and began to worship her through the agency of a gayal. Another owner of the land is known as Doley Tshewang. He is considered to be the cliff deity (*draktsen*) and dwells in the southeastern cliff located close to Shobleng. When the early Golengpas heard a cock (*khari*) crowing from the cliffside, they took it as the mount of the deity and began worshiping him in the form of a cock. Finally, the shallow stream further down in lower Goleng is believed to be inhabited by the male spirit being (*düd*) Krikpa Choijay. Once, when the people cast their nets into the pool, they found a head of sambar deer (*Rusa unicolor*), locally known as *shawa*, trapped in their fishing net. They then took the sambar deer as the mount of the deity and designated it as the symbol of the deity.

While all Golengpas are linked to a matrilineal totemic lineage, at marriage men join the wife's lineage by adopting their wife's totems. The husbands have moral obligations to assist the main house associated with their wife, which they satisfy through contributions in kind and facilitation of the collective ritual, rather than at the main house of their mother. All the new households join their main house to conduct an annual ritual intended to stimulate long life and fertility and, of course, increase economic production. This ritual coincides with the hiatus in their farming work, which is the period prior to the planting of rice, their main crop. It is only in this annual ritual that their totemic emblems make an appearance in the form of the ritual cakes (*torma*) of their deities riding their specific animal mounts. The offerings of these ritual cakes obligate the deities to reciprocate with their blessings.

In the social world of Goleng, objects, symbols, and supernatural beings that are situated in the high reaches, elevated and to the north, are considered pure and more virtuous than those that lie in the southern lowlands and valleys. Although Goleng is a scattered settlement, the four main houses

follow the same scheme of pure/impure and great/little that is dictated by the spatial elevation. The nexus of the power of the four main houses, their topographical differences, and the hierarchy of their gods therefore constitute the heart of their social world. The once-powerful Dung House is constructed higher up the slope than the other three houses and worships the most powerful deity—Rematsen—in the form of a horse. The Kudrung House is built on a lower level than the Dung House and worships the deity Samdrup. Below the Dung and Kudrung Houses are the Pirpön and Mamai Houses. However, the Pirpön House is located slightly above the Mamai House. This may be because the Pirpön House was established by the people who immigrated from Shobleng, where *nepo* Doley is believed to be domiciled, and is worshiped in the form of a cock, while the Mamai House, known for tax evasion, regard sambar deer as the totem representing their deity.

It is, however, important to note that the presence of the lineage house does not lead to the physical segregation of other households according to their lineage totems. It is common to come across new *dung* or *pirpön* households in the middle of a group of *kudrung* households, or for that matter any other households, and vice versa. While Golengpas do not eat horses, there are no prescribed rules restricting them from eating other totems. As indicated earlier, a great majority of Golengpa households originated from the Mamai House. Of the fifty-four households in Goleng, only five are connected to the Dung House. The current householder of the Dung House is Yudron, and her two sisters recently started new households somewhat on the periphery of the village. Like other household members descended from a common ancestor, they share mutual obligations and other social roles.

It is socially mandatory for the subsidiary households to partake in the collective ritual performed annually at the village temple. But their participation must start from their lineage house—the Dung House. All the above five *dung* households are liable to contribute an equal share of the main food items, namely beaten rice (*chan*), rice (*chung*), and alcohol (*ara*) to the Dung House. In the presence of the heads of collateral households, their contributions are measured by the current householder of the Dung House before mixing them in a large receptacle. The collective offerings are then carried off by the main householder of the house to be offered to their respective tutelary deity at the temple. Mixing them is the sign of both dominance and approval. This act sustains their membership in the lineage. While the ritual is actually performed in the village temple, the householders may not risk making the offering of these main food items at the temple prior to the

endorsement by the main householder of the Dung House. Doing so would lead to an automatic forfeiture of their membership. Hence, the contribution in kind is key to the lineage membership, as it reconfirms their consanguineal connection as well as reverence to the progenitor *dung*. The same rule applies to the rest of the lineage houses' collective rituals.

The Founding of Buddhist Temples in Goleng

Buddhism came to Goleng through the agency of celibate monks in the 1960s. This, however, does not mean that Buddhism was nonexistent in Goleng before the interactions between them, except that prior to the 1960s they had neither a temple nor their own circle of lay *chöpas*. This has put Golengpas in a difficult position, especially during the ritual season, requiring they hire lay *chöpas* from elsewhere. Against that backdrop, I shall now examine why it took so long to build a temple in the first place, who were the primary religious actors responsible for the founding of Golengpa temples, and, finally, what forces motivated them. In so doing, I focus on two events that recast local religious history: the founding of first temple and the subsequent construction of the school for lay *chöpas* (*gomde*).

As will be clear, the religious landscape of Goleng is cluttered with the idea of "great" and "little" tradition (see Chapter 9). Clerical Bon does not exist in Zhemgang, or for that matter in Goleng. Alongside Bon, the Peling branch of the Nyingma school is widely practiced not only in Goleng but also across central and eastern Bhutan. While both Peling and Drukpa Kagyu traditions are antagonistic to Bon, the former is independent of the latter, which is a state-sponsored religion. The state-sponsored Drukpa Kagyu is mostly concentrated in the district offices where the administrative and monastic institutions are based and has limited control over the Peling tradition, or for that matter other branches of Tibetan Buddhism practiced at the local level. This is particularly true of villages in central and eastern Bhutan, bearing in mind that their village temples are mostly affiliated with the Nyingma school.

Pema Lingpa, the founder of this home-grown Peling tradition, was the great fifteenth-century treasure revealer (*terton*). His teachings, based on the discoveries in Bhutan and Tibet in the form of relics and scriptures, quickly flourished across Tibet and the pan-Himalayas and became the main religious tradition of proto-Drukpa-Bhutan. The first celibate Buddhist master to arrive in the "Bonish" Goleng was Geshe[12] Pema Thinley (c. 1897–1970) of

the Peling subschool. Although born in Kurtoe, he spent much of his life in Bumthang and primarily followed the Peling tradition. His scholarship being recognized, he was sent to Jangchub Choeling monastery in his hometown by Princess (Ashi) Choni Wangmo. He was accompanied by Lama Therchung from Nangkhar in Bumthang, who was to play a pivotal role in the region by founding temples.

As recounted by Tshering Wangdi, who served as an attendant to Geshe, Geshe spent some years in Kurtoe but eventually went to Tibet to study under the accomplished master Polu Khenpo Dorji of the Nyingma school. The exact date of his departure and return from Tibet is not clear, although Tshering Wangdi claims Geshe was between forty-five and fifty years old when he arrived in Goleng. The mastermind of the process of "taming" the more or less Bon-centric Goleng was, however, another disciple, Lopön Lhendup, from the nearby village of Tsaidhang, who was also the uncle of Tshering. He followed Geshe and invited him to propagate Buddhism in the remote villages, particularly in Nangkor county. The starting point of Buddhacization was his own village and gradually expanded to Chamtang[13] village and then to Goleng. He single-handedly constructed a small temple in Chamtang in circa 1958–1960 for his master, although Geshe spent much of his time in Tali and Changlochen[14] in particular. In the 1960s, Geshe identified an area for the construction of Zangdokpelri[15] in Tali, and his disciple Therchung accordingly built it.

Following the Chinese occupation of Tibet, Polu Khenpo was forced to escape to India. When Geshe was alerted to this news, he along with Lopön Lhendup traveled to Mysore and invited their master to Zhemgang. Due to the influx of Tibetan refugees, it was then extremely difficult to travel to Bhutan; however, Geshe capitalized on his connection with Ashi Wangmo. Rather than the popular places in Bhutan, Polu Khenpo was later ushered by his disciples straight to the remote villages of Zhemgang, where he traveled widely, giving teachings and empowerments before finally spending the later part of his life in Thimphu.

On the other hand, Geshe chose to remain in Tali, primarily to pursue the unfinished project of temple construction. Children and adults from Goleng, Tali, and Shobleng villages were enrolled in the newly built Chamtang temple as lay *chöpas*, and many of the present-day lay *chöpas*, including Lopön Pema, have their pedigree from this institution. While mediation was a part of the curriculum, performing rituals was the main emphasis, and as villagers perfected them, lay *chöpas* conducted the seasonal ritual in their

villages for the first time, thereby standardizing the prevailing ritual patterns, practices, and symbols they represented. In order to systematize and regulate the ritual praxis, these lay *chöpas*, at the behest of Geshe, gave a new impetus to the construction of temple in other villages such as Goleng. It is clear that Goleng then did not have many houses, let alone a place of worship. Hence, approximately ten years after the construction of Chamtang temple, the first ever one-story temple was built in Goleng circa 1967–1970, primarily by the lay *chöpas* of Chamtang themselves with little assistance from the villagers of Goleng.

Buddhist monks such as Buyul Lama[16] and others have visited Goleng several times, but Buddhism began to take shape only after the construction of this temple. Toward the end of his life, Geshe made his principal disciple, Lama Therchung, regent and instructed him to oversee Tali and Goleng temples. In 1993, Tali Zangdokpelri[17] was extended under the auspice of the Central Monastic Body of Bhutan and currently serves as the important Drukpa Kagyu institution where clerical celibacy is upheld. One of the most important contributions of Lama Therchung to Goleng was the expansion of the old temple. The present-day two-story temple was built under his supervision, and the mural of the temple was later sponsored by the Ninth Gangteng Rinpoche.[18] It was only during this period that the rearing of pigs was abolished, and live-animal sacrifices were discouraged.

The disciples of Geshe from Goleng were the two important religious actors: the temple caretaker (*koinyer*) and the village astrologer (*tsipa*). Their sons took up these roles, rendering them like a family title that can be inherited only by males. To reinforce the propagation of Buddhism in Goleng, there was a second event that led to the founding of another temple—the school for lay practitioners (*gomde*)—in 1994. The son of astrologer, Lopön Pema was the chief architect who also supervised the construction of a temple that was built by Golengpas on free labor. The mural, statues, and the residence of the principal were sponsored by the district office, and Lopön Pema, with a renewed power and responsibility, was made its principal by the head of the District Monastic Body (*dratsang*) upon the recommendation of Golengpas. Nevertheless, they do not maintain direct affiliations to the state-sponsored Drukpa Kagyu subschool. During its initial stage, the school was fairly successful, but in subsequent years, enrollments stagnated, as did the religious training at the *gomde*, leading to its decline. The *gomde* is therefore now closed because the old lay *chöpas* have completed their studies, while the majority of children are attending the Western-style school in the village.

There are two distinct historical events in Goleng both of which led to the founding of temples in separate time frames. The first was, of course, built by the first-generation disciples of Geshe, while the second was built by the second-generation disciples. The construction of the first Buddhist temple and the prohibition on the rearing of pigs, however, did not result in a direct campaign against the Bonpos and Bon practices per se, although they were key to making Buddhism more important. Nor was it associated with, as reported elsewhere (see Ortner 1989), rivalry and competition between the Buddhist lamas for political or religious dominance. The founding of first temple was indeed oriented toward establishing what I shall call pure or "philosophical Buddhism" by refining, ameliorating, and resystematizing the existing form of Buddhism, which I shall call "village Buddhism" following Spiro (1982). Balikci (2008) has employed the term "village Buddhism" to designate the Buddhist practices exclusive to the local Buddhists, who include both married lamas and lay *chöpas*. In Goleng, village Buddhism is rather treated as the contemporary lived religion that is largely syncretistic in the sense that it has incorporated non-Buddhist beliefs that are primarily elements of Bon and local cultures. It is therefore ritualistic and primarily concerned with the pragmatic aspects of everyday life of the ordinary people and the lay *chöpas* alike. In general, it thrives in village temples rather than in the bigger monastic institutions, yet it is not bound by a particular school or subschool. On the contrary, philosophical Buddhism in some measure corresponds more closely to Spiro's (1982) "nibbanic Buddhism," Samuel's (1993) "clerical Buddhism," and Gellner's (1999) "soteriology or salvation religion" since it is concerned with breaking free from rebirth while at the same time being mostly confined within the walls of formalized institutions such as big monasteries (*shedra*) and meditation centers (*drubde*).

This philosophical Buddhism is limited to the habitation of dedicated monks, whether celibate or married, in an institutionalized or reclusive setting, where learning, practicing, and actualizing of the doctrinal knowledge and lore are their primary concern. While it is a philosophically oriented tradition, philosophical Buddhism is, however, not always concentrated in the state-sponsored establishments, for many parts of such institutions are also the locus of religious activities related to pragmatic aspects of Buddhism. For instance, many of the state-sponsored district religious institutions, such as the one in Zhemgang district, are predominantly centers specializing in rituals rather than in in-depth study of sutras and other core Buddhist texts. Nonetheless, the villagers do not particularize or differentiate these two

categorizes of Buddhism that are linked together in a single entity, for in the absence of philosophical Buddhism, they view village Buddhism as the pure form, which is, in effect, the transformed philosophical Buddhism.

Philosophical Buddhism is therefore scholastic and concerned primarily with the transcendental and nirvanic aspects of Buddhism. However, village Buddhism should not be taken for granted as the tradition that is exclusive to married lamas and lay *chöpas* or as completely devoid of soteriological aspects, nor philosophical Buddhism as the practice that is limited to reincarnate and educated lamas or as bereft of certain elements of pragmatism and worldly ideals. Unlike in Balikci's (2008: 30) "conventional Buddhism," which, according to her, is propagated by reincarnate and learned lamas. As such, the marital status and the physical semblance of the practitioners, such as dress and hair, do not define their boundary because they may be celibate, cloak themselves, in the dress of renunciate monks, and simultaneously be village Buddhists. Others may be married and cloak themselves in the white costume of *ngakpas* and be philosophical Buddhists. The only defining line between them is their emphasis on the pragmatic and nirvanic aspects, which are expressed through the physical/internal, this-worldly/otherworldly, and mundane/extramundane dichotomies. For both village and philosophical Buddhism, the concept of karma and merit is central in generating samsaric and nirvanic pleasures respectively.

In the 1960s, Golengpas were accustomed to rearing pigs in the name of an annual Buddhist ritual *loched* that is dedicated to propitiating the pantheon of dharma protectors (*dharmapalas*) and seeking renewed protection against diseases and misfortunes in the coming year. The pigs were killed prior to the ritual season, and various types of alcohol were brewed well in advance. Like the villagers, who were served with meat and alcohol, the lay *chöpas* would be well inebriated before the completion of the ritual. As part of the oblation, a small amount of meat was also offered up to tutelary deities. The rearing of pigs for the ritual and subsequent offerings contradicted Buddhist ethics. Hence, rather than eliminating the Bon practices, the founding of the first temple was oriented toward reforming the localized Buddhist practices by the lay *chöpas* where meat and alcohol had become an integral part of the Buddhist ritual.

The establishment of the second temple was, in principle, to facilitate the purpose of the first temple by instituting an upgraded center for teaching and learning, but upon closer scrutiny, other concocted schemes for control over Bon in village become apparent. After Lopön Pema, ostensibly the village

astrologer, took up the position of the head of lay *chöpas*, he was engaged in a range of pursuits that were designed to eliminate Bonpos mainly by substituting their rites with Buddhist rituals. His accession to power coupled with his growing influence on *goshé nyenshé* transformed the Bon practices, from prohibition of live-animal sacrifices to the drafting of a Buddhist version of annual Bon ritual—*rup*—as I shall show later. On the whole, while the Buddhist mission to prohibit live-animal sacrifice and reform the prevailing rituals, which involved offering of red meat, was successful, the form of Buddhism in Goleng is still, by and large, characteristic of village Buddhism. The lay *chöpas* of Goleng are least concerned with the idea of soteriology and transcendentality.

The subsequent lama missionaries and the local lay Buddhists with some support from the state gradually began to denigrate Bon practices, viewing them as animistic, incorrect, and evil. The Buddhist proselytization is part of Bhutanese state's bringing the periphery into the norms and practices of the center, as, in the 1960s, there was an urgent need for Bhutan to refashion its religious identity. But this civilizing influence of Buddhists was also in actuality the result of the shift from the center of Buddhism in Tibet to the Himalayan regions, where an influx of Buddhist masters who left monasteries in Tibet in the aftermath of Chinese annexation sought to transform local practices, notably live-animal sacrifices, as they became refugees in a new land. Yet as will be seen later, while Golengpas may be Buddhists in faith, they appear more Bonpo in their daily rituals.

The evidence of complementarity and influence between Bon and Buddhism is conspicuous, and I shall return to them in the chapters to follow. Given the plethora of local deities and spirits, village Buddhists cannot grapple with the volatile nature of local deities and spirit beings, for a great majority of them are reckoned to be untamed and undomesticated. For instance, many of the supernatural beings such as guardian deities (*yul-lha*) and mountain gods (*tsen*) reside in the village and surrounding mountains. Some of these high mountains are still unclimbed by people. This is not because of their height, but because they are abodes of supernatural beings. Lake deities (*tsomen*) and demons (*düd*) inhabit nearby lakes, gorges, and rivers. Every facet of cliffs and slopes is the domicile of cliff deities (*draktsen*), while the land is home to various subterrestrial and terrestrial beings, such as serpent spirits, and various owners of the land (*lu* and *sadag*).

It is clear that the founding of the first Golengpa temple was crucial in refining the localized Buddhist practices of the lay *chöpas* themselves. With

the construction of the second temple, the lay *chöpas* with renewed powers were rather engaged in training new lay Buddhists with the aim of replacing the Bonpos, and consequently eliminating Bon practices. With this shift, the way in which Bon is viewed by lay Buddhists changed, leading to the controlling of Bonpos. Although every effort was made by lay *chöpas* to control and eliminate Bon practices in Goleng, the Golengpas' sacred geography and complex social structure defied the Buddhist mission to expunge local Bon beliefs. Bon continues to exert its influence on the dominant Buddhist system, which in turn influences the political and religious spheres of life despite the Buddhist hegemony and the attempt to systematically suppress the local practices. The late arrival of Buddhism and the weak Buddhist presence in Goleng today is another obvious reason for the tenacity of Bon and its relevance to people.

3
Soul Loss and Retrieval

This chapter extends the ongoing relevance of Bon by focusing on the belief in the five life elements, which are considered to be in flux unless they are placed under constant surveillance by performing the correct rituals. It looks at the ways in which their five life elements, particularly the soul (*la*), can be threatened by the multiplicity of supernatural beings pervading Golengpas' worldview. The second half of this chapter turns to the local Bon pantheon, which includes a wide range of gods, deities, and spirit beings, in relation to the fluidity of the five life elements and their centrality to Golengpas' everyday lives. The overall thrust is to illustrate that it is within this complex local cosmology that the idea of fluctuating five life elements as the foundation of a successful life operates. The chapter concludes by arguing that it is the belief in the soul and a range of untamed supernatural beings that gives the Bonpos an important and ongoing place in people's lives.

The Fluidity of Five Life Elements

In Golengpa exegesis, regardless of status or lineage, everyone is born with five inherent elements that operate as their vital energies. I call these powers "five life elements,"[1] as they are essential prerequisites for life for every human. They are not hereditary, nor can a person with strong elements share them with the people with weak elements. According to Sonam Rinchen, who is the vice principal of the School of Bhutanese Astrology, Pangrizampa, the five life elements are life force or life essence (*sok*), body (*lü*), economy or prosperity (*wangthang*), wish-fulfilling force (*lungta*), and soul (*la*). However, many scholars have listed only four elements, leaving out the popular force—*la*—which has its roots in pre-Buddhist Bon. Each of these elements may function independently, but they are closely related in their purpose and the person's life. These five life elements are predicated on the synthesis of Indian (*kartsi*) and Chinese elemental divination (*nagtsi*), and

as I shall show, they regulate the individual's success, health, and indeed life itself.

The *sok* as a life essence can be readily translated into vital power that strengthens one's life, while *lü*, which is the "physical frame" in Da col's (2012) words, constitutes the physical or somatic power that is essential in preventing untimely aging and diseases by re-establishing youth. Likewise, *wangthang*, which has been described by scholars as the "field of fortune," is an economy or prosperity power responsible for amassing wealth and wherewithal by magnetizing another mystical power—*yang* (cf. Barth and Wikan 2011). The concept of *lungta* has been already discussed by many scholars, but Karmay (2009 [1997]) goes into more detail than earlier researchers. He demonstrates that, considering the common aspirations of ancient Tibetans—that is, to own an ideal horse (*tachok*) whose speed is equivalent to wind—the wind horse (*rlung rta*) is a later transformation of river horse (*klung rta*), which itself is the metamorphosis of the dragon-horse (*lung ma*) of Chinese mythology (415). For Stein (1981) *lungta* represents one's own "breadth," while for Snellgrove (1980 [1967]) and Karmay (2009 [1997]) it stands for one's "well-being." In any case, *lungta* is particularly associated with wish fulfillment, and hence it is a wish-fulfilling power that enables the person to accomplish and realize dreams and goals.

Finally, like *lungta*, the concept of *la* has also been widely studied (see Lessing 1951; Nebesky-Wojkowitz 1956; Mumford 1989; Tucci 1980; Snellgrove 1989 [1961]; Holmberg 1984; Karmay [2009 [1997]), yet as Samuel (1993) notes, it lacks consistent meanings and forms. For Samuel, the *la* corresponds to Tambiah's (1970) concept of northeast Thai *khwan*, which is associated with worldly vocation rather than otherworldly pursuits. However, all of them agree that *la* is a pre-Buddhist belief that is widely regarded as a term for the soul. The *la* can be considered a soul or psychological power that is the most important element on which the rest of the four vital principles hinge. By extension, it is the life principle or the essence of all other vital principles whose separation from the person's body can result in destabilization of the structured vital forces, eventually rendering the person "lifeless." These life elements are dynamic and, as a result, prone to fluctuate because of opposing forces that are beyond their control. They can rise and fall sharply, but they can also ritually be manipulated while falling. Although all of these vital forces are capricious, volatile, fragile, and highly mobile, the *la* is the most likely to flee (*la tor*) the body, to stray over wilderness, thereby increasing the liability of being predated (*la chod*) by supernatural beings.

A person's *sok*, *lü*, *wangtang*, *lungta*, and *la* elements act as the foundation of a successful life. By successful, I mean a person with a long life and healthy body, whose economic situation is consistently prosperous, whose means of achieving aspirations and dreams are characterized by a charmed path (*lamdro*), and, last, whose soul is always conscious. The individual must possess all of these attributes in good measure, as their being too strong or too weak poses an equal risk. The state of one's five life elements, however, keeps fluctuating from one year to another (and sometimes even daily), inducing a fairly unbalanced level of each element every year. As will become clear, it is axiomatic that the seesawing of life elements is intertwined with vicissitudes of life and fortune. A person with a weak life element this year may have a strong life element the next year. By the same token, a person with a strong life element this year may have a weak life element the following year. Others might, on the other hand, cumulate life elements for consecutive years, while some undergo degeneration of life elements for years until they regenerate ex nihilo. All in all, these life elements are never stable.

In Golengpas' world, it is vital for a person's life elements to correspond and synchronize with the new animal year's elements. Each Bhutanese lunar year (*lo*) is associated with one of the five ordered planetary or astrological elements[2] and twelve ordered zodiac animals.[3] To possess "high" life elements, one must establish compatibility among them. The interplay between the elements of a year, animal, and person makes life elements fluid and highly deformable in response to these other ever-changing component forces. For instance, the person's *sok* must match the animal year's elements, which also fluctuate from one year to the next, in order for the former's vitality to increase (*sok dhar*). If they match, the person is in possession of strong *sok* for the whole calendar year. On the other hand, if they do not match, the person is affected by weakening vitality (*sok gud*). The same thing can be said of *lü*, *wangthang*, *lungta*, and *la* because life elements are affected by the animal year's elements as though they were the person's original life elements. Possessing strong life elements can be seen as climbing the social ladder, as people with high powers, especially *wangthang* and *lungta*, are associated with the high end of the social hierarchy.

When life elements are exhausted or weak, one cannot achieve one's dreams or live a long and healthy life. For example, a person with declining vitality power (*sok gud*) attracts a life-threatening obstacles (*barché*) in multifarious manifestations, completely unpredictable, yet inevitable. Deficient

sok wears the person down until, in its fluctuations, diminishing vitality power transforms into a perfect vitality power (*sok dhar*), like a waxing moon. In short, increasing vitality power supports a long life. In the same manner, the person whose somatic power is on the wane (*lü gud*) is doomed to contract diseases (*nad*), while the person with a perfect and waxing somatic power is immune. Hence, a strong or increasing somatic power presupposes a healthy body irrespective of sex. Likewise, the person with a perfect and waxing economy or prosperity power (*wangthang dhar*) will be successful in wealth-generating business. However, no matter how successful in business the person may be, a degenerating economy power (*wangthang gud*) will soon exhaust the wealth that he has accumulated over the years. Waxing *wangthang* is the gateway to prosperous life.

Golengpas believe that if a person possesses a declining wish-fulfilling power (*lungta gud*), hard work and dedication will be in vain even if one works late into the night. A person with a waxing wish-fulfilling power (*lungta dhar*) can dramatically accomplish (*lamdro*) everything, even seemingly impossible tasks. Finally, the *la* operates as the soul and as a result pervades the person's body or the person as a whole. As a soul power, it supports the person's intellectual and mental aspects. A person is believed to be alert, conscious, and mentally stable through waxing soul power (*la dhar*). Declining soul power (*la gud*) disrupts consciousness, making the person dull, lifeless, even delirious. When a person is mentally inert and physically torpid, the only possible result is the malfunction of the other life elements. In light of its relationship with the other life elements, *la* is the dominant element because it is not only the building block of the life element matrix but also the desideratum for well-being and success (cf. Karmay 2009 [1997]).

Common Rituals for Strengthening Declining Life Elements

Golengpas believe that five life elements are governed by the animal year's elements although *sok*, *lü*, *wangthang*, and *lungta* seem to rely on the single *la* substrate on which they are permanently superimposed. A declining *la* destabilizes the other life elements and can cause sudden death, even of the person with a strong *sok*. Without waxing soul power (*la*), which is apparently

lowest in the astrological hierarchy, the wish-fulfilling power (*lungta*) cannot function properly because only a person's active, stable, and conscious *la* can complement and propel the *lungta* power. In other words, without mental stability, the person is incapable of formulating intelligible goals, let alone possessing *lungta* power, which is the basis for achieving the prosperity power (*wangthang*). Once *lungta* power is set in motion, it turns the wheel of *wangthang* power, creating a favorable milieu, translatable to a profusion of wealth, for the somatic power (*lü*) to thrive on. Finally, a healthy body with robust *la* power can facilitate a strong vital power (*sok*) that supports a wholesome individual with a very long and prosperous life. Although there is no strict causal relationship between these life elements, they complement one another along a bottom-to-top axis.

I have stated that *la* is the essence of life elements, but it cannot always guarantee the increase of the other elements. *La* sustains a person's life only by linking the life elements together. For instance, even with waxing *la* power, the person without waxing *lungta* power can never accomplish his or her wishes and desires. By the same token, without waxing *wangthang* power, a person cannot accrue wealth but can easily exhaust it. Similarly, even if the person follows a healthy eating plan, the body cannot be healthy if one has a degenerating *lü* power. Finally, the end of *sok* practically brings an end to a person's life, and a healthy individual with a declining *sok* can never live a "full life" even if in possession of waxing *la*, *lungta*, *wangtang*, and *lü*. Nonetheless, until the person has completely exhausted the ritually restored *sok* power, which can be extended numerous times, *la* acts as the core force for human existence. Thus, as maintained by village astrologers, the *sok* and *la* powers are homogeneous since both can bring death if they are completely exhausted or are abducted by supernatural forces.

Declining *wangthang* and *lungta* powers are generally considered the main factors responsible for making a person vulnerable to malicious beings. However, the evidence presented thus far suggests that it is declining *sok* and *la* that can render a person vulnerable to these beings. While declining *lü*, *wangthang*, and *lungta* are more inclined to cause suffering than immediate death, for men the *sok* and *lungta* powers are second only to *la*. This is so for practical reasons. A man, according to Principal Rinchen, spends the majority of his time outside of his house, usually on business enterprises in which he is destined to confront difficulties and threats. Without strong *lungta* power, accomplishing his goals is improbable. From the vantage point

of the local astrologer-cum-village priest Pema Wangchuck, accomplishing business goals or fulfilling masculine duties is only possible when men possess strong *lungta* and *sok* powers.

Women on the other hand must hold a strong *lü* power because, as lifegivers, they must have a healthy body. High *lü* power is manifested in a healthy body. A woman who holds the key to household wealth must also possess *wangthang* power because without it her husband's enterprises will fail. If a woman has very weak *wangthang* power, despite her husband's success, accumulated wealth will disappear. Hence, prior to marriage, the alliance between the life elements of couple is determined so as to predict their subsequent future or to maximize their economic success. A waning element can be increased only through a restorative ritual that must be conducted prior to exhausting the element that is weak. Each of these rituals has its own set of requirements for action, and the choice of ritual depends on a person's wealth and energy. Evidencing the accommodation between Bon and Buddhism, the mitigation of declining life elements relies on an amalgamation of both Buddhist and Bon rituals. Some rituals have become so central to Buddhists that there are no specific Bon rituals in Goleng that are relevant to increasing *sok*, *lü*, and *wangthang* powers.

Among Golengpas, the ritual concerning the vitality power is purely Buddhist. A person with weak *sok* must in abstain from taking lives and save sentient beings by taking part in life-releasing rites (*tse thar*). Additionally, the person must receive long-life blessings (*tse wang*) and recite the mantra of long-life Buddha Amitayus (*Tsepakmé*). According to my astrological interlocutors, techniques to increase declining *lü* are physico-religious activities, such as circumambulating religious structures like a stupa or temple and doing regular prostrations, rather than, as asserted by Barth and Wikan (2011), observing a "careful and restrictive diet" (36). Based on the Buddhist idea of accumulating merits (*sönam*), a person must promote beneficial actions (*gewa*) by making offerings (*jimpa*) not only to the Three Jewels[4] (*Könchok Sum*) and monks but also to lay and humble people (*ngenlong*) in order to increase a declining *wangthang*. Another popular ritual to expand one's *wangthang* is to perform a ritual of accumulating *yang* power (*yangkhug*).

A person with weak *lungta* must string prayer flags along the mountain ridges and hills and commission recitation of Buddhist texts such as *lungta* prayers and antigossip (*mikha*) rituals. *Lungta* was a secular offering ritual in

pre-Buddhist Tibet that involved fumigation with juniper leaves, especially in the high mountains (Karmay 2009 [1997]), but after it became assimilated into mainstream Buddhism, *lungta* power is represented on the flags by an excellent horse (*tachok*) carrying a wish-fulfilling jewel flanked by four animals, namely the mythical garuda[5] (*chung*), dragon (*druk*), tiger (*tak*), and lion (*senge*) in each corner. Sometimes the horse is replaced by King Geser,[6] but accommodating these changes requires a consecration ceremony (*rabné*)[7] by a Buddhist lama either before or during the planting, hanging, or tossing of *lungta* flags, thus making it a daily new reality. Finally, a person with weak *la* power must conduct rituals similar to those required of a weak *sok* person, including the accumulation of *sok* power. A person can also conduct alchemical rituals such as buying back the abducted *la* and *sok* through ransom rituals (*lalu* and *lud*), both of which use texts despite the Bon origin of some aspects of the ritual.

Apart from the *tsekhug lalu* and the recitation of various Buddhist scriptures, the Golengpa lay Buddhists have no specific magico-religious ritual to address the soul loss caused by a specific supernatural being. In Goleng, the *lalu* rituals are performed by the lay Buddhists, as one can rarely find a single celibate monk (*gelong*) or reincarnate monk (*trulku*) in the village. These lay Buddhist practitioners, except for Lopön Pema Wangchuck, who was the former principal of the now-closed Goleng lay Buddhist school (*gomde*), are part-timers. There were more than ten practitioners in Goleng in 2017 who during the ritual season became *chöpas* by donning their red scarves (*yabmas*), while for the rest of the year they work as full-time farmers. Further, Golengpas do not have a Buddhist version of shamanic rituals performed by a ritualist who is a medium of Buddhist protectors (*sungma* or *chökyong*). While I have come across three such *chökyong* in central Bhutan, all of them resided in upper Trongsa; they were not invited to Goleng.

In the absence of *chökyong* and other specific Buddhist rituals to retrieve the abducted soul, people turn to the local Bonpos, giving them a vital role in Golengpa society. Not only are the local Bonpo shamans associated with local deities who are in turn conceived to be the primary cause of soul loss, but their rituals are generally far cheaper and sometimes even conducted for free in exchange for a cup of alcohol. One such rite is the primordial Bon ritual for buying back the soul in a form of a spider—which is free of any syncretic elements. Apart from the Buddhist *lalu* and *lud* and the primordial Bon rituals, I did not come across reinvented rituals[8] among the Bhutanese Bonpos.

The Primordial Bon Ritual for Recapturing the Abducted Soul

As in central and northern Asia, Golengpa Bonpos make reference to the multiplicity of souls, although the number is not at all consistent. They believe that the soul usually resides in the body, though it sometimes inhabits external entities such as a tree (*la shing*), lake (*la tso*), mountain (*la ri*), and stone (*la do*) that are especially dedicated as its location. The idea of souls residing in lakes and mountains is predominant among religious and noble persons, as they can be only transmitted through the patrilineal line. The souls dwelling in trees and stones, on the other hand, are associated with both noble and common people: the parents, during the birth of a child, can plant the particular tree of their choosing, regardless of sex. Since the soul tree (*la shing*) is also known as life tree (*sok shing*), Bhutanese astrologers, Golengpa astrologers included, argue that soul power (*la*) and vitality power (*sok*) are very similar if not identical. That said, the *sok* perishes with the body and becomes permanently disembodied, while the *la* is believed to be immortal, capable of living in its inanimate entity, and in turn re-inheritable by the lineage.

The idea of soul loss is widespread not only among the Tibeto-Burman people (Desjarlais 1992: 139) but also among people as distant as Siberia in the north and Cambodia in the south. The *la* is extremely vulnerable to demonic beings, who can easily abduct and hold it captive in their domain, and also to fright that can let the soul easily escape the body. Therefore, in the event of a lone journey—either at night or day—toward the steep cliffs, deep lakes, or high mountains that are populated by deities and demons, a sudden fright can lead to the loss of person's soul (*la tor*). This is so because when the person with weak *la* is frightened, the body (*lü*) involuntarily ejects the *la* or creates a suitable circumstance for the occupying deities and demons to capture the soul. Without such a state in the victim, supernatural beings may not be able to seduce the *la* unless the person is experiencing chronic deprivation of the five life elements or the person's *la* is wandering—host-less. All in all, by destabilizing the accompanying life elements, the loss of *la* makes the person delirious until the *lalu* ritual is commissioned.

There is a Bonpo way of retrieving the abducted soul—which is original, unmodified, and completely different from the mainstream *lalu* rituals described by various Buddhist and Clerical Bonpo scholars elsewhere (e.g., Samuel 1993; Lessing 1951; Karmay 2009 [1997]). This ritual is known as

"brushing the soul off" (*la prok*) from the branches, particularly from those of artemisia (*dhungmin*) plants, and can be conducted by all kinds of Bonpos.[9] It is dramaturgical in nature, in the sense that the soul is restored in a form of a spider that assumes an agential role. In Goleng, the soul and spider are near homophones, and the two terms are used interchangeably. The soul is commonly abducted by *düd* beings, but given suitable circumstance, the *tsen*, *lu*, and some forms of gods (*lha*) are also inclined to capture it.

Ideally, if the victim does not improve after the Buddhist *lalu* rituals and making a ransom offering of rice and egg by a Bonpo, the spider should be rummaged in a bunch of artemisia plants by shaking its branches repeatedly on a rug placed next to the person. The *la prok* ritual is on the decline in Goleng, but it is not completely ignored. It lies inert beneath layers of techniques dominated by lay Buddhist rituals, and when they are ineffective, the Bon rituals are activated. Given its infrequency, I could not witness the ritual being performed for the sick, but I requested that Bonpo Chungla, who had conducted this ritual for many years, to demonstrate it for me after one of the Golengpa men who was unwell agreed to act as a patient.

The *la prok* ritual demonstrated by Bonpo Chungla at his own house involved offerings of rice and egg to the supernatural soul abductors, and subsequently laying the spider on the victim's head. The Bonpo, with the help of his acolyte, continually jiggled artemisia branches on the rug until he found a spider. Seeing a spider, he intoned, "Now bring me the golden soul, bring me the silver soul, bring me the bronze soul, bring the life and soul, bring the head and body, and bring me everything I ask for," expressing the multiplicity of souls. Bonpo Chungla told me that if a spider appeared on the rug during this ritual activity, the soul was successfully retrieved, although different species represent different spirit beings in Bon cosmogony. For instance, the worldly class of gods of the upper realm are symbolized by white spiders, while the *tsen* and other beings of the middle realm are embodied by red spiders. The subterranean beings such as *düd* and *lu*, inhabiting the lower realm, are manifested by black spiders. The remaining colors represent the hordes of variously helpful or harmful agents mostly lurking in the middle and lower realms.

During the first half of the ritual demonstration, the Bonpo was not able not find any spiders on the rug after repeated shaking of branches. Hence, the acolyte was asked to bring a fresh bunch of *dhungmin* and the ritual was repeated in an attempt to give an idea of how the lost soul is

reconnected to the body. After several rounds of foraging for spider, the Bonpo announced a successful retrieval of soul with three spiders on the rug. The possessing spirt, thought to be a nearby *düd*, was then seduced with offerings of rice, egg, and meat as the Bonpo directed the soul to enter the body by placing the spiders on the patient's head and commanding the soul to enter his body:

> I have brought everything including your soul. Now penetrate into the head and tongue, enter into the brain, move into the liver and stomach, transpierce through the thighs and joints, access all the organs, and remain there forever!

The efficacy of this ritual is determined by the number of spiders collected. Bonpo Chungla affirmed that three spiders on the rug was extremely auspicious. Not a single spider on is the rug is inauspicious; hence the process must be repeated until the spiders are found—although sometimes the spiders are never found. If the Bonpo cannot find a spider after several rounds, this ritual, or even this particular Bonpo, cannot restore the lost soul. Failure to retrieve the soul necessitates the person's commissioning a shamanic ritual by a "specialist" Bonpo (see Chapter 5), which is considered a more advanced healing ritual.

The Local Divinities of the Golengpa Bon Pantheon

The fluidity of the life elements should be understood on the lines of the same typological model of supernatural beings built on hierarchical principles. In principle, the Buddhist and Bon pantheons form the opposite poles of the religious landscape of Goleng. While the Buddhist pantheon constitutes the otherworldly goals mainly concerned with the continuity of life through a single lifetime's enlightenment, the Bon pantheon reflects this-worldly pleasures and social benefits, such as a healthy and prosperous life. Samuel (1993: 26) has explained the dichotomy of this-worldly/otherworldly through what he calls "bodhi and pragmatic" orientations. The worldly pantheon is generally composed of worldly dharma protectors (*jigtenpai tsungma*) and the multitude of worldly gods (*jigtenpai lha*), including the universal and autochthonous beings who are simultaneously entangled in territorial identity and

religious spaces. In the Buddhist sources, the classification of these worldly gods varies, but the most popular grouping is the "eight classes of gods and demons" (*lhadre degye*),[10] which itself has several classifications.

In this classification, however, one comes across some spirits with a similar inclination and overlapping attributes, inhabiting the same domain and causing similar sicknesses, while others neither harm nor demand offerings. As attested by the lived experience of religious practices in Goleng, some of these classes are irrelevant, while the legion of free-floating and amorphous beings that are only found locally permeate people's sociality. This collection of local gods and deities is reinforced by the range of corresponding Bon rituals oriented toward a specific numen, given that they can be easily angered by pollution (*dib*) and transgression (see Tashi 2021). Although Golengpas are occasionally protected and blessed by these beings, like other Bhutanese people, they are also subject to the mercurial temperamentality of these local divinities and often fall prey to them. The only technique to avert their wrath or to make them well disposed toward the faithful is to execute a timely propitiation.

While recognizing the utility of the Buddhist classification, the Golengpa Bon pantheon can be best illustrated by classifying the gods and demons into five main classes that can in turn be further divided into several subclasses on the basis of their cosmological attributes, including their spatial orientations (Table 3.1).

This classification is by no means exhaustive, but it takes into account the major types of divinities that are central to the Golengpa Bon pantheon and Golengpas themselves. Based on the perceived hierarchy and the shamanic cosmology of three worlds, constituting the worlds of gods, *tsen*, and *lu* beings, the first is the class of gods (*lha*), who are divine beings with their own abodes in their respective celestial realms. They are compassionate and well disposed not just to humans (Samuel 1993: 163) but to animals and other nonhuman beings too. While they occupy the apex of the hierarchy, they are nonetheless considered to be worldly beings, for they have not attained enlightenment or Buddhahood.

The second is the class of *yulha-dralha*, beings who mostly reside in the high mountains and hills. The *yul-lhas* are the local or village (*yul*) gods who are worshiped as protecting deities of the regions, while the *dralhas* are war (*dra*) gods who are now invoked during conflict and regional archery tournaments. They may constitute both *dralha* and *yul-lha*, although

Table 3.1 The Five Classes of Local Gods and Spirit Beings

Class	Subclass	Orientation	Abode
Lha (gods)	Odé Gungyal (primordial Bon mountain god)	Male	Respective heavens
	Tonpa Shenrab (claimed to be the founder of the reformed Bon)	Male	
	Gyajin (Indra)	Male	
	Wangchu (Shiva)	Male	
Yul-lha-Dralha (village and war gods)	Oath-bound Gyalpo (*damcan gyalpo*)	Male	Temples and mountains
	Yul-lha (village/local gods)	Male/female	
	Tsen (mountain deity)	Male/female	Temples and mountains
	Dragtsen (cliff deity)	Male/female	Cliffs
	Nepo (owner of the land)	Male/female	Land/soil
	Dralha (war gods)	Male	Temples and mountains
	Kyelha (birth gods)	Male/female	Temples and mountains
Sadag-Shidag (lords of the soil)	*Lu* (serpent spirits)	Male/female	Underground, lakes, and streams
	Düd (demons and demoness)	Male/female	River, gorges, cliffs, and deep valleys
	Mirgola (female forest spirit)	Female	Forests
	Phorgola (male forest spirit)	Male	Forests
	Shing-ge Lhamo (tree deities)	Female	Trees
	Tsomen (mermaid)	Female	Lakes
	Shadag Ridag (owner of the mountain)	Male	Mountains
Mamo-Sondre (spirit beings)	*Shindre* (spirit of dead men and women)	Female	Wandering beings
	Sondre (evil spirit of a living woman/witch)	Female	Female bodies
	Dre (ghost)	Female	Wandering beings
	Small Gyalpo (personal *gyalpo* spirit)	Male/female	Male/female bodies
	Duklha (poison god)	Female	Female bodies
	Mamo (ferocious feminine spirits)	Female	Female bodies

(continued)

Table 3.1 Continued

Class	Subclass	Orientation	Abode
Gowelha-Kyimlha (Household gods)	*Polha* (personal male god)	Male	Male bodies
	Molha (personal female god)	Female	Female bodies
	Kyimla (house deities)	Male/female	Houses
	Go'i Lhamo (door deities)	Female	Doors
	Godre'i Lhamo (window deities)	Female	Windows
	Thablha (hearth gods)	Male/female	Hearths/stoves/kitchens
	Gung'i lhamo (ceiling deity)	Female	Ceilings

one comes across some *dralhas* who are not *yul-lha* and vice versa. Some of *yulha-dralha* beings have been converted by Buddhists to become the protectors of Buddhist temples, while a great number of others are still untamed. The next class is *sadag-shidag* beings, who are lower, in terms of both power and vertical register, than the *yulha-dralha* complex. They are mostly the owners of the land and serpent spirits (*lu*) dwelling in low-lying hills, valleys, gorges, ravines, lakes, rivers, and so on. *Sadags* are the owners (*dag*) of the soil (*sa*), while *shidags* are the owners of the territory or place (*gzhi*). In this sense, they appear analogous to *nepos*, who are the owners of smaller territories. Like *yul-lha-dralha*, some *sada-shidag* beings have been incorporated into Buddhism, and such partially converted beings can be found throughout Bhutan.

Then there are amorphous beings who are hosted by certain people, mostly women, and hence operate somewhat like their doubles. They are wandering beings mostly representing the female body and are grouped under the *mamo-sondre* class. The *mamos* are generally portrayed as fearsome female spirits, individualized in the form of an animal-headed female body, who are inherently malicious. The *sondre* beings on the other hand are the witches or evil spirits of living women who are moderately malignant. Various ancestral-like spirits such as the poison god (*duklha*) and *gyalpo* belong to this class, but it may also subsume other evil human spirits not listed elsewhere. Finally, the personal (*gowe*) and household (*kyim*) gods are designated as the *gowe'lha-kyimlha* class. They are a set of five personal protective deities born together with the child (Stein 1972; Tucci 1980; Nebesky-Wojkowitz 1956) and household deities (Aziz 1978; Samuel 1993) respectively. While they too appear as

"multiple doubles" of a person, unlike *mamo-sondre* beings they are benevolent and helping spirit beings.

Goleng as a sacred village is characterized by the pluriverse of Bon divinities, which is attested by the multiplicity of propitiatory rituals and festivals, and the blessings and sicknesses attributed to them. In the villages, they are ranked according to their perceived power, so that people may prefer one over another. Such preferences are manifested in the way they worship, propitiate, and connect themselves with deities who, in return, bless them with prosperity, a healthy life, and fertility. Golengpas believe that divinities who are domiciled in the high elevations, such as mountains, the atmosphere, space, and the firmament, are benevolent, powerful, and higher than those that inhabit the lower part of the world. Because of their geospatial location, the latter are malevolent beings who lack powers to bless worshipers. Hence, there are tendencies for villagers to associate themselves with the distant, higher gods rather than the nearby, lesser deities and spirit beings.

The highest god, who has been worshiped for centuries in Goleng, is Odé Gungyal. He is believed to be reside in his heaven above the thirteen sky realms (*namrimpa chusum*). Similarly, the Hindu gods such as Indra and Shiva are invoked, particularly in the annual rites that concern fertility of cattle and humans. They are the most popular "universal" gods in the Bon pantheon, in the sense that Golengpas invite them annually from their heavens to Goleng. They are propitiated only once a year, during the annual Bon rite, and then ignored. This is also the case with the primordial god, Odé Gungyal. While both Odé and Hindu gods occupy the central place in the Bon pantheon, their absence in the village for the remainder of the year empowers the local deities on the ground. Golengpas, however, do not have any dedicated annual ritual for these autochthonous beings, and hence they are the ones who trouble villagers throughout the year.

The autochthonous beings can be further divided into two subclasses: regional and local deities. The regional popular deities of Goleng are domiciled in parts of Trongsa, Bumthang, and Tashigang districts, and their powers are expressed in terms of their influence and the size of their mountain abodes. On the other hand, to record all the local deities of Goleng is a daunting task since every facet of nature is believed to be inhabited by supernatural beings. The local deities can be subdivided into lineage and nonlineage deities. As seen earlier, there are four main lineage houses each with specific lineage

deities with whom Golengpas are associated. In addition to the lineage deities, there are a number of supernatural beings who reside in locations such as mountains, hills, valleys, river gorges, waterfalls, cliffs, big trees, rocks, and water ponds. While Rematsen is the highest-ranking lineage deity of the local divinities, all the lineage deities are invoked at least four times a year—that is, during the two *phorgola* rituals, *tsen* and *düd*, and *rup* rituals. The other minor nonlineage deities are also invoked during these annual rituals as part of the larger retinue, but there are no separate annual rituals assigned to propitiate them.

The four lineage deities, especially Rematsen, may have some influence over the rest of the local deities, but it is by means a total dominance. This was attested to by the wrath of marginalized nonlineage deities residing in the periphery of the village who are prone to curse Golengpa bodies, causing endless sicknesses, misfortunes, and troubles. Because of their geographical and physical contiguity with humans, the nonlineage deities are frequently disturbed and polluted, leading to their abducting souls. Hence, it is often the nonlineage deities who are required to be appeased on a regular basis given the fact that Golengpas worship lineage deities in preference to the nonlineage deities and spirit beings, who are also domiciled close by. Some of the popular but capricious nonlineage deities are Sangchu Umchu Lhamo, Aum Samkharmeth, Tolong Brag *nepo*, and Tong Tongphai *düd*. The former two are female.

Sangchu inhabits a small pond (*um*) just below Goleng proper where the village school is located. Tolong *nepo* is domiciled in the cliff (*brag*) somewhere close to Rematsen, and for this reason he is believed to be the slave of the latter. Among them, Aum Sangkharmeth, who resides in the hills in the lower part of Goleng, is by far the most powerful. The Indian laborers working for a company constructing power lines in 2017 could not build a pylon on the hill where the deity is believed to be based. Each time the Indians tried to level the ground, their machines broke down. In fact, several new machines were rendered inoperative and a landslide occurred even during the dry season. Finally, Tong Tongphai *düd* lives on the other side of the Mangdechu River, and he is known for causing heartache among the villagers who disdain his existence. While the Bonpo, because of his location, does not invoke Tong Tongphai *düd* during the annual rituals, the villagers propitiate him because it is often such neglected deities who inflict sicknesses. In addition to these nonlineage deities, the majority of Golengpas

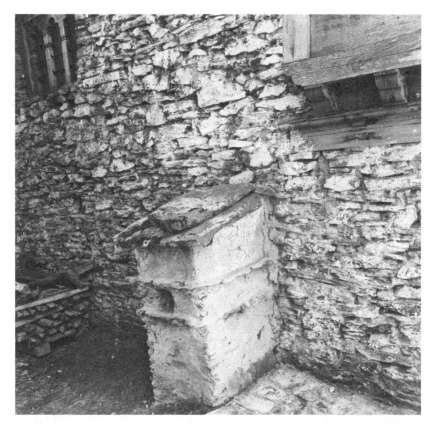

Figure 3.1 The abode of serpent beings

have a stone slab structure (*lubum*, also *lugum*) (Figure 3.1) next to their house that accommodates the serpent spirits (*lu*).

All of these nonlineage deities lack iconographical representation, yet each of them is identifiable by unique attributes and orientations. According to their class and location, the way they harm Golengpas varies from deity to deity. While one causes mainly heartache, another can cause chest pain, and others can cause many different sicknesses each with its distinctive and recognizable characteristics. Yet the spectrum of symptoms overlap in the eyes of the villagers, and which deity is involved can only be ascertained by the Bonpo using various techniques of divination (*mo* or *thamba*). The diagnostic and divinatory traditions vary according to the deities and the Bonpos themselves, but the most common forms are the uses of dice and

sortilege[11] divination (*sho mo*), drum divination (*nga mo*), rosary divination (*phrengba mo*), rice divination (*drä mo*), arrow divination (*damo*), mirror divination (*melong mo*), finger-breath divination (*tho mo*), and sheaf or offshoot divination (*shomda mo*). In the case of rosary and dice divinations, the values symbolizing auspiciousness and inauspiciousness may again vary in a fashion similar to different techniques of divinations. Last but not least, some Bonpos claim to possess a special power and modus operandi that enables them to determine the cause, for instance by way of clairvoyance or through interpretation of omens and signs.[12]

The preceding examination shows that the relevance of Bon rituals to Golengpas' everyday lives is underpinned by the shamanic cosmology of three worlds. The idea of cosmos consisting of three worlds, namely the upper world of gods dwelling in the sky, the middle world of various classes of spirit beings sharing the land with humans, and the lower world of subterranean beings inhabiting the underworld, pervades Goleng, and for that matter Bhutanese cosmology. Humans are mere "guests" sharing the world with various terrestrial supernatural beings who in turn are viewed as its original owners. While some of the local deities and spirit beings who were incorporated into Buddhism are considered benevolent, others who are independent of Buddhists are conceived as harmful beings. A great many of them are characterized by malevolence and animosity toward their human counterparts often manifested in the form of sicknesses and mental conditions.

Golengpas' long-standing interest in Bonpos and their rituals is in part due to the centrality of the five life elements with emphasis on *la*, without which people can easily become ill. *La*, being a highly mobile entity, must be constantly guarded from supernatural beings, as it can leave the body and be devoured by them, rendering the person sick, which is often characterized by mental instability and physical torpidity. The primary cause of soul loss is the plethora of unconverted supernatural beings who occupy every facet of Golengpas' social and religious landscape.

It is perhaps surprising, given that the threats to *la* are largely posed by these unconverted beings, that there no specific ritual by Golengpas' lay *chöpas* deals with soul loss, particularly when a certain untamed autochthonous deity is believed to be behind the abduction. It is the combination of the volatility of *la* and its centrality to people, and the latter's immediacy to

nature, according to the shamanic worldview of three worlds, that threatens the life elements, giving Bonpos the upper hand over the lay *chöpas* in dealing with amorphous, omnipresent, and unsubjugated beings. In other words, soul loss and the shamanic mythos of various classes of supernatural beings perpetuate Bon practices and beliefs in Goleng. Having provided this account of the complexity of the Golengpa pantheon and the volatility of life elements that are fundamental to a successful life, I turn to threats posed by these supernatural beings to Golengpas' health and welfare, primarily by affecting their five life elements.

4
Dealing with Threats to Health and Welfare

The groundwork having been laid for how the five life elements, with emphasis on *la*, can be threatened by local deities and spirit beings, this chapter examines the ways in which Golengpas can become sick due to the immediacy of supernatural forces, including personal spirits of some Golengpa families, and describes basic remedial rituals that I witnessed in my fieldwork. It addresses a range of threats to Golengpas' everyday life, health, and welfare posed by supernatural beings from the local Bon pantheon who, while pervading the Golengpas' worldview, have largely remained within the domain of Bonpos. While Buddhists view these local deities and spirit beings as too marginal to be subjugated or incorporated into the Buddhist pantheon, some of them have continued to harm people despite their incorporation by the lay *chöpas*. In other words, the propitiation of the incorporated local deities by Bonpos has not ceased, given that there are no specific Buddhist rituals to appease them. The ubiquity of the idea of fluctuating five life elements, the shamanic worldview of sharing this world with nonhumans, and the rituals concerning the placation of supernatural beings reveal that Bon is central to Golengpas' ways of dealing with life's everyday anxieties and misfortunes.

Protective and Healing Rituals

The interplay among the high gods, benevolent lineage deities, and malevolent nonlineage deities and spirits makes the local pantheon and corresponding Bon rituals of Goleng variegated and complex. Yet the binary of host-guest relationship characterizes their ritual landscape. The supernatural beings are the hosts, while the human counterparts are mere guests whose relationship with the former is shaped by the frequency of propitiatory rituals. The Bonpo on his part acts as intercessor by conducting rituals oriented toward healing the multiplicity of illnesses caused by malevolent beings and protecting humans against such beings, which are materialized, through

his reparative and curative soundings, in the form of metaphorical idioms, images, and *tormas*.[1] Furthermore, through the agency of his personal gods and shamanic powers, the Bonpo travels to places and spaces for negotiation by offering effigies to the spirits who are behind the affliction. While some of these rituals are observed as annual rites, others are performed as frequently as daily, weekly, or monthly, because the deities are easily angered but are not easily pacified.

Golengpas believe that in order to live a healthy, long life, they must receive constant blessings that can only be procured through offerings to gods and deities. Since many generations of their ancestors have worshiped them, Golengpas propitiate a range of local deities and spirit beings to maintain an amicable relationship with them. Nonetheless, because of their spatial contiguity, the peace is oftentimes exploded, especially when people—whether deliberately or unintentionally—leave their divinities unpropitiated, or if their places of abode are damaged or polluted. To illustrate the nature of protective and healing rituals, I will present some common rituals dealing with the sicknesses believed to be caused by the presence of various personal and nonpersonal spirit beings, and describe how the Bonpos deal with the subterrestrial spirits, terrestrial deities, and various ancestral-like beings of the Golengpa pantheon. One ritual that is oriented toward both protection and healing is concerned with serpent spirits (*lu*). As mentioned earlier, humans are guests in the middle realm (*bar*) of *tsen* and other nonhuman denizens. Above (*teng*) the middle realm of *tsen*, there exists a parallel world of gods (*lha*), and below (*wok*) them there are the underworld spirit beings, who are mostly *lu*. The *lu* are, however, not exclusively water elemental beings because they dwell beneath land and rocks. Further, the *lu* can transfigure from the purebred, wholly serpent spirits to hybrid *lu*: *lu* mutant mermaids (*tsomen*).

In general, *lu* are believed to be the wealthiest among the original owners of the land. When the purebred *lu* are cajoled to live beneath the structure (*lubum*) constructed next to the house and flattered through propitiatory ritual, the house occupants can be blessed with good fortune. On the other hand, when they are neglected, they are also known for punishing their human neighbors. According to Bonpo Dophu, who is a *lu* specialist, the wholly serpent spirits can be divided into four broad categories according to their physico-psychological dispositions and behavioral tendencies. First are the white *lu* (*lumo karmo*), who are individualizable in white-colored serpents. They are the most benevolent class of *lu*, in the sense that they do

not afflict humans with sicknesses unless they are wedged among stones in a wall or in structures erected by human activity. Their disposition can be upended, however, especially when humans fail to distinguish *lu* from inanimate stones that are believed to be the metamorphosis of *lu* beings. So employing the *lu* stone (*ludho*) for construction purposes backfires on contraveners, causing them to suffer from various *lu* diseases. Otherwise, white *lu* are benign beings who possess highly coveted economy-generating power (*yang*).

The yellow *lu* (*lumo sermo*) are second only to the white *lu* when it comes to benevolence and economic or *yang* potentiality. They are represented by yellow serpents. However, like *lumo karmo*, they can cause sickness when people defile, disdain to propitiate, or trap them under a stone wall and wooden posts. The final two groups are the rainbow *lu* and the black *lu*, embodied by multicolored and black serpents respectively. The former, believed to be an amalgam of *lu* and *tsen* beings (*lu tsen*), are considered malevolent because the synthesis of two distinct entities makes the new being all the more noxious. *Lu tsen* are hostile to human neighbors and bears antagonistic inclinations to all sorts of human actions. Finally, the black *lu* (*lu nak*) are characterized by malice and infamy given that they are mostly associated with demons (*düd*) who can afflict humans with sicknesses despite periodic propitiations. Because of their intrinsic malevolence, they are considered ill-intentioned beings. As evinced in the series of adoptions of benign *lu* beings by humans, unlike *lu tsen* and *lu nak*, both *lumo karmo* and *lumo sermo* can live harmoniously with humans, as they bless the household with wealth and fortune.

The dutiful worshipers are blessed with fortune and luck, while various serpent diseases (*lu'i nad*) are meted out to contraveners as retribution for neglecting these beings or polluting their sanctity. Traditionally, leprosy was believed to be directly caused by *lu*, and the pain in the lower limbs, boils, sores, and various skin diseases are still believed to be associated with them. Hence, before the construction of a new house, Golengpas perform an obligatory ritual involving burial of a treasure vase (*yangbum*), which is meant to seek *lu*'s approval, and hence their blessings. The nexus between the household and the *lu* is established by this prescribed ritual, and so is the reciprocal arrangement between them. It is nonetheless vital to avert their lurking malevolence through regular cleansing and appeasing rituals, mostly by the Bonpos.[2] Golengpas recommend walking with caution because they believe the soil and every stone are the networked dwellings of

lu. They must never bash a dry branch for firewood against the ground or a rock because such blind strikes could injure *lu* inhabiting that area. For instance, slapping a branch on a stone could culminate in a severe body ache in the offender, mirroring the injured part of the *lu*'s body. If the transgressor injured its lower body, the *lu* torments him or her by afflicting pain in the abdomen, while wounding the *lu*'s back triggers a severe backache. Such mirror effects are considered an open declaration of its physical agony and pain—which can be gauged only through the degree of the pain the contravener suffers.

While *lu* are well known for their *yang*, it is only rich *lu* beings who are endowed with such power. Such rich *lu* are embodied by white and yellow serpents. The *yang* helps accumulate all sorts of wealth, from money to domestic animals and from material wealth to healthy children. In addition to the *yangbum* beneath the house, *yang* powers are also normatively stored in another *yangbum* inside the family shrine, never to be opened even during the "recalling of *yang*" (*yangkhug*) as they can flee and disappear into nothingness. The rich *lu* beings are naturally looked on as good *lu* who are helpful and protective, and the household members placate them by cajoling them to live in the *lubum* constructed next to the own house. On the other hand, the poor *lu* who lack *yang* powers are considered harmful and malignant. They may be ritually driven away from their environs. While it is commonly believed that the good *lu* is always associated with wealth, property, and cattle, on the ground, people seem to be afflicted with the so-called *lu* diseases by both unappeased poor *lu* and the distressed good *lu*.

Bonpo Pemala, the de facto official Goleng Bonpo, himself was the victim of a hostile forest *lu*. He told me that some years ago, he had cut down a tree in a nearby stream, and the following year he suffered from severe leg pain that almost paralyzed him. Golengpas are deprived of proper medical facilities, and as indicated earlier, there is no BHU in their village as such. Nor do they have a traditional Bhutanese medicine center (*sowa rigpa*).[3] They are, however, entitled to receive service from a monthly outreach clinic (ORC) provided by the health staff from Yebilaptsa hospital in Trong county, which is the nearest medical facility. The half-day-long ORC service is assisted by the village health worker (*drongkher menpa*), whose main task is to link the village with the nearest public health center. The village health worker is usually untrained and receives no renumeration. Bonpo Pemala consulted the nearest hospital and underwent a treatment following the advice of a doctor who believed he was suffering from bone tuberculosis. Since there was no

improvement after the regimen, the Bonpo lost faith in biomedicine and refused any surgical intervention. He advised his family members to inspect the tree that he had hewn down instead.

Particular attention was to be paid to whether the fallen tree had pierced the earth. His family members reported that one of its branches had penetrated the muddy earth. Bonpo Pemala immediately realized that the leg of the *lu* spirits living below was injured by this branch. With the help of his family and friends, the Bonpo rushed to the spot to appease the offended *lu* by making reparatory prayers and offerings. Following instructions, his acolytes were asked to dislodge the branch that had penetrated the ground, to figuratively liberate the trapped *lu*. According to the Bonpo, everyone there smelled rotting flesh, which they believed to be the odor of the *lu*'s injured abdomen. The Bonpo argued that if he had relied on Western medicine, the fallen branch would have destroyed the *lu*'s lower body, which in turn would mean the putrefaction of his own lower limb. For Golengpas, well-timed propitiations generate timely blessings, while neglected propitiations engender recurring afflictions. The Bonpo greatly improved in the weeks following these actions.

The rich serpent spirits ought to be propitiated regularly through a purificatory-propitiatory ritual known as *lusang*, but for maximum effectiveness, it should be always conducted according to the astrological almanac. The *lu* beings are propitiated only on certain days of each month in which they are believed to be active (*lu theb*), primarily by offering popped rice and sprinkling the milk of a red cow around the *lu*'s abode. Alcohol is detested by all types of *lu* and the offering of modern dairy products is generally avoided. The *lu* beings remain mostly in hibernation, so conducting such rituals on the non-*lu* days (*lu theb muth*) is useless and dangerous, as it will only upset slumbering *lu*. While the basic rituals are generally conducted by all kinds of Bonpos—whether hereditary or nonhereditary—I came across a Bonpo who is considered a specialist in serpent spirits (*lu'i Bonpo*) to whom I shall return in the next chapter (Chapter 6).

In any case, the complexity of supernaturality in the social life of Golengpas is articulated in their adage alluding to dual ownership of their mind and body. It is an expression that often comes as a reaction to the bickering among themselves: "We do not have gastronomic spirits (*tsekpa*) in our mouth, we do not have familial spirits (*gyalpo*) in our mind, we do not have poison gods (*duklha*) in our hand, and we do not know black magic

ritual (*ngan*)." All of these supernatural beings operate somewhat as personal spirits whose powers can be unleashed to threaten other people's life elements as the person who hosts them become envious and offended by them. While the conflicts and disputes among neighbors can arise in relation to the idea that some families host untamed spirits that are feared by others, the Bonpos, by propitiating these spirits, are also engaged in conflict resolution through the mitigation of social problems and minimization of the outbreak of disruptions between neighbors and among communities. Hence, the Bonpos assume an important role, not only healing people but also reducing and resolving the relational disputes in order to create a harmonious society. I shall deal with each of these spirits in turn.

The Big *Gyalpo* Beings

In Tibetan Buddhist religious landscape, *gyalpo* beings are glossed as masculine spirits of evil kings and fallen monks (see Samuel 1993) who were bound by oaths administered by Guru Rinpoche and subsequent Buddhist masters. One usually finds such *gyalpo* in the temples represented by either white- or red-colored guardian deities. While the white always represents good and peacefulness, Nebesky-Wojkowitz (1956) maintained that only red-colored *gyalpo* are wrathful and hostile. The *gyalpo* are not only bound by oath to become Buddhist protectors but also accorded auxiliary powers and leverages in status. Their powers are attested by their control over vast territory and a large number of retinues. Samye Gyalpo[4] of Tibet is typical of this category since he is widely worshiped in Bhutan and other Himalayan states. Nonetheless, a range of *gyalpo* spirits who lack iconographical representations and forms are also found locally within the houses; they can be considered ancestral spirits.

In Goleng, there are two more variants of *gyalpo* whose power, unlike the oath-bound *gyalpo*, are limited to certain territorial locations. The first one is what Golengpas call the "big king-spirit" (*Gyalpo dhogmala* or *Gyalpo chedpola*) who despite its own retinue seems fairly parochial. Yet they are far more powerful than the other variants of king spirits who are simply called *gyalpo*. The big king-spirit has power over an extensive territory. The second is a familial *gyalpo*, whose power is limited to a household and village. It is quite common to come across households in a

given village with their own familial *gyalpo* spirits. Because of their limited power, they may be regarded as small *gyalpo*, but both depend on the family and demand regular propitiations. I have grouped the small *gyalpos* and the oath-bound *gyalpos* under the *mamo-sondre* and *yul-lha-dralha* headings respectively.

While all three variants of *gyalpo* are worshiped in Goleng, their propitiation varies, in terms of both ritual and offerings. The oath-bound *gyalpos*, who are already incorporated into the Buddhist pantheon, are propitiated only by Buddhists, including the lay *chöpas*, while the untamed *gyalpo* spirits are dealt with exclusively by Bonpos. Buddhists have no prescribed ritual for the non-oath-bound *gyalpos*, and the Bonpos cannot deal with the oath-bound *gyalpos*. The propitiation of oath-bound *gyalpos* such as Samye Gyalpo / Gyalpo Pehar, who form the pantheon of Goleng Dharmapalas (*chökyong*), is undertaken annually by lay *chöpas*, but given the plurality of non-oath-bound *gyalpo* spirits, the most frequently propitiated *gyalpos* are the big king-spirit and small *gyalpo* spirits. The former is believed to reside in the high mountains in Bumthang, while the latter are domiciled in the village, particularly in a specific household.

Bonpo Sangay is a Golengpa in-marrying husband (*magpa*) from Bumthang. His expertise lies at the intersection of *gyalpo* and Shartsen rituals. He holds that according to one strain of lore, when the disguised *Gyalpo dhogmala* from Bumthang visited Goleng at an unspecified time, he was met with ill-treatment and exploitation that vexed him greatly. Upon his return to Bumthang, he promised to take revenge on Golengpas by afflicting them with sicknesses. In addition to the big king-spirit, there are less powerful household *gyalpos* who cause endless, but less serious, sicknesses.

Four Golengpa households are thought to be in possession of familial *gyalpo* beings, which are strikingly like ancestral spirits who have lived with the household for many generations. Upon inquiry into their history, I found out that these household members are the descendants of a Bumthangpa man who arrived as *magpa* many generations ago. He brought along an ancestral artifact that is possessed by the *gyalpo* spirit. Since heirlooms are passed from one generation to the next, if *gyalpo* spirits are attached to the objects of antiquity, they may be linked to ancestral spirits. Some families in nearby villages also have the tradition of treasuring an age-old altar-like spirit-palace (*gyalpoi phodrang*) somewhere inside their house. They are said to make a libation of *ara* in three cups once every morning and evening,

without which the *gyalpo* could turn its wrath and misfortunes inward to the family.

In Golengpas' parlance, the *gyalpo* spirits can settle in or attach (*chak*) to their family heirlooms. While they can be inherited by birth through both sexes, they also seem, in the case of small *gyalpo*, to be transferable through antique possessions. When propitiated, they are inclined to help the family, but are prone to do harm when the family is disinclined to appease them. The families hosting the *gyalpo* spirits are somewhat stigmatized by the community, and make every effort to avoid displeasing them, for doing so would invoke lurking wrath. In the section to follow, I shall first turn to a ritual appeasing the big *gyalpo*.

Gyalpo Shul Du: The Ritual of Dispatching the Big *Gyalpo* to His Palace

The rituals for the big and small *gyalpo* differ significantly, both in structure and in elaborateness. According to Bonpo Sangay, a severe headache, ache in the hand and leg joints (*kangtsik lagtsik*), and fatigue are symptomatic of angry *gyalpo* spirits, but the severity depends on which *gyalpo* caused the sickness. These symptoms are mere precursor to the Bonpo's diagnostic procedure, which involves divination. The ritual is elaborate, especially if the big *gyalpo* is behind the sickness as the victim will not convalesce unless the spirit is treated like a human king by leading him back to his palace in a majestic manner. Conventionally, the ritual setting should be embellished by preparing thrones, banners and flags, brocade trappings, and, most important, elaborate offerings so that the big *gyalpo* is appeased and satisfied to return to his palace.

The ritual I witnessed was conducted by enacting the origin myth of the big *gyalpo*. The point of departure in this narrative is that Goleng is frequented by the big *gyalpo*, who exacts retribution for ignoring him during his first visit. The Bonpo began the ritual by first packing the copy of belongings of the big *gyalpo* who has intruded into the house of the victim. The adornments, an ornate hat, sword, and saddle for his horse and ceremonial buntings, were well prepared, for if they are too modest, the big *gyalpo* will return to cause more trouble. Along with lavish ornamentation, the spirit was offered three meals of cooked meat and eggs on banana leaves, placed facing the door. The main meal was supplemented by three cups of

locally brewed beer (*bangchang*) and three additional feasts and drinks. The latter were absolutely necessary to avoid the wrath of a hungry and tired *gyalpo* undertaking the long and tedious journey back to his.

While Dorji (2009), following Lévi-Strauss, maintains that the *gyalpo* is expelled from the house of the victim either by storytelling or by threats, in this ritual the big *gyalpo* was enticed by the Bonpo to partake of the offerings. Rather than storytelling, the ritual was oriented to enacting the origin myth and to appeasing but also deceiving the big *gyalpo* through trickery. This is by far more propitious because expelling the big *gyalpo* through injunction and menace will only lead to his quick return, more aggressive and more wrathful than ever. The big *gyalpo* is inclined to return to his palace when he was given the royal treatment; hence, the Bonpo here functioned as both summoner and minion to achieve that aim. He does so through inveiglement by orchestrating the departure of the *gyalpo* on the outside of the house and ritually accompanying the big *gyalpo* back to his palace. Rather than new and expensive possessions, worn-out slippers, old clothes, and unwanted objects constituted his accoutrements (*dzong*). These discarded articles were then animated by the Bonpo through a series of metaphorical expressions; once they were embellished, they operated as bait for the big *gyalpo*. The big *gyalpo* was cajoled by the Bonpo into eating the first plate of food and drink by announcing the offerings—which included welcoming drink (*dhong chang*), food (*zey*), and departure drink (*shul chang*)—and imploring the spirit to return to his palace:

> O precious *gyalpo*, hark now!
> Please return to your abode with pride and thankfulness.
> Remain there until the Mangdechu River reverses it direction
> Until the crow turns white in color
> Until the tongue is formed in the mouth of a quail[5]
> And until the molds are formed on this ritual table.

The ritual table was then quickly overturned, marking the consummation of the ritual feasting. To signify the egress of the big *gyalpo*, the acolyte carried the *dzong* toward a distant spot. The Bonpo for his part was engaged in an oral journey, which involved leading the big *gyalpo* to his palace, thus drawing "an idealized map of the entire region" (see Samuel 2013: 82) that subscribes to the spirit's powers. As he escorted the big *gyalpo* to Buli via Tali village to the north of Goleng, the big *gyalpo* was implored to loosen the fetters on the head, hands, heart, and legs of the victim. Before they climbed

down to Wangdigang River, Zhemgang proper was their next destination. From Wangdigang they walked past the dreadful precipice of Riotala and traversed the thick forest and several small villages between Phangzur and Dangdung. The first stop of this arduous journey was at the house of an old couple in Namser, who are probably hosts of the *nawen*[6] ritual. Their odyssey then took them to the high ridges of Phataigang and Ngangdag above Langthel. They had a brief respite at Ngang Lhakhang because Dokhrong, their final destination, was still far away. While his palace is assumed to be located in this mountain, the nebulosity of the ritual journey as they traveled farther north made the odyssey all the longer. It was in the extreme north of Bumthang in Dhur village where the big *gyalpo* was finally abandoned.

The mental and dramaturgical structures of the ritual, which involve mockery and chicanery, have a positive impact on the victim. While the *gyalpo* ritual is a mental journey, Bonpo Sangay argued that it is a dangerous undertaking. As a guide, he is risking his life and that of the victim. The Bonpo must never choose the residence of inhospitable hosts on the journey or lead him through an inaccessible route but follow an unobstructed course to a real geographical place trod by humans. Like a grueling real-life journey, it involves a seesaw of events that continually drain the vitality of both incorporeal "guest" and corporeal "guide." Thus, in each hiatus, a felicitous offering of the remaining feast and liquor was made by the Bonpo, apparently to obviate the indignation of the big *gyalpo* spirit. (In recent times, the big *gyalpo* has also been sent off in a car; however, the villagers believe that this method is inefficacious.) Once back inside his palace, he was surrounded by an entourage of attendants, drawn from shepherds, wranglers, cowherds, swineherd, and goatherds. The final adulation of the ritual is below:

> The titleholder of the golden seat, please remain on the golden throne.
> The throne holder of the silver seat, please remain on the silver throne.
> The owner of gold, please live among gold.
> The possessor of golden trumpets, please stay inside the trumpets.
> The master of holy scriptures, please dwell in the sacred scriptures.
> The owner of bell and hand drum, please settle yourself inside the bell and hand drum.
> The holder of religious horns, please reside in the pair of oboes.
> The heritor of cymbals and drums, please inhabit the rumbling cymbals and drum.
> The owner of great cliffs and passes, please be domiciled in the cliffs and passes.
> Now please remain in your respective abodes!

When the final oblation was tossed into the air, the main householder quickly shoved past onlookers to clean up the residuum that smudged the floor. Casting the offering in the air signifies the arrival of the *gyalpo* at his palace, while sweeping the muck off the floor ensures the *gyalpo* will not return in the house. This omen is embedded in Golengpas' sociality: unless they are dealing with an anathema, they refrain from sweeping floors when their family members and friends embark on a long journey. The above incantation portrays the big *gyalpo* as something like a Buddhist convert *gyalpo* or one of his retinue, given that he is adorned with Buddhist attributes and implements. Nonetheless, the big *gyalpo* is seen as an intruder who disrupts the unity of the household by causing sicknesses. This might imply that the partial incorporation of worldly divinities into Buddhism does not always lead to a radical transformation of their evil nature or prevent them from harming people. This failure is one of the reasons why Bonpos come to the fore in villages despite all the opposition. I shall now turn to the ubiquitous small *gyalpo* spirits, who can form a symbiotic alliance with the family upon its entry into the house through the agency of certain objects of antiquity.

The Small or Familial *Gyalpo* Spirits

The small or familial *gyalpo* spirit is by far the most common in the villages. It is generally inherited by all children of the family who hosts the *gyalpo* spirit, regardless of sex. The female *gyalpo* is, however, more common, although the technique of attack and mitigating ritual concerning both sexes remains the same. The mood of the person who hosts a *gyalpo* affects the mood of her *gyalpo* spirit, as they seem to be inseparable from the mind of the person who possesses it. The familial *gyalpo* acts as a weapon that strikes neighbors, especially when its host is jealous or envious of them. It afflicts them with sickness, which may lead to death, and harms their household economy and domestic animals even though people may not have reciprocal envy toward the *gyalpo* host. Through the agency of the host, the familial *gyalpo* spirit is able to talk (*gyalpo kha toth*) to a person with weak life elements, which is tantamount to harming them. In this sense, a person with the familial *gyalpo* spirit is feared, though people consider such a person as somewhat lowly.

The female *gyalpo* spirits are well known for capturing the property and wealth-gathering power (*yang*) of neighbors. If the *gyalpo* host were not assisted during the harvesting period, it would have a corresponding effect on

the crop yield of the ordinary person without such supernatural force. First, since the ordinary person did not help the *gyalpo* host, the former would anticipate nothing but a similar course of action from her. Second, the *gyalpo* spirit, in retribution for such action, can affect the other person's crop yield by boosting its own host's production. As indicated earlier, upsetting the mind of the *gyalpo* host directly upsets her familial *gyalpo* spirit, which in turn decreases the productivity of others while increasing their susceptibility to disease primarily by snatching their "yielding force"[7] (*'ong*). While *'ong* is closely related to the concept of the fortune-gathering force "*yang*" because both of them help amass wealth, the *'ong* force is associated only with crop yield. The *'ong* supplements the work of the *yang* by increasing the yield, particularly of grain and liquid. For instance, Golengpas believe that a cup of rice from a sack that is full of *'ong* can feed four to five people because when it is cooked, the grains multiply exponentially, thus increasing the quantity of the meal. Likewise, a bag of rice that has good *'ong* can last for several months despite continual usage.

The consequences of refusing to help or of disregarding labor exchange with the *gyalpo* host do not come into effect until the owner starts threshing crops. During manual threshing, which involves beating grain against a log or a stone, the familial *gyalpo* spirits can reduce the grain yield of others by pulling the *'ong* toward the field of their host, and hence increasing the productivity of the latter's crops. The Bonpo must, instead of dispatching the spirit, quickly propitiate it by performing a ritual that involves libation and tossing of rice as an offering. Here the Bonpo merely calls out the names of those who are believed to be the hosts of the familial *gyalpo* spirits as he expresses regret for not helping them. This ritual operates to let the victim regain full control over her crops and farm, placating both the familial *gyalpo* and the person who hosts that spirit. Although the familial *gyalpo* spirit seems to reflect the envy of a person toward others, it may be viewed as a helping household spirit because it can direct impersonal forces such as *'ong* and *yang* toward its host.

Autochthonous Demons

Unlike *gyalpo*, *düd* spirits are usually demons who are inherently malevolent beings. In Goleng, mirroring the evilness of *düd* spirits, a person who is wicked and rude is labeled an evil man (*düdpo*) or evil woman (*düdmo*).

Although the *düd* spirits do not help humans, in order to be well disposed, they require constant recognition through regular propitiation, which, until recently, entailed live-animal sacrifices. The Bon beliefs suggest that *düd* spirits are one of the original owners of the land who share the world with humans by occupying every hollow, stream, river, gorge, and waterfall. They are believed to be manifested in the form of big black snakes, and, considering their attributes, I have listed them among the class of *sadag-shidag* beings.

The amity between humans and *düd* spirits is quickly upended when certain households miss timely propitiations, or if they transgress the natural order of things. In such scenarios, the *düd* spirits will reach out their prickly hands toward that household and snatch away the soul (*la*) belonging to one of the family members with weak life elements. *Düd* spirits pervade the rural Bhutanese landscape. Considering the number of streams, creeks, cliffs, gorges, and valleys, there are probably more *düd* in Goleng than any other spirits. As demonic beings, they are the primary spirits that capture human souls. Screaming near the gorges, rivers, and streams will displease them, leading them to kill people's souls (*sok ched*), which is tantamount to killing a person. Similarly, meeting with sudden fright near the dangerous locations inhabited by *düd* spirits can result in the escape of soul (*la tor*) from the body.

In the idiom of ritual efficacy, divination always presuppose any healing rituals. Divination by the Bonpo is important for diagnosing the cause of sickness. His judgment is based on the combination of his psychic powers and the bodily symptoms the patient demonstrates. According to Bonpo Pemala, a person usually suffers from a very high fever, severe body ache, recurring goosebumps, and cold chills if *düd* spirits are behind the sickness. If the Bonpo determines that the illness was caused by a *düd* spirit, a propitiation of *düd* spirits (*düd chod*) is performed in the late evening. The Bonpo must discern the particular *düd* spirit causing the sickness, although the ritual for propitiating *düd* spirits is the same for all irrespective of their strength, power, and control.

Bonpo Chungla maintains that there are numerous *düd* spirits in a single stream, let alone along the Mangdechu River. By reason of proximity to the river and streams, Golengpas are subject to ceaseless attacks by *düd* beings. The ritual and offerings are far less complex than in the *gyalpo* ritual, requiring minimal foods and less time. The ritual that I witnessed was performed outside in a sequestered place close to the house of the victim. A sheaf of artemisia was burned as precursor to the sacrificial offering. Upon invoking

the nearby *düd* spirits, the Bonpo, who was not a shaman, communicated in a nontrance state with the spirit world and offered a plateful of rice with a boiled egg and fermented alcohol (*ara*). In exchange, the Bonpo summoned the particular *düd* who is domiciled in the lower stretches of the Mangdechu River under the command of his tutelary deities, who included Bonpo Tonpa Shenrab, to return the soul of the victim by articulating their names, animal signs, and sexes. At the end of the ritual, if the patient does not recover, the soul must be restored by brushing off the soul (*la pok*) from artemisia leaves before consulting the Bonpo shaman. While all the local divinities are prone to capture human souls, this modality of restoring the abducted soul in the form of a spider is common when *düd* spirits are behind the loss.

Demonesses and Witches

Mamo spirits are wrathful and malicious feminine spirits, while *sondre* are believed to be witches or evil spirits of a living woman, both of which I have listed under the *mamo-sondre* class. While Buddhists consider them two separate malignant spirits, laypeople conceive of them as a single entity. Golengpas believe that when *sondre* escape the body at night to hunt for human souls, they become the *mamo* spirits individualized in a form of a female body. Hence, rather than a separate entity, the sondre and the victim are treated as parallel. The *sondre* operate in a fashion similar to the familial *gyalpo* spirits in the sense that both are ancestral-like beings that function as the "double" of a living person. Unlike familial *gyalpos*, these spirits can manifest in the forms of fireflies, but they are restricted to females and are not inherited at birth.

Like familial *gyalpo*, *sondre* spirits are helpful to the persons who host them. While they cannot bring the blessings of long life and good health, they help the host by stealing the life elements of others. A popular myth narrated by a senior villager during my fieldwork describes how *sondre* spirits transformed into fireflies in order to hunt for not only human souls but also wealth and properties.

> There lived a rich girl and a poor girl who used to herd their cattle together in the high hills. Although one of them had fewer cattle, both had an individual set of milk churns of the same size. Despite more milking cows, the rich girl witnessed a sudden drop in butter production. In contrast, the

poor girl extracted an increased amount of butter, something beyond what her milk could yield. The rich girl grew suspicious. In order find out the cause of this strange decrease, one late evening the rich girl pretended to be asleep. As soon as the poor girl fell asleep, she saw a firefly come out of her mouth. The firefly first entered the milk churn belonging to the rich girl and then returned to her own milk churn. The activity was repeated for the rest of the night as though the firefly was transferring the "essence" of milk. Toward dawn, the firefly discontinued its long and arduous task and returned toward the poor girl's bed. It eventually entered into her from where it came.

The next night, the rich girl again pretended to be in a deep sleep. When the firefly entered her container, she nimbly sealed the hole of the container with a clump of banana leaves. The poor girl did not wake up in the morning. Wondering what to do next, the rich girl slowly cleared the leafy knot to investigate what role the insect played in her sleepiness. The firefly escaped from the hole and flew straight toward the sleeping girl and dissolved into her in a flash. The poor girl who remained asleep then woke up and started describing her dreamy experiences in a doorless dungeon.

As the double of a living person, the *sondre* spirit remains inert during the day, when the host is physically and mentally active. The *sondre* can only become active when its host body and its consciousness are in deep slumber. During the dead of the night, when it slips out of the body of the host, it is always unnoticed by the other family members. It transforms into fireflies and blue fireballs (*mamo gami*) and combs through the village looking for human souls. The circular blue lights are visible to any human eye, but according to Golengpas they lack heat. While the *sondre* spirit is engaged in its soul-hunting enterprise at night, the host body remains inactive and unconscious, in that the host cannot reactivate consciousness without reintegrating the disembodied *sondre* spirit. During such a state, she may be completely immune to noise or any sort of pandemonium.

There are many Golengpas who have seen the *mamo* fire metamorphose into insects such as fireflies when they attempted to grab it. The village at night is said to be populated frequently by varying sizes of blue fireballs, which ultimately congregate at one spot to integrate themselves into one big ball. It is believed that they have their own "queen" or chief, represented in the form of a bigger fireball that naturally attracts the smaller ones. When an

ordinary person strikes this union with a stick, it breaks into a multitude of smaller fireballs that are capable of functioning individually. Bonpo Pemala holds that when the individual's search for a soul is unsuccessful, the *sondre* spirits, like humans, unite together to bolster their force and energy. They traverse valleys and mountains of villages until the early dawn, following the mountain ridges that are their main highway. However, not all the *mamo-sondre* spirits appear to be malicious, because sometimes they may help a person with strong life elements.

Discerning the *Sondre* Host

When a person confronts a *mamo* fireball, the first course of action is to capture it and hold it carefully—not too tight and not too loose. Eventually, the fireball will turn into a firefly or a yellow wasp—both of which individualize the *sondre* person. While in some cases the insect is stored in a milk container, others are confined to narrow spaces, such as under a bell or inside a small sack (*sangku*) or a container. If the container is airtight, the person must pierce it so that the real person does not risk suffocating. This aperture acts as a yoke that connects the *sondre* spirit with its host body as the host person may die if the insect dies. For instance, if a limb of the insect is injured, the *sondre* host will have a severe pain in the corresponding limb. According to Bonpo Chungla, the firefly must be placed on the head of a person in order to identify its host.

In Golengpas' understanding, there are two ways in which *sondre* spirits can harm humans. The most common *sondre* attack is the snatching of the soul (*la*) of a person by the impersonal spirit manifested in the form of a firefly or a yellow wasp. The other technique is more physical because the victim can see the form of the *sondre* spirit who is attacking. In other words, the *sondre* spirit metamorphoses into a *mamo*, which is far more powerful than its former status. As attested by Bonpo Sangay's experience, the first form of attack is unknown to the victim per se, while the second is believed to be experiential, so that the host person can be recognized through her voice and physicality. One can hear the spirits chatting among themselves along the village path, at the crematorium, on the crossroads, and at other places within the village. This apparition operates in complete opposition to that of the actual *sondre* person. She appears malicious, crackles, and entices the victim to follow her away from his house. She makes the witness hallucinate,

transforming unsafe and perilous domains so that they seem safe and peaceful. However, in both cases, the physical *mamo* or *sondre* body remains inactive, mostly unaware of the flight of the spirit.

There was one *sondre* attack in Goleng that was typical of the rare physical confrontation with supernatural forces. The victim was Bonpo Sangay himself, and the attack occurred only recently. The Bonpo, while returning from work in the evening of one waning lunar night, was confronted by several Golengpa women. He was slightly intoxicated by *ara*, and drunkenness makes the person vulnerable to evil spirits. It can lead to sensory impairment that becomes silliness, and, most important, being drunk triggers the people's personal gods and protectors to partially abandon them. It is in such state that people are able to see gods and demons (*lhathung drethung*). According to Bonpo Sangay, that night he was in the *lhathung drethung* state and was coerced to follow the injunctions of the *sondre* spirits manifested in the form of Golengpa women who he thought were real people. He was climbing uphill when they steered his direction downward toward lower Goleng. Some of the women called out to him to follow them, while others pushed him through the woods.

As they descended downhill, he was first asked to take off his outer clothes. The first instruction was to hang up his sword (*patang*) and then to take off his shoes. Before too long they asked him to take off his cloak (*gho*), followed by his shirt and half pants. In this way, the *mamo* spirits first attacked the Bonpo physically before aiming to abduct his soul. As he approached closer to the cliff that is close to the gushing river, the Bonpo fortunately began to realize what was happening and grabbed hold of a white tree. To his dismay, he saw all of the women turn into fireflies circling the very tree he was clinging to. Bonpo Pemala claims that he was saved from the final soul attack by the divine intervention of a Buddhist master who appeared to him as a yellow umbrella-like object and brought his mind back home to reality. When he regained his sense, the Bonpo realized that it was the *mamo* spirits who had physically transposed him to the precipice. According to villagers, he was wearing only underwear on his return the next morning and remained mentally disoriented for over a year.

Golengpas believe that the physical attributes of a host person are uniquely fluid. Her complexion frequently changes from white to red to black and back. When successful with her catch, she turns white, satisfied, beautiful, and, most important, very powerful. On the other hand, when unsuccessful with her catch, she becomes dark, red, gloomy, and irascible. Merely being

seen, scratched, and bitten by *mamo* spirits or passing by them can result in sickness that requires the Bonpo's intervention. In order to determine if *sondre/mamo* spirits are behind the sickness characterized by body ache and muscle pain, Golengpas usually scrub the affected part of the body with an Indian madder (*tsuth*). If the patient was bitten, scratched, or beaten by *sondre* spirits, it crystallizes a montage of bluish scars that are viewed as marks of the *sondre*'s fingers or teeth. In general, the mitigating ritual against *mamo* attack must be conducted in the evening, but the exact time may vary according to the age of the victim. During my fieldwork, the ritual for an adult victim was performed after 9:00 p.m., while for the children it can be executed after 7:00 p.m. The details of the *mamo* ritual also depend on the location of the attack. If the confrontation between the *mamo* and the victim occurred in a "hive of *mamo* activity" (*mamoi tang*), such as at a crossroad or other area teeming with spirits, an elaborate shamanic ritual with additional sacrificial ritual cakes must be commissioned.

Although the *mamo* spirits should be summoned from the four cardinal directions, including crematorium and crossroads, the oral journey of the *mamo* ritual by Bonpo Pemala did not involve traveling any further away than nearby villages and towns. The territory covered in the ritual was relatively much smaller than in the *gyalpo* ritual, as the Bonpo traveled only to Tali, Kyikhar, Buli, and Zhemgang proper to gather *mamo* spirits. After the summoning, they were fed with a meal, popped rice, and raw and cooked eggs, which represent the body and vital organs of the victim. Unlike in other rituals, the Bonpo here threatened the *mamo* spirits under the command of the Bon pantheon to feast on the offerings:

> The boiled egg is the body of the victim.
> The raw egg is the soul of the victim.
> I ask you to relish these well-replaced offerings
> Because it is the command of Bonpo Tonpa Shenrab.
> It is the command of Bon gods and goddesses.
> It is the command of male and female garuda (*khyung*).
> It is the command of my Bon masters.
> There are powerful male and female Bonpo shamans (*pawo*).
> There are illustrious male and female Bon priests.
> There are exalted Bon masters.
> Under their commands, now devour the offerings I have offered
> And henceforth stop tearing human souls and bodies!

The additional offerings constituted *Oroxylum indicum* (*namkaling*) flower and alcohol. At the end of the ritual, these offerings were cast by the acolyte, including the raw egg, around the ritual altar that was constructed outside the victim's house. The offerings were discarded at a crossroad, given that anything that is dangerous is believed to be found at one of the crossroads. The Bonpo then determined the ritual's efficacy by relying on the state of the discarded raw egg. In this instance, the raw egg was found broken, indicating the *mamo* spirit's acceptance, thus prognosticating the recovery of the victim. The Bonpo holds that, if the raw egg remained unbroken despite being repeatedly thrown at a stone or on hard ground, it foreshadows the *mamo*'s refusal to free the abducted soul. Until the egg cracks open, the Bonpo must repeat the litany, sometimes even invoking Buddhist deities and making additional offerings, including the clothes of a victim. The situation is similar if *düd* spirits refuse to take the offerings.

Bonpo Pemala maintains that the power to make *mamo-sondre* beings accept the offerings under duress depends on the Bon priest's physical and mental abilities. The Bonpo must have power (*wang*), which comprises physical force, spiritual realization, and, most important, the "oral" power to summon the *mamo* spirits. A Bonpo with power and oratorical skills is idolized, respected, and heeded by the *mamo-sondre* beings, who constantly observe the shifting powers of Bonpos. Bonpo Pemala argues that another reason why Bon priests should be strong is that if they are both physically and mentally powerful, they can actually see *mamo* spirits partaking of the offering and identify the host persons. In such an event, if the *mamo* spirits collecting the offerings have their palms turned upward, it indicates the willingness of the spirits to return the soul, but if their palms are turned downward, it signifies the refusal to release the abducted soul. If the Bonpo is weak and old, the *mamo* spirits can consume his soul instead of the sacrificial offerings.

Shartsen: The Eastern Mountain Deities

The mountain deities (*tsen*) inhabiting towering mountains and deep cliffs are believed to be red in color, symbolizing their ferocity, fertility, and masculinity. I have grouped these deities under the class of local deities (*yullha*) and war gods (*dralha*). *Tsen* can be both male and female beings and are propitiated to gain their favors, especially during conflicts, wars, and

regional games. In some areas, *tsen* spirits have been converted into Buddhist protectors by Buddhist masters, so they are propitiated by both Bon and Buddhist priests. Golengpas propitiate several *tsen* deities, of whom the most notable are their own Rematsen, Kibulungtsen of Bumthang, Mugtsen of Trongsa, and Shartsen of Tashigang. Except for Rematsen and Shartsen, they are male deities. As Karmay (2009 [1997]) notes, there seems to be a close spiritual and familial link between these deities and local chiefs to the extent that some of the nobilities and local strongmen (*nya gey*) are believed to be fathered by them. Nevertheless, *tsen* deities are not always expected to be well disposed to humans, for they can cause all sorts of sicknesses and sometimes even death when the faithful displease or stop propitiating them.

Shartsen is a collective name for a family of Buddhist-convert female mountain deities (*tsen*) who are domiciled in the high mountains of eastern (*shar*) Bhutan. They are the only eastern deities propitiated in central Bhutan. Although the Buddhists propitiate them using their own ritual corpus, the villagers have never stopped resorting to the Bon version of Shartsen ritual. Jomo represents the apex of the Shartsen hierarchy and is believed to reside in a mountain in Merak-Sakteng along with her daughter Tsongtsongma and her husband Dangling. There is confusion with regards to the identity of Tsongtsongma, who according to some Bonpos is male, while others believe it to be one of many daughters of Jomo. Similarly, some believers claim that Dangling is the brother of Jomo herself, while others still argue that he is the husband of her daughter. But all the narratives agree that Dangling fathered many children with local women. People like Bonpo Sangay, who is one of the Shartsen ritual experts, hold that they are a legitimate couple with their own retinue that is attested during the propitiatory ritual. According to him, Dangling lives somewhere below the abode of his wife in Tashi-la, while Jomo inhabits a hill in Serkyemla above them. Topographically, Jomo occupies the highest mountain realms, signifying her superiority over her daughter and son in-law. The three women whose names all end with "Dema" and merchants (*tsongpon*) like Norbu Zangpo and Dawa Zangpo make up their collective pantheon.

According to another popular view, an evil king once ruled a certain village in southern Tibet. With the help of these deities, a group of people assassinated the king and fled south to relocate in the present-day Merak. Jomo took up Merak-Sakteng as her abode, while her brother Dangling settled in Dangling Lake in Khaling, Tashigang. There is no mention of Tsongtsongma in this migration history, however. With the renewed

territorial hegemony and added supernatural powers, the control of Shartsen deities began to spread beyond the eastern horizon. Bonpo Sangay believes that the chief of *Shartsen* seldom afflicts people with illness, but Dangling and Tsongtsongma and their retinues are well known for causing various sicknesses. Jomo herself is thought to be a vegetarian among her retinue, which constitute flesh-loving deities, hence making the meat or red offering (*mar tsog*) a mandatory part of the Shartsen ritual. In any case, they seem to be a family of closely related deities who were assigned mountains of varying heights as their specific abodes so that their powers are reflected by these peaks that represent them.

In the Golengpas' religious landscape, Shartsen are the most dreaded deities, so much so that Golengpas dare not say their name. Fearing their wrath, they respectfully euphemized them as the "big cause" (*dhon dhogmala*) if Shartsen were believed to be behind the sickness of a person or animal. The Shartsen ritual is usually conducted by a specialized Bonpo, particularly when a woman is unable to give birth, or if cattle have turned infertile. It is also performed when a person, irrespective of sex, suffers from a severe stomachache. During the ritual, a cow was sacrificed until recently, and some strict dietary restrictions are still being imposed on the householder and the Bonpo. Prior to the ritual, the consumption of pork by the Bonpo is dangerous and totally impermissible. He must also refrain from eating other types of meat and from indulging in sex. Likewise, the ritual patron must maintain cleanliness, and the *tsog* offering should never be prepared by a menstruating woman. Currently, meat of the dead animal or fish from the nearby meat shop substitute for animal sacrifice.

During my fieldwork, the Shartsen ritual was conducted by Bonpo Sangay, who is well versed in dealing with the sicknesses associated with the Shartsen deities. The propitiation started with the preparation of the ritual table. On the center of the table, five small flags made from slender branches of *Euraya cerasifolia* (*merbai*) tree were erected. In areas where *merbai* is unavailable, an artemisia plant will suffice. Except for the terminal and a few auxiliary buds, the rest of the leaves of the branch were cut off, and its tip was tied with a piece of white scarf. On its right, two brae[8] of paddy and a male dress (*gho*) were installed as an offering to Dangling. On its left, a container of cotton and a female dress (*kira*) were offered to Tsongtsongma. The five flags in the center were of course an offering to the main deity—Jomo. Before it, the *dzong*, which is far more elaborate than in the *gyalpo* ritual, was set up

next to the ritual table. The *dzong* constituted a display of expensive male and female clothes, including precious jewels and much-coveted stones. Behind these offerings, another twelve smaller flags were erected. A separate offering that includes fried alcohol (*marchang*) for the war commanders (*mägpön*) and a large bowl of *tsog* offering for their retinues were made. Both omitting offerings for the retinues and the making of polluted offerings will result in repeated attacks. If the alcohol in the jerrycan, for instance, is opened or used, the owner must add yeast to restore its purity and freshness. The offerings were, moreover, incomplete without cooked beef and fish.

The Shartsen ritual is an oral journey that does not involve the Bonpo entering a trance. As in many rituals, the Bonpo first introduced the patient and described the ritual setting, including the location of the house from where propitiation is made. His verbal journey followed the high mountain ridges that connect the abode of Shartsen in Tashigang with Goleng village. Following the mountains ridges shortens his oral journey and expedites the propitiation. Unlike in the *gyalpo* ritual, there was no mention of valleys or plains because the Shartsen deities never travel on foot in these areas. With his verbal incantation that created a spontaneous lift, Bonpo Sangay landed on the top of Remongya Mountain, which is the abode of their local deity, Rematsen. Then he transported himself to the crest of Malaya and other prominent mountains in upper Zhemgang. With each line of incantation, the Bonpo traveled farther from Goleng by leaps and bounds until he arrived in Tashila, which is demarcated by three diversional paths.

After the ritual, Bonpo Sangay elucidated the destinations that these paths lead to. While the left path leads to the abode of Dangling, the middle path ends at the abode of Tsongtsongma. The right path takes him to the abode of Jomo, which almost touches the roaring sky. The Bonpo emphasized that he should not let the crossroad disorient his consciousness but pick the right path that takes him straight to the abode of the main deity. Approaching Jomo's immaculate abode, he sees three mighty divinity flags (*lhadhar*) of differing heights, whose scriptures and contents are unknown to Bonpo, fluttering endlessly. He should walk past them, away from the great, medium, and small *lhadars*, into the patches of green lawns. Amid them there are stairs of different sizes made from various materials that all lead to the palace of Jomo. He must choose one of them and then climb up the single golden ladder without which he would not gain entry into her abode. The invitation of Shartsen deities and their retinues was made from the vestibule.

As attested by the ritual incantation, the deities and their host of retinues consented and arrived at the patient's house in Goleng by flying, sometimes riding on the wind and the sun's rays but still following the mountain route. All of them were portrayed as wealthy beings donning their brocade gowns (*geychen*), combat boots (*dralham*), and coveted jewels and precious stones of the three worlds that adorned their torsos. In their hands, they hold the wheel of a certain mantra unintelligible to the Bonpo himself. The arrival of deities is materialized in the form of sacrificial oblation on the ritual table as Bonpo sincerely supplicated them to release the life force or soul of the victim.

The response of the Shartsen deities and the efficacy of the ritual were determined by rice divinations conducted while inviting the deities and dispatching them. These predictions involved the Bonpo grabbing a pinch of rice from a cup and tossing it in the air while keeping hold of a few grains. The remaining grains are signs of whether the deities have accepted the offerings or not. An even number of grains is interpreted as inauspicious, meaning the patient may not recover and further intervention by Buddhists or another Bonpo is required. While the count of one, three, or five grains is propitious, the five grains that represent the five golden doors of Shartsen are considered *too* auspicious (*zang thal*). Being ultra-auspicious increases the odds of inauspiciousness and latently encourages ill-boding events. Three grains that represent the silver doors is the coveted number, as it has no inherent elements of ominousness. Receiving three rice grains signifies that the deities are pacified and the patient will recover. Finally, two grains represent bronze doors and are a harbinger of impending death, reflecting the implacability of the deities in question.

As in the *gyalpo* ritual, extreme care was taken while guiding the deities back to their abodes because if they are not pleased in any way, the deities will not release the soul, or will let one of their retinue remain to wreak havoc in the family. In order to successfully invite and pacify the deities, the Bonpo emphasizes the "depth of mind" (*semgi ing*) of the ritualist, which is equivalent to specialization of the Shartsen ritual. The Bonpos must have a certain degree of accomplishment so as to acquire techniques that will empower them to oblige the deities to accept offerings under duress. Although his expertise was externalized by three grains during the divination, Bonpo Sangay says that he is sometimes unable to appease the deity even with lavish offerings, and consequently the sick person does not survive.

Poison Givers: We Are Pure and Clean People

As mentioned earlier, Golengpas describe themselves as exceptionally pure—that is, without the gastronomic spirits (*tsekpa*) who are responsible for causing diarrhea and stomachache in the person who refuse to offer them food. Similar to hearth gods (*aii zön*), the *tsekpa* spirits are also the double of the craving that is possessed only by certain people, particularly for food and drink. When *tsekpa* spirits see someone feasting on a delectable meal, the person is believed to release these spirits into the food, culminating in sickness. For instance, olfactory feasting is enough to stimulate saliva in the mouth of passers-by; thus they end up ejecting *tsekpa* (*tsekpa ra pa*) spirits toward people who are unwilling to offer food to the former. Hence the latter may fall sick, and the only remedy is the Bonpo's tossing the same food into the air and simultaneously calling the names of those who supposedly bear *tsekpa* spirits. As seen already, *gyalpo*, particularly the familial *gyalpo* spirits operate in a similar fashion, but among them, the black magicians are the most feared in Goleng (see Chapter 5).

A poison god (*duklha*) is a malicious being whose power is vicious, inexhaustible, and transgenerational. Poison gods are apparently not grouped under the eight classes of gods and demons, but they too are ancestral-like beings and operate in the same manner as *sondre* spirits. *Duklha* are, however, inherited only by females at birth, although they are also believed to be transferable through material possession, as in the case of the familial *gyalpo* spirit. Consequently, I have grouped it together with the *mamo-sondre* cluster. The people hosting poison gods are somewhat ignored and stigmatized as obnoxious individuals but never overtly. Like hearth gods, the poison god is not ubiquitous but can be found sporadically across Bhutan, especially in central and eastern Bhutan.

In Goleng, there are currently three matrilineally related households where the claims of hosting poison gods are strong. Such claims are, however, made by others, rather than those households themselves. Their symbiosis with the poison gods goes back to the origin myth, which I shall explain in the sections to follow. The main ability of the poison god is to harm others through the unrestrained commensality of their host. Hence, as Bloch (2005) showed, commensality and hospitality, particularly in the house of a poisoner, are cautioned against, as the host and her poison god conspire to poison the guests. This is attested by the Golengpa advice that says, "Befriend the black magicians but alienate the poisoners."

The poison god is characterized as a sneaky, impersonal being with an ability to creep into the body of a person, most commonly through ingestion of food and drink. It then affects the person who carries it, both mentally and physically. While the victim usually suffers from acute diarrhea, vomiting, stomachache, boils, and so on, such afflictions are, rather than food, attributed to the poison god who infiltrated the person's body. Thus, restraining hospitality and intimacy with the poison hosts precludes commensality between them, which operates as a conduit for the poison god to prey on the ingester. On the contrary, the unrestrained hospitality and social nicety toward the black magicians absolve them of any underlying reasons that could warrant their unleashing their power. So in a community where both of them are extant, the black magician arguably has the upper hand.

The poisoners in central Bhutan do not gain merits (*sonam*), nor do they host poison gods to accumulate them (cf. Lichter and Epstein 1983). It is purely a primordial pre-Buddhist belief in which the host acts as the medium for sustenance of the poison god. The Golengpas argue that the host through commensality imperils the person to be infiltrated by her poison god primarily to placate it and avoid its wrath against her. They claim that lacking success in hosting commensality would trigger categorical attacks by the poison god on its very host and their relatives. Unlike in the sphere of hearth gods, where food should be ingested only through its host, ordinary people should refrain from ingesting alimentation of any sorts, directly from the host or her family members who hosts poison gods. As the antithesis of hearth gods, the host here exercises complete authority over her wealth in the sense that she is never required to make offerings to her poison gods themselves. Hence, food and drinks, which are impregnated not with poisoning powers but with an impersonal poison god who would prey on the ingester, were offered to the guests unreservedly. The local narratives argue that if the host, who is usually the main householder, is unsuccessful in cajoling outsiders into partaking of the meal, she may attempt to give it to her relatives.

In actuality, the victims of poison gods are chiefly those with weak life elements. Yet such people can shield against attack while still ingesting food from the god's host. While the poison god is transmitted only through hospitality and commensality, there are numerous prescribed techniques for subverting its power. To determine the presence of poison in alcohol, Golengpas recommend drinking in a "silver-coated cup" (*za'i japhor*) that is made from a burl from a special tree. The cup is self-activating and will boil if the substance in it embodies the poison god. They can also evade a poison god by simply staring at the ceiling of the house because guests are surveilled

by the poison god from above. Staring at the ceiling before ingesting food implies that the person is conscious of the intention of the poison god above. Additionally, there are certain Buddhist antidotal mantras that are recited before partaking of a meal at the poison god-hosting houses. According to Golengpas, an ill-starred person with weak life elements who ignores the observances becomes the easy victim of acute diarrhea, vomiting, stomachache, boils, and so on.

According to da Col (2012), the poison gods among the people of Dechen in Tibet roam freely from one household to another in the form of snakes and other beings without "fixed patterns" and randomly settle in the household with weak life elements (183). The other modality that underpins the drifting nature of poison god is that it can metamorphize into snakes and cast-off precious objects, which reanimate in the form of inanimate entities and enter the house. Hence it seems that every Dechen household stands an equal chance of being the inheritor of poison god, who would choose the less fortunate or possibly random households as its temporary host.

Within Goleng sociality, while the origin myth of the poison god and how it entered Golengpa households corresponds to the narrative of Dechenwas, the synergy between the poison gods and host is fixed and permanent. The poison lineage (*dukgyud*) in Goleng was established when some women brought home certain cursed objects from the mountain that were believed to be abandoned by certain traders. Although Golengpas are uninformed about what the objects might have been, the traders were said to have left a note on a rock foretelling that, since these women had bought "snake bile" from them, they would give poison. The poison god then began to operate like an ancestral god that has the tendency to proliferate and establish intergenerational symbiosis with their progenies, though the role of chief legatee is assumed by the eldest sister of the family.

Treating the Poison Attack

As mentioned already, poison attacks manifest in the sudden development of large boils, a feeling of fatigue, and certain conditions such as heartache and diarrhea. The patient in Goleng presumed to be affected by a poison god usually does not go to the hospital for treatment because the attack is considered incurable by biomedicine. Instead the sickness can be remedied by both lay *chöpas* and Bonpos. In the Buddhist treatment, blessed water (*ngag chu*) is prepared by a lay *chöpa* who recites several rounds of certain mantras and

then repeatedly blows onto the affected part of the victim's body. The water is eventually given to the patient in the early morning, and that works toward counteracting the effects of poison.

There are multiple Bon methods to treat poison attacks; however, sucking out the poison is the most common. During my fieldwork, the Bonpo first silently chanted secret mantras—that is without the movement of lips—before blowing fiercely on the boil, which in turn is seen as the spot where the poison cyst or the mother of poison (*duk ama*) is located. The Bonpo can suck out the poison with his mouth, employ a razor blade to drain off the pus, use a drinking glass or the horn of a bull to suction out the poison, or burn the boil itself with fire.[9] In one case I witnessed, the biting method was used to draw the poison out from the leg of the patient. Golengpas view this poison cyst as a metamorphosis of the poison god, which hence needs to be completely removed by repeatedly sucking it from the bite. The successful removal of a poison cyst from the patient was attested by the transformation of supposed poison—pus and blood—into a texture resembling an egg when strong *ara* was sprinkled over it. Golengpas still caution themselves and their loved ones from visiting the houses of persons who are hosts to a poison god. There is a covert avoidance of poison households by making excuses to avoid eating at their house as reflected in an account below by a Golengpa woman who recounted her experience at the house of alleged poison giver.

> It is easy for the poison god to attack us if our life elements are weak. But if they are strong, we do not need to recite mantras or drink from a silver-coated cup because the poison gods cannot attack us. However, we cannot predict the state of our fluctuating life elements. Some years ago, I along with my middle son, who was then a toddler, went to see a family when their mother (an old poison giver) passed away. The elder sister (the current poison giver) insisted on drinking black tea. Though I hesitated, both my son and I had a cup of tea at her insistence. The next day, a giant and painful boil appeared on the buttock of my son. The boil became bigger and worsened each day. It never showed a sign of recuperation. Later I approached my uncle, who is a lay *chöpa*, and requested a *ngag chu*. I gave his holy water to my son, and of course I drank it too. The next day, the boil unbelievably burst, and there were three big holes from which the poison escaped the body.

As indicated above, the households who are alleged to be hosting poison gods still seem to be covertly stigmatized. However, the narrative surrounding the

origins of poison gods in Goleng demonstrates that the poison hosts come from the households whose ancestry can be traced back to persons who acquired strange artifacts usually containing substances such as organs of snakes. It is the materiality and uncommonness of such possessions in the community that resulted in the stigmatization of those who possessed them as "poison givers." Although poison gods are feared by people, there is always a way to evade them. One common formula is to mentally recite some mantras before accepting a meal or drink. In recent times, the sucking of poison by the Bonpo is the matter of secondary recourse since boils are now mostly treated with the Buddhist blessed water; yet the Bonpos are sought to complement the Buddhist treatment, which does not always succeed in eliminating the poison god predating the victim.

Gyalpo, *Sondre*, and *Duk* Beings as Economy-Generating Spirits

Earlier, based on the ritual journey and paraphernalia of the big *gyalpo*, I have alluded to the Buddhist convert *gyalpo* who visits Goleng via Bumthang. Yet the big *gyalpo* is considered an unwelcome guest who has intruded into the household of the victim. He is by no means reckoned an ancestral being but conceived as an outsider whose mere presence in the household makes the family members fall sick and destabilizes their life elements. The family, as temporary host, is required to feed the big *gyalpo*, who is unwilling to return to his palace. However, the frequent return of the big *gyalpo* to the family insinuates that he may be analogous with the familial *gyalpo* spirits who are characteristics of ancestral spirits. Unlike the big *gyalpo*, whose travel is long, in terms of both distance and time, the connection between the familial *gyalpo* spirit and the family who host it is never really severed because the spirit's power is confined to their village. In other words, its intrusion is limited to the neighbors in close proximity to its host and it cannot wander off beyond the periphery of the village. Yet the family members are required to regularly propitiate it for leaving the spirit unappeased may afflict one of them with sicknesses. The sicknesses inflicted on the family members of its host and neighbors are homogeneous with sicknesses attributed to the big *gyapo*.

The *gyalpo*, *sondre*, and poison divinities share common structural features that are characteristic of ancestral spirits, or the remnant of ancestral beings, insofar as they operate as the "double" of their host. They are hosted only

by certain households and primarily inherited through matrilineal lines. Importantly, these spirits function as good fortune-gathering beings for their host, who as a woman and the head of the household is given the responsibility of running the family. Yet their modi operandi to accumulate *yang* in order to lead the family slightly differ. As previously mentioned, the impersonal *yang* is regarded as a wealth-generating force that is much coveted by Golengpas. It is "vital yet volatile" (da Col 2012: 175) and can easily escape from the confinement of the household when its householder offers things—whether food, objects, or beverages—to others. Fearing their *yang* will be reduced to nothing, Golengpas, for instance, always put back a pinch of rice into the container, and likewise, they rub money on their chest before giving it to others. Retaining a few grains of rice will help *yang* to remain in the storage, just as much as rubbing money on their chest will magnetize the leaving *yang*.

The idea of *yang* as an essential element of wealth and prosperity pervades sociality and is therefore sought and secured by the host through the agency of these gods, not only in hospitality and commensality settings but also through intrusion into the fields and houses of neighbors. For instance, the *gyalpo* and *sondre* spirits are inclined to intrude into the rich households or their bountiful fields, and for that matter affect its household members by destabilizing their life elements, particularly when their hosts are unlucky and envious of the economic prosperity of others, which translates to waxing *yang*. These supernatural forces seem to destabilize their *yang* by weakening the economy or prosperity power of their household members, thereby bringing their economic activity to a complete halt. On the other hand, the *yang* in the sphere of a poison god is transacted in an unrestrained hospitality that is apparently controlled by the poison god itself, without whose power the household *yang* is liable to flee through the conduit of food and drinks. The poison gods disrupt the accumulated *yang* belonging to the household of the ingester by permeating the food with poison so as to destabilize his life elements, thus rendering him sick.

The foregoing should dispel stereotypes and myths surrounding these spirits who are often depicted in a negative light. Rather than parasitic (cf. da Col 2012), these beings regulate the flow of economy within the household by symbolically affecting the other's *yang* while strengthening their hosts' economy-generating power. Like ancestral gods who are inherited through matrilineal lines, they assist their hosts and their progenies in increasing their collective but fluctuating familial *yang*, which is essential for

every Golengpa household to thrive. The households who are believed to be hosting either *duk, gyalpo,* or *sondre* spirits are in general quite rich, and consequently powerful.

It is perhaps, more than anything, the belief in the dynamics of the five life elements, particularly the *la,* that has created a fertile ground for the supernatural beings to thrive on. These nonhuman beings inhabiting the Golengpas' landscape are consequently seen as the primary abductors of *la,* without which people can fall ill. It is these supernatural beings' affiliation with Buddhists that increases the importance of Bonpos today. With several Golengpa households believed to be hosting certain spirits that are viewed negatively by others, the roles of Bonpos are not limited to just healing persons whose life elements have been affected by such supernatural beings. By strengthening the life elements of the people affected by familial *gyalpo,* poison gods, and *shondre* spirits, the Bonpos are also involved in mending the troubled relationships between the families and communities.

The notion of personal spirits beings hosted by closely related households in the manner in which they operate to strengthen the economy of the host person creates a new vector of understanding of the workings of these impersonal forces, who are largely portrayed by people in a negative light. While the stigmatization of these households seems to have arisen purely because their ancestors were outsiders and brought along some exotic artifacts with them, the families believed to be hosting such spirits are more prosperous than others. The Golengpa families with and without personal spirits then reflect wealth inequality, which in turn is seen as the main factor that creates rifts among the households. These social tensions are reinterpreted through the sicknesses leading up to the weakening of person's life elements such that Golengpas, in absence of healthcare facilities, feel it necessary to turn to the Bonpos to strengthen them. This is Golengpas' one way of negotiating social problems resulting from the economic gap between disparate social groups. To sum up, it is the dearth of healthcare service in the village and the weak Buddhists presence that have left the utility of Bon rituals unchallenged and ever relevant to the villagers. But the general Bonpos may not always be successful in curing sicknesses ritually on their own, and, hence, further interventions by specialist Bonpos such as *lu'i* Bonpo and Bonpo shamans may be commissioned.

5
Controlling the Bon Priests

This chapter is concerned with the rituals by two specialist Bonpos that I witnessed during my fieldwork. Both of these rituals are conducted to deal with soul loss, especially when believed to be caused by the powerful *tsen* and *lu* beings. It examines how the specialist Bonpos acquire their skills to deal with these beings from a perspective of shamanic training and ultimately become powerful in the village. The second part of this chapter engages the political contexts and consequences of the anti-Bonpo sentiments of the state and key court cases that revolve around village resistance to state intrusion. It considers why the district office, and for that matter Buddhist state, felt it necessary to appoint the first official Bonpo in the Zhemgang district and subsequently in Goleng village. It then looks into the negative consequences of this unprecedented recognition by the district office that a number of unofficial Bonpos faced at the village level. The ways in which the powerful Bonpos are being controlled by the district office reveals the realization of Buddhists that they have to make concessions to Bonpos and Bon beliefs that are deeply embedded in the Golengpa worldview.

Lu'i Bonpo: Becoming a *Lu* Specialist

The mobile soul can escape the body, and the soulless body can in turn become inert because, without the constant habitation of the soul, it is a mere shadow. In Golengpas' beliefs, if the patient shows no sign of improvement after medical treatment and preliminary rituals by Buddhist priests and generalist Bonpos, such spirit beings are not just powerful but independent of Buddhists and can only be pacified by conducting advanced rituals by specialist Bonpos. Depending on the cause, the ritual options are carried out by either a *lu'i* Bonpo or a Bonpo shaman, both of whom are specialists. Consequently, the ability of these specialist Bonpos to deal with the powerful local deities and spirit beings by healing the patients engenders a heightened

level of Buddhist scrutiny. One Buddhist approach to controlling the Bonpos' increasing power is to formally recognize a general Bonpo as an official village Bonpo while banning the specialist Bonpos from conducting any Bon rituals. Despite this new intervention, Golengpas, upon retirement of the first official village Bonpo, appointed one of the previously banned Bonpos as the official Bonpo without consulting the district office, thus reflecting the importance of specialist Bonpos.

I begin with one such Bonpo who is considered a specialist dealing with *lu* beings (*lu'i Bonpo*). While the tradition of Bonpo dates back to pre-Buddhist times, the *lu'i* Bonpo seems to be a recent phenomenon, at least in central Bhutanese social experience. Bonpo Dophu of Bumthang, who is originally from Samcholing, Trongsa, is a well-known *lu* specialist. He has traveled widely in Bhutan, including Goleng, curing the illnesses apparently caused by the *lu* beings. Over 60,900 *lu* beings in the form of stones under houses and in stone walls had been extracted by him as of March 2018. The Bonpo has a scale of fees for each district based on distance, and given the distance from Bumthang, a price of Nu. 10,000 ($166) was charged for a single ritual in villages in Zhemgang district. This service fee is unique, as there are no equivalent experts who have undergone such training or possess similar ritual efficacy over sicknesses particularly those caused by *lu* beings.

The training that the *lu'i* Bonpo underwent differs greatly from the classical shamanic training. He is not a hereditary Bonpo, nor has he been trained by a senior Bonpo but is believed to have been chosen by gods. I shall return to Bonpo shamans' training later, but for now I will describe how an ordinary farmer became an overnight expert on *lu* spirits. A single ecstatic experience dominated by a phantasmagoria of extraterrestrial beings elevated him to the position of *lu* specialist. In a dream, what he called a "half-dead phenomenon," he experienced three distinct phases, namely, traversing the hell realm, demons chasing him, and finally, three dakinis (*khandroma*) cajoling him to leave the this-worldly realm. He recounted the following experience to me, which is somewhat like a supernatural training.

> In a vivid early morning dream, I found myself in the hell realm, where the Lord of Death (*Shinje Chögyal*) in a near-death experience directed me to go back to the human realm so that I could devote my life to Buddha dharma. In the dream, I was engaged in a flying contest with a well-known but deceased Buddhist monk and outstripped him. Nevertheless, I did not become a monk nor a lay Buddhist practitioner.

After a year's hiatus, I had another spectral experience. This time a great number of demonesses with their upper fangs plowing the earth below and their lower fangs smashing the sky above chased me until three rainbows appeared before us. However, the sighting of rainbows instantly transposed me from the savage hell to an exquisite domain festooned with garlands and trappings, apparently welcoming me with lavish offerings. As I entered the gate, I saw three rainbows touched the floor only to be transformed into three beautiful dakinis who hummed in unison that they had come to liberate me. While they tried to coerce me into complying with their injunction, I refused their solemn proposition and insisted on meeting my aged parents before leaving for the celestial realm with them. My obstinate refusal to transmigrate to heavens left them upset, forcing the dakinis to leave and give an ultimatum in which they determined to return in a week, riding the first sunrays. As they evaporated to nihility, I woke up from the tiring journey at 3:00 a.m. Later I realized that this divine intervention saved my life from the demons.

After this vivid dream, which Bonpo Dophu considers to be his formal spiritual training, a Buddhist lama of Thowadrak in Bumthang was consulted so as to interpret his phantasmagorical experiences and the ultimatum issued by the dakinis. Bonpo Dophu maintained that he was advised by the lama to perform a dakini ritual to stabilize his long life (*khandrotenzhug*). Accordingly, the Buddhist ritual was commissioned to prevent the dakinis from returning in his dreams. Nonetheless, after a month, the dakinis did return in his dreams, but this time to choose him as a *lu* specialist. Thus, like Siberian shamans, he started to receive, in a series of dreams, training on techniques for divining and for performing healing rituals, rites for releasing of trapped *lu*, and the visualization of gods. These techniques and rituals were indoctrinated by the nameless god who appeared during every ritual whispering in his ears in a form only intelligible to the Bonpo himself. Since then, he had received a blessing from the gods and *lu* beings, and became famous for his unique divination and the nature of his therapeutic ritual treatment.

In 2017, Bonpo Dophu was invited from Bumthang to Goleng by a family whose members were believed to be affected by the malevolent *lu* beings residing beneath their house. This family had already commissioned various Buddhist and Bon rituals conducted by lay *chöpas* and general Bonpos. In additional to these rituals, the family also consulted biomedical practitioners and had undergone several treatment regimens for the sickness, which is

characteristics of what the villagers call *lu nad*. As mentioned previously, skin diseases and joint aches are considered to be sicknesses caused by the unappeased *lu* beings. They required a specialist Bonpo's intervention given that remedial rituals by Buddhists and general Bonpos and biomedical treatments were ineffective, and that these beings were not incorporated into Buddhism. I shall now turn to the ritual of extracting *lu* beings (*lu shong*) by this specialist Bonpo—*lu'i* Bonpo.

The Ritual of Releasing Trapped Serpent Spirits

Bonpo Dophu has developed a unique ritual oriented toward realizing the trapped *lu* being manifested in the form of stones. The ritual of extraction of *lu* began with a fumigation of the house, for doing so creates a favorable situation for making an accurate and reliable prediction. The *sang* or fragrant incense offering is a precursor to divination, and the actual ritual for it increases the chances of restoring the purity of the defiled *lu* beings. Dietary restriction is an integral part of the ritual process, especially when dealing with the mercurial temperament of *lu*, and the *lu'i* Bonpo observed them diligently not only in the course of ritual but also during the divination. Given that the *lu* beings can easily be polluted and therefore angered, he abstained from ingesting meat, egg, and vegetables like garlic and onion and all kinds of alcohol, which are considered impure and defiling.

He began with a unique method of divination called "finger-breath divination" (*tho mo* or *tho thamba*) in which he used a mini sash-like strap that was approximately two and a half *tho*[1] long to measure his finger length. Holding the tail end of the strap slightly lower with his left hand while placing the crest of it on the center of his forehead with his right hand, he invoked a great number of spirit beings. The Bonpo with closed eyes called each spirit being of the local pantheon to interrogate it about its role in the victim's sickness and thereafter measured his finger length with the strap to evaluate the being's response. Parity of lengths between the strap and the Bonpo's finger length is auspicious, indicating that the specific spirit being did not cause the sickness. If the strap appears shorter than his two *tho*, that particular spirit is behind the sickness.

Although the *lu'i* Bonpo communicated with a range of spirit beings, the sicknesses seem to be always caused by the *lu* beings. Analogously, for Bonpo shamans, the spirits causing sickness are predominantly *dud* beings, while for

general Bonpos, the local spirit beings are the primary abductors of human souls. In any case, if *lu* are behind the sickness, the ritual concerning the release of a displaced *lu*, the ritual of placation, the ritual of seeking liniment (*ngak mar*), and the ritual of directing the displaced *lu* to its true dwelling follow. Apart from the first divination, these rituals were all conducted outside the house without a specific ritual altar or any altar arrangement. The patient was treated not as a person but as an animal,[2] particularly of the animal sign she belonged to. Instead of mentioning the patient's name, the Bonpo referred the sick person by her birth animal sign throughout the ritual. The same applies to other rituals by Buddhists and general Bonpos: the patients are always referred to by the specific animal sign of the year they were born in. The Bonpo probed the cause of the sickness by interrogating material objects and immaterial spirit beings whose responses to each question was determined by gauging his finger breadth:

Did the ritual objects (*chösham chala*) afflict the female sheep[3] person with this illness?
Did the statues (*ku*) afflict the female sheep person with this illness?
Did the religious scrolls (*ku thang*) afflict the female sheep person with this illness?
Did the religious texts (*pecha*) afflict the female sheep person with this illness?
Did the ritual-water cup (*ting*) afflict the female sheep person with this illness?
Did the golden vase (*bumpa*) afflict the female sheep person with this illness?
Did the throne (*thri*) afflict the female sheep person with this illness?
Did the butter lamp cup (*kongbu*) afflict the female sheep person with this illness?
Did the evil king-spirits (*gyalpo*) afflict the female sheep person with this illness?
Did the male dead spirits (*shindre phoshin*) afflict the female sheep person with this illness?
Did the female dead spirits (*shindri moshin*) afflict the female sheep person with this illness?
Are witches and demonesses (*sondre* and *mamo*) behind the sickness?
Did the demons (*düd*) afflict the female sheep person with this illness?
Did the serpent spirits (*lu*), owner of the land (*sadag*), afflict the female sheep person with this illness?

Did the dharmapalas (*chökyong*)⁴ afflict the female sheep person with this illness?

Are birth god (*kyelha*) and village god (*yul-lha*) behind the sickness?

Did the mountain deity (*tsen*) afflict the female sheep person with this illness?

Did the gossip by general people (*mikha*), gossip by enemies (*drakha*), and gossip caused black magic (*phurkha*) afflict the female sheep person with this illness?

Did the black magic (*ngan*) afflict the female sheep person with this illness?

Were her name and animal sign [written on a piece of paper] hidden under the earth or stone?

Did poison (*duk*) afflict the female sheep person with this illness?

Is the provocateur of nerve disease (*drangtsong zerkham*) behind the sickness?

Did the eastern deity [Shartsen] afflict the female sheep person with this illness?

Except for the *lu sadag*, the Bonpo's finger breadth and strap were of equal length, indicating that the other possibilities were not the cause of sickness. While questioning the *lu sadag*, the strap, however, did appear shorter than his two *tho* and revealed that it was the nearby *lu* who caused the sickness in the female sheep person. As he kept mumbling incantations, the Bonpo ventured on divining why it cursed the victim with the affliction and quickly determined that somewhere among the jumble of stones—which forms the main wall of the traditional house—the *lu* was wedged between ordinary stones. To locate the *lu* manifested in a form of stone, the Bonpo's tutelary gods were invoked outside the house.

Once the general location of the hemmed-in *lu* was identified, the Bonpo walked outside the house with his strap to determine its exact spot, but the Bonpo was now in a silent mode. He pointed the upper end of the strap at each stone in the wall and simultaneously gauged his finger breadth to discern the *lu* stone (*ludho*). After a few minutes, the sui generis semblance of a certain stone caught his attention, and when he reperformed the divination, the length of the strap was shorter than his two *tho*. Thus, this particular stone was confirmed as the metamorphosis of the trapped *lu*. (The Bonpo maintained that sometimes several *lu* stones were found in the same location, depending on the number of patients and the variation in symptoms.) The acolyte was then instructed to remove it from the wall—posing a considerable risk to the foundation of the house because without crowbarring and pickaxing it was impossible to draw it out.

Following the successful extraction, the *lu* stone was treated like a newborn, given a bath by the acolyte in a cold running water. After carefully brushing the dirt off, he placed it on a plank where the real expiation rite was conducted. The space was first fumigated with dried juniper leaves, dispensing a therapeutic effect, and the *lu* stone was sprinkled with diluted cow's milk to restore its lost purity. The Bonpo, on behalf of the household, confessed and atoned for their iniquitous actions by decanting drops of milk onto the stone, which he said was feeble but still had an "active life." The *lu* being was debilitated not by age per se but because it was imprisoned among the real stones in the wall and was compressed by both the real stones and the humans who lived in the house. The Bonpo treated the stone as a "real" *lu* being; except to him, it remained indistinguishable from ordinary stones. As noted earlier, if the enervated *lu* perishes because of the constriction, it will have a reciprocal effect, especially on the family member with weak life elements. Here the Bonpo's ritual was timely because the stone still had an active life.

Purification tactics such as the use of juniper or cypress incense and cold-water bathing are not effectual until the final milk bath purgation, as the milk is the conduit for not only cleansing but also redressing the negativities directed toward the *lu* beings. This elaborate milk shower reaffirms that these beings are inherently pure and prefer to distance themselves from dirt and impure humans. Nevertheless, sprinkling them with pure milk for a certain period of time is unlikely to expiate the vindictive *lu* without a shower of exaltation.

The Bonpo then supplicated the following tutelary deities and their retinues of the four cardinal directions, which constituted his self-created cosmology, restoring the severed relationship between the household and *lu* being.

O! chief (*magpön*) Nima Özer, chief Dawa Özer, and Sernak Butri
Dorji Kandro [dakini of Vajra form] of the eastern sphere
Pema Lingpa[5] of the western sphere
Dorjisempa[6] (*Vajrasattava*) of the northern sphere
Rinchen Jungné[7] (*Ratnasambhava*) of the southern sphere
Orgen Rinpoche [Guru Rinpoche] and Bonpo Tonpa Shenrab
Khandro Yeshe Tsogyal and Khandro Mandharava[8]
The father god, Yablha Karpo
Guru Dorji Drolo,[9] Zhabdrung Ngawang Namgyal,[10] and the deity Chakna
 Dorji[11] (*Vajrapani*)

Now let the Bonpo serve you, let the Bonpo offer you
The white serpent spirits (*lumo karmo*) and your retinues
Luna Senak Rinchen,[12] the king of *lu*
Your princes and princesses
Your great fathers and mothers
Your shopkeepers and salespersons
Your commanders and foot soldiers
Your male and female servants
From now on, please stop abducting human souls
Please cease inflicting sicknesses on the victim's head
Please cease afflicting the victim's mind with psychogenic disorders
Please cease plaguing the victim's legs with disabilities
Please stop tormenting the victim's hands with dysfunctionalities
Now please cease activating debilitation on the victim's body
Because today I am making offerings to you and your entourages
I am personally serving you all the perfumed milk and popped rice
If the female sheep person is hidden in your golden casket
If the female sheep person is secreted in your silver casket
If the female sheep person is imprisoned in your stone casket
If the female sheep person is interned in your water casket
If the female sheep person is sequestered between the high passes (*laptsa*)
If the female sheep person is buried under the bridge
You must free her now from captivity and from sicknesses and listlessness
Please free her from leg pain, knee ache, painful joints, swollen and itchy body parts
You must release her from your thralldom, for I the Bonpo have now freed you
You have spent many years between these stone walls, tamped down by the stones, woods, and corrugated roof
But today, I the Bonpo came and emancipated you from the space of torment
I, the Bonpo now elevated you to a heavenly state.

The realm of *lu* is portrayed as an independent and complex world with its own king, queen, princes, princesses, merchants, soldiers, and servants. As wealthy beings, their treasures are stored in caskets made from gold, silver, and precious stones. However, as the Bonpo's incantations indicate, these caskets also serve as repositories for the abducted souls of human

counterparts. They are hidden in the netherworld by the *lu* beings who are related to the injured *lu* on the surface, and they will release the captured souls only when their members are set free. Considering the deep location of this repository—the underworld—it is only this specialist Bonpo who, with the help of his powerful pantheon, can retrieve the abducted soul. The Bonpo therefore looked for the patient's abducted *la* mostly in the underground inhabited by subterrestrial beings. Once the trapped *lu* was liberated, it was, along with its relatives, supplicated to help the Bonpo in finding the patient's lost soul. In the Bonpo's ritual language, they are obliged to repay the Bonpo's favors by finding or releasing the abducted soul from their caskets hidden deep in their domain. In the case of several *lu nad* victims with different symptoms, the Bonpo can follow the same dialogic divination and extrication of *lu* because symptomatic variations indicate separate *lu* beings who are either trapped inside the same stone wall or elsewhere close to their house.

After completion of the expiatory ritual, the making of special blessed liniment (*ngakmar*) was a desideratum for the Bonpo, as the ritual efficacy emanates from the butter. While it is primarily prepared by Buddhist lamas and lay *chöpas* by chanting relevant mantras and blowing repetitively over it, in this case, neither method was used to make the *ngakmar*. Instead the Bonpo supplicated the injured *lu* and its relatives for favors, particularly to convert the ordinary butter into a blessed liniment. This goal was fulfilled by coating the stone with fresh butter while his pantheon of deities, the injured *lu*, and the *lu* king along with its retinue were invoked to bless the smeared butter. Once the stone was well lubricated, the remaining butter on his hand, when connected with the buttered stone, became the liniment. It was later used to massage the patient's affected legs and hands, indicating the release of the soul from the world of *lu* below. This was one of the ways in which the *lu* reciprocates the kind acts of human counterparts.

The butter was seen to exude therapeutic powers. According to the Bonpo, it can cure painful legs, painful joints, itchy skin, swollen legs, backaches, and other ailments, all of which are symptoms of *lu nad*. It is thought that this butter was blessed by the supernatural *lu* beings in return for the Bonpo's help in dislodging its member from the stone wall. Hence, this ritual rekindles a principle of mutuality between the human and nonhuman beings and expresses a unique reciprocal creditor-debtor relationship. The final rite

associated with this ritual event was to divine the direction of the *lu*'s original abode, given that the members of the household were unable to ascertain the exact location from which they collected this particular *lu* stone, but even if they had known, the Bonpo's divination was indispensable. So the final divination was conducted to identify the appropriate direction for the *lu* stone to be placed. Accordingly, it was carried to the stream by his acolyte and for one final time, the Bonpo resorted to divination in which his pantheon was reinvoked. Employing his finger-breadth technique, the Bonpo identified the rock at the center of the stream as its original abode and instructed the acolyte to install the *lu* stone on top of it. The *lu* stone was abandoned there after it and its surrounds were showered with milk and popped rice, while simultaneously adjuring the *lu* beings under the command of Bonpo Tonpa Shenrab to reverse the condition and grant the victim a healthy life, good appetite, sound sleep, and strong life elements.

To pacify the injured *lu* beings, the Bonpo invoked his unique pantheon comprising a certain Bonpo by the name of Tonpa Shenrab and several Buddhist deities including Guru Rinpoche and Chakna Dorji. Throughout the ritual, he called himself a Bonpo, making the ritual cosmos an assemblage of Buddhist and Bon deities. However, Bonpo Dophu had no idea that the founder of Clerical Bon carries the same name, nor did he have an idea of the existence of Clerical Bon. The same thrust existed in his training, which was prudently focused on an attempt to bring some uniformity by employing Buddhist elements, such as experiencing "near-death experience" and commissioning *khandrotenzhug* for long life, on the one hand, while reflecting Bon characteristics, such as receiving the teachings directly from the gods, on the other. Such incorporations reflect people's strong beliefs in both Buddhism and Bon despite the official opposition between the Buddhists and Bonpos.

One way of increasing the legitimacy of new Bon rituals is performing for a Buddhist monk. As maintained by my interlocutors and Bonpo Dophu himself, he was approached by a high Buddhist lama based in Bumthang, seeking his *lu*-releasing ritual so that a trapped *lu* at his monastery could be disenthralled. This indicates that Buddhists themselves have been influenced by the shamanic worldview of three worlds in which *lu* beings inhabit the lower realm. Furthermore, the commissioning of the Bonpo's *lu* ritual by a Buddhist lama indicates the latter's inability to deal with the wide range of untamed supernatural beings who pervade the world.

Ways of Becoming a Bonpo Shaman

In Goleng, the most advanced form of shamanic retrieval of soul is conducted only by Bonpo shamans. In the section to follow, I first examine how these powerful Bonpo shamans get their powers and briefly describe the shamanic ritual I witnessed in 2017. The word "Bonpo" denotes "invoker" or "conjurer" (see Snellgrove and Richardson 1968) or is simply an equivalent of "shaman" (Hoffman 1944, cited in Stein 2010: 252). Recognizing their incredible power and association with gods, Bonpo shamans in Bhutan are generally called *pawo* and *pamo*, which literally mean "hero" and "heroine" respectively. While all shamans (*pawo*) are Bonpos, not all Bonpos are total Bonpo shamans because all Bonpos do not enter a trance, though all of them have techniques to communicate with supernatural beings. The individual names for shamans nevertheless differ from region to region as well as according to typology and gods who possess them. For instance, the Bonpo shaman possessed by deities such as Geser, Jomo, Chungdu, and Terdag carry a prefix of their god, so that they are known as *Geser pawo, Jomo pawo, Chungdu pawo,* and *Terdag pawo* respectively. While the shaman's social roles are primarily healing and protecting people from evil spirits, they are sometimes involved in harming others through the knowledge acquired in contact with their possessing gods.

There are three ways to become a Bonpo *pawo*, who, like a generalist Bonpo, mostly works as a part-timer. A person regardless of sex can become a shaman through either hereditary (*pha gyud*) or divine selection (*lha'i tumpa*) or through self-aspiration (*rangi lübpa*). The main difference between them is the locus of shamanic training they undertake. The hereditary shaman is generally an aspiring male son who receives training and blessings from his shaman father. Their shamanic links may go back to a long line of genuine shamans of antiquity. Both sexes can be god-selected and self-aspired shamans, which Eliade (1964) calls "spontaneous vocation and self-made" respectively. While the former is elected through divine selection, the latter becomes a shaman by receiving initiatory training from one of the senior shamans whose possessing god inspires him.

The prospect of the nonhereditary or autodidactic shaman becoming possessed by gods is relatively poor, and hence, like their counterparts in central and northern Asia, they are often regarded as ineffectual even after rigorous training. Yet people still consult them, especially when the causes of misfortune and sickness are unknown; when the corresponding rituals by Buddhists

and Bonpos, including the god-selected and hereditary shamans, are ineffective or they are unavailable in the locality; and when medical treatments are inefficacious. The hereditary and self-aspired shamanic trainings are characterized by memorization of incantations and magical spells, the practice of voluntary trembling and techniques for ritual divinations, and the learning of a secret god's language (*lha ke*) from a shaman master, and differs greatly with the god-selected *pawo's* training, although at a later stage, the formal endorsement of the god-selected *pawo's* vocation entails receiving a final training from a shaman master.

In Goleng, the god-selected *pawo* are considered the most powerful and authentic shamans, to the extent that when they die, they go straight to their god's realm, although hereditary shamans can be equally powerful when possessed by gods. Golengpas believe that they can drink boiling oil, eat fried sand directly from the hot frying pan, take a red-hot sword in their mouth, and ultimately run it through themselves while engaging in a ludic dance. In the past, Golengpas had many powerful god-selected shamans, but in 2017, there was only one self-aspired practicing Bonpo *pawo*, who as indicated above, is seen as less powerful than the former. Chungla, the former official Bonpo, was himself an unsuccessful shaman initiand. However, close by in Berti village there is a female god-selected *pamo* who is consulted from time to time by the people in Goleng either by inviting her to Goleng or getting the ritual of shamanic retrieval of a lost soul performed in the nearby town or Berti itself.

Scholars have written a great deal about shamanic trainings (e.g., Mumford 1989; Eliade 1964; Winkelman 2000; Webb 2013), so I will not go into great detail here, except to point out some aspects of the shamanic training of this divinely selected female shaman (*pamo*). *Pamo* Karma, who is from Berti village, holds that her shamanic training was characterized by mental disintegration rather than "ecstatic experience." She recounted to me how her late mother used to narrate her initial shamanic possession, in which she first trembled violently while feeding on her mother's breast. That was the first indication of a certain god taking possession of her in order to make her its mouthpiece, but the spontaneous trembling returned again when she attained the age of six. By then her episodic body-shaking phenomenon was accompanied by multilingual "self-talking," which, according to the locals, is uncommon for a person who had never traveled beyond the frontier of a monolingual village. The first shamanic chanting occurred around that time; she repeatedly called herself the god Grablha,[13] who later

became her principal possessing god. *Pamo* Karma shared her extended training with me after the ritual of shamanic retrieval of lost soul, to which I shall return:

> At eight, I vanished, leaving behind absolutely no clues. The villagers looked for me everywhere—in the bushes, rivers, and mountains—until I returned after two long years. Subsequently, I divulged my journey to Paibang, which is a three-day journey on foot, to receive initiations from a male shaman living there. However, I did not know how I arrived or went there. I had chosen the male shaman as my master without prior information and commitments, let alone acquaintance with him. Nonetheless, after practicing with this male shaman for some time, I realized that my possessing god is different from his. Thus, I reverted to my unconscious search for a shaman who is the vehicle of the same god. After several months of search, I was able to find the right shaman, from Goshing in lower Zhemgang, who after one year of initiatory ordeals confirmed me as the apodictic shaman of Grablha.

This phase of her life was characterized as mentally unbalanced and punctuated by psychotic behavior and the loss of external reality. In fact, those days it took weeks to arrive in remote places like Goshing and Paibang. The finding of a right master, at the end of initiatory schema that involves savoring the solitudes of forests, making a precarious journey to cliffs and mountains, swimming up the rivers, feeding on insects and wild plants, holding nettles (*kui*), falling repeatedly sick, and so on, is central to a shaman's future career. The neophyte's shamanic training must be prolonged until the right master worshiping the same god is found. The idea of gods and deities with unequal powers pervades the shamanic world insofar as during the initiatory trainings, the neophyte can receive many initiations from shamans of different gods and traditions. Doing so will not just complement the shaman's primary god's powers but also secure these different gods' help during the perilous journey to the underworld.

Pamo Karma is believed to have received trainings from multiple shamans, and hence is in possession of numerous gods, including Geser, thereby making her ritual very reliable and powerful. Because of the power of her possessing gods, the involuntary trembling of her body was so strong that a single man could not control her. The initiatory symptoms of shaman-hood, such as recurrently falling sick, losing one's appetite, and trembling violently

without stimulus, are the harbinger of a god possessing the person as the medium. These behaviors later became her normal disposition, particularly while in trance. When possessed by a god, devilish trembling and delirious mind characterized *pamo* Karma's body, and she became terribly sick when abandoned by the possessing god. This schema can be seen as the single most effective technique to cure others, that is, using the knowledge and training acquired from her gods.

In order to become a genuine shaman, the novice must undergo a series of harsh initiatory "conditionings" that come and go without a fixed pattern. Yet they possess no threat to the neophyte's life because, according to *pamo* Karma, during her training, despite great peril and uncertainty, the primary god would come to rescue her. The neophyte's mettle is assessed through these initiatory ordeals and upon her being deemed a suitable host, the corporeality of the profane shaman's body, which is prone to diseases and attacks by evil spirits, is transformed into a sacred shaman body. This transformation by the possessing god elevates the shaman to a state like a demigod whose life is sustained by the duality of mortal and immortal beings.

Once the god was satisfied with the initiand's adaptability to harsh conditions, it selected *pamo* Karma as its medium—the "chosen one." But as mentioned earlier, she was required to pursue a senior shaman of tradition to complete the process. Although failing to locate such a master would usually result in psychogenic illness as well as forfeiture of her shaman-hood, *pamo* Karma holds that the potential god comes to the defense of evil spirits until the initiation from an appropriate shaman is received. This indicates that a senior shaman's endorsement is equally important because they are the one who can authenticate as well as consummate the tripartite relationship between god, shaman master, and the neophyte by completing the initiatory training started by the primary god. Furthermore, she can only return home after this dual endorsement, for without their imprimatur, she cannot assume the new identity—shaman.

The primary god of each shaman is known by the generic term "male god" (*pholha*) or "female god" (*molha*), but their gender can be altered according to the shaman's sex. For instance, *pamo* Karma's primary god, Grablha, is a peaceful male being (*zhiwa*), but he can also become *molha* for female shamans. Similarly, most of the regional gods appear to be male, although many shamans consider them to be epicene. The shamans' costumes are dependent on the type of god that possessed them. *Pamo* Karma wore a popular headgear known as a "white turban" (*thodkhar*), along with a drum,

garland of animal fangs, and other ritual costumes that are the archetype of Bonpos. On the other hand, a shaman in Shobleng who is possessed by Geser wore paraphernalia of a five-pointed crown (*rignga*), employed a bell and *damaru*[14] instead of the shamanic drum, and communicated in Tibetan during a trance, thereby reflecting both Buddhist and Tibetan influence. According to *pamo* Karma, shaman-hood can be forfeited if the shaman does not honor her gods by performing propitiatory rituals on a monthly basis, conform to dietary restrictions, purify her body, or if the shaman receives Buddhist teachings, blessings, or consume Buddhist offerings such as *tsog*. The Bonpo shamans are independent of Buddhist lamas, and the latter do not have a role in endorsing them, as attested to by the Bonpo shamans that I met during fieldwork, who all agreed that receiving blessings from Buddhist lamas can result in the withdrawal of their primary god's protection. Having said that, some shamans may nonetheless receive blessings from Buddhist lamas[15] who are believed to be descendants of legendary Bonpo masters.

The Shamanic Retrieval of Lost Souls

Golengpas' treatment trajectory is complex. They may begin with lay *chöpas* or general Bonpos, or some may even visit a local health center prior to any ritual intervention. In 2017, an educated person was suffering from a severe backache for many months, so he consulted ritual virtuosos and biomedical practitioners at the nearby hospital, who prescribed some pain relievers. The lay *chöpas* conducted rituals to propitiate *mamo* spirits and gave him blessed butter (*ngak mar*) to massage the affected area. In the patient's words, the *ngak mar*, just like an analgesic drug, temporarily palliated the pain, but it reoccurred with more vengeance after a few days. He then consulted a general Bonpo, who divined that he had been hit by the *sadag*'s arrow. Consequently, a ritual was performed that involved the uprooting of invisible arrows from his back through a series of gesticulations and reparatory incantations. Since none of this relieved the pain, he finally sought several astrologers to divine the cause of his severe backache, and all of whom determined that the malevolent local *tsen* had abducted his soul and that the shamanic ritual must be commissioned to recapture it.

The patient recounted to me that, when he along with his friends went to Berti village, he was terrified by falling boulders. This event apparently occurred at the domain of powerful *tsen* beings—three spirit-mothers of Berti (*Aum pünsum*) who are matrilineal *tsen* deities residing principally

in the three-peaked hills near the Mangdechu River even as they cast their wrath on people as far as Goleng, Tsanglajong, and Zurphey in the south of Mangdechu River. People consider them to be the mother of hot-weather disease (*tsathpa'i ama*), which is tantamount to malarial sickness, as the victim usually displays symptoms consistent with malaria. At any rate, when the person is attacked by them, it leads to death if shamanic ritual is not undertaken in the patient's favor.

Pamo Karma has a close relationship with these local deities and was thus invited over to the patient's house to retrieve the abducted soul. She came directly from her cowshed without clean clothes and ornaments, but the host was kind enough to provide her with clean clothes, which he did not want her to return. Her ritual setup was without a doubt less elaborate, and therefore much cheaper, than other Bon and Buddhist rituals. In fact, the shaman's acolyte took only a few minutes to prepare the offering on the ritual table that was draped in a white linen. On the raised table, three different clean (*tsang*) offerings were placed: two cups of "clean rice" (*chungdre*), two cups of "clean alcohol" (*düdtsi*), and a cup of "clean water" (*chutsang*). Yet the arrangement of these offerings was quite complex and much more so when the Buddhist butter lamp was placed between the two cups of rice and cup of water. The cups of alcohol were arranged behind in alignment with the butter lamp and the cup of water, all of which were exclusively made to the shaman's *molha* who helped her recapture the lost soul.

Agarwood was then burned to purify the room and the ritual table itself; in the shamanic ritual language, only Bon rituals and Bonpos are entitled to use agarwood incense. A winnower with a considerable amount of popped rice mixed with *Oroxylum indicum* flowers (*namkaling*) was quickly laid at the foot of the table by the acolyte. Finally, a carpet for the shaman was unfolded in front of the offerings, marking the end of the ritual setup. Once the preparation was complete, the patient carefully tucked a monetary offering/gift (*nyandar*) under the first cup of alcohol, which, as in *lud* ritual, was offered as his gift to the evil spirit who was responsible for abducting his soul. *Pamo* Karma then finally inspected the arrangement of these offerings herself.

Pamo Karma sat on the assigned seat, and the first thing she did was to hold a fresh cup of *ara* and sprinkle it over the ritual space with her finger before gulping down the remainder. Then she began her ritual, which lasted about an hour, by beating the drum, first slowly and then gradually faster as she began to murmur the incantation. She rhythmically intoned chants to the tempo dictated by the drum, firmly held by her left hand, almost rubbing it against her cheek. During the incantation, she mostly stuck out her cheek at

the drumhead, although occasionally distancing her face from it, as though her gods were inside the drum. *Pamo* Karma began to tremble as soon as she started beating the drum, for it directly connected her with her god. She outlined the details of the patient and his location and, through a repertoire of ritual implements, prayed to her primary god to descend a ladder, feast on the offerings the patient had made, and possess her.

Once possessed, the acolyte, instead of speaking to the shaman, communicated directly with the shaman's god. In other words, the acolyte treated the shaman as the embodiment of the god because the shaman herself cannot see or hear and becomes insensate until the god leaves her body. It was the acolyte who not only interpreted the divination but also understood the conversation between her primary god and evil spirits. The first part of the ritual was basically a dialogue between the shaman-self and *molha* as *Pamo* Karma wheedled her god to descend on the nine-rung ladder that is the axis mundi to connect the two realms by directly connecting to the patient's roof vent. *Pamo* Karma's *molha*, on the other hand, repeatedly asked if the shaman had rolled out the white mat (*tan kar*) in the sky that acts as the spatial pathway for the gods to cater to human calls.

While the drumbeats helped the shaman to connect with her gods, the primary god in question agreed to enter the house, and for that matter the shaman's body, only when it was impressed in totality with the rules for arrangement of offerings. In case of missing or making inappropriate offerings, the household members were chided by the primary god through the agency of the shaman and often resulted in an involuntary hitting of the acolyte with the drumstick, but the shaman herself was never punished by the god. After the ritual, *pamo* Karma informed me that it was actually the dissatisfied gods who hit the acolyte and the household members for not making appropriate offerings. To check the ritual perquisites, her *molha* asked the following questions before descending on the ritual table:

> In that place, are there clean water and clean rice (*chusang chungdre*)?
> Do you have clean alcohol (*düdtsi*)?
> Do you have fresh butter (*mar*) and flour (*phi*)?
> Are there incenses of *Rhododendron anthopogon* (*balu*) and *Rhododendron setosum* (*salu*)?
> Is the room fumigated by the agarwood (*aguru*) incense?
> Did you unfold the golden ladder?
> And are the nine gods present?

Through the agency of the shaman, the primary god asked for the pure incense (*sang rab*) and the pure water (*chu rab*) until *pamo* Karma convinced her *molha* that they were ready on the ritual altar. These essential materials, including the unfolding of imaginary white mat (*tän kar*) and ladder from the sky, were prerequisites for the successful ritual because her god and its retinues can only be obliged to descend to the ritual table when such offerings are duly made. This indicates that the descent of the primary god is contingent on the purity of the offerings; that is, an impure oblation can trigger the god's refusal, leaving the shaman unpossessed by her *molha*.

After possessing the shaman, the primary and secondary gods assumed absolute authority over the shaman body as they traveled to known and unknown geographic spaces, such as mountains, deep valleys, crematoriums, cliffs, streams, rivers, and the realm of spirit beings. Upon entering a trance state, *pamo* Karma became rather inert, and it was to these gods, particularly to her *molha*, that the acolyte directed the patient's question of soul loss and the evil spirit beings behind it. This indicates that it was the gods, rather than the shaman, who looked for the lost soul by communicating with a myriad the supernatural beings inhabiting these spaces. While the shaman was embodied by gods in every sense, *pamo* Karma appeared different from their South American counterparts, as she neither was epileptic nor altered her consciousness or induced trance through the use of narcotics and mushrooms. Although she occasionally drank alcohol during the various stages of shamanic ritual, both the shamanic flight and trance were achieved through the aid of her *molha* and other secondary gods, use of ritual implements and symbologies and, of course, the proper initiatory training.

According to Goleng Bonpos, genuine shamans see or hear those present at the ritual, nor can they remember their god's divination and shamanic journey because they are stupefied by the presence of gods. This phenomenon was attested by the postritual event when *pamo* Karma wanted to know what was predicted in the divination. It was the acolyte who eloquently recapitulated the whole shamanic journey and the divination, which *pamo* Karma heard without uttering a word. In some shamanic rituals that I observed elsewhere, the acolyte translated a "secret language." All of these phenomena underline that the shamanic ritual and the restoration of the lost soul are the work of the shaman's gods since the shaman remains unconscious in the liminality of the inside and outside of the shaman body.

This Bon ritual was not about soul flight but rather an inert medium through which primary and auxiliary gods took turns communicating with

the evil spirits as they collectively searched for the lost soul. The secondary gods, like a fluctuating wave possessed and abandoned, and repossessed and re-abandoned the shaman body throughout the ritual. Her *molha* and the retinue became generous inasmuch as they took due care of all the people present at the ritual because the ritual meant an immanent risk of having their souls abducted by the angered evil spirits who were mistakenly accused of capturing the victim's soul. The ritual implements employed by *pamo* Karma can torture evil spirits. For instance, during the séance a deaf *sindre* spirit of a deaf woman who died in an automobile accident pleaded with *pamo* Karma's god not to hit her hard with the drumstick. This suggests that drumbeats can be used to repress the evil spirits with each strike until they confess to abducting soul and subsequently return it right away.

Although the divination was performed in a trance state, it is believed to be more reliable when more gods are involved in the process. Therefore, *pamo* Karma's *molha* summoned secondary gods to encircle her and asked them a series of questions before executing the divination:

> Did the astrologers arrive with their dices? Did the excellent Bonpos arrive? Did supreme male Bonpo shaman arrive? Did the supreme female Bonpo shaman arrive? Did the peerless gods arrive? Now arrange a hundred dice for the hundred astrologers. Let's divine!

During the divination, *pamo* Karma reduced the intensity of drumbeat when the harmful agents who caused the sickness were expected to respond to her god's questions. The dialogue between her gods and the accused evil spirits became apparent when the latter responded in coarse voices mumbled by ventriloquism and slow drumbeat. As *pamo* Karma reduced the intensity of her drumbeat, the three-mother mountain deities (*tsen*) of Berti finally began communicating with the *pamo*'s gods in voices resembling elderly women. Shortly after, the acolyte announced a successful retrieval of not only the victim's soul but also various souls belonging to unspecified people who were straying into the domain of *tsen* beings. According to the acolyte, the god who recaptured the victim's soul was the primary god *molha*—Grablha—although a host of secondary gods were also present.

The interesting thing about the divination was the gods' recommendation for additional rituals, which were sometimes Buddhist. While the Golengpa lay *chöpas* are antagonistic to all kinds of Bonpos, these Buddhist rituals that complement the shamanic soul retrieval were later pursued by the lay

Buddhists at the behest of the patient's family, reflecting the complementarity between them and the fluidity of people's religious beliefs.[16] As attested by the soul retrieval ritual, the shaman's task was limited to inviting her gods and dispatching them to their heavens through the same roof vent. The buying or recapturing of the lost soul and the journey to the underworld were, on the other hand, the absolute work of her gods, thus making *pamo* Karma and her shamanic ritual unique. Bonpo shamans are so powerful that they often veer away from the strictures imposed by Buddhists. I shall now look at the ways in which these powerful Bonpos are seen as threats by Buddhists to people, including the lay Buddhists themselves.

The Official Bonpos of Zhemgang

In rural Bhutan, to become any kind of official religious figure is to secure the source of what Bourdieu (1984) calls "symbolic capital." The Bonpos who have the knowledge of black magic rituals (*ngan*) are viewed as so powerful that people refrain from arguing with Bonpos even if they are wrong. Within the village, people can easily come under the domination of such Bonpos—including the qualified lay *chöpas* who themselves often end up being the victim of an asocial Bonpo.

Bonpo Karma was formally recognized as an official or state Bonpo (*zhung-gi Bonpo*) of Zhemgang proper in 2005, and since then has been receiving a monetary benefit from the district office for his services to the community. His prerogatives are performing divination and monthly propitiatory rituals for the village and local gods (*yul-lha* and *shidag*) such as Dorji Rabten, Kibulungtsen, Drabu Gyaltshen, and five *lu* beings residing in the courtyard of the *dzong* that houses the monks of the district monastic body. According to him, his selection as an official Bonpo was adjudicated exclusively by non-Zhemgangpa officials who came all the way from the capital, Thimphu, because Bonpos' powers are believed to be ineffective against outsiders and, of course, the state officials. Bonpo Karma maintained that, over a decade ago, the state (*zhung*) had summoned all the Bonpos of Zhemgang district to the *dzong* primarily to observe their ritual practices and to reconfirm the authenticity of their Bonpo vocation.

In the courtyard of the *dzong*, when the adjudicators, comprising clergy and high-ranking officials, ordered the Bonpos to describe the rituals they conduct in their respective villages, some reportedly admitted that fish or

other animals were sacrificed. Others said that they make live sacrifices on the fifteenth day of the lunar month, which is regarded as one of the holiest days by Buddhists. Since the officials involved in this attestation were on a mission to prohibit the practices of live-animal sacrifices and black magic rituals, an edict was immediately issued to Bonpos ordering them to henceforth refrain from live-animal sacrifices, while concurrently recognizing a handful of Bonpos who did not practice animal sacrifices. Since then, red meat has been banned by law from Bon religious offerings, and, as I shall show later, failing to abide by this order leads to grave consequences.

Bonpo Karma holds that during the attestation some of the powerful, divinely selected shamans began to tremble violently and entered a trance because their gods were displeased by the confirmation of shaman-hood by non-Bonpos. According to Golengpa Bonpos, a similar certification of Bonpo shamans was also organized in recent years by one of the previous governors (*dzongdag*) in Buli. One after another, the Bonpos were summoned to the stage, where mustard oil was being heated in a large, traditional frying pan. As the pan turned red, one of the officials was supposed to place it on the shaman's head to validate if the shaman was genuine. The genuine shamans, when challenged or threatened by other forces, would immediately be possessed by their gods, empowering them to carry the red-hot pan with ease while dancing wildly. Such acts were witnessed by many Bonpos and villagers alike, and are testimony that genuine shamans are protected by their gods when in danger. Some Bonpos emphasized that charlatans do not dare to face the advancing red-hot pan, so they will instead plea for exemption from punishment. While the Bonpos ceased the live-sacrificial ritual almost in its entirety, some of them are still believed to be practicing black magic rituals in secrecy. A few recent judicial cases concern the controlling of the powerful Bonpos who were deemed to be experts in black magic rituals, and it is to these lawsuits I now turn.

The Official Bonpo of Goleng

Following the certification of Bonpo in Zhemgang proper, the official Bonpo effect proliferated in other villages and became a deep-seated stigma, particularly in Goleng. The village Bonpos were persecuted by imposing restrictions on live-animal sacrifices and the practice of so-called black magic rituals that are characteristic of Black Bon. Generally, the black Bonpo is very powerful

and can easily dominate fellow villagers, including the Buddhist monks. Golengpas truly believe in their power and the effectiveness of black magic as much as the black magician believes in them. For instance, if the black Bonpo is not apportioned new possessions or helped by village friends—be it during the harvest season or through corvée labor—they are certain that they will fall sick. The person may even die unless he makes personal offerings and requests the same Bonpo to perform a remedial ritual for him. According to the villagers, there are different types of black magic rituals in which the black Bonpo hands over a person's soul in the form of an effigy to their possessing gods and others, such as local *tsen*, *düd*, and *nawen* beings.

Golengpas explain that black Bonpos demand respect and all sorts of prerogatives associated with it. If a person denies the black Bonpo's expectations or engages in dissension with him, the soul of that person is surrendered magically to one of his gods with whom he shares a close relationship. The only tactic to compensate is to approach the black Bonpo with gifts (*chöma*) and apologize for not being able to help him or for disagreeing with him. Golengpas recommend a sincere apology by a victim and his family members so that the black Bonpo will be obliged to perform the curative ritual. In the end, the black Bonpo will forgive the offender by performing a ritual that is an act of indirectly accepting his responsibility for their illness.

As I shall show below, the restriction on Bon rituals in Goleng—that is both White and Black Bon rituals—was the direct corollary of Bonpos engaging in live-animal sacrifices and black magic rituals. People believe that an angered or jealous black Bonpo can kill the best cattle, destroy good crops, and perform magical rituals to punish their enemies. Some villagers were afflicted with constant sicknesses, reportedly by one of the black Bonpos in the village; and hence, due to intense and lasting fear caused by black magic, a group of victims filed a case in the district court in the early 1990s. In that landmark case, the court appointed Bonpo Chungla, who embraces White Bon, as the first official village Bonpo of Goleng and prohibited the rest of the Bonpos from performing Bon rituals and divinations thereafter. After that case, the main Bonpo who was accused of necromancy left the village permanently, while the newly appointed Bonpo fell ill. Golengpas tag that entire year with poor harvest and shrinking livestock—as they saw no daily Bon rituals, let alone the annual rites such as *rup*—a phenomenon they had never before witnessed.

Besides Bonpo Chungla, there are four other Bonpos in Goleng, one of whom is a shaman. Bonpo Chungla, who is in his nineties, never resorted

to harmful rituals in his entire life but had to resign from the post of village Bonpo because of his age. Furthermore, he underwent a major abdominal surgery in the early 2000s that he believed was made necessary by a black magic ritual by a man of Lhotsampa[17] origin who married his neighbor. Because of Bonpo Chungla's illness, a letter of appeal asking officials to rescind the prohibition on Bonpo activity was submitted by the former people's representative (*chimi*) Dechen, countersigned by twelve village elite on the twenty-third day of the third lunar month of the water bird year, corresponding to 12 April 1993. They requested reconsideration of the decision on the Goleng Bonpos and proposed Bonpo Drakpa for the new position of officially appointed Bonpo. However, the judge declined to overturn his previous ruling, as the nominated Bonpo was among those prohibited from performing Bon rituals and divination. But the need for a new Bonpo became ever more urgent, as the verdict did not end people falling sick, insofar as the *goshé nyenshés* were left with no choice but to consider ignoring the court judgment by making Bonpo Pemala, who was also prohibited from performing Bon rituals by the court due to his involvement in live-animal sacrifices, as their new official village Bonpo.

On the other hand, the *goshé nyenshé* do exercise power within the village and resist the Bonpo too. For instance, while *chimi* Dechen attempted to make the Bonpo of his choice the official village Bonpo, he also, along with the chief lay Buddhist, played a key role in prohibiting Bon practices in Goleng. Since the early 2000s, Golengpas have been served by Bonpo Pemala, who helped them conduct the *rup* rite against all odds. Recently, he began to divide his time between Goleng and Gelephu, as he had to nurse his wife, who was suffering from a paralytic disease. Yet, as corroborated by villagers, he is still conducts Bon rituals for the benefit of people of Gelephu, which is one of the major towns in southern Bhutan. This is also believed to be the case with Bonpo Ngedup, who left Goleng permanently. During the 2017 harvest season, Bonpo Pemala came to Goleng and stayed for a few months helping his eldest daughter with paddy-harvesting activities. Before he returned to Gelephu, I met with him frequently to discuss issues arising from an unprecedented lawsuit (see "Bonpos in Court" below) to discuss the state of the Bon *rup* rite. Although he had previously engaged in animal sacrifices, he is now totally against any form of meat offering and often makes a strong recommendation to his Buddhist counterparts to refrain from offering cooked meat to Buddhist protectors (*Dharmapalas*), which is a standard practice across Bhutan.

Bonpo Pemala is, then, a quasi-official Bonpo of Goleng in the sense that while there is an official prohibition on him practicing Bon rituals, he has assumed the full responsibility of the official village Bonpo. Nonetheless, in recent years, he confided, he has become less interested in filling the much-contested position of the official Bonpo, whose main duty is to perform the annual *rup* rite. While he will continue to help people wherever he lives, the politicized Bonpo position—whether at the village or district level—does not appeal to him. His indignation over the injustice suffered by the Bonpos is reflected in the following comment.

> *Rup* is a three-day throat-drying enterprise that can wear you down completely, yet I do not receive a working meal, let alone daily wages for what I am worth. During the previous Bonpo's (Chungla) term, a group of Golengpas went to his home in lower Goleng and respectfully offered him a few bottles of alcohol before inviting him for the ritual. Then they would serve him with delicious food and drink during the next three days. Once the ritual was completed, they would walk him back to the village with some gifts consisting of few bottles of alcohol (*ara*). In my case, there is none of that, though some good people are sympathetic, considering the responsibilities of the Bonpo. Last year a few right-minded people initiated a deliberation on whether to provide a daily wage or not, but there was never a definitive decision. You know, after the ritual, some people do not even talk to me, which is an act of snubbing the blessings I bring for the entire year. This is so disgusting! I do not feel like I should be performing *rup* anymore. I decided not to come for *rup* last year, but a group of Golengpa men, including the village headman (*tsogpa*), came with their vehicle to pick me up from Gelephu.

Traditionally Bonpos were treated with respect and honor, but now it is difficult to find many people who genuinely respect them. Yet Bonpos are needed here, there, and everywhere and at any time. The three-day *rup* rite is actually a wine-and-dine liturgy, but the offerings for the village Bonpo are on the decline, particularly after the court ruling, even while they continue to maintain consistency in the offerings of foods and drinks for the gods. Bonpo Pemala maintains that he is demanding neither a daily wage nor a lavish meal, although there is clearly discontentment on his face.

On one occasion, I saw a junior Bonpo, Pila, requesting he continue his role until his last breath—the same plea made by Golengpa villagers—because

they believe that other Bonpos lack the skill and experience to invoke the mountain deity Rematsen. It is argued that other Bonpos do not enjoy a good relationship with the mountain deity. According to Bonpo Pemala, an inexperienced Bonpo who has not yet established a bond with the deity is unable to invoke Rematsen, for as the chief of local gods she requires elaborate offerings with sacred adornment as well as a good depth (*ting*) of ritual knowledge, which manifests in the form of oral skills and cosmological knowledge of the relationship.

Bonpos in Court

There have been two major lawsuits against Bonpos in Goleng with a lasting effect on the future of Bon practices. Both of them revolved around powerful Bonpos who were deemed to be knowledgeable about black magic ritual. These Bonpos were somewhat isolated from the other villagers, who feared them, creating a rift that meant both the court and people at large relied on hearsay evidence to establish the causality between illness and their black magic rituals.

The first litigation arose in the late 1980s when three Golengpa villagers, namely Dema, Duba, and the late Chokmo, fell seriously ill around the same time. Everyone, including the diviner,[18] suspected black magic, prompting them to accuse the most feared Bonpo, Ngedup, who is a *magpa* to a Golengpa woman, of casting spells against them. A bitter feud ensued, almost dominating the Golengpa social world, before ultimately reaching the district court in Zhemgang. During the court hearing, Bonpo Ngedup refuted the allegations against him by citing other Bonpos who also perform the rituals, which involve live-animal sacrifices. Hence, for his expertise in Shartsen ritual, which involved live-animal sacrifice, Bonpo Sangay, who is also a *magpa* to a Golengpa woman, was thrust into the legal limelight. This, of course, led to a contestation between the two Bonpos, who otherwise held the same religious beliefs. Eventually, the court delivered a verbal verdict barring both of them indefinitely from performing Bon rituals.

According to *chimi* Dechen, the situation concerning Bonpo Sangay was exacerbated when another woman, who is the current village headman's mother, became severely ill. Her family consulted a local lay Buddhist diviner who indicated that Bonpo Sangay was responsible for her sickness, but finding no way to resolve the issue at the county level, her husband, Tashi,

filed a case with the district court. During the court hearing, Bonpo Sangay denied any knowledge of occult power and challenged the plaintiff to expose, if any, his black magic training and lineage or at least name his black magic master or his family member's association with the so-called black magic ritual. Unable to provide evidence to prove the allegation against the Bonpo, he later had to withdraw the case.

The second lawsuit in the early 1990s against the Goleng Bonpos concerned live-animal sacrifice and black magic in which a hunting (*nawen*) spirit was allegedly employed to harm others. Dema, who claimed to be the main victim of the black magic, attributed the legal proceedings to a land dispute among closely related households. She was a close neighbor of Chokmo, who was directly involved in property disputes with the accused Bonpo in question, and gave me a brief background to the land conflicts that led to competing claims, sparking the alleged black magic ritual attack:

> An area of terraced land was the nexus of the feud and animosity between the de facto and de jure owners. Chethey and her sister were the legitimate owners of the land and house but they neither paid taxes nor took care of the fields. For many years, it was Chokmo and her husband who took care of these properties by assuming the role of the main taxpayer (*khraipa*). Since Chokmo was the main taxpayer of the house, she became the de facto owner and, according to the law, it was legal for her to cultivate the lands that belonged to the household and even own it after a certain number of years. However, Chethey, who was brother-in-law to Bonpo Ngedup, developed a plan for seizing not only the land but also the paddy cultivated by Chokmo. He illegally harvested the paddy and hoarded it in my cellar, which was then attached to Chokmo's house. This forceful land grab resulted in a legal case between them. As expected, the court verdict upheld the ownership of the land in favor of Chokmo, and it ordered the return of the land along with her paddy. Since then, ill luck has started to befall the Chokmo family. First, her herds of horses and cattle began to die in succession, and gradually her father and his relatives became sick and passed away one after another.

Dema maintains that the sickness then slowly began to attack her and her family in its entirety: her father died from an abdominal swelling and later her uncle showed similar symptoms and passed away, before the sickness tormented her. Dema for a prolonged period of time suffered from a sickness

that was more itchy and painful than scabies, given the skin on her fingertips cracked and peeled off, discharging blood and fluid. Golengpas believe that they suffer from such itchy skin when they have been bitten by a *nawen* spirit belonging to an accomplished Bonpo or hunter. This sickness is patterned and timed, and it usually occurs twice a year, especially during the paddy-sowing and paddy-harvesting seasons. In Golengpas' worldview, the Bonpo's grudge against her and his concerted effort to seize the paddy and the land are crystallized in such timed sickness. Dema argues that several pharmaceutical drugs and healing rituals were unsuccessful in treating her condition, and, as corroborated by her daughters, Western doctors at Yebilaptsa hospital advised her that it was not a medical disease. However, I could not verify this claim, as these missionary doctors working in that hospital left the country in the late 1990s.[19]

Dema's grandfather then began knocking on doors to garner people's support and evidence for his petition to drive out the black magic. After collecting many thumbprints from the villagers, Dema and her grandfather filed a lawsuit in the district court accusing Bonpo Ngedup of afflicting them with sicknesses by employing his *nawen* spirit. Chokmo and Duba joined the party because their husbands and relatives had died from a similar sickness. Here Duba is an interesting figure who was also an alleged victim of Ngedup's black magic ritual. As Dema recalls, Bonpo Ngedup vowed to inflict pain and death on Duba and her husband when he learned that his highly priced mule was accidentally shot dead by a traditional crossbow trap that was set up on the farm fringes by Duba's husband in an effort to stop wild animals plundering and ransacking their sweet buckwheat. She claimed that her husband became sick and shortly afterward passed away as per his promise—that is, to avenge his mule.

During the court hearing, Dema claimed that Bonpo Ngedup's brother-in-law Chethey, who was a former county head (*gup*), took advantage of his experience and saved his uncle by producing a medical report that stated she had contracted certain diseases that became serious recently because of dirt and certain foods. According to the victim, she made a final visit at the hospital and her doctor still maintained that her sickness was the work of the supernatural. But after these hearings and trials, the itching sickness and wounds healed on their own—that is, without medication or healing rituals. Since then there has been no recurrence, not only in her case but also among other Golengpas. The sicknesses and misfortunes caused by black magic ritual are still current in nearby villages, especially those where there

is no tradition of appointing an official village Bonpo, reflecting the lack of Buddhist state surveillance.

In 2017, a family from Tsaidhang village filed a lawsuit against a man for alleged black magic ritual. The victim was in his fifties and, as in the case of the Golengpa patient, suffered from a severe pain accompanied by a burning sensation all over his body. Most important, these symptoms struck only at night, particularly between sunset and the first rooster's crow, and he became better during the day, in the sense that he does not feel that excruciating pain. Like Bonpo Ngedup of Goleng, the accused was believed to have warned the alleged victim during one of their arguments to wait and see if he could live as a human being.

In Golengpas' world, it is the work of a black Bonpo, irrespective of symptoms, if the sicknesses are timed or patterned—whether through a daily, nightly, or seasonal illness. The day-night-season variations in the intensity of sicknesses when accompanied by explicit or inexplicit admonitions by the black Bonpo objectify black magic ritual, making it uniquely realistic to the faithful. Some black Bonpos implicitly ask their opponents if they are interested in living a long life, while others forthrightly warn them to see if they will be able to wake up the next morning. These kinds of warnings and threats posed by the black Bonpos are a forerunner of subsequent sicknesses, though their severity depends on the performer's black magic ritual experience, as they are believed to possess a varying degree of black magic accomplishment.

The Politics of Black Magic Rituals

Prior to the 1990s, there were no roads in most of the villages in Zhemgang, and there are still no good roads that connect these villages. So people traveling often have to spend a night in a village on their way to their destination as it is a popular custom that continues down to the present day for the villagers to host travelers—strangers and wayfarers—for a night at their house. In most cases, the guest returns the host's kindness, usually in a form of cash (*shuljab*) before leaving the house, but gift giving is not restricted to tangible goods and services, since intangible lore such as religious knowledge can be equally gifted, and quite often such a gift is truly appreciated by the receiver. This esoteric knowledge is the source of good food and gives access to social status and power and, therefore, is crucial in maintaining social hierarchies.

On the other hand, not all forms of gifts promote bonding or social cohesiveness. While the exchange of tangible things like goods and services certainly improves social relationships, bestowing intangible gifts such as "esoteric" religious knowledge can be disastrous for social bonding, as it can be a source of destruction of social cohesiveness, especially when the social hierarchy is threatened through contestation of powers. Therefore, gifting supernatural knowledge such as black magic rituals is often seen by villagers as a tool for social power.

Another unique method for establishing an abiding relationship between the host and the guest is for the host to adopt the guest as sister, brother, or parent. Such fictive kinship perpetuates gift exchanges and is characterized by strong reciprocity, which determines the future of the guest-host relationship. The guest must have either given the host goods at their first meeting, have left *shujab* prior to their departure, or granted some religious knowledge after several years of their extended relationship. Similarly, the host must provide hospitality both in words and in deeds. A guest leaving no *shujab* indicates that he is either dissatisfied by the host's hospitality or has no intention of spending another night there in the future—throwing himself into a precarious situation, as the chances of with the same host become slim.

One famous example of pseudo-alliance concerns Tshewang from Digala and Ugyen from Shobleng villages. Tshewang was a frequent traveler famed for his mastery of infamous black magic ritual. His status gave him access to common people and their properties; thus, he had a host of hosts wherever he traveled. Yet he adopted Ugyen from Tsaidhang, who settled as *magpa* in Shobleng, as his son in order to cement the host-guest relationship between them. They became intimate over time and the adopter-father asked his adoptee-son if he ever dreamed of receiving "delicious foodstuffs" (*zey shimpo*). Apparently, *zey shimpo* in their ritual language metonymically stands for social prestige and preference associated with the power of black magic ritual. Because of his supernatural power, the black Bonpo received royal treatment and extravagant foods for free, which in the Bonpo's terms is equivalent to delicious foodstuff. A senior Shoblengpa villager related the following narrative to me:

> Under the guest-father's guidance, the adopted host-son practiced some chanting of a mantra unknown to the entire village for seven days and seven nights without coming out of the room or meeting any visitors. We heard that nobody can read the text, as it is written in an unknown language. After

a week, the guest-father decided to resume his journey to Buli. His host-son reciprocated his guest-father's precious religious gift by offering him delicious foods and escorting him down the narrow gorge that marks the end of Shobleng village. At the small hill, they stopped to rest next to the cave that used to accommodate more than twenty travelers. In the night, the guest-father expressed his intention to assess the level of his host-son's black magic ritual accomplishment. So he commanded his host-son to test his accomplishment by blowing on the cave where Tsaidhangpas spent their nights during their frequent trips. He boasted that if he practiced diligently, the cave would split. The host-son chanted the mantra one hundred times and blew in the direction of the cave. The cave, which did had had not even a sign of crevices, split into three pieces, confirming his rapid mastery.

In late 2017, I visited this cave, which is located just above the main path connecting Tsaidhang, Nyakhar, and Buli with Sobleng and Goleng villages. Considering the frame of the collapsed structure, it could have well accommodated over twenty travelers; currently, the cave is almost covered by bushes and shrubs, but one can clearly see the three large rock splits, which look fairly fresh. Not every Shoblengpa appreciates the history of this broken cave, but according to Tshultrim, who was a retired policeman from Shobleng, the persecution of black Bonpo in Zhemgang started in 1983. However, Bonpos came under increased scrutiny of the state between 1985-1999 during which the black Bonpos were identified by relying on hearsay and rumor.

Among the accused Bonpos was Tshewang, who was charged with using black magic ritual to kill people in the villages of Ngangkor and Bardo counties. Tshultrim maintained that a group of policemen escorted Tshewang from his village in Digala to the district headquarter in Zhemgang, and as they passed through Shobleng village, it was a perfect time for Tshewang to perform another round of assessment. But this time, instead of his adopted son's black magic accomplishment, he intended to review his son's morality and commitment to him. As he approached his adopted son's house, Tshewang sang out that he was being taken to jail and he would love to have a final *zey shimpo* to quench his thirst, caused by the sun that was at its zenith. He expected his adopted son to personally offer a good alcoholic beverage (*bangchang*) and meal, but unfortunately, Ugyen was away from his home.

Ugyen's wife, Chingmo, apparently feared for her husband's safety as she was au fait with her husband's black magic ritual training under Tshewang's

guidance. So with much shaking and trepidation, she filled a bottle with *bangchang*—unfortunately, from the wrong jar—and offered him the low-quality alcohol. Tshewang said some prayers before trying the drink, only to find it tasteless, which he saw as a deliberate act to dishonor him. He threw his drink at the house and left the scene, remarking: "The relationship between the adopter-father and adoptee-son is now broken. Henceforth he is not my son, nor am I his father." Tshewang presumed that Ugyen was hiding from police at his house while his wife calculatedly offered him leftover *bangchang*, which he took it as a categorical contestation of magical power by his adopted son. While Tshewang was taken to Thimphu and said to be imprisoned for three years, probably in Chamgang prison, three days and three nights after this event, Ugyen passed away suddenly after vomiting blood in his death throes with his body reportedly arched and his eyes dislodged in horrific pain. Both Shoblengpas and Golengpas were sure that it was the work of Tshewang's black magic ritual.

There are only two options for avoiding black magic ritual, according to Golengpas. The first method is to practice nonviolence by attempting never to quarrel or engage in hostilities with the black Bonpo because the former can easily end up being the latter's victim. The alternative approach is to trick the black Bonpo into drinking menstrual blood or ingesting the victim's feces so as to sap his life elements. This mode also involves naming and shaming black Bonpos by letting them walk naked in public places. In so doing, their supernatural powers are believed to be diminished so that they remain mostly inert, especially in the face of victims. In extreme situations, there have been incidents in which a group of people, it is believed, conspire to murder a black Bonpo by throwing him off a cliff.

The problem created by the verbal verdict in the first court case resurfaced when Bonpo Pemala's wife suddenly fell ill. Bonpo Pemala claimed that the divination and symptoms clearly manifested the signs of attack by Shartsen, who we have already seen is associated with fertility. Previously, when Shartsen deities were involved in inflicting sicknesses on humans, prompt sacrifice of a cow or bull was mandatory. But the Golengpa Bonpos were already prohibited from performing live sacrifice following the first court decision in the late 1980s, so Sonam, who, according to Bonpo Pemala, was a lay *chöpa*, took matters into his own hands and slaughtered a cow and offered its meat to the Shartsen deities. He administered the ritual by saying his own version of an incantation, and the Bonpo's wife recovered from the sickness and gave birth to a healthy baby. The next day all hell broke loose when

officials from the district office, including the police, arrived in Goleng to investigate the sacrificial ritual. The Golengpa Bonpos were summoned, including Bonpo Pemala and Bonpo Sangay who are the specialists in Shartsen sacrifices.

The other main purpose of the officials' visit was to find out who exactly possessed a *nawen* spirit that was allegedly used as an agent to harm others. After interrogating all the Bonpos, the officials, however, found them innocent of animal sacrifice, as the ransom ritual was actually conducted by the lay *chöpa* Sonam, who was spared immediate punishment but banned from conducting sacrificial rituals. Bonpo Pemala argued that if one of the village Bonpos had been involved in the Shartsen ritual, all of them would have received a severe punishment. The officials then shifted their interest to Bonpo Ngedup, who was by then believed to be a putative Bonpo of *nawen* spirit. However, Golengpas fear Bonpo Ngedup more than the highly hierarchical government bureaucrats, in that they did not dare to touch the shared irrigation channel during the farming season or his properties without seeking prior permission from him. A person disrespecting him in any way, including not contributing labor during the farming period, risked annoying the powerful Bonpo. While possession of a top dairy cow breed or agisting them on the black Bonpo's field, growing healthy crops, and reaping bountiful harvest can pose an equal risk of upsetting the Bonpo, the direct exchange of harsh words or, most important, arguing or fighting with him will result in the offender's becoming bedridden almost immediately after the incident.

As Bonpo Pemala maintained, the investigators stormed into Bonpo Ngedup's house and seized his hunting equipment—bows and arrows, spears, hunting ropes, and other tools that are believed to house the *nawen* spirit. They took him to the district court for purportedly inflicting harm on others and burned his hunting tools before his eyes even as Ngedup was believed to have run out of arguments and was forced to drink menstrual blood in order to repress and pollute his evil powers.[20] According to *chimi* Dechen, the court forced him to circumambulate Zhemgang town carrying his bow and arrows to overcome his negative energies and powers. Today, Golengpas argue that if it were not for the fact that Chethey was a local leader and his relative, they would have incarcerated him.

The Bonpos of Goleng and Shobleng, the lay *chöpa* Sonam, and Dorjimo, a female shaman well known for her excellence in divination, were summoned to appear in court. Excepting Bonpo Sangay, who had already passed the scrutiny during the initial investigation, they all took a solemn oath to never

again engage in animal sacrifices or black magic ritual. The agreement letter concerning this final verdict was shared with me by *chimi* Dechen, who assumes the role of prominent man in Goleng:

> As per the order of the honorable judge, Division of Infraction (9) 901-1960, the court has summoned six Bonpos (Chophela, Pemala, Dorji Ngedup, Dorji Dolma, Dorji Drakpa, and Sonam Lhendup) who were engaged in live-animal sacrifices. The court ordered them not only to prohibit live sacrifices and other forms of Bon sacrificial rituals but also to refrain from techniques of astrological and other methods of Bon divination. During the court hearing, they maintained that, apart from various forms of divination, which is as per Goleng people's wish and request, they did not perform black magic or sacrificial rituals.
>
> Henceforth, the Bonpos have vowed not to perform even smoke offerings (*sur*), let alone major Bon rituals and divination. So in accordance with the previous court order (173), except for Chungla, who is responsible for performing fumigation and burned offering, the aforementioned Bonpos are banned indefinitely from conducting any kind of Bon rituals.
>
> In the event of noncompliance, the six Bonpos and the householder who sought their ritual assistances, being guilty of offense, are liable to pay a fine of Nu. 1,000. Furthermore, both the Bonpo and the householder shall be incarcerated for the breach of this agreement for a period of six months. A copy hereof was issued to the six Bonpos as hereunder:
>
> 1. Chophela
> 2. Pemala
> 3. Dorji Drakpa
> 4. Sonam Lhendup
> 5. Chophela (Dorji Ngedup's representative)
> 6. Dorji Dolma
>
> Signed by the Judge of the Zhemgang District

Different Bonpos were summoned several times to appear in court in different time periods, but the court never passed a formal decree. However, in this final case, which involved four Bonpos and one lay *chöpa* in a cow sacrifice to Shartsen deities, the legally binding letter of agreement where the Bonpos unanimously vowed not to perform any Bon rituals and divinations was issued. Their pledge of commitment as the law requires is attested to

by their individual thumbprint and the drinking of holy water bound by a promise (*nachu*). Bonpo Chungla was nominated as the first official village Bonpo by the court, but there were no clear by-laws to regulate the election of his successor.

It should be clear that the evidence presented thus far suggests that live-animal sacrifices and black magic rituals are the two primary Bon practices that give impetus to current Buddhist antagonism, leading up to the formal recognition of general Bonpos while prohibiting others, including the specialist Bonpos. The appointment of an official Bon priest is also in part the powers of specialist Bonpos, given that the lay *chöpas* themselves are not completely immune from black magic rituals. The lay *chöpas* can equally fall under the powerful Bonpo's subjection, as attested by many narratives about black magic rituals that have claimed the lives of Buddhist masters. Nonetheless, through such interventions, the Buddhists create what Foucault (1975) calls "docile bodies" to control the powerful Bonpos, while at the same time perpetuating Buddhist hegemony over Bon under the veneer of a civilizing Buddhist mission.

Although a handful of Bon gods and deities were subjugated and converted to Buddhism, Buddhists did not eliminate the Bonpos, nor did they render Bonpos nugatory or godless given the fact that the number of untamed Bon gods and deities is far larger than those who are considered to be tamed. In fact, it seems that the Buddhists were interested in incorporating only powerful Bon gods while disdaining the lesser autochthonous beings. In this sense, there are actually no specific Buddhist remedies against the sicknesses believed to be caused by the untamed local deities and spirits who are commonly associated with abducting souls. The Golengpa Bonpos maintain that the untamed local deities are more willing to cooperate with the local Bonpos, who have been living and dealing with them for years, than the higher Buddhist priests from other districts. While there are Buddhist parallels oriented toward buying back the abducted soul (*lalu*), they were not as popular as the shamanic ritual given the recency of and weakness of the Buddhist presence in Goleng. Furthermore, it is the Bonpos who know the precise cause or the spirit beings behind the sickness because of their knowledge of, and a close affinity with, the local pantheon, and thus they can administer appropriate rituals for the sick person.

Switching between Buddhist and Bon rituals, particularly by a Buddhist monk in Bumthang, indicates that Bon beliefs are not just important to villagers alone but also to Buddhist priests themselves, who have been

making concessions to Bon by accommodating certain Bon beliefs. The complementarity between the Buddhist and Bon rituals is evident among the villagers, who often seek both the ritualists. For instance, most of the shaman's divinations included additional Buddhists rituals, which are accordingly requested by the patient to be performed by lay Buddhists, while the advanced shamanic ritual itself was conducted in order to complement the prior rituals by lay Buddhists, general Bonpos, and biomedical treatments by health practitioners.

The Bonpo shamans, particularly those divinely selected and hereditary, were pigeonholed by Buddhists as too powerful and in need of policing. These Bonpo shamans were seen to be deviating from their magico-religious purposes by engaging in black magic rituals and animal sacrifices. This has culminated in the Buddhists' and government's realization that they have to make concessions to Bonpos by appointment of an official Bon priest. The refusal to comply with the court order by the villagers, who appointed their own second official village Bonpo, however, demonstrates the extent of Bon beliefs, which are deeply ingrained in Golengpas' religious and social landscape. It is to the unintended consequences of the appointment of an official Golengpa Bonpo for the most important annual Bon ritual—which is the driving force of the local economy of agriculture production and prosperity—I now turn.

6
The Annual *Rup* Ritual

By examining the close relationship between the *dung* nobility and the primary *rup* god Odé Gungyal, this chapter provides the religious and sociocultural contexts within which *rup* is deeply embedded. It considers the significance of the god Odé Gungyal and of *rup* to the *dung* nobility, under which lies Golengpas interest in keeping the annual Bon rite going. It also looks at the changing status of the *dung* nobility, who, while now largely powerless after the fall of feudalism, are still prestigious, particularly during the *rup* rite, which gives them ceremonial duties that make them central to Golengpas' identity as a whole. Finally, this chapter examines the centrality of the annual Bon rite—*rup*—that I witnessed in Shobleng village because of the problems in developing a consensus to perform the ritual in Goleng. Various postjuridical events at the Goleng village and the appointment of the current de facto Bonpo by the villagers, albeit unlawfully, offer a window into how Golengpas' complex religiosity is being reshaped by *rup*, through which Bon beliefs continue to persist.

The Significance of *Rup* to the *Dung* Nobility

Each time I asked the Golengpa villagers about the implications of recognizing an official Bonpo on their annual Bon rite, I was given the same response that reaffirmed the centrality of *rup* to Golengpas' social, cultural, and religious identity. Goleng villagers maintain that *rup* has been passed down from one generation to the next (*phagyu bugyu*) and therefore is by no means a tradition that can be outlawed. In fact, *rup* is so central to people that all Golengpas stop working for three days to celebrate it. What is even more surprising is the fact that Golengpas, including the lay Buddhist *chöpas*, are prohibited from conducting any Buddhist ritual during *rup*. Their actions are policed by the Bonpo so that the community is fully involved in observance of the Bon rite, which in turn gives prominence to the Bonpos. The centrality

of *rup* is underpinned by the existence of the *dung* nobility in Goleng and their interest in *rup*, whose significance to the former has its footing in the conceptual relationship between the primary *rup* god and the nobility's supposed ancestors.

Rup is a three-day annual rite observed in winter by a cluster of villages, Nyakhar, Tsaidhang, Kyikhar, Dakphai, Goleng, and Shobleng of Nangkor county in Zhemgang. It is believed that *rup*, in which the supreme Bon god—Odé Gungyal—is invoked and propitiated along with lesser local deities and spirit beings, began as early as the time of formation of the land and sky (*sachak namchak*). Literally *rup* means "support." The cooperation villagers show in putting on the communal rite is known by the same label—their donating, volunteering, and, most important, "coming together."

The identity of the *rup* god Odé Gungyal is somewhat muddled, although some Golengpas claim that he was first propitiated when Zhabdrung came to Bhutan in the seventeenth century. However, as will be clear, *rup* is obviously a pre-Buddhist rite that likely extends far back to remote antiquity, almost sharing coevality with the primordial Bon god. Apart from Odé Gungyal, each of the villages has its own chief local deity whose powers vary within the locality, primarily on the basis of lineage organizations. For instance, Dralha Karchung is the main deity of Tsaidhang and Nyakhar villages, while Chunglatsen is Buli's main mountain deity. Other villages like Tali, Goleng, and Shobleng propitiate the same territorial mountain deity—Rematsen, who is sometimes referred to as the precious great *tsen* (*tsenchen yeshi norbu*). Rather than the eschatological dimension of life, as in Buddhism, the ritual activities constituting the *rup* rite are devoted to pragmatic concerns such as fulfillment of human interests, including prosperity.

The *rup* rite is the domain of Bonpos, with the Buddhist priests prohibited by the presiding Bonpo from performing any Buddhist rituals. The local narrative relates it to the legend of a racing contest between Buddhist and Bonpo masters. Golengpas have it that Guru Rinpoche and Bonpo Tonpa Shenrab were engaged in a race toward a summit in Lhasa, Tibet (*tse* Potala), mirroring the popular contest of miracles between Milarepa, the eleventh-century Buddhist master, and Naro Bonchung, the Bon master at Mount Kailash. Just like Naro Bonchung, who was defeated by Milarepa in a race to the summit of Kailash, Bonpo Shenrab lost to Guru Rinpoche in scaling the summit of Potala. Consequently, the days of the year were allocated between them, and Bon became marginalized because Shenrab could only secure Guru's agreement for Bon ritual to be performed on three days in the

entire year. Golengpas believe that these three days coincide with the three-day *rup* rite.

Although the Bon masters, including Tonpa Shenrab, were invoked during the *rup*, Odé Gungyal (pronounced locally as "Odé Gonjan") is the main god responsible for bringing protection, economic prosperity, and the blessings of fertility on humans and their domestic animals. According to Nebesky-Wojkowitz (1956), Odé Gungyal was the "old god of the universe" (*sid-pai lhagan*) before becoming a primordial mountain deity (*tsen*). Donning a silk turban and cloak, he personifies a great mountain range of the same appellation to the southeast of Lhasa and is believed to be the great father-god of eight great mountain deities forming the most famous pantheon of the "great nine gods of the universe" (*sidpa chagpai lha gu*) (Nebesky-Wojkowitz 1956: 208–209). The origin of the first Tibetan king, Nyatri Tsenpo, who was the progenitor of the Yarlung dynasty, which in turn shares close links to the nobility of Zhemgang, goes back to the creation of the great nine gods of the universe. Nyatri Tsenpo and the nine gods are believed to have descended from a divine apical ancestor (Karmay 2009 [1997]: 434) whose relationship is attested by the propitiation of these nine gods including the main god Odé Gungyal by his descendants who inherited the title of *tsenpo*, implying their divine origin.

It may be recalled that the *dung* nobilities of Zhemgang are associated with early Yarlung kings of Tibet. They are believed to be not only the direct descendant of Lhawang Drakpa of the Yarlung dynasty but also the reincarnation of Drakpa Wangchuck, the descendant of the divine Guse Langling, who was in turn said to be dispatched to Ura, Bumthang, by Odé Gungyal from his celestial realm. Although the origin of *dung* is a subject of debate, the close association between Odé Gungyal and the nobilities of Zhemgang is manifested in the *rup* rite of Goleng. During the *rup*, Odé Gungyal is invited by the Bonpo to descend on Golengpa houses in general, and the Dung House in particular, all the way from his heaven via Yarlung, Tibet. Similarly, the *kharphud* rite of eastern Bhutan mentions the Tibetan god-King Nyatri Tsenpo, while some of the Bonpos call themselves Tonpa Shenrab (see Pelgen 2004: 127). Interestingly, these rites are performed only by Bonpos as though to reflect their ritual roles for, and relationship with, the early Yarlung kings.[1]

Annual Bon rites such as *rup*, *shu*, *kharphud*, *mitsim*, and *gadang*, during which Odé Gungyal is invited to the respective villages, are observed by only certain villages in Zhemgang and eastern Bhutan around the same time—winter season—to bring protection and economic prosperity for the

coming year. It is a rite where the *dung*, other nobilities, and their ancestral gods mutually seek each other. These annual rites are only observed by the communities that still have the remnants of nobilities, or at least local chieftains preserving close association with the collateral nobilities, whose legendary origins go back to the early Yarlung kings and, by the same token, to the primordial god—Odé Gungyal. Thus, these annual rites are in fact celebrated in honor of the nobles while at the same time propitiating their antecedents and ancestral deities for their protection.

The Goleng *dung* today has a strong interest in carrying on with the celebration of *rup*, which is now one of the only occasions that their lineage's sacred character is honored. In fact, it was only during this rite that the Goleng *dung* nobility was endowed with any social preference as reflected in the ritual sequence, seating arrangement, visitation from god, and so on. The *rup* rite thus is a social space in which the *dung* nobilities re-enact their former political ascendancy, which has largely disappeared today. Hence, *rup* can be seen as the only avenue within which the "sacred" character of the Goleng *dung* family can be sustained. While it is only the *dung* nobilities that are projected during the *rup* rite, interest in *rup* is shared with all Golengpas. This is primarily because of the change of *dung*'s place in Goleng—that is, from a powerful feudal chieftain to relegated nobles after the abolition of feudalism in the late 1950s. Yet in Goleng, the noble titles are still held, albeit without political power. Although there are only five *dung* households in Goleng today, the *dung* nobility has remained central to Golengpas' sociality to the extent that it has now become an important part of Golengpas' identity, especially in relation to *rup*.

Rup Rules and Consequences

Each *rup* brings economic prosperity and healthy life, and with the year coming to an end, these blessings must be revitalized by reconducting the rite around the same time of the year, which is characterized by biological dormancy. While the *rup* manifested itself like a thanksgiving formulated for a successful year, the rite has some stringent rules that can have adverse consequences that are detrimental not only to a particular contravener but to the whole community of celebrants. The concern with the strict observance of *rup* was attested to by the senior villager's refusal to arbitrate the dispute between a recently wed couple who were accused of infidelity on the eve

of the 2018 *rup*. A victim's mother made the following complaint to *chimi* Dechen, who is one of the village elite:

> My son was smoking with her in the toilet, but it was a late night. When her husband, who slept early, walked to the toilet, my son felt uncomfortable and ran away from the scene. When her husband discovered that the woman was his wife, he became suspicious. So he chased him through the moonlit area until he held him by the hand. The husband then insisted that my son must take his newly wed wife.

The next morning, the parents from both sides came to see *chimi* Dechen separately, requesting he arbitrate the dispute. It was, however, postponed until the end of *rup* since such disputes can convulse the society at a time when the rite is transfiguring the village into a harmonious—or more precisely an ideal, heaven-like community—where negative emotions such as anger, hatred, dissension, jealously, and other social problems should be unheard of. To achieve that state, the Bonpo proclaimed a series of restrictions concerning the negative emotions and social actions that had to be cast aside, for they could obstruct Golengpas' journey toward the ideal *rup* world.

The Bonpo became very powerful during the entire ritual period, imposing various ritual rules. Individuals defying the rules were subject to the Bonpo's prescribed punishment, which they had to accept without complaint. For instance, a person commissioning a Buddhist ritual, gambling, quarreling, or using agricultural tools was liable to pay to the chief Bonpo a mulct of nine *brae* of rice, nine *bün*[2] of alcohol, nine rolls of cow's hide, and nine bundles of meat. The people were warned by the Bonpo to take effective precautions once the warning had been issued either by the Bonpo himself or through his acolytes. The proscriptions are generally the same as in the village rites in which god Odé Gungyal is invoked. Table 6.1 lists the consequences of some widely accepted restrictions.

Golengpas consider quarreling, eating meat, performing household chores, and working in the field as sacrilegious during the *rup*, and in danger of dragging the whole community into economic misfortune. Hence, Golengpas were prepared to deal with all kinds of anger and injuries that the ritual activities of *rup*, which involved pushing and pulling, may cause. On the other hand, the fluidity of profaneness was revealed during the *rup*, especially when the open space for the *phorgola* rite that was otherwise an animal shed and filled with animal dung became a sacred space.

Table 6.1 Consequences of Noncompliance with Ritual Rules

Activity	Consequence
Digging up the soil	Brings more pests and weeds
Felling a tree or chopping firewood	Increases the risk of getting injured by trees and wood
Consuming meat	Brings grasses and weeds as thick as an animal's fur
Touching cotton, eggs, or other white substances	Triggers wildflowers and weeds and makes the land infertile and barren
Unhygienic cooking or preparation of the offerings by a menstruating woman	Results in birth deformities

Outline of the *Rup* Rite

Golengpas had to skip the *rup* rite for at least two years, of which one was due to the unprecedented court case that banned Bonpos from performing all sorts of Bon rituals (see Chapter 5). The other was during my fieldwork, when the de facto village Bonpo left for Gelephu after the harvest in early winter. As I have mentioned already, Bonpo Pemala was now splitting his time between Goleng and Gelephu, where his sick wife was being nursed. The remaining Bonpos of Goleng were either not approved by the district court or Golengpas themselves, or they were inexperienced, particularly in the *rup* ritual, which is the key to unlocking the blessings of important Bon gods and local deities.

In 2016, a few Golengpa civil servants along with headman (*tsogpa*) traveled all the way to Gelephu to pick up the Bonpo so that he could preside over the *rup* rite. I asked the same headman and *goshé nyenshé*, including the chief lay Buddhist, Lopön Pema, in mid-2017, about their plans for the forthcoming *rup*. They merely expressed indifference to both the *rup* rite and villagers' concerns. Lopön Pema argued that a Bonpo is no longer required to perform *rup* since a lay Buddhist *chöpa* can do so. As the chief village *chöpa*, Lopön Pema was antagonistic to Bonpos and Bon rituals. When I asked him about the *rup*'s future, he commented:

> We have now collated a ritual text by relying on the Bonpo's verbal ritual so that a lay Buddhist *chöpa* can perform *rup* in the absence of Bonpos. We have also identified a particular *chöpa* who originally comes from a Bonpo

family, and he is happy to take up the role. Regardless of their current faith, any person who comes from a Bon family background can successfully perform a Bon rite such as *rup*. As you know, Bonpos are prohibited from performing Bon rituals. We will soon witness the Goleng *rup* being performed by the lay Buddhist *chöpa*.

Lopön Pema had already identified the lay Buddhist *chöpa* without actually consulting the people, headman, or district office. A copy of Lopön Pema's Buddhist *rup* was shared with me by one of the *goshé nyenshé* persons, and, unsurprisingly, it was a watered-down version of the Bonpo's *rup*. The Buddhist *rup* text, which is not yet in effect, was just one and a half pages in length, although the actual verbal ritual by the Bonpo can last thirty minutes to an hour, especially during the rite at the first four lineage houses. Although the text starts with the purification of the local deities before making the offerings and the sealing of the several animals' mouths, it nevertheless neglects all the rituals concerning the second and third day, never mind the invocation of the main Bon god of the *rup* rite.

The majority of Golengpas felt ambivalent toward Lopön Pema's unilateral action due to the fact that *rup* is a Bon rite, and it ought to be performed by the Bonpos and Bonpos alone. Although the villagers do not deny that a person sharing genealogical ties with the Bonpos can become a successful Bonpo, they expressed fears for the community's well-being and economic prosperity. Given the content of the Buddhist text, villagers argue that it will not only fail to generate the blessings but also bring about spiritual discontentment among the faithful. In fact, when Bonpo Pemala was in Goleng in 2017, he was implored by the villagers, including the junior Bonpos, to remain in the village or to return for the *rup* rite in the following months. But Bonpo Pemala did not heed them, probably because this request did not come from the village elite, such as the local headman and Lopön Pema.

The village headman is democratically elected every five years, and as the people's immediate representative at the county level, his primary roles are making important decisions on behalf of the villagers and organizing communal village rituals. Nevertheless, since the *chöpa*'s plan for *rup* was clear to the people and Bonpos, the village headman seems to have ignored the polarizing religious actors quite successfully by remaining indifferent to both the parties, not because he wanted to abolish *rup* but because he does not quite like the idea of Lopön Pema's uniliteral decision. In other words, the village headman, who is informed about Golengpas' culture and heritage,

seems to be in tune with the general public. Rather than letting the *chöpa* dilute the richness of *rup*, villagers believe that the ritual ought to be continued by the Bonpos.

I indicated earlier that Bonpo Pemala clearly demands recognition and better treatment such as his predecessor Bonpo Chungla received. In 2018 there was no presiding Bonpo although all Golengpas, including the *chöpas'* households, prepared ritual objects and foods on its eve and made their individual offerings on the first day of *rup*. Ironically, the Bonpo's no-show was the explanation given by the village headman and Lopön Pema for the poor observance of their annual *rup*, but the villagers attribute it to the sheer lack of social coordination by the headman and Lopön Pema's plan to replace the *rup* Bonpo. The *rup* rite is performed on the tenth, eleventh, and twelfth of the twelfth lunar calendar in Goleng and on the eleventh, twelfth, and thirteenth day of the twelfth lunar calendar in Shobleng. Hence on the second day of Goleng *rup*, I traveled to Shobleng to witness their *rup* rite.

Prior to going to Shobleng, I had spent substantial amount of time with the de facto village Bonpo, Bonpo Pemala, who had been conducting the Goleng *rup* for the many years. Bonpo Pemala explained to me several times how the Goleng *rup* rite was conducted, realizing that I might not be able to witness the *rup* rite during my fieldwork. Later, while I was attending the first day of the Goleng *rup* and the entire Shobleng *rup* cycle, his descriptions helped me appreciate the differences and similarities between the two rites and understand their meanings and significance. Based on the observation of *rup* rites and Bonpo Pemala's explanation, I shall first present a brief sketch of *rup*.

Shoblengpas have no recognized nobility as such, but they have a feudal structure similar to that of Golengpas where the main Khraipa House had exercised a great deal of power over other households. Except for the date, the ways in which the three-day *rup* rite is organized remain largely the same (see Table 6.2). The first and the second day of *rup* constituted the rite of the holiday of sealing (*dham lam*), the rite of forest gnome-like spirits (*phorgola/mirgola*), and the holiday of the populace (*mang lam*). The final day involved the observance of the rites of the holiday of seed and personal crops (*sön lam* and *boleng lam*), followed by an archery match among the men. While each ritual has its own significance, the sealing ritual (*dham dham*) overshadows others. These observances are the basic components of *rup* shared by Golengpas and Shoblengpas.

Both in Goleng and Shobleng, the first act was the preparation by each household of the offering (*tsog*), which consisted of cooked rice, a variety of

Table 6.2 *Rup* Rites and Rituals

Days	Activities
Rup eve: *Dham dham*	Invocation of Bon gods, local deities including *nawen* spirit
	Purification of house
	Sealing the mouths of wild animals and pests
	Banana leaf divination
Day 1: *Dham lam*	Observing the sealing ritual rules
	Phorgola ritual
	Offerings to the Bon gods and local deities (at the attic and open space)
	Offerings to the Buddhist deities at the temple
	Buckwheat paste divination
Day 2: *Mang lam*	Imposition of sealing ritual rules on the populace
	Tug-of-war divination
	Sealing the village
	Garpa impersonation
Day 3: *Sön lam / Boleng lam*	Capitalizing the blessings by sowing the first grains for the year
	Celebration of the blessings through archery contest

cereals and dishes, buckwheat noodles (*puta*), and buckwheat paste (*karjud*). Women cleaned their respective houses, and men made cups from bamboo node plugs and collected banana leaves. All of these preparations were completed well ahead of the event because villagers were not allowed to engage in mundane activities during the ritual.

The invocation and propitiation of the chief god, Odé Gungyal, along with Tonpa Shenrab and important local gods and spirits with precooked offerings began from the prominent houses, that is Dung House in Goleng and Khraipa House in Shobleng. The first four offerings at the four lineage houses of Goleng, which were made on the basis of their ranking, which is almost defunct in non-*rup* days, were actually the heart of the three-day rite, as much as the making of offerings at the Khraipa House was to Shoblengpas. The oblations at the remaining households follow the first offerings, which are made at the houses of nobility and prominent families and can last until the next morning, depending on the number of households. In what follows, I shall describe these rites sequentially by emphasizing their symbolism

and relations to the economy and well-being of the people of Goleng and Shobleng.

Dham Dham: *Rup* Divinities, Divinations, and Sealing Rites

On the eve of *rup*, the first and foremost rite, called sealing the mouths of animals and of misfortune- and sickness-causing agents (*dham dham*), was performed in the dead of night. Both Golengpas and Shoblengpas, including the Bonpos, believe that they had to start the sealing rite as early as 10:00 p.m. considering the number of households. This rite was characteristic of Bonpo Pemala's "throat-drying enterprise," as it involved visiting all the households and subsequently sealing the mouths of harmful animals in each household. The Bonpo must always complete the *dham dham* rite before dawn so that he can begin the *dham lam* observance the next morning. While Goleng had sixty-nine households, Shobleng had only ten households. Yet Shobleng Bonpo started the rite at 10:00 p.m. so that it could be completed well ahead of time. The timing of this rite is important, not just to cater to a large number of households, but to increase its efficacy by conducting it in the period of dormancy and in the dead of night, when most animals and pests are asleep.

The Bonpo's preliminary ritual constituted cleansing of the offerings and the houses, which had already been physically cleaned prior to the *dham dham* rite by householders. He first ritually cleansed the offerings and house structure, including household gods such as the door, hearth, rooftop, and window gods, who are polluted because of their dependence on humans. Doing so enabled him to transform each household and then ultimately the whole village into a perfect community characterizing the heaven of god, without which Odé Gungyal will not descend. They were verbally cleansed by burning *poiker* and incense accompanied by fumigation with varied divine plants (*lhashing*) such as the smoke of precious leaves of *balu salu*, divine tree *shungpo shing*, *mani rudra*, and *khempashing*. The final verbal purification of the house was with nine types of sacred trees (*shingna gu*) and nine types of sacred waters (*chunagu*).

Bonpo Pemala argued that while it is only difficult for the junior Bonpos to invoke the local deity Rematsen, the most important part of *rup* was to invite god Odé Gungyal via Tibet. That would be impossible if the village

had not been appropriately cleansed and the offerings not purified by a senior Bonpo. The Bonpo must have a good depth of knowledge to be able to invite the god to descend, riding on the *namkaling* flowers and popped rice in a golden cauldron (*zangchu*). Along with god (*lha*) Odé Gungyal, father (*yab*) Tonpa Shenrab was invoked, primarily to actualize the blessings of all other local deities under his command. However, unlike Tonpa Shenrab, who was invoked as an ancestral Bon father in *rup*, Odé Gungyal was presented with the characteristics of the primordial Bon god who, according to the Bonpo's invocation, had created the world and life. The Bonpo's opening praise demonstrates the centrality of Bon rites to the nobilities of Zhemgang:

> You are the exalted one who created the sky
> You are the victorious one who created the land
> You are the owner of all beings
> We have neither neglected gods nor glorified their retinues
> You god Odé Gungyal, who dwells in the heaven above thirteen realms (*namrimpa chusum*)
> The bird year is coming to an end and the year of dog is fast approaching
> In this threshold, we reaffirm our loyalty to you and seek your continued blessings
> You have been worshiped by our ancestors since time immemorial
> Dagpai *ponpo* was assigned *rup*
> Buli *ponpo* was assigned *shu*
> Shingkhar *dung* was assigned *karipu*
> Nyakhar *dung* and Goleng *dung* were assigned *rup*
> Tagma *dung* was assigned *mistim*
> And finally, Bjoka and Ngangla *koche* were assigned *gadang*.

These Bon rituals were assigned somewhat as a family ritual to a specific nobility whose descendants are still found in the region. Contrary to *rup*, which was mentioned in relation to the Goleng *dung* nobility, the Shoblengpa Bonpo reiterated Bon rituals in relation to particular villages rather than the noble families. This is so because Shobleng has no legitimate nobility, although the main Khraipa House from where the *rup* rite begins claims a connection to *dung* nobility.

Next was the rite of propitiation of the *nawen* spirit being.[3] The Shobleng Bonpo invoked *nawen* immediately after the descent of god Odé, seeking the

blessings of skills and marksmanship on hunters and their weapons. This was followed by the propitiation of four lineage local deities, nonlineage deities, and spirit beings and invocation of their respective blessings in the form of bumper harvest and healthy family. The incantation of the Shobleng Bonpo was highly evocative of ancient Bon practice and in agreement with the explanation by Bonpo Pemala below.

> Divine (*lha*) Odé Gungyal
> Father (*yab*) Tonpa Shenrab
> Earlier, the ritual was not ahead of time
> Today, the ritual is not behind time
> Our ancestors worshiped and extolled your blessings
> Like them, we their humble progenies continue their exquisite legacies through these offerings
> And to further that bond is to make offerings in the right place and at the right time
> You the exalted beings must feast on them and must return again next year
> We pray that you never turn your back on our posterity
> Please bring along the king and queen of life (*tsé yi* or *lo yi gyalpo* and *gyalmo*)
> Our family and children must live a full year and full life
> Please grant us good health and long life
> Bird *koktikomo*[4] from India has arrived
> Now it is time to sow the seeds
> Please grant us wealth and the seed of economic prosperity.

Both Golengpa and Shoblengpa Bonpos informed me that *rup* is oriented toward good harvests, long life, and timely rainfall, all of which were sought by Bonpos by making various offerings on behalf of the family. Varieties of foods, namely buckwheat noodles (*puta*), popped rice (*chan*), rice, fermented rice wine (*changkoi*), sliced ginger, Sichuan pepper, wet fish, garlic, halved cheese, butter, beef grains of beefsteak plant (*nam*), and so on, constituted the *tsog* offerings. These offerings must be prepared only by men, and pregnant women must stay away from them. If the offerings are prepared by a woman, she risks having a child with birth defects. Similarly, if the leftover food and alcohol are offered to the gods or the presiding Bonpo gets drunk before the end of *rup*, the annual harvest will be poor, and so will be his own health. The offering of *tsog* along with a butter lamp at its center

was arranged on the banana leaves that were evenly spread on a large cane winnower. Between each offering, the fermented alcohol (*changkoi*) in decorative bamboo cups were placed ritually. In Shobleng, some houses had started offering in metal cups, although Golengpas still made the offerings in bamboo cups. Alongside the offerings, farming tools and weapons were laid out on the floor for blessings.

One of the integral parts of the *dham dham* rite is the divination by the Bonpo where the success, fortune, and health of the family members in the coming year are predicted. The modality and interpretation of the *rup* divination is straightforward, as the Bonpo employs only a strip of banana leaf and tosses it into the air. If the leaf faces outward, it is a sign of auspiciousness, and if it lands facing the floor, it is inauspicious. The Bonpo and the villagers maintained that death or economic instability will occur in the family if the divination is inauspicious. However, the Bonpo did not explain how to remedy this outcome when I was present in 2018. This divination was commissioned in each house and for each household member, during which there was an incredible amount of excitement because the villagers believe that it is the key divination for the coming year.

Once Odé Gungyal along with the family of the gods of seeds and local deities were invoked and well-propitiated, the Bonpo began the sealing rite (*dham dham*). With the help of their gods and local deities, the mouths of harmful pests and wild animals who are otherwise detrimental to growing crops were sealed by tying them with the strips of banana leaves. Furthermore, the mouths of different types of diseases and misfortune-causing evil spirits that are lurking were also sealed employing the same procedure. The Bonpo acted as a medium between the gods and the villagers by delivering the people's concerns and plights while at the same time requesting the gods bless and protect them on behalf of the community. As corroborated by Bonpo Pemala of Goleng, the mouths of the following animals and illnesses were sealed during the 2018 Shobleng *rup*:

We are sealing the minor illness and seasonal flu (*nerig chungwa*)
We are sealing all types of major diseases (*nerig chewa*)
We are sealing the malicious gossip of humans (*mikha*), the gossip of black magicians (*phurkha*), the malicious gossip of enemies (*drakha*), and the gossip of ordinary humans (*kokha*)
We are sealing the *shondre* and *mamo* spirit beings
We are sealing the mouths of various birds (*serbja*, *ribja*, and *shebbja*)

We are sealing the mouths of uncle bears (*aku wäm*)
We are sealing the mouths of tinkly porcupines (*üsai sile*)
We are sealing the mouths of white-chest bears (*wäm brangkhar*)
We are sealing the mouths of wrinkled deer (*khasha nyermig*)
We are sealing the mouths of red gorals (*basha gum-mar*)
We are sealing the mouths of white-bellied boars (*phag lokar*)
We are sealing the mouths of branched samber deer (*shawa ragpa*)
We are sealing the mouths of red-eyed deer (*khasha migmar*)
We are sealing the mouths of brother monkeys (*acho pra*)
We are sealing the mouths of long-tailed rats (*nyipai jukreng*)
We are sealing the mouths of insects that live underground
We are sealing the mouths of birds that fly in the sky
We are sealing the mouths of those insects that lay eggs
We are sealing the mouths of those harmful animals that give birth.

The multiplicity of diseases, various sicknesses caused by supernatural agents, and the mouths of insects, pests, and wild animals were all sealed by the Bonpo. The villagers believe that the animals listed have some degree of strength such that these animals must never be called by their ordinary names.[5] The Bonpo, however, did not seal the *yang* of crops, livestock, and long life, but instead supplicated the god Odé Gungyal and local deities to bless them with a healthy family and the powers for economic prosperity and long life. I have translated the Bonpo's requests to the god and local deities not to seal the essential elements of life:

But we will not seal the nine types of grains (*duna gu*)
We will not seal the life (*tsé*) and life force (*sok*) of the people
Nor we will seal the *yang* power of cattle, wealth, and economy
We are not going to seal the heavens above
We are not going to seal the middle world of *tsen* (*bar tsen*) and humans
We are not going to seal the subterrestrial world below (*wok lu*)
We are not going to seal the *yang* of domestic animals
Let us be free from disease and live a happy and prosperous life
It is time we sowed the field with crops
It is time we paid land charges to the original owners (*nepo*)
So please grant us bountiful harvest and timely rainfall throughout this new year
For this, we pray to you, god Odé Gungyal.

The final part of the *dham dham* rite was to reseal the mouths of animals and misfortune- and sickness-causing agents by walking to other rooms, particularly to the kitchen, where alcohol and residual *tsog* offerings on banana leaves were ingested by the Bonpo and other members of the community. They subsequently yelled, "Seal it, seal it!" (*dham dham*) in unison before quickly returning the banana leaves, which act as the sealant of negativities, to the Bonpo. Although the fangs of tiger, leopard, pig, monkey, porcupine, and other wild animals were traditionally buried along with the banana leaves to make the sealing rite more effective, it was only the leaves that were buried under the doorstep during my fieldwork. Stomping the buried leaves and installing a flat stone on the spot marked the end of the *dham dham* rite, which, as previously indicated, was organized for each household and lasted until dawn.

As confirmed by Bonpo Pemala, following the propitiation at the Dung House, the *dham dham* rite was conducted at the Kudrung, Pirpön, and Mamai Houses. The offerings at the four main houses, particularly at the Dung House, should be most elaborate, with the Bonpo spending substantial time on the propitiation of gods and local deities, seeking their blessings, and most importantly, sealing the mouths of harmful agents. It is important for the Bonpo to execute the ritual with great care and precision, as these four main houses represent the whole community. The elaborateness, however, decreases according to their former feudal power, so much so that the *dham dham* rite at the rest of the households was conducted with no specified time or particular order after the completion of the rites at the four main Houses. As in Goleng, there was no hierarchy among Shobleng households once the *dham dham* rite at Khraipa House was complete.

The efficacy of the sealing rite is explained by the villagers' harmony with the Bonpo's rules. Otherwise speaking, the mouths of wild animals and disease-causing insects can metaphorically be sealed only if the community is sealed from the outside world through a strong display of social solidarity.[6] In the language of the *rup* rite, outsiders are a potential threat who by passing through their village break the "seal" of the *dham dham* rite and let diseases, misfortunes, and wild animals loose in the village. The number of bamboo cups depended on the lineages and the standing each house and household held. Both in Goleng and in Shobleng, the bamboo cups had to correspond to the number of *tsog* offerings on the banana leaves. The Goleng *dung* family had the highest number of offerings, with thirteen bamboo cups of fermented rice alcohol (*changkoi*) and thirteen leaves of various offerings,

although they somehow did not offer buckwheat noodles (*puta*) or dried fish in 2017. In addition, they made offerings of three additional *tsog* on Chinese-made plates, one of which was offered at the temple the following day, while the other two were shared among other households as part of *mitsim tsog*, which was sprinkled over each house on the first day. The three other houses had only nine bamboo cups, while the rest of the Golengpa households had between four and seven.

In Shobleng, the highest count was that of the main Khraipa House, with twenty-seven *tsog*, although it had only nine bamboo cups of *changkoi* offerings. Furthermore, the Khraipa householder also made three small offerings to the *nawen* spirit at the center of the offering table, reflecting her power over other households who had fewer offerings. While the number of *tsog* must be proportional to the number of bamboo cups, the Khraipa House had far less bamboo cups compared to the Goleng *dung*, indicating the lack of former nobility. All in all, these offerings reveal the power structure and the ways people derive authority from rituals in relation to former nobility in shaping the community's worldview.

The Rites of the First, Second, and Third Days of *Rup*

The first day of *rup* is known as *dham lam*, which literally means the formality (*lam*) of sealing or closing (*dham*) the mouths of wild animals, birds, disease-causing insects, and misfortune-causing agents that harm humans and the productivity of their crops. The ritual rules were strictly observed by the community members because acting according to them maximizes the efficacy of the *dham dham* rite. Eating meat, working in the field, conducting Buddhist rituals, and exchanging materialities and harsh words were prohibited during the entire *rup*. The villagers were not allowed to give even a drop of water to outsiders, nor can they say any word that is filled with hatred and jealousy. Outsiders traveling via Goleng or Shobleng must remain in the village until the *rup* is over. For example, Bonpo Pemala had stopped a high-ranking Buddhist lama, just as other powerful officials had been stopped by the previous Bonpos. According to the villagers, letting outsiders pass through the village signifies two dangers: first, the outsiders could affect the insiders' volatile *yang* power of economic prosperity and long life, and second, the sealing rite becomes impotent when the fabric of social cohesiveness is weakened.

The *phorgola* ritual was the highlight of the *dham lam* rite. *Phorgola* is a male forest gnome-like being who with his magical stick is believed to be able to turn into different forms of animals and humans. Like the female forest gnome (*mirgola*), *phorgola* are generally mischievous when their abodes in the forest are disturbed. Hence, the villagers maintain a proper decorum while foraging in the forest for provisions or herding their domestic animals. *Phorgola* can harm people by making them deaf or dumb, but they can also gift them with precious jewels as evidenced by some living victims of such occurrences in some parts of central Bhutan. During the *phorgola* ritual, an elaborate offering was made on an altar in an open space to divinities who were neither from Tibet nor from India, but rather local deities. The main deity of this ritual was Rematsen, although many other local deities, including *phorgola* beings, were equally propitiated.

According to Bonpo Pemala, Rematsen, along with three important lineage deities and other nonlineage beings, are invited based on the supernatural hierarchy. Rematsen, also considered the chief local deity of Shobleng, was invoked by the Shobleng Bonpo along with some local deities of Goleng and their own host of lesser local deities and spirit beings. A constituent element of *rup* known as *mitsimla tsog* was also made on this day to appease *gyalpo*, *shindre*, and *sondre* spirts. Although it seems that *phorgola* beings have relatively less role in sealing the mouths of the already suppressed animals and misfortune- and disease-causing agents, they were propitiated at least three times a year primarily to complement the economic aspects of the annual *rup* rite. Once such *phorgola* ritual was performed during the propitiatory ritual of *tsen* and *düd* (see Chapter 8) in which the local deities are directed to monitor and defend the crops from ever-noxious beings.

The second and third days of *rup* are characterized by an extended formality of the sealing rite by the whole community, including the travelers and visitors. It is oriented toward realizing the curtailment of the economic and social crisis for the coming year. The second day is simply known as *mang lam*, which is the day of formality (*lam*) among the populace (*mang*). It was more demanding than *dham lam* because, as the name suggests, the rules of the rite must be observed by people from all walks of life—that is, whether they are young or old, man or woman, insider or outsider. Hence in case of emergency, an outsider must leave some cash or trivial paraphernalia such as a safety pin in lieu of attending *rup*. The villagers hold that doing this is the only way to ensure that their blessings are not leaked and exhausted.

The final day of *rup* is known as *sön lam*, which means the formality (*lam*) of

sowing the first seeds (*sön*) for the coming season. In Goleng, the Bonpo and the main *dung* householder sow paddy seeds in the *dung*'s farm, followed by *boleng lam*, which is a formality (*lam*) of private or personal crops (*boleng*). The Bonpo and the main *khraipa* householder of Shobleng indeed sowed the paddy seeds in the latter's farm. The restrictions were relaxed by midday with a drinking party (*changkor*) and archery matches, both of which serve as avenues for celebrating the successful *rup*.

All the *rup* days entailed a divination by the Bonpo, making each rite all the more significant. On the *dham lam* day, a distinctive divination employing buckwheat paste (*karjud*) was performed to predict the abundancy of crops. The Shobleng Bonpo did so by splashing *karjud* on the main beam of the house, oven, door, altar, and walls. As the paste gradually congealed into disparate shapes resembling crops, the Bonpo made predictions solely relying on these shapes. If it formed the contour of a paddy grain or its panicle (*gang*), a bountiful paddy harvest was predicted for the household. If the paste appeared like the shape of an ear of corn, a cornucopia of maize was heralded for the coming year. As seen on the walls of houses of Golengpas and Shoblengpas, the dried paste remain on the walls throughout the year, reminding the occupants of the god's forecast until they receive a new divination.

After this divination, a ritual ensued in which the faces and the bodies of villagers were suffused with the same paste. Interestingly, women were the main actors who spearheaded this ritual activity. While they anointed the people of all ages, they showed no mercy if the fake *garpa*, other males, and outsiders attempted to dodge *karjud*. This anointment entailed forceful compliance and often led to a violent game between the painter and the painted. In Shobleng, in fact, it turned into a jape when the males hopped into the battlefield. Both Bonpo Pemala and the presiding Shobleng Bonpo maintained that anointing themselves with the pure paste as part of the ritual unction on such a holy event guarantees shielding from diseases and misfortunes and retaining *yang* powers.

The ritual rope fight between men and women was another form of practical divination for their farming works on the *mang lam* day. The ratio of 1:2 was maintained throughout the ritual fight in that for every five men, there were ten women on the other side of the rope. The women winning translates to bounteous paddy production, which is coveted by one and all, and if the men win instead, it indicates that they will have an abundant dough of buckwheat (*chotan*), which nobody likes. However, whether it was because of

their love for rice or not, the Shoblengpa men had never managed to win. Despite intense effervescence, these aggressive games were carried out in the most peaceful way, exuding the true testimony of their faith in *rup*, and the blessings it brings.

Rup and Its Future

Rup is all about food, wine, and revelry, and expresses social collectivity. It is observed during the off-farming season—that is, before the start of a new lunar year—in which Golengpas and Shoblengpas halt their farming and daily chores by hanging up their agricultural tools to gather together for a social purpose. It is quite impossible for the gods and people to turn their backs on each other given that the gods and local deities were invoked by situating people's requests within the seasonal farm work, which makes the need of their offerings and blessings even more realistic. The fact that god Odé Gungyal is propitiated only once in a year underpins the villager's interest in *rup*, which embodies the important blessings.

It is only during the *rup* that people's daily works and Buddhist rituals are embargoed for three full days. As the single most important Bon rite, *rup* perpetuates Bon practices by exciting the community members to unify themselves and observe the common ritual, as doing so confers great blessings. The sounds arising from Buddhist rituals, chores, and farming works can by no means scare away the gods, but they inhibit villagers from transforming their village into an ideal *rup* world. While the forms of annual Bon rites vary, Odé Gungyal is a universal god of the collective annual rites that are performed at this time of the year around the Zhemgang region. For instance, Odé Gungyal is invoked as the chief god during Wamleng *kharphud*[7] (pronounced locally as "Odé Gongjan") and *kharphud* ritual of eastern Bhutan,[8] although the god Odé Gungyal (pronounced locally as "Wadan Gungdan") in the latter was mistakenly identified as Lord Brahma of Hinduism.

Yet Lopön Pema, the chief lay Buddhist *chöpa* of Goleng, has begun to document the Bonpo's *rup* incantation following the precedence set by Talipas[9] for their annual *shu* rite. The text is, however, watered down and lacks important elements of *rup*, such as inviting the primary Bon gods, although conducting *rup* in a syncretic fashion will certainly re-enliven Bon beliefs rather than eliminate them. There are two parties with contrasting views in

relation to the future of *rup*. The first group comprises *goshé nyenshé* persons along with the chief lay Buddhist *chöpa* and others part-time *chöpas* who want the *rup* Bonpo replaced by the lay *chöpa*. The other group is constituted by government employees, businessmen, and youths with a plan that is the antithesis of the former's wishes. Since the official village Bonpo is only exempted from the labor corvée, this latter group is now planning to recompense him so as to encourage this part-time profession. The national television department was invited by them to document *rup* in 2015, realizing the need to create awareness of their culture. By rerecording, telecasting it to the nation, and remunerating the official Bonpo, they are positive that the new Bonpos will be encouraged to continue the tradition of *rup*.

Lopön Pema's antagonism toward Bonpos definitely played a role in Goleng's dry 2018 *rup*, although some villagers argue that the Bonpo's children want him to stop presiding over it. A large group of youth awaiting the arrival of the presiding Bonpo on the eve of the 2018 *rup*, however, suggests the continuation of *rup*. Some of them came all the way from other districts while others came from lower Goleng to attend the *dham dham* rite. These youths were thrown into commotion when there was no sign of the Bonpo Pemala, yet they waited beyond midnight by the bonfire for the senior Golengpas to initiate the *dham dham* rite. To make things worse, the village headman was nowhere to be seen because he simply left the matter in the hands of the people, while they expected him to organize things. The disappointed youths insisted on seeing the village headman in the middle of the night to seek an explanation over his nonobservance of this annual Bon rite.

In early 2019, I communicated with one of my informants to ascertain whether Golengpas will observe their *rup* or not. She made the following comments:

> We are definitely going to observe *rup* this time. We will organize it ourselves and not leave it in the hands of the village headman or government employees. It is time that we the villagers took on the sole responsibility for our culture. Last year, many fell ill, and most of our crops were infested with insects. So the yield was very poor. Many Golengpa farmers are attributing it to the nonobservance of *rup*. We are going to request Bonpo Pemala preside over *rup*.

For Golengpas and Shoblengpas, the blessings of *rup* are veritable and often individualized with a bountiful harvest, economic prosperity, and overall

well-being of the community. However, the rarity of these aspects of life coupled with nonperformance of *rup* deeply worried Golengpas both physically and psychologically. Hence, they had to come together and address the issue through *rup*. As in the 2018 *rup*, the village headman was out of the frame when Bonpo Pemala was, according to Tsultrim Wangmo, invited by a group of villagers who personally urged him to preside over *rup*. He consented to stay in Goleng after the harvest season and a large-scale *rup* was observed with grandeur from 15 to 18 January 2019. The offerings of dried fish, *puta*, and an elaborate *tsog* of nine types of foods were made. Everyone observed the entire ritual as per tradition, and Bonpo Pemala, for the first time, also received Nu. 3,000 ($50) as honorarium from a few government employees, though the continuity of remunerating the Bonpo remains uncertain.

This ritual event indicates that whether Bonpos are prohibited from practicing their rituals by the state and village elite or not, they must act as a go-between by connecting the people with their Bon gods and deities who are central to community's life, fertility, and economy. This is mainly due to the fact that the Buddhist rituals are more expensive than Bon curing practices, and that the lay Buddhists of Goleng do not have parallel remedial rites oriented toward addressing all the sicknesses believed to be caused by the local supernatural beings. Golengpas believe that without god Odé Gungyal's help, their field will be a barren land inhabited by ailing people plagued with misfortunes and short lives. Because of their links to god Odé Gungyal, the *dung* nobilities are central to the success of *rup* as much as the *rup* rite is to the perpetuity of *dung* nobilities themselves. The *dung* nobilities receive a muted reverence in terms of ritual preference and ceremonial roles for at least three days a year. For example, the *dham dham* rite, and for that matter *rup*, began at the Dung House in Goleng and at the main Khraipa House in Shobleng. The Goleng *dung* householder was entitled to other preferences, such as making the *tsog* offering at the temple on behalf of Golengpa villagers, sowing the first seed for the year, and distributing a modicum of her offerings to rest of the households as *mitshimla tsog*. Furthermore, it was only the *dung* nobility that does not make offerings to peripheral local deities such as *phorgola* beings during the *phorgola* rite.

The *rup* rite can be seen as the primary arena within which the diminishing powers of the nobility and the other lesser secular titles are re-expressed by re-enacting the social hierarchies and its power relations that were once so important to Golengpas' social organization. But this Bon rite is simply not

just important to the *dung* nobility; it has also become central to Golengpas given that the *dung* nobilities during the *rup rite* are extolled through the agency of the god Odé Gungyal. While the Bon rituals are characteristic of shamanistic-animistic practices, *rup* is typical of ancestral worship, perpetuating the nobility's lineage not only by giving them religious roles and preference, but by invoking god Odé Gungyal who, as shown already, has a close association with the nobilities themselves. This communal ritual thus provides a sense of community history and is deeply associated with Gelongpa identity and the local lineage system, which ascribe status to the local nobility. In other words, it relates to the social production of key hereditary groups as well as the village as a collectivity.

It goes without saying that the *rup* rite was skipped due to the arbitrary decision by the district court that lacked prescribed rules for the selection of the future official Bonpo, and the chief lay Buddhist's opposition to the de facto official Bonpo appointed by the villagers. Despite writing the Buddhist version of text for the *rup* rite and the identification of a lay *chöpa* who comes from a Bonpo family, Golengpa villagers organized the 2019 *rup* ritual on their own and remunerated the Bonpo for the first time. This can be attributed to the importance of *rup* to the *dung* nobility, and the centrality of the *dung*'s god Odé Gungyal, and for that matter the *dung* family, to Golengpas' identity, which in turn continues to ensure the relevancy of Bon beliefs in Goleng village. In this sense, the Bon beliefs are sustained by the persistence of the nobility in whose lineage everybody is interested, given the prevalence of the remnants of highly stratified social structure.

7
Phallic Rituals and Pernicious Gossip

An enormous concern for the people in the village is the fear of pernicious gossip. The omnipresent gossip can bring misfortune, ruin the physical body, disrupt fertility, destabilize family and economy, and ultimately exhaust the five life elements. People believe that the human world naturally harbors hostile influences that cause different types of misfortune, and illness-causing gossip is just one of them. One of the ways to deal with it is Bon rituals that emphasize fertility and draw on phallic symbolism. This chapter examines two phallic rituals, that is, Bon and Buddhist, which are centered on protection, fertility, and reproduction. It focuses on the significance of phallus to the villagers and investigate how the phallic objects, in the context of the antigossip ritual, prevent misfortune due to pernicious gossip that is rife in their sociality. It then looks into an annual Buddhist *chodpa* festival in which the phallic symbol is incorporated to show how and in what ways the Bon beliefs are perpetuated by lay Buddhist *chöpas*. The chapter concludes by reflecting on the phallic symbols employed in this festival, which the villagers consider an important component of the annual Buddhist festival.

Phallic Symbols

Phallic symbols generally represented in two different forms—images and objects—characterize Bhutan's religious, cultural, and social landscapes. The former are popular in western Bhutan, where the images are painted on walls and the main door, although some people hang phallic implements on the corners of their houses. The latter practice is widespread in central and eastern Bhutan, where the phallic implements are hung on the cardinal corners of houses and sometimes more prominently above doors. One can also see wooden phalluses planted near houses, paths, on cultivated farmland, and hung on the necks of treasured calves. The phallic implements are held by the masked elder (*gadpo*) and festival jesters (*atsara*) during the major Buddhist festivals and are known by a common name—*wangchen* or

wangchen chenpo. In all cases, people believe that they will bring blessings of fertility and protect them from hostile influences, among which gossip (*mikha*) is the most significant.

Mikha literally means people's (*mi*) gossip (*kha*). It is a gendered phenomenon, with the vast majority of gossip believed to be by women. Some women are even feared, given that gossip can become spiritualized and turn malicious. Regardless of one's faith, people deem *mikha* malicious, as it is believed to be caused by the evil intent of envious persons. While scholars (e.g., Kapstein 2006) have used the term "malicious gossip" to refer to *mikha*, I call *mikha* "pernicious gossip" in this book. This is primarily because there are different types of *mikha*, not all of which are inherently malicious. *Mikha* includes benevolent gossip (*jamkha*) by envious persons at the most rudimentary level, although it can become malign over time. Some other well-known forms of gossip are adversarial gossip (*drakha*) caused by one's enemies, necromantic gossip (*phurkha*) by black magicians, wonted gossip (*kokha*) by gossipmongers, and lecherous gossip (*sokha*) by sexual predators. These forms of gossip can be guarded against by phallic symbols, without which they can metamorphize into a ruinous curse (*kharam*)—which is far more dangerous than *mikha*.

The extensive phallic symbolism in rite, in some of which Buddhists are involved, is evidence of the persistence of Bon because the rites are un-Buddhist. Paradoxically, the presence of these phallic symbols may raise suspicions that people are already suffering from pernicious gossip. The phallic symbols are not found in the mainstream Buddhist centers, nor do they have a place in philosophical Buddhism. Apart from the Bon rites, the rituals that involve phallic symbolism are prevalent only in annual Buddhist festivals that are not immediately oriented toward attaining enlightenment, but rather concerned with themes that are important to the laity and the general populace, such as commemoration of the victory of good over evil forces. These annual Buddhist rituals, however, do not have a specific rite devoted to the phallic ritual cakes per se, although they are set down on the same altar where a great number of ritual cakes depicting Buddhist deities are placed.

People believe that phallic paintings and objects can repel pernicious gossip, including evil forces and bring fertility to the family. The belief is widespread that phallic symbols in Bhutan are the creation of Drukpa Kunley (1455–1529) of the Drukpa Kagyu school, who is believed to have subjugated a medley of autochthonous evil beings in western Bhutan by practicing an unorthodox approach. While the people in western Bhutan saw the origin of

their rampant phallic artworks on walls, often painted red, as Kunley's creation, most parts of central and eastern Bhutan were never visited by him. Thus, Drukpa Kunley seems to have merely revitalized the role of the phallus in western Bhutan without modifying the underlying function of the primordial phallic ritual that is still extant in central and eastern Bhutan. This Bon ritual, in which a wooden phallus plays a primary role, is clear evidence that the beliefs are ancient, contradicting the Buddhist narratives that attribute the origin of phallic symbols to the Drukpa Lama.

Kharam, akin to *mikha*, literally means the gossip (*kha*) that ruins (*ram*) a person both emotionally and physically. It is a form of fully developed *mikha* that can enfeeble victims by affecting their five life elements, including their emotional and physical state. A body affected by *mikha* must also ritually be separated from it in order to restore its status to *mikha*-generating agents from *mikha*-hosting bodies. *Kharam* is an invisible force but is also apparently palpable. All sorts of unwholesome acts such as jealousy, envy, and hatred can trigger *mikha*. A beautiful or an ugly couple invites incremental *mikha*, and so does a new achievement or job promotion. Buddhist priests and political leaders are equally susceptible to falling sick from *mikha*. In addition to the person's physical and mental health, *mikha* also causes conflict, altercation, and infidelity between couples. The rattling of the main door, frequent mooing of cows, and incessant snorting of pigs without any obvious reason are all believed to be caused by *mikha*. Similar signs also apply to dogs and hens, among others. The death of a favorite cow or other domestic animal, and an unsuccessful undertaking, are generally ascribed to *mikha*. Because of this, many villagers do not share their important plans with their distant relatives, let alone the neighbors, as *mikha* operates to counter and disrupt them.

According to the official Bonpo Karma of Zhemgang proper who conducted the *kharam* ritual in 2017, incest between unidentified siblings at an unspecified time and place in the past, who were unaware of their sibling relationship, is the genesis of the present-day *mikha*. The *kharam* ritual is still relevant in the villages when other rituals, traditional medicine, and biomedicine fail to address their problems. The Buddhist equivalent of gossip ritual is known as *mikha dradog*, which is far more popular among the Bhutanese as a whole. It is used to expel *kharam*-causing *mikha*; in it *mikhas* are gathered and externalized in an effigy personifying a gossip girl (*mikhai bumo*) from China (Kapstein 2006). As is apparent, the gossip girl in this ritual is an unwelcomed outsider that the community must, at the end of the

ritual, cast in an easterly direction so as to drive *mikhas* back to their place of origin and to ensure their community is free from pernicious gossip. While villages like Langtang in northern Nepal believe that Buddhist *mikha* ritual was first performed while the Samye[1] monastery was being constructed in Tibet (see Lim 2008), the frequent attribution of Buddhist versions of *mikha* ritual to Padmasambhava, who made Buddhism Tibet's state religion in the eighth century, seems to be generally accepted.

The foregoing evidence suggests that the phallus is a guardian to fend off *mikha* that inflicts *kharam* on people, but a closer investigation of the phallic symbols reveals that instead of providing protection by refracting them, they attract *mikha* to the extent that upon sighting the phallus, people unconsciously generate either malicious or benevolent *mikhas*. In this manner the phallic symbols operate as implement that absorbs, occludes, and exhausts *kharam*-causing *mikha* and misfortunes associated with it. The fetishism of phallic symbols precludes the rudimentary and fully developed *mikha* of neighbors and passerby from striking the household members who dwell in or own the property. The phallus attracts and absorbs both the unconscious and conscious pernicious gossip directed either at the owners or residents of the property. It also stimulates the rudimentary gossip which is not yet primed to transform into an obnoxious *kharam*. In this sense, gossip, which is predominantly viewed as a female attribute, is also being controlled by these phallic symbols in a way that reflects some of the tensions within the matrilineal social organization.

The Antigossip Ritual

The antigossip or *kharam* ritual involves the construction of a pernicious gossip pole (*kharam shing*) bearing a phallus. It is very different from the Buddhist *mikha* ritual, as it has no ritual cakes (*torma*) and does not require ritual instruments such as cymbals, drums, or oboes. Nor does it demand conformity to the formalized ritual altar or setting. It is, however, governed by a unifying normative rule—that is, to sustain the significance of the number nine, which appears in the ritual with great frequency and significance. According to Bonpo Karma, the ritual can be performed only in the evening of the twenty-ninth day of a lunar month, but taking into account the severity of the patient, Bonpos can risk performing relatively protracted ritual on the eve of the twenty-ninth day so that through a long,

elapsing night, its early hours are effectively utilized. While the efficacy of the ritual and the safety of the patient and the presiding Bonpo are certain only if the *kharam* ritual is performed on the twenty-ninth day of the ninth lunar month, according to some Bonpos it can also be performed on the ninth and nineteenth day of each month. This commitment is taken very seriously.

Bonpo Karma claimed that the *kharam* ritual traditionally lasted a whole night—that is from late evening until the first crow of a cock, though the ritual I witnessed in 2017 was completed within three hours. It is probably true because if the Bonpo recounted the whole *kharam* legend concerning the incest between the siblings, it might well take the whole night. Bonpo Karma holds that this *kharam* ritual, which involved the construction of a phallic structure, is elaborate, all-encompassing, and as effective as Buddhists' *wangchuma* ritual. The *kharam* structure or simply the *kharam* pole is an exaggerated replica of the male organ with the female genitalia incorporated in the structure (see Figure 7.1). The phallic implement affixed to the *kharam* pole is popularly referred to by the name of *wangchen* or *wangchuck chenpo*,[2] which is also the term used by people to refer to Lord Shiva. Such references to Shiva are a strong indication that these penetrating phallic symbols of different sorts known under the same appellation are in fact connected with Shaivism.

The theme of nine-ness runs throughout the ritual. In the ritual I observed, nine types of differently colored thread, nine boards, nine branches of broom grass (*Thysanolaena*), nine types of sprigs, nine types of cereals (*duna gu*), nine twigs, and nine scoops of rice constituted the final *kharam* structure, which functioned as a unified whole although it was constructed out of many disparate constituents. With its base sharpened as much as its sharp-edged twin branches, the y-shaped structure that represents the *kharam* pole very much resembled a hunting spear. This horizontal pole operated as the substructure for the phallus, which was the heart of the *kharam* structure. The masculinity was individualized in the form of an erected phallus lodged securely outward-facing in the cleft formed between the cascade of nine boards and the knot from where the branch bifurcated to form the V-shaped tree stock. The phallus that was painted red was inserted in a reverse direction, with its head protruding from the surface of the structure. The natural V-shaped branches were connected by fastening nine miniature staves to express femininity. To complement the quality of femininity, both the flanks formed by the nine boards were painted red. The wooden daggers and

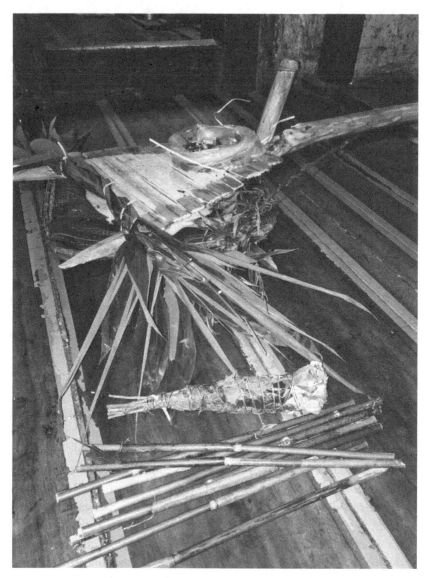

Figure 7.1 The phallic kharam structure

swords on the knot were also painted red, presumably as part of the Bonpo's weapons, although it was never used during the ritual.

A rooster, as in *kharam* ritual for cattle, was sacrificed until recently, and its blood served as the natural paint that animated the *kharam* structure. The cock's head was offered to appease negative forces, but the rest was eaten. In

order to obscure the unevenness between the cascading boards and the twin branches on which the phallus is bound, a bunch of broom grass flowers and leaves were attached on its periphery as though to supplement the elements of amorousness by replicating pubic hairs. The patient's gown (*chupa*) was placed on the winnower[3] forming the foundation of the ritual altar. On the *chupa*, nine scoops of rice were evenly spread to make the underlying *chupa* almost inconspicuous in the center. The large *kharam* structure that had been constructed by the Bonpo from a debarked trunk of *Rhus chinensis* (*brampa seng*), although it is actually the duty of the household members, was laid on the *chupa* facing the main door for the entire ritual period. Considering its basal position, the *chupa* reflects humans' inherent vulnerability and their constant subjection to *kharam*-causing *mikha*. Bonpo Karma maintained that it is crucial to ensure that the phallus and its sharpened base are always positioned facing toward the main door.

On the consummating genitals, an unclosed plastic bag was placed, though people used a black sack (*sangku*) prior to the proliferation of plastic bags. Various edibles and noncomestibles, including nine scoops of nine cereals, nine leaves of *sangja*, nine stems of *tsuth*, nine bulbs of garlic, nine pieces of onion, nine morsels of Sichuan pepper, nine tea leaves, nine handfuls of *lhazey* and *lungzey*,[4] nine pinches of salt, nine pinches of butter, nine pieces of meat, nine pieces of boiled eggs, and nine pieces of cakes or cookies were put in the bag. Close to the *kharam* structure, separate offerings were also made on the elevated but portable ritual table. A cup of rice, alcohol, and clean water (*chu sang*) were also arranged on the mini-table as in the shamanic ritual. Until the commencement of the ritual—after 9:00 p.m.—additional offerings were added to the point where the householder had offered a bit of everything he had. The abundance of offerings was accomplished primarily through the Bonpo's persistent observations as though some impersonal force was dictating to him. Finally, the Bonpo blew on the receptacle that was filled with corn kernels by chanting a formula that sounded to me like a modified Buddhist mantra. Later these kernels were used as dispelling agents (*dhok jor*) that tame the resistant *milkha* and those who generate them.

The offerings for *mikha* ought to be more elaborate than the offerings to the Bonpo's tutelary gods. Therefore, an exaggerated offering that constituted foods the patient had eaten in his lifetime and the drinks he had drunk in two different lifetimes are verbally offered. On the other hand, Sichuan pepper and garlic, which are commonly considered impure and polluting foods by Buddhists, are offered unobtrusively in this ritual emphasizing the

170 WORLD OF WORLDLY GODS

antitheticality between the two worldviews. Once the preparatory ritual was completed, crumpled cash was carefully cast among the offerings by the patient, which served as his gift for procuring or restoring (*nyen dhar*) his lost state. Supernatural beings, just like humans, expect gifts during their occult encounters and departures. With the ritual preliminaries completed, the *kharam* structure on the winnower was positioned between the window and inner door facing the main door. The Bonpo then employed nine stems/sticks of broom grass to beat the whetstone, one after another. This formula is known as *kharam poklo*, meaning "beating or destroying" (*pok*) the *kharam*. With rhythmic incantations, he initiated his mental journey to Tibet (*Bod*) in the north and India (*Gya*) in the south, and summoned *mikhas* from four directions. As he verbally assembled them, he beat the whetstone with the stick to crush the pernicious *mikha*.

Bonpo Karma sometimes called himself a yogi (*neljorpa*) and was unusually concerned about his own safety during the ritual because the *kharam* ritual poses a great danger to the celebrant's life. This was indicated by his frequent supplications to his tutelary gods to guide him throughout the ritual journey while at the same time being compassionate to his adversaries. To convince his gods about his purity, he stated that he was free from birth and death pollution, and begged for their blessings during the ritual because it involved an uncertain and perilous mental journey into the vastness of four different directions without entering a trance state. His gods were entreated in the following manner:

> O! Please bathe and purify us when it is time for ablution
> Our body polluted from birth (*kyedib*) and death pollution (*shidib*)
> Defiled by pollutions associated with marriage (*bagdib*) and widowhood (*yugdib*)
> Soiled by disease and uncleanliness
> Let us bathe and purify ourselves at this right moment!
> O thirteen Bon gods[5] (*dralha chusum*), please be vigilant
> O *gyalpo* spirits, please be alert
> O other tutelary gods and retinues, please do not be preoccupied with other thoughts
> O gods and deities who occupy the vastness of the firmament (*teng*), middle (*bär*), and underground (*wok*), please be attentive!
> I, the Bonpo who was born in the sky but brought up on earth, am destined to perform this ritual

It is not easy to be a celebrant of heaven above
It is not easy to be a celebrant of the *tsen* of the middle realm
It is not easy to be a celebrant of the *lu* down below
It is not easy to be a celebrant of *yul-lha* and *shidag*
Gods, do not be distracted (*thug mayeng*) while undertaking this long journey
Do not protract the ritual break either (*yoon mareng*)
Please do not mistake the right from left and the right or left.

While the number nine is significant in this ritual, according to Ekvall (1959), the symbolic number thirteen is also deeply embedded in Bon cosmology. Bonpo Karma's main tutelary gods consist of thirteen famous Bon gods along with the congeries of local deities and spirit beings. Before he began his long and perilous ritual journey, rice divination was mandatory to ensure the stability of the Bonpo's own emotional and psychological states rather than that of the patient. As previously mentioned, even numbers are always considered inauspicious, and repetition is the only method to remedy their appearance, while odd numbers are always valued as favorable. The god's firm protection of the Bonpo was ensured by five rice morsels. The divination was followed by a libation for his gods, and in return, auxiliary protections for his ritual enterprise were re-sought. As in the shamanic ritual, he then drank the offering of alcohol, which, of course, seems to ignite his innate force, which is central in undertaking the ritual journey.

With a cup of *ara*, the first stick was used to journey to the east—the land from where the sun and moon rise and the precious guar (*bamen*) are found aplenty. The whetstone underneath was struck with the stick rhythmically by the Bonpo as he verbally invoked *kharam*-causing *mikha*. The Bonpo not only prescribed ritual actions for the householder but also enacted his own roles. For instance, the householder was asked to open the main door, which is emblematic of the arrival of *mikha* from the east. The mustered *mikhas* were repeatedly pounded in an inexorably increased tempo with the stick until it became symbolically enervated. Such extirpation of *mikha*, and for that matter *kharam*, was individualized in the crumbled and contorted stick. Finally, the invisible *kharam* were symbolically hurled into the gaping plastic bag before the householder was ordered to close the door again so as to keep the amassed *mikha* from escaping to freedom.

Another cup of *ara* was gulped down as he reached out his hand for the second stick. But this time there was no libation for gods, though it served the

same function as in the first drink. Beating the whetstone even harder, he now pursued southward in India. The formula of pounding the *mikha* and locking and unlocking the door followed until the stick was worn out. Thereafter, with another cup of *ara*, he traveled to the west, which in the Bonpo's exegesis is the land of rakshasas[6] (*sinpo*). The same formula ensued. Finally, he traveled northward to Tibet for reasons similar to previous journeys by following the same strategy. Having gathered all the *kharam*-causing *mikhas* into the plastic bag, the prearranged offerings containing nine types of oblations were offered to the legions of *mikhas*, which are now radically incapacitated—lacking their powers. In this way, the *kharam*-causing *mikhas* that are lingering in the vast expanse of earth, including those that have already struck humans, and those that are likely to strike them in the future, are first assembled, then crushed, and finally laid to rest in the bag full of offerings.

Next, he verbally traversed the underworld, space, and other uncharted lands. The crushing of *kharam* with his fifth stick coincided with additional offerings, including the raw and boiled eggs, alcohol, and cereals. It was at this stage that a bunch of nine different sprigs was used to wipe off the *kharam*-causing *mikha* from the bodies of the patient and all the household members. Wiped over the body from head to toe, the bunch of sprigs removes *mikha* and *kharam* that are deep-seated in the patient's body and emotions. At the end of the all-embracing wipe, each person blew on the sprigs, exhaling their inner or mental *mikhas* that were in their rudimentary state. Hence, all the members, including the patient, now entered the liminal state because to permanently actualize the free *mikha* body, the Bonpo had to ascertain that the *mikha* had departed by tossing the sprigs at the main door. If the sprigs land with shoots or heads pointing in the direction of the main door, it indicates the successful exit of *mikha* from the patient, and for that matter from the house.[7] In this ritual, the sprigs pointed to the main door on the first throw, and the patient and household members took turns stepping on it, thereby enacting the annihilation of *mikha* from their bodies.

The sprigs were jettisoned into a plastic bag and the main door shut in quick succession. The bag that now held a multitude of disembodied, pernicious, *kharam*-causing *mikhas* was securely sealed and tied by attaching it permanently to the *kharam* structure. By the end of the ritual, the Bonpo was in a wrathful state because of the battle against the powerful and resistant *mikha*. Assisted by his own ritual incantations, which were occasionally punctured by modified Buddhist mantras, his eyes bulged, his voice rang out, he pounded his thighs and violently shook, and he flung corn kernels

(*dog jor*) hard at the door and over the *kharam* structure in the fight to subjugate the negative forces. Finally, using the last three sticks, he struck the whetstone, seeking wealth, prosperity, fertility, and long life that had been threatened by *kharam*. In contradistinction to the six sticks, the last three sticks were intact and treated with reverence. They were placed at the top of main door, assigning the door god to guard the house against sneaky *mikhas*. The ritual concluded with one more divination for the Bonpo's own well-being.

As attested by the Bonpo Karma's rhetorical ritual incantation, human beings are the primary source of *kharam*-causing *mikha*. During the sequence of ritual journeys, he repeatedly recounted the sources of *mikha*:

> From where did *mikha* originate in the first place?
> Long ago, *mikha* originated from the east, where the sun rises
> From where did *mikha* originate in the first place?
> Long ago, *mikha* originated from the mouth of respected and qualified monks (*tsendhen lama*)
> From where did *mikha* originate in the first place?
> Long ago, *mikha* originated from the mouths of powerful kings (*wangchen pönpo*)
> From where did *mikha* originate in the first place?
> Long ago, *mikha* emerged from the land of common people (*miser*)
> From where did *mikha* originate in the first place?
> Long ago, *mikha* emanated from the mouths of fathers (*yab*) and mothers (*yum*)
> From where did *mikha* originate in the first place?
> Long ago, *mikha* arose from the face of teenage boys (*na chung*)
> From where did *mikha* originate in the first place?
> Long ago, *mikha* originated from the face of tonic damsels (*menchung bumo*).

According to this chant, the hotbed of *mikha* is in the east, where the precious gaurs are found in large numbers, probably pointing to China, as in Buddhist *mikha* ritual (see Kapstein 2006). However, the ordinary gossip in this ritual is not always limited to the "gossip girl," or for that matter women, for it is also, in principle, caused by high lamas and powerful kings, essentially by all humans regardless of location, age, rank, and power. In other words, *mikhas* originate from the human body, which is also the only place where *mikhas* thrive. Yet the effects of gossip tend to vary according to the

sexes, although all *mikhas* need to be ritually disembodied from the source and from the host body in order to destroy them. This makes the antigossip ritual purely a household affair basically addressing the bad luck caused by the pernicious gossip of outsiders such as immediate neighbors, which may include one's own relatives.

During the ritual, *mikhas* caused by these different human agencies were materialized in varied offerings that were made for them. Among these offerings, which eventually became ritual detritus, was an egg that was securely placed on the *kharam* structure. It was quite distinct from the other offerings, which were either cooked or dried. This singular egg was, first, raw, and thus containing life. Furthermore, the raw egg was placed in the bag only after the completion of the gathering and crushing of the *mikha* from the four cardinal and intercardinal points. In contrast to the boiled eggs and other offerings, this egg was never cracked open, nor did it conform to the ritual rule of nine-ness but was treated with extra caution. Unlike the *chupa*, which represents the patient's "double," the egg acted not only as bait to attract *mikhas* but also as a deceptive offering to appease, and subsequently trap, *mikhas* through trickery. With this chicanery, the Bonpo was able to set the patient free by removing the patient's *chupa* that was beneath the *kharam* structure. This process was a scheme of freeing the patient and sealing the *kharam*-causing *mikha*.

At its successful conclusion, this ritual rids the household members of bad luck and misfortune and invokes the *yang* of fertility (*mige yang*), the *yang* of cattle (*norge yang*), and the *yang* of prosperity (*druyi yang*) for the benefit of the patient and the household members. *Yang* powers were invoked because they can seriously be depleted, especially while making offerings to supernatural beings and humans alike. As previously mentioned, *yang* can leave the house through the agencies of drinks, cash, and other types of offerings, all of which are crucial in accomplishing the ritual's efficacy. Hence, Bonpo Karma did not pause, but with another cup of *ara*, sought the blessings of long life and strength by soliciting the vase of long life (*tsé yi bumpa*) and the vase of power (*wang-ge bumpa*) from his tutelary gods.

In the Bonpo's words, the parents would be hereafter surrounded by an array of girls on their left and an array of boys on their right. Last but not least, the Bonpo, upon the command of the king of birds (*labja gongma*), crowed three times to mark a new day and the successful annihilation of *kharam*-causing *mikha* in a single night. To disinherit pernicious gossip, the *kharam* structure, along with the *mikhas* in the plastic bag, were removed

from the house without disassembling it. The *kharam* structure was erected at the crossroad with the phallus directed away from the house in the early morning. In this manner, the malignant *mikhas*, which are now believed to be crushed and annihilated, remain sealed and attached to the *kharam* structure until it falls into decay.

The Phallic Rituals of the Annual *Chodpa*

Throughout central Bhutan, there is an annual communal ritual known by the name of *chodpa*—a deformation of *chopa* (*mchod pa*)—which literally means offerings. It is now mainly a Buddhist festival and observed for three to four days, making offerings of the recent harvest to tutelary gods such as *dharmapalas* and local deities through a series of parallel events by the lay Buddhist *chöpas*, *gadpo*, and other laypeople. *Chodpa* is always performed in the village temple by the *chöpas*, though it incorporates visible elements of Bon practices. It is a collective ritual executed by a variety of ritual actors so as to re-establish the harmonious relationship between humans and nonhumans, and release social tensions and conflicts accumulated over the past year. While there are some variations in dates, it is generally celebrated between the tenth and sixteenth days in the winter and spring seasons.[8] Various Buddhist mask dances by the laity along with the ritual of Lama Norbu Gyamtso, both of which are attributed to Terton Pema Lingpa, are the main Buddhist ritual. However, there are some *chodpas* that have mask dances involving phallic objects that are not Buddhist. Goleng *chodpa* is one of them, reflecting the arrival of Buddhist influence after it originated.

Chodpa preceded *rup* and, in fact, seems to be an extended celebration of the original harvest ritual at the paddy fields that is no longer celebrated in Goleng. Each Golengpa household takes turns in the preassigned role of sponsor (*jinda*) for the calendrical *chodpa*. Sponsoring the ritual by contributing ten *brae* of the recently harvested rice for the purpose of making ritual cakes (*torma*) is the main responsibility of the benefactor. A gigantic main *torma* is prepared out of seven *brae*, while two other smaller ritual cakes are made from one *brae* of rice each. It is also obligatory for each household to contribute some cash, dairy products, vegetables, and a bundle of firewood in the presence of a storeman (*ngerpa*) who maintains records of the contribution. The main offering to *dharmapalas* and local deities is in the form of popped rice from the recent harvest. Unlike other contributions, the

collection of popped rice is undertaken at the four main houses, whose heads mix them in a collective bowl. The *chöpas* transport the bowl to the temple along with the statue of Zhabdrung in a musical procession, and after the ritual, these offerings become much-coveted *tsog*, for they individualize the blessings of their tutelary deities for the coming year. Hence, the *tsog* are distributed equally among the community members by the group of volunteers.

Prior to the ritual I observed, the *chöpas* prepared decorative butter (*karjan*) and ritual cakes (*torma*). The biggest *torma*, which took the central position, was known as guru (*lama*), and it was flanked by two smaller cakes that represent deities (*yidam*) and dakini (*kandro*). One of the important *tormas* among the multitude of smaller cakes was the phallic *torma*, which was referred to as *ogyaala*—the onomatopoeic crying sound of a baby. At the end of the ritual, it was the prerogative of the benefactor to take the main ritual *torma* along with the miniature phallic *torma*. The main *dung* householder played an important role in this ritual by pouring a libation on the altar immediately after the three main *tormas* were placed on the ritual table. A pitcher of alcohol is always brewed in her house specifically for this ritual, and it should be customarily offered by herself. The *chöpas* began with ritual chanting and elaborate ritual music alongside the seven women who periodically made the offerings of songs (*lugi chedpa*). This unique tempo, created by an amalgam of ritual chants, songs, and religious instruments, was interrupted by occasional sustenance in the form of tea, food, juice, and so on, throughout the entire period of the festival. While the three-day ritual is generally performed by *chöpas*, there is one interesting ritual known as *hoi-ya-hoi* that deserves closer scrutiny.

As stated earlier, Golengpas do not have mask dances, but a unique fertility rite known as *hoi-ya-hoi* ritual is conducted on the eve of the full moon night of the tenth lunar calendar. When I observed it, it was led by a senior *chöpa* and involved a bawdy battle between men and women. The villagers hold that the *hoi-ya-hoi* ritual, which runs almost for the whole night without break, was until recently led by a male elder (*gadpo*) who represents a syncretic character embodying both Buddhist and Bon beliefs. In recent times, the role of *gadpo*, which I shall discuss later in detail, has drastically declined in Goleng, and I did not see him perform during the annual *chodpa*. Golengpas attribute the fall of the *gadpo* to the lack of experts who have the knowledge (*shepa*) of the *gadpo* and his verbal ritual journey. Hence, a part-time *chöpa* seems to have replaced him by performing a different ritual without wearing a mask.

This ritual dance involved the chanting of the Buddha Amitayus[9] (*Tsepakmé*) mantra inside and outside the temple by both young and old. With clashing cymbals, the mantra *om ah hung ahyür jana tsedrum* was chanted by the *chöpa* three times, wiggling about at each chant. In the end, he quickly spun himself around, signaling the women dancers and other spectators to accompany him by dancing and shouting *hoi-ya-hoi* in unison. According to Lopön Pema, the *hoi-ya-hoi* ritual entails driving off negative forces, including pernicious gossip, as it began immediately after throwing out another cake for evil forces (*gektor*). This *gektor* is an anthropomorphized effigy that dispels obstructive evil forces by placating them as a sacrificial offering. Some of the ritual chants were meant to demarcate the borders between the obstructive spirits and humans, while others were meant to be the harbinger of successful expulsion.

The whole formula was repeated three times inside the temple before being performed outside the temple accompanied by the massive crowd of young and old. Although the ritual chant was purely a Buddhist mantra for long life, the villagers who circumambulated the temple along with the *chöpa* did not chant it. As soon as the *chöpa* completed one full mantra, the army of chanters wildly cried *hoi-ya-hoi* in unison instead. Interestingly, each vociferation was driven by a predatory intention of attacking the opposite sex, whereby some of them shuffled their feet, while others stampeded through the throng trying to attack the abdomen of other participants. Hence, the chanting of *hoi-ya-hoi* slowly turned into an explicit fight between the sexes. The throes of excitement were reflected in every face, dimly lit by the nearly full moon, as they see the brief recurring period of ritual as the opportune moment for engaging in virile activities.

Although sometimes it was difficult to identify the attackers, no one seemed to be really vexed with the assailants because lurking in the darkness to attack an easy target was the only payback they can imagine. This battle continued until the dawn, and according to the villagers, it sometimes led to sexual activities between both unmarried and married persons. Through such amorous behaviors, it reignites the seed of fertility that is fast declining among the old and not yet matured among the youth. At any rate, the community relaxed the social rules, at least for each fleeting period of the *hoi-ya-hoi* chant. While there was no direct or expressive physical touch between relatives, they repeatedly rubbed or hurt the backsides of both socially accepted nonrelatives and relatives in plain sight of their close relatives in the dark, which is otherwise prohibited.

The Buddhist Phallic Ritual Cake

In addition to the *hoi-ya-hoi* ritual, an awkward-looking *torma* in a shape of a phallus among the small Buddhist ritual cake has already been pointed out. This cake is easily identifiable by its stiff bearing with visible ejaculate in the form of butter. The phallus and its testicles were painted in red but had no specific ritual dedicated to it. However, since the Buddha Amitayus was invoked during the ritual, the *chöpas* maintain that the phallic *torma* and its fertility properties, which later operate as an independent source of blessings for fertility or creation, stemmed from the Buddhist long-life ritual (*tsé drup*). After accumulating the blessings for the entire ritual period, it was only on the final day that the phallic *torma* became a symbolic "neonate" fully primed to reincarnate as a child for an infertile couple.

The neonate individualized in the phallic cake was carried by one of the senior men in his pocket treating as though it were his own child. Hence, considering its onomatopoeic name, this cake was handled with extreme care as it was carried to the house of the infecund couple. The baby cry sounds "ogyaa ogyaa" were vocalized by the bearer until he entered their bedroom. Instead of handing over the "baby *torma*" to the couple, the bearer placed it on the couple's bed, which was prearranged by the couple themselves for the supernatural newborn. The couple then quickly jumped on the bed and slept for some period of time. This phallic cake does not typify a Buddhist *torma*, though it perfectly intermingled with rest of the ritual cakes in the sense that they were all installed on the ritual table, made from the same ingredients by the same persons, and intended for the same festival. This suggests that it was included in the Buddhist ritual in an attempt to incorporate the rituals that preexisted the arrival of Buddhism. Considering the raw and ribald nature of the *ogyaala torma* without specific ritual to buttress its significance, it seems certain that it was part of the pre-Buddhist ritual that was traditionally performed by the *gadpo* persona.

In addition to this phallic *torma*, the final phallic object that dispenses the blessings of fertility throughout the year on infertile Golengpas is a natural rock phallus. The rock phallus was extracted by Bonpo Chungla from the deep cliff of Chungkula-brag overlooking the downstream of Mangdechu River during his unsuccessful shamanic initiation. The senior villagers maintained that the relic, weighing over twenty-five kilograms, was singlehandedly transported by Chungla from the distant, rugged mountain without mortal help. The awestruck villagers installed it in the temple

cellar alongside the Buddhist protective deity, as they believed it to be the blessing of certain gods who were behind Bonpo Chungla's shamanic sickness. Bonpo Chungla, who was ninety-four years old in 2017, genealogically belongs to a family of shamans, and as a result, he is considered an appropriate vessel for hosting gods, and for that matter becoming a shaman. He fell sick several times in his formative years, but his shamanic training could not be completed. I asked him about his discovery of the large rock phallus, prompting him to tell me about his initiatory illness:

> When I was around twenty years old, I was possessed by Geser. One day I was suddenly repossessed when I was walking to the village crematorium. Since then I do not remember events clearly except that I never walked the human path, but, in a semiconscious experience, I flew from hill to hill, mountain to mountain, and high up to down below instead. I could swim upstream in the Mangdechu River and stand on my feet while jumping from the top of a tall pine tree or a cliff. I became so strong that even a group of strong men could not hold me down. However, I remember meeting a small boy, who was supposedly an orphan (*dhou busa*), inhabiting a small cave in the wilderness of a mountain cliff. At any rate, when I arrived at the clifftop, I extracted from the middle of the cliff the gigantic rock phallus, which I carried with absolutely no effort. Placing it on my shoulder, I veered sharply eastward and then turned northward before finally descending on the temple courtyard. It was only when I arrived at the courtyard of the temple that my feet touched the real ground.

According to senior Golengpas, the late *chöpa* Pema Tashi witnessed Bonpo Chungla's arrival along with his large object and attempted to carry it; however, to his surprise, he could not even budge it. Later, many other villagers tried to lift it, but none of them were really successful. Bonpo Chungla believes that he was possessed by Geser, and he considers the orphan to be the manifestation of Geser, who supernaturally assisted him in collecting the rock phallus. His power and dominance over other village shamans during his initiatory training were then attested during *pamo* Chozom's ritual, who, according to Bonpo Chungla, was possessed by lesser gods. Bonpo Chungla prided himself upon his power such that he intruded into a shamanic ritual being held by *pamo* Chozom and disrupted it by tossing her from the altar, with *pamo* landing a few meters away. While *pamo* Chozom did not revolt or dare to resist his bellicosity, she did not mute her prayers to the Bonpo

Chungla's gods. Bonpo Chungla claims that *pamo* Chozom pleaded with the possessing god Geser to cancel his candidature for shamanhood by vowing to worship the god herself. After this instance of blocking his shamanic selection (*trog lok*), he was never repossessed.

Since these events, the rock phallus has begun to embody the attributes of fertility for the Golengpas, although in recent times it has become increasingly associated with childbirth and protection of a child (see Chapter 8). Currently, Golengpas are concerned about the safety of their children and do not explicitly seek fertility blessings from it. In fact, many of them prevent unintended pregnancies by adopting family-planning techniques. However, that is not to say that the phallic *torma* of *chodpa* is not conveyed to the house of the ritual sponsor or the couple who wants to procreate. For instance, during the 2017 *chodpa*, the phallic ritual cake, along with the main *torma*, was taken to the main sponsor's house.

The Phallic Rituals by the *Gadpo*

As maintained by the senior villagers, the *hoi-ya-hoi* and *ogyaala* rituals conducted by *chöpa* employing Buddhist mantras must have been a part of the ritual conventionally performed by a comical personality known as the male elder (*gadpo*) who is also affectionately referred as a father (*apa*) *gadpo* in Zhemgang as a whole (cf. Aris 1976). The *gadpo*, who is often accompanied by a female elder (*ganmo*), usually wears a dark or brown mask bearing a funny countenance of jocularity with clear marks of deep wrinkles and gray mustaches signifying the age of the *gadpo* and the antiquity of the very ritual he performs. In contrast to ordinary people, the *gadpo* was shabbily clad in an ankle-length maroon *chupa* that further distinguished him from the other attendees at the ritual. The *gadpo* is invariably seen wielding a giant wooden phallus—sharing the same antiquity as the mask—which operates as his main *gada*[10] to navigate through the community's social problems and issues in relation to gossip.

It is apparent that because of his appearance and ritual paraphernalia, the *gadpo* evokes great sacred power, yet he is characterized by amity and the conviviality of familiality. While the *gadpo* appears too old to walk, often requiring a walking staff, he represents youth to the young, masculinity to the adult male, and fecundity to the female. He is a free-spirited figure characterized by levity and frivolity, diametrically opposed to religious and

nonreligious personages, young and old, sacred and profane, males and females, relatives and nonrelatives, and so on. Such heterodoxy is, however, not possible without his protean phallus that embodies the potency to breach the barrier that divides sacred from profane. As will be clear later, the *gadpo*'s potency to magically travel to the three realms[11] is driven by the phallus, which in turn transforms the former into a protean actor. So is the mercurial nature of the old *gadpo*, who becomes physically licentious and verbally obscene not just to a selected group of people but to all, including strangers. Currently, the masks of the *gadpo* and *ganmo* are securely preserved in the temple, but as mentioned already, Golengpas no longer perform the *gadpo* ritual. However, the *gadpo* ritual is held at the nearby village of Gomphu, which I witnessed in 2017 and helped me understand the significance of the phallic *torma* of the annual *chodpa*.

Since the formalized *gadpo* ritual was discontinued in Goleng some decades ago, I only observed the *hoi-ya-hoi* and *ogyaala* rituals, which assumes primacy over the *gadpo* ritual, on the fourteenth and fifteenth day of the tenth lunar calendar. On thirteenth and sixteenth of the same month, I journeyed to Gomphu village to observe a *gadpo* ritual that had continues down to the present day. Gomphu *chodpa* is a four-day Buddhist festival that replicates Phagla *chodpa* of Tamshing and other unique mask dances of Jampa monasteries in Bumthang. However, I shall only deal with an ambiguous *gadpo*, particularly two specific rituals. The first one was conducted on the evening of the thirteenth day, which is the eve of *chodpa*, while the other was performed in the morning of the sixteenth day, the final day of the festival. The Gomphu *gadpo* and his ritual slightly differ from his counterparts in lower Zhemgang, such as in Goshing and Ngangla, where the *gadpos* worship handheld phalluses as rediscovered treasures (*ter*) and personally bless the community as though they were holy relics. Furthermore, prior to the *chodpa*, the *gadpos* of lower Zhemgang enter a retreat (*tsam*) for a period of a month or so, as preparation for their forthcoming rituals.

A role of the *gadpo* is to entertain the devotees and ensure a well-organized festival, which is peculiar to central Bhutan. There are no *gadpos* in western Bhutan, and it is the mainstream chief clown (*atsara gongma*) who coordinates the local festivities in that area. Although the origin of the *atsara* figure is often attributed to Indian Buddhist masters, both *gadpo* and *atsara* wield large phalluses. Hence, their semblance and comportment make them ambiguous characters who are neither really Buddhist nor fully Bonpo. On the eve of *chodpa*, the first ritual actor was the *gadpo*, who functions as the

icebreaker for the subsequent rituals. This ritual is known as the "creation of land/world" (*sachak*) by *gadpo*; it accompanies the examination of mask dances (*chämjü*) by the head mask dancer (*chäm pön*). While the latter was rehearsed in an open courtyard, the *gadpo* ritual was performed inside the temple.

The *gadpo*, before showing up to the main hall, which was populated by people of all ages, went to sleep in the inner sanctum after sipping several cups of *ara*, making it necessary to implore him to wake up from his purported or perhaps real doze. After several prompts, he peeped through the curtain only to return to the sanctum, presuming that it was not yet time to create the "new" world. He did this multiple times, arousing the crowd's curiosity, and their patience paid off when he came out displaying his large wooden phalluses and bawdy behaviors. Upon entering the hall, he was welcomed by thundering clashes of cymbals and drums with which his deportment excellently synchronized. The first thing he did was bow to the main shrine by rubbing his entire body in a prone position before offering the phallus to the Buddhas and Bodhisattvas as a gift. Instead of walking, he slithered through the crowd occasionally placing the phallus on his head until he finally arrived right under the nose of the chief lay *chöpa*. Turning toward the array of lay Buddhists, he gifted another phallus hanging from his waist to the chief lay *chöpa*, who was sitting on an elevated seat facing the main shrine.

The *gadpo* first greeted the chief lay *chöpa* by asking if his life elements were ascending upward, and if his penis were descending downward. Shortly after that conversation, the *gadpo* began creating the "new and unique" world ex nihilo by invoking five Buddha families:

> Under the realm of Vajrasattava of the east, the new world is conceived
> Under the realm of Rathnasambhava of the south, the new world is conceived
> Under the realm of Amitabha of the west, the new world is conceived
> Under the realm of Amoghasiddhi of the north, the new world is conceived
> Under the realm of Vairochana of the center, the new world is conceived.

In Buddhism, the world spontaneously formed on its own. But in this ritual, a whole new world was created by the *gadpo* for humans who are still dwelling in the world he had created the previous year, suggesting the assimilation of beliefs. The newly restructured universe was created by first forming different but smaller worlds under the five different Buddhas of the five cardinal

points. Later these five smaller worlds were conflated in order to create the new unified whole. Once these disembodied worlds were unified into a single and stable universe, the old dwellers were symbolically transposed to the new world.

The *gadpo* then began his action-oriented and dialogical engagement, imbued with funny and obscene witticisms, with *chöpas* who posed him questions spanning a wide range of concerns such as his origin and reasons for visiting their village. During the dialogic exchange, both the *chöpas* and the *gadpo*, as attested in the verses below, viewed the *gadpo* persona and phallus as one and the same being, each component categorically indistinguishable and inseparable from the other, thus implying that the life force or vitality of the *gadpo* hinges on the appellation of phallus, which is individualized by the inanimate object. The *gadpo* described his genealogy in paradoxical verses, praising himself[12] and his long and arduous journey to the human world upon the *chöpa*'s inquiry into his origin and from whence he had come:

> When I (the penis) descended from the heaven (*tengchok lha*), an assembly of one hundred people offered me an incense of aromatic plants (*sang*), but I never saw a faint whiff of smoke.
> When I (the penis) descended from the summit of White Mountain (*Gangkar Tise*), an assembly of one hundred people organized a welcome reception, but I never received even a glass of water.
> When I (the penis) arrived in the land of humans (*miyül*), I was the owner (*dhagpo*) of one hundred maidens, but I never saw one when I went to bed.
> When I (the penis) departed the land of subterrestrial beings (*luyül*), I was the owner (*dhagpo*) of one hundred female gayals (*jatsamo*), but I never received a mouthful of buttermilk.
> In the past, I (the penis) served as the commander in chief (*mägpön*), and as a result, I have a deep wound on my head.
> In the past, I (the penis) served as the king (*pön*), and as a result, I wear the mark of a sceptral crown.

While the *gadpo*'s attributes are extremely fluid and complex, he was often an archetype of the supernatural characterized by the air of mystery and numinousness. As reflected in his paradoxical verses above, he related his origin to antiquity, and, like a shaman, he can ascend to heaven as well as

descend to the underworld. The *gadpo* explicitly mentioned that he, and for that matter the "penis," descended from the heaven above and traveled through the three realms, including the *lu* world, before arriving in the human world. He first descended from the upper realm of gods and witnessed one hundred people welcoming him with incense, but upon examination, the *gadpo* saw that there was no one, let alone the incense smoke. The *gadpo* then arrived at the top of magnificent White Mountain—referring to Mount Kailash—where he saw one hundred people preparing a welcome reception for him, but on approaching closer to the base, there was no one, let alone a celebration of his arrival. Then, as he arrived in the realm of humans, the *gadpo* was surrounded by one hundred beautiful girls, but upon further inspection, there was not a single woman when he went to bed. Finally, returning to the earth from the realm of *lu*, he saw himself as the owner of one hundred female gayals, but again after repeated scrutiny, he had to admit that there was not a single gayal, let alone its meat and dairy products.

The *gadpo*'s ritual journey was characterized by movement from general to specific locations, descent from above to below, and the higher to lower valleys. Except for heaven, the snowcapped White Mountain and certain places in Tibet and Bumthang are real places. But as in the shamanic journey, the account of his trans-realm voyage became hazier as he traveled through the expanse of murky territories often unclimbed and untrodden by himself and others. Nonetheless, as he got closer to the local sphere, he improved the specificities by adding the details of not only the name of the locality but also the name of popular caves, rivers, cliffs, and lakes in the region. The *chöpas* and audiences, including the *gadpo* himself, assumed that he arrived from Bumthang in the north of Zhemgang, although during the *shepa* explanation it was declared that he descended from the heaven of Indra (*Lha Wangpo Gyajin*) to bless the community with fertility and prosperity. During the conversation, the *gadpo* maintained a Bumthangpa accent, while the rest of villagers talked in a local dialect. It was furthered attested by the *gadpo* while recounting his stay at the cave and forests along the mule track that connects Zhemgang and Bumthang. However, once the places of the specific region easily identifiable by the villagers were exhausted, his exciting nights were recounted in the following metaphor:

> I spent a night at the base of a twin cave [testicles]
> I spent a night in a bushy place [pubic hairs]
> I spent a night near under the solitary cave [clitoris]
> I spent a previous night in a damp space [female organ].

The display of sexually explicit conduct and content was a common goal of *gadpo* ritual. Each of these statements was followed by a burst of roaring laughter among the devotees, which include parents, children, siblings, relatives, friends, and acquaintances. In this ritual, the chief *chöpa* was the primary interrogator who stimulated the *gadpo* to vouchsafe his sexual experiences. He acted as a medium by constantly pushing the *gadpo* to indulge himself in lewd remarks, salacious gestures, and sexually explicit stories—in the process titillating both the audiences and interrogator himself. The chief lay Buddhist's quest, the audience's mirth as attested by sonorous laughter, and the *gadpo*'s phallus along with the publicization of his sexual encounters contributed to accomplishing their collective objective of boosting the community's fertility.

As attested by the *gadpo*'s words, the *gadpo* also brought blessings to agriculture and the economy. Every year a package of goods, such as 105 bags of clothes, 105 bags of dry pork, 105 bags of yak meat, 105 bags of rice, and so on, is believed to be dispatched from his heaven. However, the *chöpa* and his devotees denied the receipt of such gifts. After this repartee, the *gadpo* appeased *tsens* who inhabit mountains and northern territories, followed by other nonhuman denizens such as *düd* who reside in the valleys, river gorges, and southern lowlands, by offering libation. Finally, the ritual was ended by reciting ribald chants to invert the misfortunes caused by various types of gossip into auspicious forces replete with the *yang* of fertility and economy:

> The penis's bottom is surrounded by bushes, let it be auspicious by circumambulating it
> The penis's waist is girdled by wrinkles, let it be auspicious by circumambulating it
> The penis's neck is wreathed by smegmas, let it be auspicious by circumambulating it.

The fertility blessing turned out to be a rather carnal enterprise the next day, as the *gadpo* occasionally shoved through the crowd of mostly young women, cuddled and blessed them with his phallic implement, brandished the phallus in their face, and amorously anointed their bodily parts. When he was away from these young women, he was engaged in symbolic copulation with his partner *ganmo* at the center of the courtyard surrounded by the crowd, while other clowns in attendance such as mainstream *atsaras* tried to distract and disengage them out of jealousy. The elderly women escaped the *gadpo*'s gusty animalism because their bodies are no longer fit for procreation. However,

when the *gadpo* advanced toward them, which was exceptionally rare, they accepted them with little resistance. On the other hand, the young women exerted unified opposition, turning the whole scenario into a tumultuous social event. Due to the raw nature of the phallus and the *gadpo*'s own countenance, these young women often shielded themselves behind the assembly of old women and males, shouting words of indignation. But in the end, the *gadpo* ultimately won the battle, as such acts and oppositions are merely a mating ritual that formulates a stairway to the blessings of fertility.

The *gadpo* with his retinue returned on the morning of the final day for the main propitiatory and fertility ritual known as *dralha pati*. He was accompanied by the *ganmo*, multiple *atsaras*, and his sons and daughters, wearing funny-looking masks. One interesting thing about this ritual was that although the character with a standard mask of the *gadpo* was present, the position was mistakenly accorded to a brown-faced mask that appeared old but without visible wrinkles. However, the role assumed by him remained the same as that of sun-tanned *gadpo* and evoked the same degree of laughter and mischief. While the meaning of *dralha*, which is "war/enemy god," is not a problem to most culturally informed persons, it is, however, difficult to decipher the second word, *pati*, which is not a Bhutanese or Tibetan word. Etymologically speaking, *pati* is a Sanskrit word for the owner or lord of the land, as in *sadag, shidag, nedag, düd*, and so on, who constitute local deities. As attested in the ritual, the *gadpo* and his retinue actually do propitiate the local deities, including the supernatural owners and lords of the locality, and hence *dralha pati* can be literally translated as the propitiatory ritual of the war/enemy gods and the lords of the earth.

I will begin with a description of their entrance into the ritual space to show the hierarchy of the *gadpo*'s retinue. In a grand ritual procession, the young *atsara*, who was a ritual preparator/assistant (*chod shampa*), preceded the phallus-carrying *gadpo*, who was the master of ceremonies, into the courtyard. They were followed by the *ganmo*, a few more *atsaras*, and other exotic-looking masked characters. The *chod shampa astara* carried a plate with five phallic *tormas*, leather whip, dysfunctional gun, and a sword, while others carried small sticks symbolizing oboes, horns, drums, and trumpets. The two masked characters carried small branches with few leaves and white scarves tied on that represented primordial prayer flags. With a loud mélange of music, they brandished their equipment and circled the cane mat three times before finally settling on it facing the ritual table. The *gadpo*, of course, sat at the heart of the row that was formed by his retinue on either side, so that

the audiences perfectly surrounded them. The *gadpo* for this ritual must have some Buddhist ritual expertise because he must offer a libation euphemized as a golden beverage (*serkyem*) to local gods and deities. This indicates that several different persons can perform the role of *gadpo* at different phases of the four-day festival.

A set of strict rules must be observed, and the *gadpo*'s retinue was constantly being monitored by the *chod shampa*, who remained standing so that he could assist the *gadpo* performance of the ritual as well as punish mischievous contraveners. Failing to follow the *gadpo*'s orders brought punishment from his assistant. Hence, except for the *gadpo*, the rest of the ritualists received gross whipping for either being mischievous or remaining idle. Although they tried to evade chastisement by maintaining equilibrium between the meddlesome and lackadaisical maneuvers, at the end of the ritual, they were doomed to be lashed by the ritual assistant as an obligatory honorarium for their service. On the other hand, the *gadpo*, as a master of ceremonies, does not seem to be precluded from the insubordination or perversity of the *chod shampa*. For instance, the *chod shampa* executed his boss's orders in a rather ignominious or antithetical fashion, but I never saw the *gadpo* lamenting.

The fertility ritual began with the libation. Along with a plate of *ara*, a platter of partially conjoined five phallic *tormas* shrouded in varying sizes of red testicles was placed on the ritual table. The *gadpo* recited abstruse chants and simultaneously clashed the cymbals and drums as each *torma* with its testicles was detached from the platter and placed on a fresh plate before being jettisoned in a specific cardinal direction by the *chod shampa* as per the *gadpo*'s divination. The *chod shampa* sprinkled alcohol onto the single *torma*, employing a bawdy movement that was filled with incivility and mockery. Such insults were further illustrated in the disposal of the phallic *tormas*, which were discarded by the *chod shampa* in the direction opposite from the *gadpo*'s orders. Hence the *torma* that was supposed to be thrown away in the eastern sphere ended up being abandoned in the western sphere, and vice versa, while the southern *torma* found its home in the north, and vice versa. Similarly, in the *gadpo* ritual language, "east" meant "west" while "go" connoted "come." In essence, everything the assistant did was the opposite of what he was ordered to do during the entire ritual.

The *chod shampa*, nevertheless, operated similarly to the erstwhile *chöpas* by assisting the *gadpo* in diffusing the seed of fertility on the phallic *tormas* by acting as his assistant in an unusually profane fashion. He mediated between

the lifeless phallic *tormas* and the *gadpo* primarily to deliver the latter's virility to the phallic *torma*, and ultimately to the community. By spraying a few drops of alcohol, the *torma* became fully activated, apparently impregnated with fertile properties, so that the castoff *tormas* were not just tossed in the air or left unattended as a mere form of provender for stray dogs. Rather the *atsara* surveyed the sea of young and unmarried women and identified one woman[13] so as to plant the *torma* on her lap. Hence the chosen one became the principal recipient of the *gadpo*'s fertility blessing.

The five worlds the *gadpo* had created on the first day of *chodpa* was represented by the people witnessing the ritual from five directions. Since the creation of the new world was incomplete without rejuvenating its new inhabitants, the phallic *torma* was severed one piece after another and presented to the individual who belongs to that group. In the *gadpo*'s ritual language, such ritual actions bring new life and vitality not only to the singular beneficiary but also to the group that surrounds, her although it was only the former who embraced the *torma*. The apportionment of the five *tormas* to the five groups of people in five different directions coalesced them into a single unified whole—which was hereafter viewed by the people as fully renewed with potency, life, and health. To supplement the blessings, the two junior masked ritualists occasionally waved the branch flags, which operated as a Bon version of Buddhists' arrow flag (*dhatar*) for drawing and increasing the five life elements of people.

On the whole, the evidence presented thus far suggests that the phallic images are reconfigured version of primordial wooden phalluses shaped by later Buddhists' narratives, as they pervade only the villages in western Bhutan that were visited and subsequently blessed by Drukpa Kunley. While the eye-catching phalluses are widespread in western Bhutan, the use of phallic objects characterizes central and eastern Bhutan. But at the logical and sociological level, these wooden phalluses and phallic images reflect socioeconomic status. They represent the social and economic reality of the people in that phallic images on concrete walls are a shining example of development, while wooden phalluses somewhat imply the opposite. The further I entered into the wildernesses—the region that was never visited by Drukpa Kunley or with less Buddhist influences—the greater the number of *kharam* phalluses I spotted. This is particularly true of remote villages located in close proximity to Panbang in lower Zhemgang.

Despite Bhutan's publicity as the phallic country, the penurious person's huts did not hang out phalluses, nor did they paint them on their wooden

walls. Likewise, the government buildings were clean from phallic defacement because people generally evade spewing *mikha* at these public properties and dilapidated huts. In other words, *mikhas*, which can destabilize the life elements, are triggered only by the best possessions, such as big houses, which belong exclusively to successful families. The villagers of Goleng, Shobleng, and Trong all believe that the common types of gossip magnetized by these best private possessions are generally *mikha* and *jamkha*, which have a corresponding effect on the household's members. But such manifestations of *mikha* and *jamkha* also pervade healthy crops, fertile fields, lively crossroads, and other expensive properties such as vehicles.

It is evident that phallic symbol's primary role is to grant or sustain fertility, which is conceived in terms of growing family, economic abundance, and thriving livestock, all of which can be threatened by pernicious gossip. But as attested by the *kharam* ritual and the narratives around phallus painting, they also exhaust the negative forces, so that harmony in the community is maintained. The phallic symbols act as antidote to misfortunes arising from pernicious gossip, which are generally seen as female creations. In this sense, the pictorial and wooden phalluses have the same significance and function except that the latter predates phallic painting. The relations of the *gadpo*'s origin to the heaven (*lhayül*) of Indra, Shiva and the phallus sharing a common appellation, Mount Kailash as the locus of the *gadpo*'s descent (which is also believed to be the adobe of Shiva), and visiting the communities during their annual *chodpa* from the White Kailash suggest that the *gadpo*—and for that matter fertility rituals and phallic symbols such as phallic paintings and implements as employed in *gadpo* and *kharam* rituals—is linked to early Saivism associated with Lord Shiva.

The extensive use of phallic symbols, which are painted on the exterior walls, hung from the eaves of houses, planted in the fields, or found in carved wooden form over doorways or around the necks of favorite animals, is the clear evidence of the centrality of Bon beliefs to the people. While people have been exposed to Buddhism for centuries, and subsequently converted to Buddhism to the extent that even some Bonpos are influenced by it, the villagers have, however, not stopped conducting Bon rituals. Among the phallic rites, the *gadpo*'s rite is conducted annually, while the *kharam* ritual is commissioned by the individual family, especially when lay Buddhist and other Bon rituals and biomedical treatments are ineffective.

The relevance of phallic rituals in the villages today can be attributed to the late arrival of Buddhism, and the lack of specific Buddhist ritual that

bestows fertility on humans and protection against the pernicious gossip that is widespread in the villages. The significance of phallic symbols becomes even more pronounced given the fact of inadequate access to healthcare by Golengpas and other rural communities. While the *kharam* ritual is mainly oriented toward preventing the effects of pernicious gossip, the *gadpo*'s ritual is primarily concerned with the blessings of fertility and prosperity, which are constantly threatened by various forms of *mikha*. On the whole, the incorporation of phallic symbols in Buddhist rituals explains the deficiency of lay Buddhist rituals in the villages that are intended to stimulate fertility and prevent pernicious gossip. Following the incorporation of phallic symbols in Buddhist ritual, which in turn expresses their importance to people's life, I turn to accommodation between Bon and Buddhism.

8
Buddhist Accommodation of Bon Rites and Practices

Out of the three major annual religious events in Goleng, the annual propitiation of local deities and demons is one example of accommodation in which the four lineage deities have been incorporated into Buddhist ritual by the lay *chöpas*. This has, however, not replaced the Bonpo's simultaneous ritual, nor the propitiation of lineage deities during the *rup* rite, which succeeds the annual propitiation of local deities and demons. Another area where Bon beliefs are particularly strong and persistent relates to the naming patterns among the villagers based on child gods, who are mostly local deities but either converted or incorporated into Buddhist practices. While these syncretic worldly gods (*jigtenpai lha*) act as children's "spiritual" parents and protectors, some villages use phallic symbols by lay *chöpas* for the same purpose, as these incorporated local gods and deities. This chapter will focus on two Buddhist rituals in which the Bon lineage deities along with other supernatural beings and the Bon god Odé Gungyal are propitiated in order to illustrate how incorporation and accommodation of Bon gods and deities by lay Buddhists remodel, reinterpret, and reinvent Bon beliefs under the guise of Buddhist iconographies, and through the agencies of Buddhist actors, thereby promoting Bon's vitality and inclusivity. The chapter, in turn, contrasts the incorporation of Buddhist and Bon beliefs in the context of the former Clerical Bon establishment in western Bhutan.

The Annual Propitiatory Ritual of Local Deities and Demons

Before the construction of Golengpas' first temple in the 1960s, there were several oral accounts of special instructions (*kabab*) left by Buddhist masters from other regions. These prescriptions were for how the local Bon deities, who were portrayed as obstacles to the propagation of Buddhism,

should be incorporated into Buddhist rituals so as to eliminate Bon beliefs. The incorporation of the local deities in Buddhist ritual was later fulfilled by formulating an annual propitiation of local deities and demons (*tsen düd solkha*) so that they are now being propitiated inside the temple. Although these local deities, when subjugated and incorporated into Buddhist rituals by enlightened Buddhist masters, can become powerful Buddhist protectors, the lineage deities remain peripheralized, neither assuming the rank of the Buddhist protectors nor the same status as the untamed beings. Nevertheless, rather than eliminating Bon beliefs, accommodation and incorporation of Bon deities and practices, particularly by the lay *chöpas*, work to perpetuate them through new forms.

If *rup* is the main annual winter rite, by all accounts the *tsen düd solkha* can be considered its parallel—the main annual summer ritual. This *tsen düd* ritual that I witnessed in 2017 was a well-organized annual event with everybody in the community involved in one way or another. It is currently being conducted by both the lay *chöpas* and Bonpos on the full-moon day of the fifth lunar month, which is one of the most auspicious days for Buddhists. This ritual is syncretic in nature, as both the Buddhist and local deities were propitiated side by side by the lay *chöpas* inside the temple and by the Bonpo outside the temple. While this reflects the complementarity between the two, there is no religious event whereby the *chöpas* and Bonpos sit together to conduct a common ritual inside the temple.

Unlike other Buddhist rituals, it had no particular sponsor or benefactor (*jindhag* or *tsawa*). Sponsoring ritual in Goleng entailed considerable wealth and energy, and hence many big rituals were typically sponsored by a group of households either voluntarily or in turn. By sponsoring such rituals, Golengpas either secure or perpetuate the status of being "big" people (*che*)— which is the highest social position in Goleng.[1] The *tsen düd* ritual was organized by the temple caretaker (*koinyer*) and the village astrologer (*tsipa*) who have specific duties to fulfill. While their roles are hereditary, the current *koinyer* does not belong to the household of the former *koinyer*. Similarly, the role of astrologer was relinquished to another *chöpa* by Lopön Pema, who was originally the hereditary village astrologer. It appears that their roles and responsibilities associated with this ritual were distributed among them on the day when the *tsen düd* ritual was first performed during Lopön Pema's father's time, who was the first native astrologer of Goleng.

During my fieldwork, this new village astrologer coordinated the ritual by taking up the role of chant master (*umze*), while the caretaker of the temple

oversaw the overall organization of the ritual. However, according to the *koinyer* and *tsipa*, both have the freedom to transgress the contour of their responsibilities, although each of them wished to stay within their domain, primarily to excel at their roles. One of the main tasks of the *koinyer* was to identify households for sponsoring meals and drinks for the people in a manner such that every household gets an opportunity to contribute to the community ritual either through physical labor or material benefaction. As in the *rup* ritual, I witnessed each household actively engaged, either directly or indirectly, in making the four different ritual cakes *tormas* of the lineage deities representing them and their households.

The *tormas* were prepared from maize flour contributed by each household by the senior lay Buddhist *chöpas*, including the *koinyer* and the chant master (*umze*), who is also a *tsipa*. While making these effigies, which constituted several Buddhist deities and the four lineage deities, Lopön Pema was present but only instructing and inspecting the work from his slightly elevated throne. Bowls of ready-made maize dough were brought to the temple by each household—either by adults or by children—and were placed at their respective main household booths dedicated to making the specific effigy of their totem. In principle, the Dung House ought to have the smallest *torma* because there were only five households in 2017 that were matrilineally associated with it. By the same token, the Mamai House ought to have the biggest *torma* considering the plurality of households that share common lineal ties with it. However, it was not the case. While the householders contributed to their respective *torma* booth, the maize dough was either equally apportioned among the four *torma* makers or prioritized to the effigy that the *torma* makers thought most important. The largest *torma* they prepared was, interestingly, that of the neighing horse with a miniature figure of the deity Rematsen riding on it. The rest of the *tormas* were of equal size, with their deities riding on their steeds (see Figure 8.1).

The only uniformity among these *tormas* of the four lineage deities is the retinues in four different configurations that surrounded each deity and their respective animal-steeds. Unlike the horse, which was always painted white, the deity Rematsen was tinged with red since, according to the *torma* maker, she did not have a specific color entitlement. While the adornment of *tormas* depends on the availability of the materials, the household members, until recently, decorated their *tormas* with precious stones and jewels. This was mainly because many fell victim to the drunk ritual acolytes who paid no

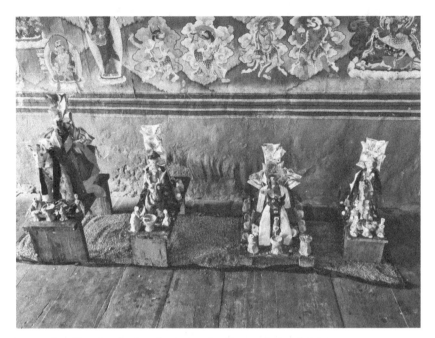

Figure 8.1 The ritual cakes depicting the four main local deities

particular attention to their responsibilities—that is, to fetch these pieces of jewelry and return them to the owners after jettisoning the *tormas* in the direction of the respective lineage deities. The *tormas*, therefore, had no jewelry but were adorned with strips of five different color fabrics (*dhar nga*) and multicolored butter slices (*karjan*), perfectly resembling shining pearls.

The *torma* of the cock was also painted red, but with the colored butter stuck on its body, its lustrous feathers were gleaming in red, yellow, green, and blue. The deity Doley Tshewang on which it was riding was left unpainted in an ashen maize flour, while the gayal on which the partially blackened deity Samdrup Gyalmo rode was painted black. Last but not least, the sambar deer was painted red, and its deity Krikpa Choijai was left uncolored, with the exception of its head, which was painted black. All in all, from the colorful butter studs to the multicolored fabrics, the *tormas* representing four lineage deities and their retinues that encircled their milieux had modest ornamentation. Over the course of several ritual stages, the intricacies of *tormas* attracted Golengpa household members, especially to make *nyendhar* offerings to the respective *torma* that represented their lineage deity. As *nyendhar* offerings, monetary notes were folded in a triangular

shape and fastened onto the bamboo offcut that was vertically fixed to the body of the *torma*.

Just like the hierarchy depicted in the way the lay *chöpas* sat to perform the ritual, *tormas* had their own hierarchy. On the basis of their education and ritual experience, the *chöpas* sat on a mat of varying thicknesses forming a straight row. The center of the row that faced the altar had a fairly elevated throne so that it was the highest spot in the setting. As the highest seat, it was always reserved for the chief ritualist—Lopön Pema Wangchuck. By sitting on the highest throne, he wields control over the other ritualists. The chant master (*umze*), who is second only to Lopön Pema, sat next to him on a modest throne. According to Lopön Pema, unless one has good experience and ritual knowledge, one cannot assume the post of a chant master. The other ritualists, whose main task was to assist *umze* by blowing the ritual horn (*dhung*), trumpets (*jaling*), and conch (*dungkar*) and beating the drum (*nga*), did not have elevated seats but sat on intricate carpet. The hierarchy of lay *chöpas* corresponded to the Buddhist pantheon, which was constituted by the large statue of Guru Rinpoche flanked by Buddha Shakyamuni and Buddha Amitayus. There were, of course, several statues of other Buddhas and Bodhisattvas in the periphery of the altar, but they were relatively smaller than these three main statues.

Returning to the *tormas*, the hierarchy among them became conspicuous long before they were arranged in a row. All the Buddhist *tormas* were placed on the elevated ritual altar facing the *chöpas* below them denoting their higher status, while the totemic *tormas* of the four lineage deities were placed on the periphery facing the door. However, the central position among the *tormas* representing the lineage deities was not always the highest, nor did it hold any prestige in occupying the midpoint of the line. The highest ranked was the one placed first in line instead. The *tormas* were placed firmly on small stands of differing heights replicating the *chöpa*'s throne, and these stands were one of the defining features of their significance. While it is a common praxis in Tibetan Buddhist rituals to set *tormas* down on the altar facing the *chöpas*, the ritual cakes of the four lineage deities were positioned facing the main door to primarily express their peripherality.

Among them, the *torma* of Rematsen had the tallest stand. Correspondingly, as I have stated earlier, the Dung House, which propitiates Rematsen, has, in principle, the noblest as well as the highest status in Golengpas' society. The remaining three *tormas* of lineage deities, as lay *chöpas* emphasized, are equals. Furthermore, the lay *chöpas* claimed that the

height and width of the stands of these *tormas* of these three lineage deities do not impact their status. The *torma* of the deer, which was placed after the *torma* of the horse, was followed by the *torma* of the gayal, who in turn was followed by the *torma* of the cock. However, the incongruity of the *torma* arrangement with the conventional ordering became evident when they were disposed of at the end of the ritual.

At the end of the ritual, the hierarchy among them was reflected when these *tormas* of lineage deities were disposed in the direction where their deities are believed to reside. The *tormas* were actually thrown away following a lowest-to-highest status order. The first *torma* that was cast out by the acolyte was the *torma* of the cock, which was accurately placed at the end of the row. As per the *torma* arrangement, the second effigy to be disposed of was the *torma* of the gayal; however, following the ritual text, it was not jettisoned until after the *torma* of the sambar deer, which was mistakenly placed in the second place, was discarded to the westside. Finally, the *torma* of the horse, which is regarded as the highest in the stratification, was the last ritual cake to be thrown out, accompanied by long and distinguished ritual music.

Currently, Golengpas associate themselves with the title of the *dung* nobility, as attested by the communal willingness to subscribe to the cult of Rematsen. By empowering the deity Rematsen with bigger *torma*, higher stand, and, most important, a high mountain abode, Golengpas make it clear that Rematsen is Goleng's main local deity, while in actuality Rematsen is essentially just the lineage deity of the Dung House. During these communal rituals, the predilection for the deity Rematsen over other three households' lineage deity is conspicuous. For instance, I learned that many *torma* makers on that ritual day were actually associated with the Mamai House, whose totemic *torma* is sambar deer. This fact suggests a conscious elevation of the *torma* of the sambar deer in an attempt to nullify the original hierarchy as recorded in the ritual text.

According to Lopön Pema, the primary aim of the *tsen düd* ritual is to avert misfortunes accumulated in the community. The misfortunes, just like the Buddhist concept of merit that can be accrued from successive virtuous deeds, are subject to buildup over time. Such an assemblage of misfortunes is translatable into sicknesses, whether of humans or livestock, poor harvest, and damage to property. Hence, in Golengpas' view, misadventures should be understood as an important harbinger of their gods' wrath warning them about the necessity of performing the ritual, and of course, the quality of the ritual offerings. Lopön Pema maintained that *tsen düd* ritual was, however,

conducted not exclusively for averting collective social misfortunes alone. It also meant seeking a fresh set of blessings for the economy and for the health of the villagers from their deities in exchange for the offerings.

This ritual is syncretic in nature in the sense that it not only involves both Buddhist and Bon deities but also, until recently, took place both inside and outside of the temple. According to Bonpo Pema, parallel offerings to the same local deities were made by him outside of the temple but in close proximity. In 2017, Bonpo Pemala was attending his sick wife in another town, and the lay Buddhist *chöpas* axed the outdoor Bon ritual against the will of other Bonpos. In addition to the four main Bonpos, there are three more persons in the village who can perform both simple Buddhist and Bon rituals. Although they seem to be less experienced, these people were willing to take up the role of Bonpo Pema, at least for a day, so that they could invoke and propitiate Rematsen outside the temple. However, the lay *chöpas* and the senior villagers, mainly *goshé nyenshé*, did not consent to their idea on several grounds. According to them, the remaining two Bonpos were not natives of Goleng, and consequently, some Golengpas tend to have little faith in them even though they had been living in Goleng as *magpas* for many years. Furthermore, some Golengpas believed that these less experienced Bonpos would bring more harm than good.

The villagers were, therefore, rather doubtful about their ritual efficacity and feared that if the deities were not summoned correctly and propitiated in a proper manner, there would be, instead of blessings, more harm in the community. Hence, granting a privilege to any inexperienced Bonpo who was believed to be unworthy of performing the sophisticated ritual was to be avoided. On the other hand, Lopön Pema advocated the prohibition of Bonpos from performing Bon rituals rather than actual Bon practices or rituals, arguing that since the local deities are incorporated into the Buddhist ritual, the efficacy of parallel Bon ritual is not really threatened. This kind of reconstruction of syncretic religious worldview by propitiating both the Buddhist and Bon deities, side by side, is common among the lay *chöpas*. The incorporation of Bon gods is also evident in other Buddhist rituals.

Buddhist Versions of the Odé Gungyal Ritual

During my fieldwork, a discovery of a Buddhist version of Odé Gungyal ritual in some villages—the same primordial god that was invoked annually

during the important Bon rituals such as *rup, shu, gandang*, and so on—took me by surprise. This textual ritual is performed by lay *chöpas* who are in actuality not qualified *chöpas* and, hence, not in a position to administer advanced Buddhist rituals independently. Like *rup*, this ritual is performed once a year, ideally close to the winter season, in the villages that no longer observe annual Bon rites. One such village is Gomphu, the same village where I observed the fertility rites by the syncretic masked ritualist—*gadpo*.

Although the Buddhist version of the god Odé ritual seems to be long incorporated into Buddhist practice in Gomphu, it is exclusively performed by only certain lay *chöpas*. In fact, most of the Buddhist *chöpas* refrain from attending this ritual, and, unlike *rup*, it is sought by only a few households. In other words, rather than a social event in which the villagers in their entirety join in, this ritual is private and performed primarily for the well-being of an individual household. Currently, there are only two lay *chöpas* in Gomphu who are responsible for performing this annual propitiatory ritual to appease the god Odé Gungyal, who, as a chief of all Bon gods and deities, occupies the central place in Bon cosmology. While these two lay ritualists call themselves *chöpas*, apart from Odé Gungyal and the white offering[2] (*karchod*) rituals, performing sophisticated Buddhist ritual independently is beyond their area of expertise. Hence, in Buddhist parlance, they and their religious activities are often dubbed "neither Buddhist nor Bonpo" (*chö min bon min*). When I asked the senior ritualist Tshering, who is in his late fifties, to make sense of this unique ritual he made the following comment:

> There are only two persons who [can] perform this propitiatory ritual to god Odé Gungyal. Actually, there were three of us, but one ritualist passed away a few decades ago. I received the transmission (*lung*) of Odé Gungyal ritual from my late teacher over thirty years ago, and since then I have been performing this ritual. While the other ritualist is younger than I, he has also been performing the same ritual for over ten years. This ritual must be performed in the morning, and we [lay Buddhist *chöpas*] and the householder who sponsors this ritual must all fast at least for the entire morning of the ritual day. We must also maintain purity and cleanliness.

The sponsoring householder and the ritualist Tshering both told me that this ritual is always conducted in the morning, fundamentally to create an ideal milieu that is analogous to that of god Odé's heaven. The *tsog* offerings are always prepared by the female householder, who must be "clean and pure," and

the actual ritual is always performed by the ritualist on an empty stomach. Nevertheless, it is simply not enough to convince the god of their purity. Hence, the household members and the lay *chöpa* become all the more determined to cleanse them through a parallel smoke-offering by burning the leaves of wild juniper or artemisia inside the kitchen and at the altar respectively. One key characteristic of this ritual is the requirement of an alcoholic offering (*pöth*), which must be prepared well ahead of the ritual season. The householder must prepare it specifically for the god Odé Gungyal because, according to her, the *pöth* offering cannot be shared with other gods, let alone with humans.

As previously mentioned, not all the households in Gomphu perform this syncretic Odé Gungyal ritual in which lay *chöpas* are involved. I found out that only twelve out of seventy households propitiate this primordial god. The ritual is normally conducted between the eighth and eighteenth of the ninth or tenth lunar month, as this period, which marks the end of astronomical winter and arrival of spring, is considered the ideal month for the propitiatory ritual. Traditionally, according to Tshering, the head of the ritualist should be wrapped in a bundle of white thread or white scarf, but, although this ritual was conducted at the main Buddhist altar employing only the drum, he did not use the headgear when I witnessed it.

While the narrative has it that god Odé has no time to visit the human world in other months or seasons, it is particularly true that by spring the sowing season begins for the farmers. Hence, the major rituals, including this one, occur around this holiday season. Unlike in the *rup* ritual of Goleng, where the god Odé is depicted as a benign divinity who blesses the faithful with good fortune and fertility when invoked and remains unbothered by the acts of the faithful when unpropitiated, if these householders don't perform the ritual on time, one of the members of the household, whether living in the village or other districts, will fall ill. According to these ritualists and the householder who sponsored the ritual during my fieldwork, an unappeased god Odé Gungyal's wrath is characterized by a severe eye, leg, or ear pain that demands immediate spiritual intervention by these two lay *chöpas*. However, when appeased, he blesses the household with prosperity.

Unlike other pre-Buddhist Bon rituals, a very old text titled "Genealogy of God Odé Gungyal" (Odé *Gungyal Gi Lharab Zhugso*), which is forty pages long, is employed by the lay *chöpa* Tshering. This text belongs to a household whose annual ritual I had the opportunity to observe in 2017. Due to fear of pollution, the text is never touched or opened during the nonritual season but

stored at this particular house. But as it is the only available text, it was widely circulated during the ritual period among the twelve households. This text has the name of an author—a Buddhist lama by the name of Sithar Dondup. According to the short biography of Lama Sakya Özer written by Senge Dorji in the mid-twentieth century, who was himself the eighth hereditary lama of Gomphu Lamai Gonpa, Sithar Dondup was the fourth hereditary lama of the same establishment and was his great-great-great-grandfather. As the orthography and aesthetic features of the text suggest, he must have penned this text in the late sixteenth century. While the locals believed that the seed of Buddhism was sown in the eighth century when Guru Rinpoche visited Gomphu and meditated at the cave (*nge gor*) within the village periphery, it seems that Buddhism only began to take hold during the time of native Lama Sakya Özer—circa the fifteenth century. But the introduction of this textual ritual in Gomphu was certainly a turning point in the campaign against Bon sacrificial rituals.

In the ritual setup, an anthropomorphized effigy of a horse-riding man following another small figurine of a partially disabled man was made from rice or corn flour. According to the ritual text and the ritualist Tshering, this handicapped figure represents Karma Yölek, probably a primordial Bonpo responsible for inviting god Odé to the human world from his heaven. By extension, the horse-riding figure symbolizes the god Odé himself, who, per the text, upon persistent prayers and adjurations by Karma Yölek agrees to descend to the human realm. This *torma* was installed on the small ritual table that was placed on the carpeted altar that houses many small statues of Buddhas and Buddhist deities. A thin piece of cloth that represents the sky cord sheltered the *torma*. The acolyte and the householder prepared a sky cord and unfurled the carpet close to the *torma* in order for the god to descend on the ritual table, and for that matter on their house, following the route shown below (Figure 8.2), from his heaven above the thirteen sky realms. Before them, cups of *changkoi*, *ara*, butter lamp, and water offerings were artistically arranged.

The interesting thing about this ritual is the openness of the ritual space, for unlike the conventional Buddhist ritual space, it was not restricted to the altar. Outside the house and the rooftop, kitchen, and other household spaces were all part of the ritual space. What appeared central is the rooftop because, as the highest point of the house, it is where these gods enter the house. Hence, a miniature branch-flag (*thar shing*) from the *merbai* tree, which itself is widely used for fumigation, with a piece of white cloth tied at its top was

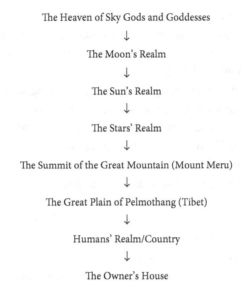

Figure 8.2 The journey of god Odé Gungyal

installed at the center of the roof. It is held that a new flag on the rooftop of these households was installed every year during the ritual, suggesting that many villages in Bhutan at one point in time actually propitiated this god, as these mini-flags are ubiquitous on the rooftops of houses that do not perform this ritual. Currently, the majority of the households in Gomphu and other nearby villages who no longer propitiate god Odé Gungyal actually do replace the rooftop flags by performing a Buddhist ritual, but only when the flag is old or when they get a new roof.

Although I was not able to verify it, Tshering maintained that the old flag must be uninstalled and used for the preparation of a *tsog* offering. The rooftop flag was connected to the *torma* by five different types of thread (*thagpa ngennga*). The end of the thread was carefully tied on the base of the flag and its other end was drawn to the altar through the main door given that there was no ceiling hole or roof vent. The horse on which the god is riding was tied to this end of the thread, connecting with the prayer flag on the roof, and with the god in his heaven. In this way, the lay *chöpa*, through the agency of the sky cord of five threads that symbolically connects the heaven of gods to the worldly house of humans, is able to be usher the god directly to the ritual altar that represents the household members. In the kitchen, where the main householder spent much of her time, simultaneous offerings were

made throughout the ritual period. Replicating the flag on the rooftop, two small branches of the *merbai* tree were planted on top of the kitchen stove, which is made from stone and mud. Likewise, two more branch-flags were installed below them on the ashes.

While a cleansing ritual was performed by Tshering inside the altar, the leaves of *merbai*, juniper, and artemisia were uninterruptedly burned by the acolyte and the main householder in the kitchen until the end of the purificatory ritual. Outside the house, the acolyte under Tshering's command also made a sacrificial libation along with separate offerings that constituted the offerings of a variety of foods and the tossing of *namkaling mentok* and *bogma* up in the air. The main ritual by the lay *chöpa* inside the altar immediately followed the offerings made in the kitchen and the outdoors. Although this main offering included eggs, cookies, and fried butter and cheese, the square-shaped pancake known as *dangje* was the main specialty. *Dangje* is made from rice flour and after chili powder and other ingredients are added, it undergoes deep frying, particularly in fresh butter. At the end of the ritual, the five threads that remained tied on the horse during the entire ritual period were untied and hastily spun into a ball by the acolyte. While the household members merely watched, the acolyte then pitched it onto the center of the roof leaving its head permanently tethered to the flag.

Thus, there are two types of offerings involved in this ritual: interior and exterior offerings, each made by a different person. While in essence the idea and nature of offerings do not differ from one another, the lay *chöpa* never went to the kitchen or the outdoors to make the offerings. It was always the acolyte or one of the household members who tossed the offerings into the open space or kitchen stove. The lay *chöpa* in red Buddhist scarf spent his time reading the forty-page text about the Bon god while banging the Buddhist drum, which is bigger than a Bonpo shaman's drum. The exterior offerings, which were exclusively made by the non-*chöpa* person, suggest that the ritual embodies elements of primordial Bon, as these offerings are made specifically to the swarm of local deities who are not yet incorporated into Buddhism. Hence, as they are not assigned a place in the Buddhist pantheon, the lay *chöpa* seems to focus on Odé Gungyal, who appears to be partially, albeit transiently, occupying a place in the Buddhist pantheon by reason of having the god's pro tem *torma* on the Buddhist altar—that is, alongside the Buddhist statues.

My intention here, rather than translating the whole text, is to make some sense of how this primordial Bon god, who is conventionally invoked by the

Bonpos during the Bon rites, was invoked and appeased by the ambiguous non-Bonpo ritualist in a Buddhist frame. In witnessing this ritual, I discovered that the Buddhist version of the Odé Gungyal ritual is performed for pragmatic reasons, and despite the presence of textual scripture, it serves the same purpose as the Bonpo's *rup* ritual. The Buddhist scripture, however, has far more details than Bonpo Pemala's verbal incantation (*mrang*) of *rup*, particularly about god Odé, including who invited him and why, and how he descended to earth, which are all of mythological significance. As attested to by the text below, Odé Gungyal was invoked primarily for pragmatic reasons, insomuch as the primacy is placed on people's prosperity:

> The people below [human world] have no king (*pön*)
> Their properties and cattle (*nor*) have no *yang* power
> Their meals have no nutritional value (*chüd*)
> Their clothes have no warmth (*kröd*).

This stanza indicates that god Odé Gungyal revitalizes the community by bringing along the blessing of prosperity and health, and increasing life elements through the agency of syncretic lay *chöpa*. Like the *rup* Bonpo, the lay *chöpa* must always receive the prior transmission (*lung*) from the experienced master before he can administer this ritual to others. While the lay *chöpa*'s red scarf may have originally served as a substitute for headgear, it was the drumbeat that, as in shamanic ritual, enabled him to journey to heaven by crossing thirteen sky realms (*nam rimpa chüsum*) to invite the god. Considering the attributes of the ritualists, one can argue that to maintain similar efficacy, this ritual must have been traditionally performed by a lay Buddhist *chöpa* who had Bonpo ancestry—the same formula the Golengpa *chöpas* are trying to emulate. Receiving the transmission, calling themselves lay *chöpas*, and, most important, conducting the ritual indoors at the Buddhist altar allows them to demonstrate the legitimacy of this syncretic ritual, although the elements of Bon beliefs were never really eliminated from it.

Child Gods and Naming Patterns

A number of local deities have been either fully incorporated into Buddhist protectors or partially encompassed within the Buddhist cosmos while still

bearing a "worldly" category to reflect their Bon origin. Some of these incorporated worldly beings became primary guardian deities of certain temples such that people embrace them as their newborn's supernatural father, or more commonly as child god (*kyelha*), primarily by receiving a name from the deity through the agency of the temple caretaker. The are many Golengpas who received their names through the practice of a child god from either a popular temple in western Bhutan or their own temple in Goleng.

A Golengpa's child may receive several names from different Buddhist masters, but only two names go on to be significant for the person. The first one is, of course, the official or public name, while the other, which is to "protect the person's autonomy and independence from magic and evil influence" (Barth and Wikan 2011: 32), is the "secret" name. While the person bears the official name throughout this life, the latter, as attested to by the Buddhist death ritual where the deceased is referred to by the secret name, is primarily to keep that person's identity and, for that matter, his or her worldly deeds from being known in the afterworld and by the Lord of Death. In fact, Golengpas believe that the deceased with a secret name and with guidance from the high Buddhist masters can swiftly take rebirth in a higher realm. In their interesting monograph *Situation of Children in Bhutan: An Anthropological Perspective*, Fredrik Barth and Unni Wikan, who were probably the first anthropologists to write about children in Bhutan in 1990, examined various aspects of children's life but took no account of the importance of a child's spiritual upbringing—the culture of child god.

In general, the common formula for naming the newborn is to approach a reincarnate Buddhist lama or a seasoned monk who chooses an auspicious name by meditation. The first name is usually lama's own name, but if it is sought during the ritual session, it can also be the name of a particular deity. As noted earlier, except for the royal family and Lhotsampas, Bhutanese, unlike their South Asian counterparts, do not carry surnames or family names in which patriarchy is deeply embedded. The two-word names that are common among the general populace carry a religious significance rather than reflecting their relationship with their parents. While the religious persons who give names are usually male, without surname regularity in the naming convention, their choice reflects neutral or matrilineal affiliation at best. The first names are in fact without gender identities, although a few educated parents recently began to combine multiple names given by various religious persons and passing their second name as patronym to create their desired new names.

The high lamas and erudite monks are not readily available to everyone, particularly among rural villages, or sometimes the significance of Buddhist masters is undermined by some powerful local deities that the villagers rely on instead. In such an environment, the child's typical name is directly received from the powerful local deities through the agency of a temple caretaker (*koinyer*) who is generally not qualified to give his own name. This unique naming system is common among the people of Wangdiphodrang, adjoining Trongsa district of central Bhutan, Haa and Thimphu in western Bhutan, and some other districts, especially inhabited by the powerful local deities who assume the role of child or birth god (*kyelha*), although in a real sense, they may not fully be incorporated into Buddhism.

One such example is Clerical Bon's protective deity Sid-pai Gyalmo, who operates not only as the protective deity of Kumbu and Shar Sergang villages but also as their *kyelha* for newborns and children alike. Similarly, Chungdu (also spelled as Khyungdung), a tutelary mountain deity of the district of Haa, is a well-known *kyelha* for the communities that fall under its territorial influence. In Thimphu, a Buddhist-convert Genyen Jagpa Milen of Dechenphug and his manifestation Genyen Dhomsangpa in Changangkha temple are widely regarded as *kyelhas* across Bhutan. During my fieldwork, I witnessed the crowd of mothers along with their babies thronging to these two temples rather than other temples and monasteries that house the statues of Buddhas and Bodhisattvas.

In Thimphu and Wangdiphodrang, these gods, as *kyelhas*, are as critical as human parents in bringing up the newborn because without seeking spiritual assistance or commissioning rituals in which these divinities are regularly invoked and propitiated, the human parents, like all the ordinary parents, are dependent on the ritual specialist primarily to protect their children from the dark forces and to stabilize their child's life elements. However, when human parents stop worshiping them, these divinities in turn neglect their responsibility, resulting in sicknesses in their children and occasionally rendering the abandoned persons unsuccessful and infertile. Hence, these human parents must seek a permanent collaboration with these divinities because it is only through such relations and sensitivities that they can maintain a healthy body and thus live a long and prosperous life characterized by a bountiful harvest, a host of healthy children, and a large herd of cattle.

As will become clear, it is common among the people that are predominantly the believers in *kyelha* divinities to escort the three-day or older neonate to the inner sanctum of the temple to seek lifetime support (*ten*)

from the popular deity even if the newborn has already received names from Buddhist monks.[3] The deity's blessings are accompanied by christening the baby through the agency of the temple caretaker. The lifetime support is guaranteed when the child receives a name from the deity as reciprocity for the child's first offering in the form of libation, cash, or butter lamp. Akin to the names given by Buddhist monks, one of the newborn's names is either the direct appellation of the deity or the temple, which, in most cases, becomes the child's permanent name.

In late 2017, I traveled to Wangdiphodrang, where the Yungdrung Bon deity Sid-pai Gyalmo is concurrently worshiped as *kyelha*, particularly at two temples—Kumbu and Shar Sergang—which are located geographically opposite but close to each other. The local inhabitants and neighboring villages that are close to these temples adopt the deity Sid-pai Gyalmo as a surrogate mother of their children by seeking her lifetime support. According to these villagers, the surrogacy or "godparent" relationship is incomplete until the child receives a name through the agency of the temple caretaker. Among the people of Shar Sergang, the first name is always the deity's name, while the second, which is given based on one's sex, is completely unrelated to either the deity or the parents. The second name, although less frequently, can also reflect the name of the deity if the first is not associated with the child's *kyelha*. The most common first name among the Shar Sergang people that I have come across is Sigye, which is believed to be a contraction of a deity's name: Sid-pai Gyalmo (also pronounced as Sipé Gyem).

This naming system becomes obvious when the locals address one another. While there is only one Dzongkha spelling, due to variation in pronunciation and accent, people also spell it as "Cigay" or "Tsigay" in English. On the other hand, the naming pattern for those children born in neighboring villages close to Kumbu temple varies from that of communities associated with Shar Sergang. In their custom, the newborn receives the name of the temple as the first name. Hence, many people of that locality who are spiritually and geographically close to Kumbu temple have "Kumbu" as their first name. This naming system is also practiced by the people of Haa, in that the local male deity Chungdu becomes a surrogate father of a newborn. Any newborn who receives a name from the temple that houses this deity usually has the first name "Chungdu."

Golengpas have a similar but not widely practiced naming custom. The most popular Buddhist protective deities in Bhutan are either Mahakalas

(Gonpo) or Palden Lhamo, but neither of them is Golengpas' main Buddhist deity. They instead worship another popular Buddhist protective deity known as Jampel Shinje, a version of Yamantaka who is considered a wrathful expression of Bodhisattva Manjushri. Yamantaka is worshiped as an enlightened deity, though sometimes, as in Goleng, he is also regarded as a protective deity. In contrast to the people of Wangdiphodrang and Haa, Golengpas usually secure protection of their newborn by turning to Yamantaka, who in turn takes up responsibilities similar to those of the range of deities discussed above.

As previously mentioned, Golengpas currently do not have a high reincarnate lama, so as soon as the baby is born, the parents carry it to the temple to establish a new bond between the newborn and the protective deity. As I witnessed on one occasion, the naming pattern in Goleng is exactly the same as in western Bhutan, albeit with the presence of a Buddhist deity. This is achieved by offering a libation, which was prepared by the parents and offered by the *koinyer*, after which the newborn received its first name from the deity through the agency of the temple janitor. Although it is usually the first name, Jampal (also spelled as "Jambay"), which is the first name of the protective deity Jampel Shinje, is the common name that the child receives, either as first or last name. Unlike in the Buddhist convention, the newborn in this naming custom becomes a sort of precious property for the deity and is constantly guarded by the latter, who becomes the baby's welfare god. According to the janitor, the deity blesses the child with a long and healthy life, protects and watches over it, assists it during misfortunes, grants blessings until the child is fully grown, and continues these blessings in every stage of life.

The discovery of the phallic relic (*nangten*) by Bonpo Chungla, which is now emplaced just below the Buddhist deity, has already been discussed in the previous chapter. This rocky phallus[4] is particularly important for the Golengpa children: while the statue of Yamantaka represents a nonworldly god, the rock phallus, according to the janitor, represents a worldly Bon god because it was discovered by the Bonpo with support from certain of his gods. According to the *koinyer*, with two different types of worship in the temple, Golengpa children can receive blessings from either one of them. This is attested to by the name they receive from the temple caretaker through his random coinage. Thus, many Golengpas have Jambay as one of their names, while many others have Tenzin, which literally means "the holder of

Buddha dharma." Some even carry both the names; however, the *koinyer* and Golengpas believe that Tenzin is associated with the Bonpo's *ten*—the phallic relic of the temple. In relation to the blessing of Bonpo Chungla's relic, the Goleng temple janitor Kinzang commented:

> All the Golengpa adoptees grew up to find decent employment, but nonetheless, because of the frequent change in temple caretaker and subsequent defilement of the relic, the efficacy of its blessings are gradually waning. But this relic is quite partial and so are its blessings and protections. Depending on the time of the day, there is an apparent variation in the degree of blessings conferred on the worshippers. For instance, seeking its daily blessing is more successful if the supplicant invokes it early in the morning. Based on a first come, first served strategy, the first person to seek the blessings is the only person who receives its full blessings. The latecomers must anticipate a partial or fractionalized blessing because they are destined to receive only the remaining blessings, which are no longer a full or whole entity. We believe that the power of its blessings attenuates, particularly when the deity has already committed to protecting the first supplicant for the day. However, it does not mean that the rest of the seekers undergo rejection by the divinity, as they receive a form of blessings that is enough to protect them from misfortunes and other unforeseen calamities.

As noted earlier, such surrogacy is established only through a ritual accompanied by oblation as well as libation. Without a ritual offering, the deity may not approve the adoption even though the newborn received the name channelized through the janitor. Once the surrogacy is established, the child then has twin parents—human and spiritual parents—who are equally crucial to its survival. The human parent is physical and therefore responsible for the nourishment of the child's physicality. The godparent, who is spiritual and metaphysical, takes up the responsibility of providing psychological safety and ensuring protection against the evil forces by connecting themselves with the child. However, according to the janitors, the distance between the child and the temple that houses the child god can prompt a disconnect or withdrawal of its blessings, which is manifested in sickness in the child. Thus, instead of medication, the parents usually re-procure and re-establish the supernatural surrogacy through a monthly propitiation

that consists of routinized libations and offerings by taking their child to the temple, for its milieu itself allows the child and human parents to reconnect with their spiritual father or mother.

This mode of surrogacy and reconnecting to one's *kyelha* is seen to rejuvenate or heal the sick altogether, and, most important, the child grows faster with the blessings of the spiritual parent. Because the mother's milk is thought to lack nutrition for the child without the spiritual parent's blessings, raising a child without the god's blessings is perilous. For the local gods, conveying their blessings on humans without reciprocal offerings assists the undeserving. The tripartite care among the child, parent, and the specific god characterized by the syncretic worldview continues until the child attains a certain age, which largely depends on its *kyelha*. However, it does not completely sever the bond between them, though it relaxes the mutual obligations. The relaxation of obligations allows older children to distance themselves from the child god as they prepare for life. All in all, their life seems to be divided between Bon and Buddhist beliefs: the initial stage of life is heavily Bonpo-centric, the mid-phase is an amalgam of both the Buddhist and Bonpo beliefs, and late part of life is heavily Buddhist-centric.

The relative influence of Bon and Buddhist beliefs varies throughout one's life; however, at all times one of them remains more influential than the other. The centrality of spiritual parents is more pronounced in the early and late phases of one's life. This is because the early part of one's life is characterized by vulnerability and uncertainty, and these conditions are reactivated by age later in life. It is these forces that, as a foreign agency, constrain a person to seek and re-seek psychological and spiritual refuge. However, the period between childhood and old age, which is regarded as the most vigorous and active stage of one's life, weakens the grip of these forces and makes the spirituality partially latent, as though it were essential only for the young and old. While the degree of spiritual concern varies throughout the stages of life, one's life is never completely free from it, even in the middle stage that characterizes the height of human vigor, independence, and intelligence.

The Golengpas' naming system not only has religious significance but also provides insights into the local customary practice. Such surrogacy or naming custom is not restricted to the people in a particular village or district. According to the temple janitors of the aforementioned temples, the

nonnative living in the domain of these local gods at the time of childbirth can easily be captivated by such custom. It is for this reason that I came across a considerable number of people, who were originally from different districts but because of their job posting were born in the villages with *kyelha* divinities, with names associated with these gods. For instance, I met people from several villages in Zhemgang bearing the name "Chungdu"—the local deity of Haa—as they were born in Haa. It then seems that there are many people with syncretic worldviews who rely on local Bon gods, at least in the early years—with their readily identifiable names—not least in the above regions. When such powerful earthly gods and deities are partially incorporated into Buddhism, people consider them higher deities while learned monks still view them as worldly gods.

The Former Clerical Bon Temple

According to Phuntsho (2014: 392), Bhutan was a place of interest for clerical Bonpos too, with visits by a number of its masters in the eleventh and twelfth centuries to rediscover treasure texts, particularly from Paro and Bumthang. There are currently two temples in Wangdiphodrang in western Bhutan that are historically associated with Yungdrung Bon. Located on the hill to the northwest of the famous Gangteng monastery,[5] Kumbu, which according to lay *chöpa* Phurba, is the localization of "one thousand statues" (*kubum*). Currently, the Clerical Bon deities are being propitiated by the lay Buddhists although they were not incorporated into Buddhism. The original temple is believed to have been founded by the Yungdrung Bon master Tsendhen Dewa, who appears as legendary as some Buddhist saints. Tsendhen Dewa also founded another Bon temple in Shar Sergang to the south of the Kumbu temple, and, considering their locations, they became his summer and winter residences respectively. According to Phurba, the original temple fell into disrepair and Tsendhen Dewa's chief disciple Druba Namgay—who was native to Kumbu village, constructed the present temple just above the previous site.

To unpack the debate surrounding the founder and the establishment of Clerical Bon in Bhutan, I witnessed the daily ritual involving the recitation of the biographical-propitiatory ritual (*namthar solkha*). However, it deals only tangentially with Tsendhen Dewa's life. In addition to daily ritual, a weeklong annual liturgy dedicated to Sid-pai Gyalmo, who is believed to be

a Clerical Bon equivalent of Buddhist Dharmapala Paldhen Lhamo, is currently being performed over three days coinciding with the death anniversary of Tsendhen Dewa. The founder in question, as claimed by Phurba, who has been serving as a janitor since 2014, is believed to be the reincarnation of the Yungdrung Bon founder Tonpa Shenrab. However, the supplicatory text, which is not datable and is without author, gives a contrasting account of his life. I have summarized the content of the text below:

> Tsendhen Dewa was born in India in his previous life and known as Metok Nyingpo, where he was a Buddhist and worshiped the Buddhas of Three Times (*Düsum Sangay*). Later he was reborn in the Ü-Tsang region of Tibet and came to be known by the name of Tshendhen Dewa. While in Ü-Tsang, he lived as a celibate and became one of the most learned disciples of unspecified Bon masters. After his scriptural education, he pursued the life of a recluse and traveled to southern Tibet (*lhokha*) bordering with Bhutan. There he practiced meditation, particularly at Lodrak and Shelkardrak caves, and performed many miracles of realization.
>
> Subsequently, he gained authority over the four planetary elements (*jungwa zhi*): earth, water, fire, and space elements, and, thus, he could fly freely in the air, travel by wind or thought, understand animal's sounds and languages, and eat by means of meditation (*tingnge zingi zey*). Since he can manifest in different forms, he magically traveled to proto-Bhutan (*Lho Mon*) prior to the founding of Kumbu temple to tame the local gods, *tsen* and *lu* beings. While he was meditating in that border area, a female shepherd from Lho Mon who came there to graze her sheep requested he visit her country. He gladly accepted her invitation and traveled to Lho Mon for the benefit of sentient beings by riding on sunrays. Through his melodious voice and compassionate mind, he benefited the people of Lho Mon greatly and founded two temples. While he could have attained the "rainbow body" in which one's body dissolves into space at death, he chose to leave his physical remains behind for the benefit of sentient beings. His body was preserved in a stupa inside the old temple, and, as a relic, it was circumambulated by spirit beings at night and by human beings during the day.

While this ritual text only adds muddle to Tshendhen Dewa's life, Karmay (2000) in his recent work argues that he is a well-known Yungdrung Bonpo figure who was born to a sacred Bonpo family of *dru* clan in the east of

Shigatse, Tibet. Relying on the textual sources written by Dorji Lingpa (1346–1405) and Gedun Rinchen[6] (1926–1997), Karmay believes that Tsendhen Dewa[7] founded Kumbu temple in the fourteenth century (2000: 7). However, Gedun Rinchen, using the Buddhist title "Zhabdrung" for the Bonpo monk without any specificity on the date of Tsendhen Dewa's arrival in proto-Bhutan, only suggests that he must have arrived in Bhutan in the seventeenth century or later—since that is when the Buddhist lama holding the title "Zhabdrung," which became a very popular religious title, founded a new state. Furthermore, the stupa believed to contain the remains of Dewa's disciple has attributes of recent architectural designs rather than antiquity. Therefore, it is highly unlikely that Tsendhen Dewa arrived in proto-Bhutan before the seventeenth century.

Shamanic Bon as practiced in Goleng and nearby villages does not have temples, monks, or religious texts, but in Kumbu one can find Bon texts and Bon iconographies, some of which are restricted from public view. For instance, along with the biographical-propitiatory text, there is a bulky piece of dusty text written in lowercase classical Tibetan (*um-yig*) without the author's name or clear title. The Kumbu temple also houses the main protective Bon deity—the Queen of the Universe (Sid-pai Gyalmo), who, according to the *koinyer*, volunteered to be the protective deity of Tsendhen Dewa while the latter was in the land of Rakshasas (*sinpo*) subduing demons. There are two statues externalizing the compassionate and wrathful essence of Sid-pai Gyalmo. From the vantage point of Kumbu villagers, the compassionate deity can also manifest in their dreams in the form of an elderly woman donning yellow robes. For instance, I was informed by the *koinyer* and the elderly woman who came to make lunch offerings of cooked meat and eggs to the deity that there are many people in Kumbu who were protected by the deity when their lives were under threat.

Until recently, the Kumbu temple, however, operated in conjunction with the Shar Sergang temple as the school for lay Buddhist practitioners (*gomde*) and had a circle of lay *chöpas*, but according to the janitor it was closed after the introduction of democracy in 2008 for political reasons, particularly to expand the voting franchise. In Bhutanese political tradition, clergy and religious communities are above politics, implying that they are not entitled to vote unless individuals resign from the clergy or cease to assume the role of a *chöpa*. Apart from the two temple janitors, there are currently no lay *chöpas*, although the janitor revealed that he can reinstitute *gomde* immediately after the government's approval.

While the deity is omnipresent, she is objectified in an old miniature statue, which according to the janitor is a compassionate manifestation of the deity. This statue divides its sojourn between the two temples. The statue is housed at the Kumbu temple during the summer—that is from the first of the fifth lunar month to the thirtieth of the eighth lunar month, while the Shar Sergang temple is responsible for the remaining months of the winter season. Apart from the old scroll painting (*thangka*), Kumbu had until recently no wrathful statue of Sid-pai Gyalmo. When I asked Phurba about the medium-sized wrathful statue of the deity that is now placed in the inner sanctum, he commented:

> The statue was sculpted in Kathmandu, Nepal, a decade ago, and I personally coordinated the safe transportation of the statue to the Kumbu temple. However, without financial assistance from a Bonpo monk of Yungdrung Bon monastery in Shimla, HP [Himachal Pradesh], it would not have been possible for us to buy this statue.

A small Buddhist temple commonly contains two shrines. The main shrine houses the statue of Buddhas, while the other shrine, which is smaller in size, houses the local deities who are partially incorporated into Buddhism. The main shrine is, of course, the center of religious activities and always open for the public regardless of status or sex. On the other hand, the sanctum is restricted, and women and polluted people are prohibited from entering it. Kumbu temple is compartmentalized into two such shrines—that is, the main temple hall and the small sanctum located next to it. While the main shrine is populated by multifarious Buddhist iconographies and texts, the sanctum houses only the Bon deity Sid-pai Gyalmo, who is considered the protective deity of the locality.

As I studied the temple, I detected the macabre artwork in the inner sanctum representing a fairly standard sort of imagery for protector chapels, with a charnel-ground setting and offerings of human and animal body parts. The base of the ritual table on which the offerings of cooked meat are made gleams with disembodied parts such as the whole and upper cranium *kapala*. There are two images of upright human skeletons close to the ritual altar, each holding an upper cranium *kapala* skull over the top. The skulls are graphically filled with steaming human blood and hearts, and between them is the flaming three-eyed Sid-pai Gyalmo riding a neighing horse, intricately carved, and elaborately adorned with precious stones. The flaming

wrathful deity has eight hands, each holding a weapon of different sorts and riding a neighing horse. Except for the caretaker, the faithful cannot enter the innermost sanctum, where the deity is placed behind a glass panel. These iconographies are superimposed by another human skeleton clutching a blood-filled skull and knee bone with its right and left hand respectively.

The upright skeleton is flanked by two human skulls and fleshless bones characterizing the votive oblation. In the uppermost closet, which is locked and bolted, a miniature statue of Bonpo Tonpa Shenrab, Tshendhen Deva's letter "AH" on a stone, the skull of an unidentified siddha (*druptob*), and other relics associated with Yungdrung Bon are hermetically sealed off to the public. While I was not able to verify the contents of the repository, according to the *koinyer*, some important relics including the statue of Tsendhen Dewa have been lost, and for this reason, the district office initiated a new approach to secure the remaining relics. These artifacts cannot be viewed by the caretaker himself, let alone the local people without the physical presence of relevant officials from the district office. Although it is not clear if the state's approach to protecting them has any link to its suppression of Bon practices, such important religious artifacts and treasures in the temples across the country are cataloged and protected by the state.

One interesting mural facing the sanctum magnetized my attention. It was a picture of the thirteen animals (*raluk chusum*) veiled by flowing drapery, partly to preclude desecration and partly to obscure its rawness. The janitor holds that there are images of thirteen animals, but one can find only eleven. The remaining two images at the bottom of the right-hand side of the mural are a human couple. The topmost row is occupied by two types of yaks and a pig, and three horses of different breeds face a dog in the middle row. A curled-up snake hissing at a snow lion, goat, and bull constitute the bottom row. The couple in the mural, who are naked and engaged in copulation, are apparently a symbol of fertility. Hence, to this day, an infertile person or a parent who lost her child seeks the blessing of fecundity from them, and some villagers maintain they have been blessed with a healthy child and child protection.

For the janitor, the explication of the mural appears as difficult as providing perspicuous accounts of the origins of the deity or the temple founder, although he asserted that the animals in the mural were tamed and domesticated by the founder for the first time in the locality. While accounting for the couple as an image of fertility is not a difficult interpretation, limiting

the meaning of the eleven animals to a mere representation of their domestication by the founder is far from convincing. More than taming and domestication, they appear to be the deity's agential beings, studded with the fire of fertility, power and prosperity, or *yang* powers. For example, the lustrous snake is usually an earthly representation of *lu*, who are well known for their wealth. Likewise, the snow lion is usually a mythical creature and considered the most precious animal in the entire region of the Himalayas, for it symbolizes much-coveted vitality and success. The rest are domesticated animals that are essential not only to traditional societies but also to the modern-day populace for food, work, and survival. The muzzles of these animals, including the human couple, are agape with a blazing fire, and, in general, such fire typifies amorousness, without which human procreation is virtually impossible. However, fire-exhaling beings can also be interpreted as the agents of the powerful deity who are imbued with the blessings of prosperity and fertility. Thus, these animals seem to be the sources of life for the worshipers, as their lives hinge on the blessings of the omnipotent deity Sidpai Gyalmo, which are suggested by these animal beings.

Currently, meals of cooked meat, eggs, and rice are offered to the deity by the janitor at least three times a day. Until recently a pig was slaughtered during annual propitiatory rituals, and cooked meat from the right side of the pig, which had been reared for the ritual, was offered to the deity. In recent times, the local people unanimously resolved to terminate the tradition of meat offering; however, this communal decision was reversed a year later after a time of misfortune and tragedy. During my fieldwork, an elderly woman entered the temple exactly at noon and handed a bowl of offerings with cooked meat to the janitor, who took it to the inner sanctum to make the formal offering (lunch) to the deity. The woman responded to my question on why the community reinstituted the offering of (cooked) meat.

> A decade ago, we arrived at a decision to cease the offerings of meat to the deity, and since then we have offered vegetarian meals. However, the following year, many people and animals became sick; the harvest of crops continued to dwindle, and natural calamities struck more often. We believe the offerings made in a form of vegetables and fruits did not appease the deity, and hence it caused sicknesses and misfortunes instead of blessings. We had little choice but to resume the practice of offering of cooked meat. While we no longer rear pigs for the ritual or for ourselves like in the days of

yore, we still offer the cooked meat and eggs, for it placates the deity to spare us from misfortunes and to increase our prosperity.

There was certainly discouragement of meat offerings by the Buddhist and other authorities, but according to the *koinyer* and the woman I met, they decided to reinstate the tradition of meat offerings because they believed that the deity ceased its protection of people when they offered vegetarian foods. Whether they buy meat from the market or not, the deity's protection appears to be procurable only through a routinized offering of meat on a daily basis.

The erection of large statues of the Buddhas of Three Times (*Düsum Sangay*), which Tshendhen Dewa was believed to have worshiped in his previous life, in the main shrine by Tenpai Nyinje (1875–1905), the Seventh Gangteng Rinpoche, in the late nineteenth century marks the Buddhist takeover of Kumbu temple. Yet we still find the statues of Buddhas and Bon deities installed in different rooms of the same temple. Most importantly, a small stupa is lodged on the altar just in front of the Buddhas of Three Times and is believed to contain the remains of the founder, Tsendhen Dewa, although there are no traces of the original temple founded by him. In any case, this miniature structure very much resembles a Buddhist stupa; yet while the Buddhist and Bon iconographies have been set alongside, the hierarchical differences between them are conspicuous. For instance, the three big statues of Buddhas occupy the central position of the main shrine, while the stupa believed to contain the body of a Bon monk is placed at the periphery of the offering table. Similarly, the main Bon deity, Sid-pai Gyalmo, is assigned a separate room that is smaller than the main shrine. This makes Kumbu a center of uniquely syncretic religious culture where both Buddhists and Yungdrung Bonpos rituals are observed side by side.

The Buddhists at Kumbu seem to be somewhat tolerant toward this Clerical Bon as Yungdrung Bon is believed to have originated from the old Shamanic Bon under the influence of Buddhism. The Buddhists refer to this new Bon as the reformed or even plagiarized Bon (*gyur Bon*) because, as discussed earlier, the clerical Bonpos appropriated Buddhists' canon into their texts and grafted Buddhist ideas and concepts onto their new rituals for new survival (see Bjerken 2004). Hence, Yungdrung Bon now have their own religious texts that are strikingly similar to Buddhist texts insofar as the only difference is that some Buddhist terms were replaced with Bon words. Furthermore,

the identity of the main protective deity of Kubum is considered a double of an important two-armed Buddhist protector, Palden Lhamo. According to Buddhists, Palden Lhamo was re-divinized by endowing a new identity and generously embellishing it with an additional six hands and weapons of different sorts. However, despite such individuations, the deity Sid-pai Gyalmo is still flaming, holding a flaming trident and blood-filled *kapala* while riding a neighing horse, making it almost indistinguishable from the Buddhist protector Palden Lhamo.

Upon closer examination of the shrine, I also found a similar modification of religious identities inside the Kumbu temple, particularly of the Buddhist monk Namke Nyingpo[8] of the eighth to ninth century, who was famed for his realization and the supposed ability to fly on sunrays. Like Namke Nyingpo, the fresco portrayed Tsendhen Dewa flying above the clouds, employing the regalia of dharma robes (*chö gho*), which are otherwise unknown to Shamanic Bon. Last but not least, the paraphernalia of Tsendhen Deva's disciple is again indistinguishable from the contemporary statue of Buddhist monk. What is most striking about these Yungdrung Bon masters is the lack of clear sense of their religious identities among the villagers, including the *koinyer*, who all assume that Tsendhen Dewa was one of the Tibetan Buddhist monks. The complexities of religious identity where the gods are made to appear fluid, transreligious, and transnational are evident in this region where Tsendhen Dewa is refer to as Zhabdrung—a Buddhist title whose usage gained currency only in the seventeenth century. In such frame, Yungdrung Bon seems to have once thrived in the Kumbu valley.

Whatever the case, it seems that one common way to suppress if not eliminate Bon beliefs has been to incorporate particular local deities into Buddhism who are powerful as well as central to the people and their village identity. The accommodation of Bon beliefs through such incorporations by some Buddhist masters, however, has not always resulted in the elimination of Bon beliefs, but rather perpetuated them through new forms. This is not only because of the heightened importance of these local deities on account of now being propitiated by the higher lay *chöpas* but also owing to the use of ritual implements such as the turban and drum that, as in god Odé Gungyal's propitiation, are typical accoutrements of shamanic Bonpos.

While in principle all Buddhist priests can, regardless of their training and knowledge, incorporate Bon beliefs into Buddhist rituals, evidence indicates

that the conversion of Bon deities into Buddhism appears to be successful only when tamed by highly realized masters such as Guru Rinpoche himself (cf. Ramble 2008). It is for this very fact that Golengpas' lineage deities are doubly propitiated through parallel rituals by the lay *chöpas* and Bonpos, which, rather than the coexistence between Bon and Buddhism, reflects the incompatibility between the two, and thus the failure to fully incorporate them into Buddhism. Since the Bonpos have not stopped propitiating these lineage deities even after their incorporation into the Buddhist version of *tsen düd* and Odé Gungyal rituals, the propitiation of the same deity by both the lay *chöpas* and Bonpos in the village also reveals a shared worldview and social identity.

The position of the ritual cakes in the annual propitiatory ritual provides clues to the status of the given local deity. That the ritual cakes of the four lineage deities occupy the lowest position in the hierarchy of *torma* arrangement attests to their status, which is still tied to the category of worldly deities. Any deity incorporated into Buddhism that is in the worldly category is imbued with the elements of Bon, reflecting the inherent opposition, while at the same time keeping the Bon beliefs alive through new forms of Buddhist interpretations. That it is primarily laypeople, rather than Buddhist monks, who are attracted to these incorporated deities points to the centrality of Buddhist accommodation, in its different forms and manifestations, as one of the agents in continuing Bon beliefs.

On the other hand, with the successful conversion of the powerful local deities into Buddhist protectors by high Buddhist masters, the Bonpos may cease to propitiate them, as in the case of prominent child gods, but that is not to say that their powers decline and become peripheralized to the people. In fact, as seen in the naming convention, these powerful deities, when subjugated and subsequently incorporated into Buddhist protectors by the realized Buddhist masters, become even more central to people. This is the case with the child gods of western Bhutan, who are originally the deities of non-Buddhist origin, that is, Bon. Some of them were converted into Buddhism by certain Buddhist masters and have now become the primary protectors of children born in that region.

In respect of Clerical Bon, while its protectress Sid-pai Gyalmo does not appear to be converted into a Buddhist deity, she is considered a double of Palden Lhamo, which the lay *chöpa*, particularly the temple janitor at Kumbu, has no problem in propitiating inside the temple that has now been converted to Buddhism. While the questions as to what extent these new

Buddhist rituals, and the Bon god Odé Gungyal and lineage deities themselves, have become Buddhist remain, Bon beliefs continue to survive not only through the Bonpos' rituals but also through the agency of lay *chöpas* and their syncretic rituals. With a clear understanding that the accommodation of Bon beliefs by the local lay Buddhist *chöpas* does not always lead to the elimination of Bon beliefs, I shall examine religious syncretism in Golengpas' religiosity in the context of great and little traditions.

9
The Persistence and Transformation of Golengpa Religiosity

This chapter continue to examine the mutual share processes and modifications between Buddhism and Shamanic Bon, and between Buddhism and Clerical Bon as a whole in order to contextualize the relationship between Buddhism and Shamanic Bon. It takes the interplay of Buddhism and Bon as its starting point for the enduring relationship between great and little traditions underpinned by the local conception of two forms of religion: mundane or worldly god's religion, and supramundane or Buddha's religion, to define Bon and Buddhism respectively, and presents new perspectives on the central distinguishing features of great and little traditions. Finally, it examines the trajectory of syncretism between Buddhism and Bon in Goleng and demonstrates the ways in which it works to weaken the distinctions between the two traditions, albeit rather unsuccessfully. Examining the process of syncretism against the backdrop of politics of religion in the wider anthropological context reveals that it operates rather to perpetuate the incorporated Bon beliefs without affecting the doctrine in totality into which they have been integrated for many years.

Buddhism, Shamanic Bon, and Clerical Bon

The complexity of Golengpa religiosity is better understood by exploring in the context of little and great traditions against which the relationship between Buddhism and Bon has to be understood. However, it may be recalled that the modification to the underlying distinguishing features of the great and little framework is an essential desideratum in this context. This is considering that a number of Bonpos are now educated and have texts for some Bon rites on the one hand, while the lay *chöpas* have not entirely rejected the Bon beliefs on the other. But first let me turn to the mutual sharing processes between different religious practices.

In Goleng, the campaign against the Bon beliefs and practices is not limited to the celibate monks, who are believed to be a primary force in eradicating Bon in Nepal and other Himalayan states (see Mumford 1989; Ortner 1978, 1995; Paul 1976). Nor is it entirely the centralized state that, with its civilizing mission, began taming and subjugating the believers of so-called false religious practices from the eighth century onward. In fact, there is currently not a single celibate or monastic-trained Buddhist monk in Goleng, let alone a resident incarnate lama. The Golengpa lay Buddhists are headed by the chief lay *chöpa* instead, who, as elsewhere, is a family man and never underwent formal religious training. Yet as the son of the village astrologer, he inherited the astrological knowledge from his father and later became the principal (*lopön*) of the lay school (*gomde*), which ceased operating a few years ago after failing to recruit new lay students. In stark contrast to the recent findings by Balikci (2008) in Sikkim, where opposition was observed not between Bon shamans and village Buddhist priests, but rather between what she calls "village Buddhism" and monastic Buddhism, and in the absence of the celibate and monastic-trained Buddhists in Goleng, the campaign against Golengpa Bonpos is very much active among the lay *chöpas*, spearheaded by the chief lay *chöpa*.

On the other hand, the state surveillance of Bon now appears to be somewhat relaxed as their missions against sacrificial and black magic rituals have been relatively successful. Despite a strong Buddhist presence, Haa in western Bhutan was the last district in the country to cease animal sacrifices to the local mountain deity, Chungdu. For many years, a yak was annually slaughtered to appease the deity, but the district officials in consultation with the state recently arrived at a decision to terminate animal sacrifices at the annual ritual. As reported by the national newspaper *Kuensel*, the deity's consent was confirmed after performing cleromancy during the last sacrificial ritual in 2013. While Haa is believed to be domesticated by Buddhist masters many centuries ago, Golengpas' exposure to Buddhist influence is a fairly recent phenomenon. Yet the Golengpa Bonpos are engaged only in White Bon rituals (*bon kar*) following the legal action against them. The authentication and appointment of official Bonpos in the late twentieth century, in which the state was directly or indirectly involved, was the state's realization of the need to make concessions to the Bonpos.

The Bonpos' rivalry has now shifted from the Buddhist state to the lay *chöpas*, who are not affiliated with the centralized Buddhist state. Yet, in order to make their campaign successful, the claim of association with a

certain popular religious figure who has a clear link with the state is quite common. For instance, Lopön Pema received a scarf, which is a symbol of recognition and power, from the former head of the district monastic body. So in the era of post-Buddhacization, syncretism and assimilation are, as previous studies have suggested, not just a mere form of domestication by Buddhist masters or illumination of the land by Buddhism. Now the practices are characteristics of White Bon ritual, so that the religious accommodation at the village level concerns mainly the power and dominance of lay *chöpas* over Bonpos. These lay *chöpas* are married ritualists and belong to Nyingma, Kagyu, or both.

Unlike Buddhist oracles, Golengpa men can become a Bonpo or Bonpo shaman independently—that is, without a Buddhist lama's influence on their initiations. They, as in many other Himalayan societies, perform manifold rituals that either complement or act as the precursor of Buddhist rituals. However, the campaigns against the Bonpos are specifically in relation to *rup* and its local variants, which seems to be because these rituals involve the whole community. While these local Bonpos are no more a threat to the Buddhist state or Buddhism as a whole, by performing an annual Bon rite within the village setting, they threaten the local lay *chöpas*' ritual power and their superiority over Bonpos. The *chöpas* therefore attempt to lessen the Bonpos' power by relegating their roles to minor rituals that demand less community participation.

As in the Himalayan Buddhist cultural worlds, Geshe Pema, a respected celibate Buddhist master, composed a ritual text for libation (*serkyem*) in which the local deity Rematsen was incorporated into the local Buddhist practice for the first time. Although the efficacy of the different rituals propitiating incorporated local deities is debated by some celibate monks, this tradition is being replicated by Lopön Pema, who composed another ritual text in an attempt to keep the Bonpos under control by subordinating the local deities through incorporation and accommodation. As discussed in Chapter 6, a ritual text for the annual *rup* rite was also composed by relying on Bonpos' ritual incantation (*mrang*), and more recently, a lay Buddhist *chöpa* who is a blood relative, that is, descended from a collateral branch of a Bonpo family, has been indeed identified to officiate at this Bon rite by Lopön Pema. Nonetheless, the local Bon deities continue to be propitiated by different religious actors, thereby increasing their importance to the people. Such accommodation is evidently the reason the later Yungdrung Bonpos accuses Buddhists of assimilation of their beliefs.

The clerical or Yungdrung Bonpos began to rediscover the hidden treasure texts (*terma*) by adopting the treasure discovery scheme of Buddhists, particularly of the ancient Nyingmapa school, which goes back to the eighth century.[1] As previously mentioned, Snellgrove (1980 [1967]) notes that the first four ways of the Nine Ways of Yungdrung Bon *terma* constitute "the whole range of Tibetan religious practice" (also see Kvaerne 1974, 1983; Karmay 1972, 2009 [1997]) primarily for the worldly benefit, which corresponds to Samuel's (1993) "pragmatic orientation," and the synthesis of what Gellner (1999) calls social and instrumental religions.[2] While the esoteric Buddhist texts were believed to be concealed primarily to prevent from getting diluted or lost in the future in the eighth century (Thondup 2014), the Yungdrung Bonpos argue that their texts were rather hidden to save them from destruction by Buddhists. The practice of burying politically sensitive topics continues in the Tibetan resistance movement today (McGranaham 2005).

In Goleng, for that matter in Bhutan generally, except for the Bon death rituals, which are completely absent both in the historical documents and in oral traditions, the other three of the Nine Ways, namely divination, propitiation of local gods, and, with some exceptions, black magic rituals, are very much part of everyday life. These practices, however, appear now more common among the Himalayan hinterlands where pre-Buddhist Bon practices have remained unreformed to the present day, rather than among the later Yungdrung Bonpos of Tibet. On the other hand, the other five ways of the Nine Ways of Yungdrung Bon, which constitute texts such as sutras, tantras, and most importantly Yundrung Bon Dzongchen[3] teachings, are something the local shamanic Bonpos are completely unaware of, let alone having the expertise in these complex philosophical dogmas. Clerical Bon's dependence on Buddhism and the ahistoricity of its legendary founder, who was elevated to a Buddha-like status, are already known. In support of the popular comments by the traditional Buddhist scholars, modern Western scholars seem to agree that the last five practices are nothing more than an effectively appropriated and modified version of Buddhism (e.g., Powers 2007: 510).

In this sense, the clerical Bonpos went on to appropriate not only Buddhist canons but also the prominent Buddhist religious figures of the past, including Padmasambhava—a cultural hero responsible for bringing Buddhism to Tibet and the Himalayan regions, including Bhutan. Padmasambhava was purported by the Yungdrung Bonpos to be the son of Drenpa Namkha[4] (see Hoffman 1979; Karmay 1972), while the old Buddhist sources show that the

latter was a Buddhist convert and the disciple of Padmasambhava (Thondup 2014). Similarly, Powers (2007) states that the canonical Yungdrung Bon texts are in truth Buddhist texts with new Bon titles and Bon terminologies for the key Buddhist terms, without alteration of the actual content. Karmay (2014) rightly points out that Clerical Bon is somewhat of an amalgam of beliefs of Hindu and Nyingmapa school of Buddhism. Nevertheless, clerical Bonpos, albeit elusively, distinguish themselves from the pre-Buddhist Bonpos (Blezer 2008: 438).

Yet in order to claim their historical indigeneity and religious legitimacy, they maintain distinctiveness from Buddhism and continuity with Shamanic Bon, although the local gods and deities of the unreformed Bon are absent in the recent publications by Western scholars that concern Clerical Bon. Blezer (2011) holds that such old narratives were recycled primarily to self-consciously suit the needs of the time—that is, to reflect the new vectors of the emerging Yungdrung Bon identity (212). On the other hand, it is well known that Buddhists accuse the clerical Bonpos of plagiarism of their sutras, tantras, and atiyoga (Dzongchen) teachings, but the latter redirects the accusation of plagiarism to the former. The accusations by the Yungdrung Bonpos are made from the vantage point or narrative of Shamanic Bon, whose local deities and gods were tamed and indeed incorporated into Buddhism for pragmatic reasons. Upon closer examination, these local deities, which play a central role in Shamanic Bon, are actually marginalized in Clerical Bon, never mind worshiped.

As I have shown earlier, the name "Tonpa Shenrab" is used during specific rituals but as a type of priest by the Bonpos rather than a legendary founder as claimed by the latter clerical Bonpos. For instance, while the people of Tingchim in Sikkim assign a space for Tonpa Shenrab alongside the altar of their *pholha*, *molha*, and other local gods (Balikci 2008: 14), there were no specific table or improvised altar dedicated to him in the Bon rituals that I witnessed. However, Tonpa Shenrab was frequently invoked by the Bonpos during the *lu*, *mamo*, and *düd* rituals as a powerful Bonpo master,[5] while, as attested by the ritual incantation below (*mrang*), the "Tonpa Shenrab" of the annual *rup* rite was referred exclusively to a certain ancestral father instead.

Invoke god (Odé) Gungyal, (and) father Tonpa Shenrab.[6]

In contrast to the elevation and deification of Tonpa Shenrab to a Buddha-like founding figure by clerical Bonpos, the name Tonpa Shenrab among

these shamanic Bonpos does not connote a Buddha-like status; rather, he was simply mentioned as Bonpo Tonpa Shenrab or father Tonpa Shenrab without alluding to a religious founder status. Furthermore, Tonpa Shenrab was only ever invoked after certain primordial Bon gods such as Odé Gungyal, suggesting that Odé Gungyal and other Phyva gods, who were believed to be apical ancestors of Yarlung kings of Tibet, are central to Shamanic Bon. Therefore, it seems that the title "Tonpa Shenrab" is a "floating signifier," rather than constituting a fixed identity of the Clerical Bon founder—which assumes various meanings and significance that are indiscriminately given at the whim of various ritualists and, of course, in different time periods. If "Shenrab" is referred to an accomplished ancient Bon ritualist, its meaning seems to be well preserved among the shamanic Bonpos who sporadically mention it during their rituals not as their founder but as a certain "nameless" Bon priest.

From Oral/Literary to Mundane/ Supramundane Distinctions

I have already pointed out in Chapter 1 that Buddhism is widely conceived not just by Golengpas but also by people across many societies in Tibetan and wider Buddhist societies as a religion that can ultimately lead its believers to enlightenment, and hence has higher and more prestigious tradition than Bon, which is viewed as religious practices that lack such soteriological doctrine. The supramundane or enlightened religion (*nangpa sangaypai chö*) is a cultural idiom for Buddhism, which is a literary tradition as well as a universal religion. So is the mundane religion (*jigtenpai chö*) and its equivalent, the worldly or worldly god's religion (*sid-pai lha chö*) for Bon, which is a nonliterary and local practice. Buddhism as a supramundane religion is, however, represented not only by the assembly of monks but also by the lay *chöpas* who are literate and, most important, unlike most Bonpos are considered village elite. *Nangpa sangaypai chö / jigtenpai chö* and *lha chö / mi chö* as conceptualized and experienced by Golengpas reveal that this indigenous theorizing of mundane and supermundane religions is indeed tantamount to the concept of great and little traditions.

These two levels, as analytical categories, are of particular relevance for Goleng because of the lack of a multiplicity of religious beliefs and the fact that the dominant Buddhism came very recently—that is, within living

memory—through the efforts of the local Buddhist missionaries from the Peling branch of the Nyingma school. The fact that Bhutanese Buddhism is compounded of Nyingma and Kagyu schools in general, and Drukpa Kagyu, Peling, and other sub-branches of Nyingma, indicates that there is no unifying central system in Goleng. Because of its remote location, Goleng has, nevertheless, remained somewhat disconnected from the mainstream centers of the Buddhist state, thereby maintaining its cultural and religious distinctiveness not only through the observance of annual Bon rites but also because of its unusual social structure, with declining nobilities on the one hand and matrilineal inheritance practices on the other. Central to Golengpa religiosity is the straddling of the divide between the supramundane Buddhism and the mundane Bon in such a way that their relationship reflects the ideas of great and little traditions.

At the same time, Goleng cannot be discounted as a peasant society, nor is its social organization comparable to that of India. In addition to improvement in agriculture, many Golengpas are now engaged in a diverse form of informal economy, and through a nonformal education system, many former illiterates are now able to read to some extent, while most of their children are either attending or have attended Western-style schools. The great tradition is therefore now being accessed by village literates who may not be elite at the national level, while the little tradition continues to be embraced by the literates and elite. In this sense, both are found in Goleng but without the underlying unity when viewed through the lens of peasant/elite and literate/illiterate dichotomies. This suggests that the conventional distinguishing features of great and little traditions such as orality/literacy, rural/urban, and peasant/elite are not static but rather dynamic and fluid, constantly shifting in relation to their meanings and boundaries. The problem then does not lie in the great/little model per se, but in the features that distinguish one level from another.

Adding to the improved access to either tradition in the village is that some Bonpos became literate and now have limited texts for Bon rites, some of which were written by lay Buddhist priests based on the oral rituals of the Bonpos. Nevertheless, while Bon has developed some literary texts, it lacks the radical sophistication of philosophies that are found in the great tradition. The little tradition is, as conceived by Golengpas, characterized by this-worldly ideals lacking the elements of transcendentally oriented philosophy or metaphysical doctrine, while the great tradition is regarded as supramundane, more prestigious than the former, with complex

philosophies that can ultimately lead them to take a higher rebirth in their next life. The development of literary texts by the little community did not necessarily lead their tradition to a higher status of great tradition because, while it has the potential to transform into a scriptural tradition over time, it nevertheless cannot develop a sophisticated philosophy that, like Buddhism, grants primacy to soteriology rather than to pragmatic concerns. Given the coexistence of the elements of great and little traditions in the society and in the same person, and the fact that Bon is by and large without the aspects of transcendentality, the idea of great and little traditions can therefore be reformulated on the basis of transcendentality and mundanity.

A diachronic change, however, shows a series of transformations in both the great and little traditions. These traditions have incorporated and continue to accommodate the opposing elements that they find relevant as well as crucial either to establish religious hegemony or to eliminate or simply to perpetuate the notion of little tradition, thereby provoking religious change. It is through such processes that Buddhism can be further categorized into village and philosophical Buddhism, which have slightly a different focus in that the former is oriented, albeit marginally, toward pragmatic concerns, rather than nirvanic liberation. That said, I agree that the great and little model is not useful for analyzing solely the various forms of a single religion. In the wider Buddhist world, Buddhists classify themselves into three major schools: Theravada, Mahayana, and Vajrayana, with their respective variants, especially in the latter, which is the newest in the scheme. Vajrayana Buddhism is prominent in Tibet and the Himalayas, and it is this category that the forms of Buddhism prevalent in Bhutan represent. Vajrayana itself has four main schools, Nyingma, Kagyu, Sakya, and Gelug, with various subbranches constituting each group. Each of these schools and subschools may have a specific specialization in the aspects of core Buddhist teachings, but the common, underlying theme across them is the Four Noble Truths, which in turn represent the foundational principle of Buddhism.

There are indeed claims of one school or subschool being more prestigious than the other, but no one form of Buddhism can be considered supreme, more authentic, and purer than another school or subschool of Buddhism, mainly because of the centrality of the Four Noble Truths to each of them.[7] Thus, this great and little distinction cannot be employed to study the relationship between and among the schools or subschools of Buddhism, let alone different world religions. The process of "universalization and parochialisation" (see Marriot 1955) or circular flow between the

two traditions depends on the established structure or Golengpas' notion of what tradition is great or little within the single, live, cultural context. The high/low distinction is a key idea of great and little traditions in that anything that is structurally or spatially higher, and philosophically otherworldly, is considered great by Golengpas, while everything that is structurally or spatially lower, and philosophically this-worldly, is regarded by them as little. Viewed in this way, Bon as the pragmatic religion of the ordinary people—that is, without transcendental elements—is destined to remain the little tradition whether or not the elements of Bon beliefs are incorporated into the great Buddhist tradition.

Despite the series of transformations of their original forms through syncretism that functions toward creating a middle ground between the two cultural extremes, the Buddhist monks and Buddhism are conceived as eternally great, and the Bonpos and Bon as eternally little, not just by the lay *chöpas* but also by the villagers even as they remain attracted to both Buddhist and Bon rituals, or for that matter to both enlightened Buddhist and unenlightened Bon deities. For instance, during the process of upward and downward circulations, the worldly Bon deities when incorporated into the otherworldly Buddhist pantheon, rather than becoming universalized divinities, have retained their original "worldly" features (*jigtenpai lha*) by becoming permanently parochialized deities. The dividing line between the great Buddhism and the little Bon in Goleng is therefore neat in that neither syncretism nor literacy can, by blurring its boundary, lead to the disappearance of the great and little divide. The great tradition in this context is transcendentally oriented philosophy with cosmological sophistication but not necessarily isolated to the domain of elite or literati. The little tradition, while it not only has features of nontranscendentality but also a philosophical vacuum with some level of cosmological sophistication, is not necessarily restricted to the realm of illiterates or the masses. Indeed the this-worldly features of little tradition are remarkably resilient to great Buddhism—a state-sponsored religion that invalidates Bon.

It should now be clear that a structural and conceptual disunity is missing in Golengpa religiosity, given that an active distinction between Buddhism and Bon is made by the ritualists of both the traditions, that is, Buddhist and Bonpo priests, and also by the villagers. Such distinctions are based on the otherworldly/this-worldly or transcendental/mundane features of Buddhism and Bon. They are not just the pure elements but also the pith and core of the great and little traditions respectively, thereby superseding

conventional distinguishing features. Given the fluidity and slipperiness of the boundary between conventional features, it is evident that the contrast between transcendentality and mundanity is fundamental to understanding the dynamics of great and little distinctions and how they relate to wider anthropological debates on cultural persistence. These new distinguishing features operate as elementary classifiers, but unlike the conventional elements of the great/little divide, they take the diversity of religious practices into account. In this vein, the mundane/supramundane divide is central to the survival of multiple great and little traditions in the same geographical area. Religions, regardless of whether they are major or minor traditions, have both transcendental or mundane aspects, but always with a greater emphasis on one or the other, as one or another orientation will emerge as predominant for any specific religion. This suggests that these aspects can very well be the universal features of great and little traditions. Therefore, attention should be drawn to this important shift of focus from the conventional distinguishing features of orality/literacy, peasant/elite, and so on, to the supramundane/mundane, the otherworldly/this-worldly, of the tradition itself.

Syncretism and the Politics of Religion

The blending of Shamanic Bon beliefs into the stream of Buddhism has been already shown. Some clergies regard syncretism as a concept that implies inauthenticity of the given religion due to penetration and mixture of diverse, incompatible religious beliefs, while others view it favorably. Within anthropology, syncretism is generally seen as a positive mechanism that is oriented toward maintaining unity in community, particularly where extant religions and practices influence one another in close proximity (Glazier 2006) although the term tend to oscillate between positive and negative uses in religious studies (Johnson 2017). The concept is also receiving renewed attention among anthropologists influenced by postmodernism,[8] who challenge the inevitability of syncretism by citing the evidence of multiple cliques inhabiting a single area only to mutually ignore each other's beliefs and cultures (Shaw and Stewart 2003), and also the fact that not all religions are mixtures in the same manner (Stewart 2011: 52–53). In recent times, the utility of syncretism in anthropological studies—that is, beyond its subjective meaning, which is limited to inauthenticity and impurity—is acknowledged

in relation to the power dimension of the contesting religious actors and fields within which syncretism occurs. Droogers (2015) emphasized that syncretism must be seen as a globalization process that is far more important than the notion of deviation from institutionalized religion (883). In other words, rather than treating syncretism as a category, the central focus has shifted from the debate over its meaning to the process by which syncretism happens (Droogers 2015) and the discourses of syncretism, both of which focus on power and agency (Shaw and Stewart, 2003).

In Goleng, there is no equivalent term for "syncretism" but expressions such as "neither Buddhist nor Bonpo" (*chömin bonmin*) are employed to refer to syncretistic practices between the two discrete beliefs. Yet there are clear cases of syncretism, most of which I have described at length, from annual propitiatory rituals of local deities and demons by lay *chöpas* to child gods and naming patterns, and from the Buddhist version of the Bon god Odé Gungyal ritual to the establishment of Clerical Bon in western Bhutan. As Droogers (2015) and Shaw and Stewart (2003) suggest scholars do, rather than its definition I shall focus on syncretism as a process of religious synthesis, in relation to the Buddhist mission of domesticating the so-called wild country and its untamed believers primarily through incorporation of Bon deities into the Buddhist pantheon.

Given the hundreds of years of friction between Buddhism and Bon, syncretism between the two can be described by paying close attention to the politics of religious synthesis and the relationship between (1) Shamanic Bon and Buddhism and (2) Buddhism and Clerical Bon. It is largely the Buddhists who have absorbed the pre-Buddhist Bon beliefs, including the shamanic worldview, by incorporating the local Bon deities into the pantheon of Buddhist protectors in the former, while in the case of the latter, it is primarily the clerical Bonpos who borrowed and appropriated Buddhist philosophies and canons, claiming them as their historical possession. Considering its inception phase, the new Clerical Bon of Tibet is clearly the result of creative bricolage of two different historical traditions essentially as a form of resilience by not only negotiating with Buddhism but also reinterpreting the old Shamanic Bon in radical ways. It is appropriate to recall that while they still claim unbroken continuity with Shamanic Bon, it was actually the Buddhists' campaign of the eleventh century that gave them a new impetus to restyle and distinguish themselves from Shamanic Bon, thus making their continuity with the old Bon spurious. Hence, the Buddhists believe their messages are being undermined only by the clerical Bonpos, whose religion is far more

philosophically sophisticated than the Shamanic Bon found in Goleng, and for that matter in Bhutan.

It may be stressed that the constant interplay between Buddhism and Shamanic Bon through the process of shared cultural idiom, synthesis, and accommodation of beliefs and practices by the religious actors is an ongoing reality in Goleng. Such heterogeneous blending of Buddhism and Bon beliefs and practices through the agency of tripartite division of Buddhist priests, Bonpos, and the ordinary people continues to make Golengpas' religiosity richly syncretic. The identities of religious priests (Bonpos and chief *chöpas*) are fixed and not open for interpretation or change because they not only conceive of themselves as specific religious actors but are also permanently glossed by the ordinary people as the agents of their respective traditions. In this sense, their religious identities are easily recognizable as much as their own traditions are distinguishable from one another.

Ordinary Golengpas, including the part-time lay *chöpas* and educated people who identify themselves as Buddhists, have no problem in propitiating the Bon gods and local deities, or having recourse to Bon rites after or prior to Buddhist rituals and biomedical therapies, primarily because Bon practices are deeply embedded in the ideas of healing with which they have grown up. While this somewhat obscures the dividing line between the great and little traditions, there is a conscious tendency to distinguish Buddhist from Bon rituals through the usage of categories such as "worldly gods" to refer to incorporated Bon gods and deities underpinning syncretic practices that operate to connect and negotiate the two extremes, though never in totality.

Unlike the relationship between Clerical Bon and Buddhism, syncretism between Shamanic Bon and village Buddhism is not viewed negatively by either. The local Bon gods and deities were incorporated by Buddhists by making them protectors in order to protect the temple and preserve the purity of Buddhism. In other words, there do not seem to be reciprocal contentions between the religious agents because incorporation of powerful Bon deities into the Buddhist pantheon guarantees that Buddhist tradition will remain pure, while perpetuating Bon beliefs through such accommodations. Upon further investigation, syncretism in Golengpas' religiosity, however, ostensibly expresses religious politics, control, and purity, particularly by Buddhism. By incorporating Bon deities that are unenlightened divinities into the Buddhist pantheon, the Buddhists are able to establish religious hegemony over the Bon believers. This is primarily because the ordinary people share close affinity with their local deities that appear uniquely real, palpable,

and accessible to them. What is at issue is the incorporation of only those local deities that are conceived as the most powerful by the people, and the indifference toward a plethora of other lesser deities and spirit beings who are never really incorporated into the Buddhist pantheon.

Syncretism in Goleng is then limited to the incorporation of powerful gods and the overriding beliefs associated with them since they, by virtue of their power, have a great many more worshipers than those lesser deities and spirits. It is tempting to argue that any local deities who are deemed or will be deemed to be powerful in the future are doomed to be incorporated into Buddhism. Although the lineage deities of Goleng are worshiped only locally, the incorporated local divinities can be worshiped either nationally or regionally depending on their power and who subjugated them. In this sense, power and dominance are always in play because by integrating the Bon gods first, Buddhists usually evade the antagonism of Bon believers that is otherwise consequent on attempts at direct conversion.

Syncretism operates toward officially deifying the gods of the other and guaranteeing the protection of Buddhism by these deified gods. It unites the believers by affecting their religious consciousness through incorporation of their most powerful local deities, in whom they have a great faith. The taming of local deities by Geshe Pema in Goleng and composing the Buddhist version of ritual text for *rup* by the current chief lay *chöpa* point to syncretism as an ongoing process of so-called domestication that in an anthropological sense can be understood as Buddhist acculturation—a teleological narrative of improvement. Nonetheless, the attempt to stamp out Bon has failed, and such borrowing, transformation, and assimilation have actually allowed people to declare and present themselves as Buddhists, while inwardly they remain heavily influenced by the worldview of Bon.

While the motivations of the *chöpas* in incorporating Bon deities and rituals are clear, the position of the Bonpos is less clear. The incorporation of the local Bon deities by the Buddhists and the appropriation of Buddhist texts by the clerical Bonpos were executed consciously to establish their legitimacy in the religious field of competing for power and dominance, while the shamanic Bonpos assimilated Buddhist ideals as a result of interaction with the opposing Buddhists. In this manner, syncretism among Bonpos can be seen as largely unintentional because the processes of syncretization have little to do with the rebuilding or recasting of their power in the religious field. Rather than reforging a new identity and religious authority, the Bonpos in this integrative scheme absorb prescribed Buddhist values for

their survival instead. Therefore, with some certainty, one can argue that intentional syncretism is mostly associated with power and dominance, while unintentional syncretism is generally concerned with coexistence, tolerance, and survival. On the whole, the antagonistic and resistive nature of the religious actors underlie the primary disposition of Golengpas that shape their religious habitus.

Returning to the friction between Bon and Buddhism, I have demonstrated that the major Bon rituals are the primary field of struggle where the hierarchy of religious actors and their beliefs are not only publicly exhibited but are subject to a renewed polarity. Esoteric knowledge is also the source of symbolic capital and access to social status and power, and therefore, crucial in maintaining social hierarchy. The lay Buddhist *chöpas* and Bonpos are inclined to clash, and their rituals usually intersect with each other, reflecting their social statuses and power relations within their complex religious history. The friction between the Buddhists and Bonpos remains covert until they meet in the social field, such as annual rites for either sustaining or establishing a new level of religious hegemony. Such clashes are stimulated by the habitus of the religious actors who possess different generational religious dispositions of their respective traditions. When that religious habitus is converged with a drive for religious hegemony within the particular religious field, the religious syncretism is foreground and perpetuated.

As seen already, the centrality of Bon in the *rup* rite is constantly challenged by the lay *chöpas* whose roles are marginalized for the entire ritual period. The Buddhist hostility toward *rup* and the official village Bonpo arises mainly due to the fact that *rup* involves mass community participation by prescribing a total embargo on the Buddhists and all the Buddhist practices. Hence during the *rup*, both the Bonpos and the Buddhists experience a renewed mutual opposition in an effort to maintain or recreate their statuses through a range of contestations. Whatever the opposition and antinomy between them, I observed no "antisyncretism" between Buddhism and Bon because syncretization in Goleng cannot easily be contained or prevented. Religious syncretism is actually functioning as the popular conduit for religious dominance and social integration for the external, foreign, and penetrating Buddhism on the one hand, and as the technique of survival and continuity for the internal, local, and all-embracing Bon on the other. It is therefore not always associated with the subversion of dominant religion or impurification of the pure religion, nor can it be reduced to their mere coexistence.

The shifting religious opposition by the centralized state religion to the autonomous lay *chöpas*, who may be distantly affiliated to the ancient Nyingma, the state-sponsored Drukpa Kagyu, sometimes both the schools, or even without any proper religious-school affiliation, is evident in villages such as Goleng. This is for obvious reasons. First, the official Buddhist mission, which was oriented toward prohibiting animal sacrifices and black magic rituals, has been successful. Following the unprecedented court order, the sacrificial rituals no longer appeal to Golengpa Bonpos, although some Bonpos elsewhere are still suspected of black magic rituals. Second, with the appointment of the official Golengpa Bonpo since the early 1990s, the remoteness of the location, and the continuity of Bon practices on the one hand, and the disappearing sacrificial practices coupled with Golengpas' exposure to mainstream Bhutanese life ushered in by the recent electrification and road connectivity, on the other, the centuries-long campaign of the mainstream Buddhists seem to be stalled.

Currently, the rivalry is between the Golengpa Bonpos and the lay *chöpas*, particularly their chief. While the chief links his anti-Bon propaganda with the historical association of Bon as a fallacious and perverted faith, and in need of religious upgrading to Buddhism, it is obvious that the lay *chöpas* and their chief without monastic training do not live up to the original Buddhist ideal. The lay *chöpas* of Goleng still do conform with the *rup* Bonpos' rule, but their chief, Lopön Pema, has become increasingly ambivalent about the prevailing restrictions on them not just because of the proscription of Buddhist practices per se but also because of the involvement of the whole community. The communal events are viewed by the religious actors as threats to their power and as an arena where the opposing religious agents contest and forge a renewed power relation. Given that Lopön Pema is more hostile to the official village Bonpo who officiates at this important Bon ritual than to other unofficial Bonpos who perform various kinds of other Bon rituals, including even some of the much-contested black magic rituals, the religious friction in Goleng is now associated with the power and dominance over the village populace rather than the popular civilizing mission of the past.

To summarize, one obvious reason for the relevance of great/little traditions in Goleng is the recency of the formal Buddhist presence, that is, in the lifetime of the senior Golengpas. Within the Golengpa religiosity, one can discern Bon being consciously viewed by Golengpas as the little religion that is, however, not capable of becoming the great tradition, while Buddhism is eternally perceived as the universalizing great religion. Bon rituals are

primarily oral, local, unofficial, and prosperity-oriented, and therefore immediately relevant to all the people. Conversely, Buddhism is official, translocal, literary, and also more expensive. The higher ritual expenses and the lack of monastic-trained or reincarnate monks in the villages point to a greater accessibility of great tradition for urban than for rural communities. Nonetheless, relegating the little tradition exclusively to the marginal groups who are believed to be mainly occupying the fringes of society, while elevating great tradition to elite who, on the contrary, are viewed to be holding a higher position at the center of their society, is problematic, particularly in the era of constant change and developments, in terms of both society and religion.

The development of texts in some Bon rituals over time raises the question of whether Bon can be still viewed within the same old inferior folk category that in Redfield's sense upheld the little tradition. On the other hand, there are those prominent people within or outside the village whom Golengpas have a tendency to call the social elite even though they have not rejected the little tradition. Basing the distinction on the literary features they do or do not possess, or the abilities of the believers to articulate or read the literary tradition, only blurs the great/little dichotomy. Rather than limiting it to conventional dichotomies such as rural/urban, local/translocal, and oral/literary, the great/little divide should be understood on the basis of two fundamental views—mundanity and supramundanity.

The analysis of incorporation of beliefs illustrated that religious syncretism in Goleng is mainly concerned with power for Buddhists—that is, primarily to establish religious hegemony in the region—and survival for Bonpos. While the Buddhists have incorporated a range of local gods of Shamanic Bon by making them their dharma protectors, the clerical Bonpos appropriated Buddhist philosophies and deities. This was primarily to compete with Buddhism in a bid to keep up with the proliferation of new Tibetan Buddhist schools in the eleventh century. While blending of practices in the case of Buddhist incorporation of local deities of Shamanic Bon is mainly concerned with controlling the Bonpos, it would be a fallacy to assume that syncretism has eliminated the little tradition. In fact, syncretism is one of the main factors that perpetuates Shamanic Bon beliefs through the renewed propitiation of local Bon deities by the lay *chöpas*. Rather than disembedding the opposing beliefs, syncretism has operated to embed them. The same can be said of the clerical Bonpos' incorporation of Buddhist elements.

10
Conclusion

The primary aim of the book has been to investigate the reasons for the persistence of Bon practices and beliefs in the face of systematized censure from Buddhist priests since the eighth century. The subsidiary aims have been to ethnographically illustrate the extent to which Bon beliefs are embedded in the village social life. In so doing, I have examined the experience of Bon as practiced by the villagers today, and how Bon through its contemporary manifestations shapes their everyday life.

Previous studies of Bon in Bhutan have been conducted predominantly by Buddhist scholars and historians who often discounted it as the religious practices of preliterate and backward communities that require religious upgrading to Buddhism. Central to the Buddhists' portrayal of Bon as divergent, antithetical religious practices is the ubiquity of the worldview rooted in shamanistic and animistic beliefs. While Bon has been studied by anthropologists elsewhere in the Himalayas, the existing literature on Bhutanese Bon rituals is written largely from the Buddhist and Bhutanological[1] perspectives and has received limited anthropological attention. This anthropological inquiry into the persistence of Bon is thus an ethnographic record of the prevailing Shamanic Bon in Bhutan, rather than of the specific localized ritual or festival of certain isolated Bhutanese communities. The theological, historical, and philosophical studies of Bon, which are mostly polemical, are mainly concerned with its soteriological problem, and by extension the role of Buddhism in taming and humanizing its believers. Contextualizing the study within a village ethnography, which is where such practices and beliefs have a stronghold, means the focus has been on the pragmatic aspects of Bon, rather than its transcendental elements.

The reasons for the persistence of Bon practices and beliefs amid censures by the Buddhist priests are multilayered, manifold, and complex. One obvious reason why Bon has persisted in Goleng is not just the recency of Buddhism but that Goleng has a weak Buddhist presence with only a handful of lay *chöpas* today. It is also owing to the sheer lack of what I have called "philosophical Buddhism" in many parts of Bhutan, as Buddhism entered

the country in close contact and engagement with, as well as in opposition to, Bon, and hence intertwined with the complex Bhutanese religious history as a result of the encounters between the two traditions. The present-day form of Buddhism in the current religio-political milieu of Goleng is characteristic of what many anthropologists elsewhere have called village or pragmatic Buddhism. In this book, it is referred to as "village Buddhism" for its attributes are more cultural and syncretistic than philosophical Buddhism per se. In other words, rather than a core Buddhists doctrinal position, the emphasis is on what might be called the "Tibetan Buddhist culture," which itself emerges as an assemblage of both philosophical Buddhism and Shamanic Bon.

In a typical community where village Buddhism is in vogue, the ordinary people, including the monks and lay *chöpas*, are less concerned with the notion of enlightenment or transcending the realms of samsara because achieving nirvana in this life is simply seen as beyond their scope or outside the bounds of possibility. The karmic and pragmatic concerns[2] are representative of the interest of wider Bhutanese society as people strive to accumulate merit (*gewa*) so as to escape the cyclicity of this samsaric life—not because of the realization but because of the merit accrued in this life. For instance, rather than studying literary texts, a large section of monks and lay *chöpas* are engaged in performing Buddhist rituals for others, thereby gaining merits that are necessary for higher rebirths. Likewise, the recitations of sutras and other core Buddhist rituals at the village temple are regularly sponsored by the laities, for so doing, they can also accrue merits commensurate with good acts. Such meritorious deeds are spiritually beneficial to both the ritualists/sponsors and self/others, and are seen as the favorable alternative for achieving at least higher rebirth in their next life. In this sense, village Buddhism is to great extent cultural and pragmatic as well as karmic, while philosophical Buddhism is predominantly transcendental and soteriological in its orientation.

While Buddhism is believed to have arrived in proto-Bhutan as early as the eighth century, the first Goleng temple was constructed in the late 1960s to reform village Buddhism and not Bon per se. It was only after the construction of a second temple that Bonpos have come under increasing scrutiny from their Buddhist counterparts, thus marking the new religious order in the village. Given that the people are largely practitioners of the Peling subschool, the underrepresentation of the state-sponsored Drukpa—a subschool of the Kagyu school—at the village level should be taken into

consideration in understanding how Buddhism operates. It is also important to note that Bon in Bhutan is a vastly different religious practice from the later Yungdrung Bonpos' construct of the term. Today, Bon in Bhutan and the Himalayas is not the same as in Tibet (Yungdrung Bon) and vice versa, as the label means different things to different religious groups, and Bon takes different forms of practice in interaction with the state religion—Buddhism.

In Shobleng, there are not many lay Buddhist priests, and for the most part, they are dependent on Golengpa *chöpas* who usually spend weeks in Shobleng during the ritual season. The majority of these existing handful of Golengpa *chöpas* are qualified in pragmatic aspects of Buddhism, in the sense that none of them has undergone a sustained solitary retreat (*tsam*) or formal study and training at higher scholastic institutions. Furthermore, except for the chief lay *chöpa*, the rest of them are part-timers who are mostly engaged in nonreligious careers during the offseason. The rituals of the lay Buddhist priests or for that matter of village Buddhism are characterized by syncretic assemblages and networks, with a strong base in the confluence of philosophical Buddhism and Shamanic Bon, which more often than not activate the Bonpos' shamanic worldviews even though they present themselves as antagonistic to Bon practices and Bonpos.

Bon remains viable, Buddhist censure notwithstanding. The lack of celibate, scholastic Buddhist monks and reincarnate lamas who are trained in philosophical Buddhism, or even pseudo-tulku, who are otherwise quite common in Bhutan, on the one hand, and the accessibility of Bonpos to ordinary people, on the other, make the Bon priests all the more handy and their rituals more prominent. As strange as it may seem, most of the reincarnate Buddhist masters appear to now be more interested in teaching the non-Bhutanese populace—somewhere in foreign and industrialized countries rather than the insiders of regional Bhutan—who lack understanding of the fundamental ideas of the pure or philosophical Buddhism. In stark contrast to the Buddhist conception of Bon, Bon rites are generally viewed by the villagers as a precursor of, or complement to, biomedicine and Buddhist rituals, particularly when the sickness is believed to be associated with the notion of loss of *la*—a phenomenon largely overlooked by biomedicine. These Bon rites, akin to what Sax (2009) has shown among the healing ritualists of Garhwal, are oriented toward addressing certain needs, whether of individual person or of family or community, that are unfulfilled by biomedicine (242–245) as "even the most advanced medical knowledge has its limits" (Pigg 1996: 191). The idea of complementarity between Bon and Buddhism

is, however, the view of the villagers, as opposed to *chöpas* and Bonpos who are seen as never sharing a ritual altar.

This study has demonstrated that the persistence of Bon is inherent in the deep-rooted syncretic worldview of the centrality of ever-fluctuating five life elements, particularly the *la*. This is a belief that has wide circulation not only in rural Bhutanese communities but in the urban areas as well. Declining *la* requires Bonpos' interventions, and even more so when there are no parallel Buddhist rituals or no lay Buddhist expert in the villages for such spiritual phenomena caused by various classes of untamed supernatural beings. People are exposed to the cosmological conception of five life elements from birth, and it remains with them the rest of their life; hence this permanently internalized worldview transcends religious, social, class, and familial boundaries. In most case, while Bhutanese profess to be Buddhist, they are attracted to Bon aesthetics and beliefs because of the incorporation of the local deities in village Buddhism and of the shamanic rituals that are seen as effective in dealing with certain everyday misfortunes.

The centrality of the five life elements in Golengpas' world is also reinforced by the immediacy of the natural environment, which is believed to be shared with a great many nonhuman beings. In their worldview, these autochthonous agents are palpable and are generally viewed in a negative light: as the primary abductors of their *la*, as the cause of misfortunes and sufferings, and finally as destructive forces capable of exhausting all other life elements that are central to their vitality and prosperity. These notions derive from the shamanic worldview of a tripartite division (i.e., upper: *lha*, middle: *tsen*, and lower: *lu*) in which the autochthonous beings are often as not regarded as the original owners of the land (*nepo*) and humans as mere guests (*jonpo*) in the middle realm of *tsen* beings. Because of their proximity to human guests, these supernatural beings are prone to harm humans by abducting their *la*, especially when people desecrate their abodes, and nonhuman entities and their agents no longer receive regular offerings. Hence, in the annual rites such as *rup* the higher gods are invoked to shield villagers from the malevolency of the local numina who demand regular offerings but deliver limited blessings on humans, and also from the crop-wrecking pests and wild animals who encircle their villages.

Because there are always senior persons, some of whom have recently returned from urban areas, to fulfill the needs of the people by becoming a Bonpo, there has never been the expectation that the younger generation will remain in the villages to become Bon priests. This indicates that

although Bhutanese people, with the exception of some Hindu followers, have been long converted to Buddhism, they have not stopped believing in these Bonpos and Bon deities. The same applies to Golengpas, Shoblengpas, and other nearby villages who self-identify as Buddhists, yet the majority of whom are also engaged in Bon rituals to increase their luck and protection from the volatile beings who cohabit with them. The Bonpos' intervention is particularly significant when their *la* is believed to be abducted by malicious beings since, apart from the general *tsekhug lalug* ritual, there is no parallel Buddhist ritual or adequate healthcare at the village level to deal with the illness seen to be precipitated by spirits who are accused of abducting people's *la*. It is only the Bonpos who possess all the necessary tools to tackle the plethora of local deities and spirits who are, while independent of Buddhists, never really appeased once and for all.

Bon is also deeply embedded in the village economy and its social organization. While the majority of everyday Bon rituals are oriented toward reinvigorating one's vitality, fertility, and longevity, the annual *rup* is primarily concerned with boosting the collective harvest and increasing livestock productivity. What is interesting is that such annual Bon rites are celebrated among the string of villages where there are surviving nobilities or their remnants connected with the certain nobilities of past, that is, the Yarlung kings of Tibet. I have shown that the *rup* rite in which the primordial Bon god Odé Gungyal is invoked is central to the ongoing status of the *dung* nobility who in turn have become central to Golengpa identity. In celebrating this annual Bon rite, the Golengpas affirm the link between the god Odé Gungyal and the *dung* family, and the importance of *rup* to the latter. The centrality of *rup* and other Bon practices to Golengpas is reflected in the district office's realization that it has to make concessions to them by recognizing Bon through the appointment of an official village Bonpo. In this sense, the Bon practices are sustained not only by the village structure, history, and declining influence of the old feudal hierarchy but also by the regional government.

Like many other pragmatically oriented religions, Bon also continue to survive by reason of its doctrines, which are concerned not only with supporting the vitality of people but also with increasing and sustaining the prosperity of the community. In other words, Shamanic Bon is what Leach (1968) has called "practical religion" that is "concerned with life here and now" (1–3). Following the omission of the annual *rup* rite in 2018 which was triggered by the indifference of the prominent people toward *rup*, Golengpas took matters into their own hands and organized what they called a very

"successful' *rup* by inviting the de facto official Bonpo from Gelephu. This undertaking was stimulated particularly by the unusual economic decline that the community experienced that year as a result of a poor harvest, pest infestation, and wild animal incidents, all of which Golengpas attribute to the failure to perform the annual *rup* rite, and by extension propitiate god Odé Gungyal along with his complex local pantheon.

Although the connectedness of Golengpas to mainstream urban Bhutan is improving, Zhemgang district itself is reckoned to be one of the least developed districts of the country. This status is perpetuated by the recent conversion of the region into protected areas that are now teeming with wildlife. Consequently, the district has endured limited development plans because of the circumscribing of developmental projects by the state. Hence, due to their environmental situation, the hazard of economic misfortune is conspicuous as one descends into the hinterlands of southern Zhemgang. The Bon practices are more common among the remote villages that are rife with economic inequality where philosophical Buddhism has not yet penetrated every layer of their social life.

With that being said, Bon cannot be discounted as simply a village religious practice since it is Shamanic Bon that, as an all-pervading religious practice, has rather penetrated village Buddhism, which in turn pervades every aspect of Bhutanese society. Rather than civilizing, eliminating, or even transcendentalizing Bon, philosophical Buddhism ended up absorbing some of the worldviews of Bon, thereby, through an inadvertent synergy between Buddhism and Bon, giving rise to a syncretic form of Buddhism: village Buddhism. This form of Buddhism in Bhutan perpetuates Bon not just through its borrowed shamanic worldview but by incorporation of Bon deities into, and replacement of various Bon rites with, Buddhist rituals, all of which are saturated with positive valance as opposed to their Bon counterparts.

The Bon beliefs are tied to the places, which in turn influence and shape Golengpas' everyday lives. While the appearance of homogeneity is ever present in rural Bhutanese social structure, Goleng is unique, and its localized ritual practices are essential for local identity formation. The local system of descent and family lineage houses with their own deity and rituals associated with propitiation of local deity to safeguard against everyday obstacles form an important part of local history and identity. The fact that villagers present themselves as Buddhists does not make them nonbelievers in Bon. Along with Bon, which reflects ordinary people's everyday lives, the Peling

subschool is popular in Goleng, but the lack of presence of state-sponsored Buddhism, Drukpa Kagyu of the Kagyu school, means that there is no unified, centralized system. In other words, the weak Buddhist presence cannot sustain a coherent cultural system, thereby enabling Bon as a local culture to continue to remain more relevant to villagers' everyday concerns and local problems.

In addition to the common Buddhist versions of mitigating rituals for increasing the five life elements, it is not entirely uncommon to encounter urban Bhutanese consulting a Bonpo shaman, or the latter surviving in the cities and towns. This study, therefore, questions the common notion of Bon beliefs as declining in the face of globalization, as the continuing relevance of Bon practices in the life of villagers contradicts it. At the same time, the shift in religious opposition from the centralized state religion to the autonomous lay *chöpas* suggests that religious change is not always provoked by the process of modernization but rather by the interests of the state and local religious actors and the histories and ideologies of their religious practices.

While the villages in Zhemgang district are still developing, it is clear that Goleng is quite a prosperous community that is connected by a farm road, and its farming systems are enhanced by electric fences jointly funded by two NGOs: the Rotary Clubs of Thimphu and Handa, Japan, for containment of wild animals. Golengpas are familiar with the market economy through sales of red rice and organic vegetables to nearby towns, and they do receive a monthly in-village health checkup from the Yebilaptsa hospital in Trong county.

Yet with a small population, the lack of accessible and reliable medical facilities in the village, and above all Goleng village's sacred geography, the Bonpos remain one of the alternative point of contacts in times of ill-health and misfortune, and act as the conduit for ritually regulating the social problems that continue to trouble people's lives, regardless of their education and status. While the Bonpos' roles seem somewhat fragmented due to constant opposition from the lay *chöpas,* their utility to the villagers has, nonetheless, not declined at all. It is evident that these villagers see no fundamental opposition between great tradition, Buddhism, and little tradition, Bon, because of the latter's efficacy in, and influence on, their everyday lives.

APPENDIX

Phonetic Renderings of Local Terms

Sl. No.	Local Term	Dzongkha Spelling	Wylie Transliteration
1	'ong	ཨོང་།	'ong ǀ
2	'khyar bon	འཕྱར་བོན།	'phyar bon ǀ
3	a-ya	ཨ་ཡ།	a ya ǀ
4	acho pra	ཨ་ཅོ་སྤྲ།	a co spra ǀ
5	aii zön	ཨའི་ཟུང་།	a'i zung ǀ
6	aku wäm	ཨ་ཁུ་ཝམ།	a khu wam ǀ
7	amai tsab	ཨ་མའི་ཚབ།	a ma'i tshab ǀ
8	apai tsab	ཨ་ཕའི་ཚབ།	a pha'i tshab ǀ
9	ara	ཨ་རག	a rag ǀ
10	ashi	ཨ་ཞེ།	a zhe ǀ
11	atsara	ཨ་ཙ་ར།	a tsa ra ǀ
12	atsara gongma	ཨ་ཙ་ར་གོང་མ།	a tsa ra gong ma ǀ
13	Aum pünsum	ཨམ་སྤུན་གསུམ།	Am spun gsum ǀ
14	bagdib	བག་གྲིབ།	bag grib ǀ
15	balu salu	བ་ལུ་སུ་ལུ།	ba lu su lu ǀ
16	bamin	བ་མེན།	ba men ǀ
17	bangchang	སྦང་གཅུང་།	sbang gcung ǀ
18	bär	བར།	bar ǀ
19	barché	བར་ཆད།	bar chad ǀ
20	Bardo Gewog	བར་དོ་རྒད་འོག	Bar do rGad 'og ǀ
21	basha gum-mar	བ་ཤ་འགྲམ་དམར།	ba sha 'gram dmar ǀ
22	Berti	བེར་ཏིག	Ber tig ǀ
23	Beyul Khempalung	སྦས་ཡུལ་མཁན་པ་ལུང་།	sBas yul mkhan pa lung ǀ
24	Bindulung	བིནྡྷུ་ལུང་།	Bin dhu lung ǀ

Sl. No.	Local Term	Dzongkha Spelling	Wylie Transliteration
25	Bjoka	ཞོ་བགང་།	Zho bkang \|
26	bogma	བོག་མ།	bog ma \|
27	bomethna	བུད་མེད་ན།	bud med na \|
28	Bon	བོན།	Bon \|
29	Bon chö	བོན་ཆོས།	Bon chos \|
30	Bon kar	བོན་དཀར།	Bon dkar \|
31	Bon nag	བོན་ནག	Bon nag \|
32	Bonbo	བོན་བོ།	Bon bo \|
33	Bonpo	བོན་པོ།	Bon po \|
34	brampa seng	བྲ་མ་གསེང་།	bra ma gseng \|
35	bsgyur bon	སྒྱུར་བོན།	sgyur bon \|
36	Buli	བུ་ལི།	Bu li \|
37	bumpa	བུམ་པ།	bum pa \|
38	Bumthang	བུམ་ཐང་།	Bum thang \|
39	Chakna Dorji	ཕྱག་ན་རྡོ་རྗེ།	Phyag na rdo rje \|
40	Chalikha	ཕྱྭ་ལི་ཁ།	Phywa li kha \|
41	chäm pön	འཆམ་དཔོན།	'cham dpon \|
42	chämjü	འཆམ་མཇུག	'cham mjug \|
43	Chamtang	ཅམ་བཏང་།	Cam btang \|
44	chan	ཅན།	chan \|
45	changkoi	ཆང་སྐོལ།	chang skol \|
46	Changlochen	ལྕང་ལོ་ཅན།	lCang lo can \|
47	che	ཆེ།	che \|
48	chibta	ཆིབས་རྟ།	chibs rta \|
49	Chimi	སྤྱི་མི།	sPyi mi \|
50	Chiwog	སྤྱི་འོག	sPyi 'og \|
51	Chö	ཆོས།	Chos \|
52	chö gho	ཆོ་ག	cho ga \|
53	chod shampa	མཆོད་གཤོམ་པ།	mchod gshom pa \|

Sl. No.	Local Term	Dzongkha Spelling	Wylie Transliteration
54	chodpa	མཆོད་པ།	mchod pa \|
55	choje	ཆོས་བརྒྱུད།	chos brgyud \|
56	chökyong	ཆོས་སྐྱོང་།	chos skyong \|
57	chöma	མཆོད་མ།	mchod ma \|
58	chömin bonmin	ཆོས་མིན་བོན་མིན།	chos min bon min \|
59	chooth	བཅུད།	bcud \|
60	chöpa	ཆོས་པ།	chos pa \|
61	chösham chala	མཆོད་གཤོམ་ཅ་ལག	mchod gshom ca lag \|
62	chu rab	ཆུ་རབ།	chu rab \|
63	chunagu	ཆུ་སྣ་དགུ།	chu sna dgu \|
64	chung	ཁྱུང་།	khyung \|
65	Chungdu	ཁྱུང་བདུད།	Khyung bdud \|
66	Chungdu pawo	ཁྱུང་བདུད་དཔའ་བོ།	Khyung bdud dpa' bo \|
67	chupa	ཕྱུ་པ།	phyu pa \|
68	chutsang	ཆུ་གཙང་།	chu gtsang \|
69	Dagana	མདའ་དགའ་ན།	mDa' dga' na \|
70	Dakpai	དག་འཕེལ།	Dag 'phel \|
71	dali chamu	དགྲ་བརླག་གཅམ་བུ།	dgra brlag gcam bu \|
72	damo	མདའ་མོ།	mda' mo \|
73	dhagpo	བདག་པོ།	bdag po \|
74	dham	བསྡམས།	bsdams \|
75	Dhangkhar	གདང་མཁར།	gDang mkhar \|
76	dhensa	གདན་ས།	gdan sa \|
77	dhok jor	ཟློག་སྒྱུར།	zlog sgyur \|
78	dhon dhogmala	གདོན་དོག་མ་ལ།	gdon dog ma la \|
79	dhou busa	དྭུ་བུ་ཚ།	dwa'u bu tsha \|
80	dhungmin	དུག་མིན།	dug min \|
81	dib	གྲིབ།	grib \|
82	Dolepchen	རྡོ་ལོག་ཅན།	rDo log can \|

Sl. No.	Local Term	Dzongkha Spelling	Wylie Transliteration
83	dong chang	གདོང་ཆང་།	gdong chang \|
84	Dorji Lingpa	རྡོ་རྗེ་གླིང་པ།	rDo rje gling pa \|
85	Dorji Sempa	རྡོ་རྗེ་སེམས་དཔའ།	rDo rje sems dpa' \|
86	drä mo	འབྲས་མོ།	'bras mo \|
87	drakha	དགྲ་ཁ།	dgra kha \|
88	draktsen	བྲག་བཙན།	brag btsan \|
89	dralha	དགྲ་ལྷ།	dGra lha \|
90	dralha chusum	དགྲ་ལྷ་བཅུ་གསུམ།	dgra lha bcu gsum \|
91	dralham	གྲ་ལྷམ།	gra lham \|
92	drangtsong zerkham	དྲང་སྲོང་གཟེར་ཁམས།	drang srong gzer khams \|
93	drapa	གྲྭ་པ།	grwa pa \|
94	dratsang	གྲྭ་ཚང་།	grwa tshang \|
95	drongkher menpa	གྲོང་ཁྱེར་སྨན་པ།	grong khyer sman pa \|
96	drubde	སྒྲུབ་སྡེ།	sgrub sde \|
97	druyi yang	འབྲུའི་གཡང་།	'bru'i g.yang \|
98	Druk	འབྲུག	'Brug \|
99	Drukpa	འབྲུག་པ།	'Brug pa \|
100	Drukpa Kagyu	འབྲུག་པ་བཀའ་བརྒྱུད།	'Brug pa bka' brgyud \|
101	Drungkhag	དྲུང་ཁག	Drung khag \|
102	drungpa	དྲུང་པ།	drung pa \|
103	drungyi	དྲུང་ཡིག	drung yig \|
104	düd	བདུད།	bdud \|
105	düd chod	བདུད་མཆོད།	bdud mchod \|
106	düdmo	བདུད་མོ།	bdud mo \|
107	düdpo	བདུད་པོ།	bdud po \|
108	duk ama	དུག་ཨ་མ།	dug a ma \|
109	dukgyud	དུག་བརྒྱུད།	dug brgyud \|
110	Duklha	དུག་ལྷ།	Dug lha \|
111	dung reng	གདུང་རེངས།	gdung rengs \|

Sl. No.	Local Term	Dzongkha Spelling	Wylie Transliteration
112	dung-gi khorlo	གདུང་གི་འཁོར་ལོ།	gdung gi 'khor lo \|
113	dung/dhung	གདུང་།	gdung \|
114	dungje	གདུང་བརྒྱུད།	gdung brgyud \|
115	Dunhang	ཏུན་ཧོང་།	Tun hong \|
116	Düsum sangay	དུས་གསུམ་སངས་རྒྱས།	Dus gsum sangs rgyas \|
117	Dzogchen	རྫོགས་ཆེན།	rDzogs chen \|
118	Dzongdag	རྫོང་བདག	rDzong bdag \|
119	Dzongkhag	རྫོང་ཁག	rDzong khag \|
120	gadhang	དགའ་མདངས།	dga' mdangs \|
121	gadpo	རྒད་པོ།	rGad po \|
122	Gangkar Tise	གངས་དཀར་ཏི་སེ།	Gangs dkar ti se \|
123	Gangteng	སྒང་སྟེང་།	sGang steng \|
124	Gangtrul Rinpoche	སྒང་སྤྲུལ་རིན་པོ་ཆེ།	sGang sprul rin po che \|
125	ganmo	རྒན་མོ།	rgan mo \|
126	garpa	གར་པ།	gar pa \|
127	Gedtongpa	བརྒྱད་སྟོང་པ།	brGyad stong pa \|
128	gektor	བགེགས་གཏོར།	bgegs gtor \|
129	gelong	དགེ་སློང་།	dge slong \|
130	Geser	གེ་སར།	Ge sar \|
131	Geser pawo	གེ་སར་དཔའ་བོ།	Ge sar dpa' bo \|
132	geshe	དགེ་བཤེས།	dge bshes \|
133	Gewog	རྒེད་འོག	rGad 'og
134	geychen	གོས་ཆེན།	gos chen \|
135	Goleng	སྒོ་གླིང་།	sGo gling \|
136	Golengpa	སྒོ་གླིང་པ།	sGo gling pa \|
137	gomchen	སྒོམ་ཆེན།	sgom chen \|
138	gomde	སྒོམ་སྡེ།	sgom sde \|
139	Gomphu	སྒོམ་ཕུག	sGom phug \|
140	Gomphu dung	སྒོམ་ཕུག་གདུང་།	sGom phug gdung \|

Sl. No.	Local Term	Dzongkha Spelling	Wylie Transliteration
141	goshé nyenshé	གོ་ཤེས་ཉན་ཤེས།	go shes nyan shes \|
142	Goshing	སྒོ་ཤིང་།	sGo shing \|
143	Gowe'lha	འགོ་བའི་ལྷ།	'Go ba'i lha \|
144	gungsar	དགུང་གསར།	dgung gsar \|
145	Guru Rinpoche	གུ་རུ་རིན་པོ་ཆེ།	Gu ru rin po che \|
146	Guse Langling	དགུ་བརྩེགས་ལང་ལིང་།	dGu brtsegs lang ling \|
147	gyalpo	རྒྱལ་པོ།	rgyal po \|
148	gyalpo chedpola	རྒྱལ་པོ་ཕྱིད་པོ་ལགས།	rgyal po phyid po lags \|
149	gyalpo dhogmala	རྒྱལ་པོ་དོག་མ་ལ།	rgyal po dog ma la \|
150	gyalpo kha toth	རྒྱལ་པོའི་ཁ་གཏོད།	rgyal po'i kha gtod \|
151	Gyalpo Pehar	རྒྱལ་པོ་དཔེ་ཧར།	rGyal po dpe har \|
152	gyalpoi phodrang	རྒྱལ་པོའི་ཕོ་བྲང་།	rgyal po'i pho brang \|
153	gyalrig	རྒྱལ་རིགས།	rgyal rigs \|
154	Haa	ཧ།	Ha \|
155	Jag lha	ཇག་ལྷ།	Jag lha \|
156	jamkha	འཇམ་ཁ།	'jam kha \|
157	Jampel Shinje	འཇམ་དཔལ་གཤིན་རྗེ།	'Jam dpal gshin rje \|
158	jandhom	ཇ་འདམ།	ja 'dam \|
159	Jangchub Choeling	བྱང་ཆུབ་ཆོས་གླིང་།	Byang chub chos gling \|
160	jatsamo	རྒྱ་འཚར་མོ།	rgya 'tshar mo \|
161	Jigtenpai chö	འཇིག་རྟེན་པའི་ཆོས།	'jig rten pa'i chos \|
162	Jigtenpai lha	འཇིག་རྟེན་པའི་ལྷ།	'jig rten pa'i lha \|
163	Jigtenpai tsungma	འཇིག་རྟེན་པའི་སྲུང་མ།	'jig rten pa'i srung ma \|
164	jimpa	སྦྱིན་པ།	sbyin pa \|
165	jindhag	སྦྱིན་བདག	sbyin bdag \|
166	Jomo pawo	ཇོ་མོ་དཔའ་བོ།	Jo mo dpa' bo \|
167	jonpa	མགྲོན་པོ།	mgron po \|
168	jungwa zhi	འབྱུང་བ་བཞི།	'byung ba bzhi \|
169	kabab	བཀའ་བབས།	bka' babs \|

Sl. No.	Local Term	Dzongkha Spelling	Wylie Transliteration	
170	Kalamti	དཀའ་ལམ་ཏི།	dKa' lam tig	
171	kangtsik lagtsik	རྐང་ཚིགས་ལག་ཚིགས།	rkang tshigs lag tshigs	
172	karchod	དཀར་མཆོད།	dkar mchod	
173	karjan	དཀར་རྒྱན།	dkar rgyan	
174	karjud	དཀར་འཇུད།	dkar 'jud	
175	Khandro Mandarava	མཁའ་འགྲོ་མནྡ་ར་བ།	mKha' 'gro manda ra va	
176	Khandro Yeshey Tshogyel	མཁའ་འགྲོ་ཡེ་ཤེས་མཚོ་རྒྱལ།	mKha' 'gro ye shes mtsho rgyal	
177	khandroma	མཁའ་འགྲོ་མ།	mkha' 'gro ma	
178	khandrotenzhug	མཁའ་འགྲོ་བརྟན་བཞུགས།	mkha' 'gro brtan bzhugs	
179	kharam	ཁ་རམ།	kha ram	
180	kharam poklo	ཁ་རམ་སྤོ་ལོག	kha ram spo log	
181	khari	ཁ་རི།	kha ri	
182	Kharphud	ཁར་ཕུད།	khar phud	
183	khasha migmer	ཁ་ཤ་མིག་དམར།	kha sha mig dmar	
184	Khasha nyermig	ཁ་ཤ་གཉེར་མིག	kha sha gnyer mig	
185	Khekharathod	ཁྱི་ཁ་ར་ཐོད།	Khyi kha ra thod	
186	khempa	མཁན་པ།	mkhan pa	
187	khempashing	མཁན་པ་ཤིང་།	mkhan pa shing	
188	Kheng	ཁེངས།	Khengs	
189	Kheng-ri Namsum	ཁེངས་རི་རྣམ་གསུམ།	Khengs ri rnam gsum	
190	Khengkha	ཁེངས་ཁ།	Khengs kha	
191	Khengpa	ཁེངས་པ།	Khengs pa	
192	khoche	ཁོག་ཆེ།	khog che	
193	Khomshar	ཁོམ་ཤར།	Khom shar	
194	khraipa	ཁྲལ་པ།	khral pa	
195	Khyim lha	ཁྱིམ་ལྷ།	Khyim lha	
196	Kikhar/Kyikhar	སྐྱིད་མཁར།	sKyid mkhar	
197	koinyer	དཀོན་གཉེར།	dkon gnyer	
198	kokha	ལྐོག་ཁ།	lkog kha	

Sl. No.	Local Term	Dzongkha Spelling	Wylie Transliteration
199	Könchok Sum	དགོན་མཆོག་གསུམ།	dKon mchog gsum \|
200	kongbu	གོང་བུ།	kong bu \|
201	kröd	གྲོད།	krod \|
202	krong	གྲོང་།	krong \|
203	ku	སྐུ།	sku \|
204	Kubum	སྐུ་འབུམ།	sKu 'bum \|
205	kudrung	སྐུ་དྲུང་།	sku drung \|
206	kudrungpa	སྐུ་དྲུང་པ།	sku drung pa \|
207	Kuenga Rabten	ཀུན་དགའ་རབ་བརྟན།	Kun dga' rab brtan \|
208	kushen	སྐུ་གཤེན།	sKu gshen \|
209	kuthang	སྐུ་ཐང་།	sku thang \|
210	Kuther	སྐུ་ཐེར།	sKu ther \|
211	kyedib	སྐྱེས་གྲིབ།	skyes grib \|
212	Kyelha	སྐྱེས་ལྷ།	sKyes lha \|
213	la	བླ།	bla \|
214	la dhar	བླ་དར།	bla dar \|
215	la gud	བླ་རྒུད།	bla rgud \|
216	lalu	བླ་བསླུ།	bla bslu \|
217	Lam lha	ལམ་ལྷ།	Lam lha \|
218	Lama	བླ་མ།	Bla ma \|
219	Lamai Gonpa	བླ་མའི་དགོན་པ།	Bla ma'i dgon pa \|
220	lamdro	ལམ་འགྲོ།	lam 'gro \|
221	Langdarma	གླང་དར་མ།	Glang dar ma \|
222	laprok	བླ་སྤྲོག	bla sprog \|
223	laptsa	ལབ་རྩ།	lab rtsa \|
224	Lha bon	ལྷ་བོན།	lHa bon \|
225	Lha chö	ལྷ་ཆོས།	lHa chos \|
226	Lha Wangpo Gyajin	ལྷའི་དབང་པོ་བརྒྱ་བྱིན།	lHa'i dbang po brgya byin \|
227	lha-mi	ལྷ་མེས།	lha mes \|

Sl. No.	Local Term	Dzongkha Spelling	Wylie Transliteration
228	lha'i tumpa	ལྷའི་བཏུམས་པ།	lha'i btums pa \|
229	lhadhar	ལྷ་དར།	lha dar \|
230	lhadre degye	ལྷ་འདྲེ་སྡེ་བརྒྱད།	lha 'dre sde brgyad \|
231	Lhagon Palchen	ལྷ་མགོན་དཔལ་ཆེན།	lHa mgon dpal chen \|
232	Lhalung Palgyi Dorji	ལྷ་ལུང་དཔལ་གྱི་རྡོ་རྗེ།	lHa lung dpal gyi rdo rje \|
233	lhashing	ལྷ་ཤིང་།	lha shing \|
234	lhathung drethung	ལྷ་མཐོང་འདྲེ་མཐོང་།	lha mthong 'dre mthong \|
235	Lhawang Dragpa	ལྷ་དབང་གྲགས་པ།	lHa dbang Grags pa \|
236	lhazey	ལྷ་རྫས།	lha rdzas \|
237	Lho Mon	ལྷོ་མོན།	lHo Mon \|
238	Lho Monyul	ལྷོ་མོན་ཡུལ།	lHo Mon yul \|
239	Lhotsampa	ལྷོ་མཚམས་པ།	lHo mtshams pa \|
240	Lhuntse	ལྷུན་རྩེ།	lHun rtse \|
241	loched	ལོ་མཆོད།	lo mchod \|
242	lopön	སློབ་དཔོན།	slob dpon \|
243	lu	ཀླུ།	klu \|
244	lü	ལུས།	lus \|
245	lü gud	ལུས་རྒུད།	lus rgud \|
246	lu nak	ཀླུ་ནག	klu nag \|
247	lu shong	ཀླུ་གཤོང་།	klu shong \|
248	lu theb mooth	ཀླུ་ཐེབས་མེད།	klu thebs med \|
249	lu tsen	ཀླུ་བཙན།	klu btsan \|
250	lu'i bonpo	ཀླུའི་བོན་པོ།	klu'i bon po \|
251	lubum	ཀླུ་འབུམ།	klu bum \|
252	lud	གླུད།	glud \|
253	ludho	ཀླུ་རྡོ།	klu rdo \|
254	lugi chedpa	ཀླུའི་མཆོད་པ།	klu'i mchod pa \|
255	lumo karmo	ཀླུ་མོ་དཀར་མོ།	klu mo dkar mo \|
256	lumo sermo	ཀླུ་མོ་སེར་མོ།	klu mo ser mo \|

Sl. No.	Local Term	Dzongkha Spelling	Wylie Transliteration
257	Luna Senak Rinchen	ཀླུ་གཙུག་ན་རིན་ཆེན།	Klu gtsug na rin chen \|
258	Lung	ལུང་།	lung \|
259	lungta	རླུང་རྟ།	rlung rta \|
260	lungta dhar	རླུང་རྟ་དར།	rlung rta dar \|
261	lungta gud	རླུང་རྟ་རྒུད།	rlung rta rgud \|
262	lungzey	ཀླུང་རྫས།	klung rdzas \|
263	lusang	ཀླུ་བསང་།	klu bsang \|
264	luyül	ཀླུ་ཡུལ།	Klu yul \|
265	Ma lha	མ་ལྷ།	Ma lha \|
266	machim	མ་ཁྱིམ།	ma khyim \|
267	magpa	མག་པ།	mag pa \|
268	mägpön	དམག་དཔོན།	dmag dpon \|
269	Mahakala	མ་ཧཱ་ཀཱ་ལ།	ma hā kā la \|
270	maipa	མའི་པ།	ma'i pa \|
271	mamai	མ་མའི།	ma ma'i \|
272	mamo	མ་མོ།	ma mo \|
273	mamo gami	མ་མོའི་གབ་མེ།	ma mo'i gab me \|
274	mamo sondre	མ་མོ་གསོན་འདྲེ།	ma mo gson 'dre \|
275	mamoi tang	མ་མོའི་སྟངས།	ma mo'i stangs \|
276	Mangde	མང་སྡེ།	Mang sde \|
277	Mangdekha	མང་སྡེ་ཁ།	Mang sde kha \|
278	mangmi	དམངས་མི།	dmangs mi \|
279	mani rudra	མ་ཎི་རུ་དྲ།	ma ṇi ru dra \|
280	mar tsog	དམར་ཚོགས།	dmar tshogs \|
281	marchang	མར་ཆང་།	mar chang \|
282	melong mo	མེ་ལོང་མོ།	me long mo \|
283	menchung bumo	དམན་ཆུང་བུ་མོ།	dman chung bu mo \|
284	merbai	སྨེར་བག	smer bag \|
285	mGron lha	མགྲོན་ལྷ།	mGron lha \|

Sl. No.	Local Term	Dzongkha Spelling	Wylie Transliteration
286	mi chö	མི་ཆོས།	mi chos \|
287	mige yang	མིའི་གཡང་།	mi'i g.yang \|
288	Migyur Tempa	མི་འགྱུར་བརྟན་པ།	Mi 'gyur brTan pa \|
289	mikha	མི་ཁ།	mi kha \|
290	mikha dradog	མི་ཁ་དགྲ་བཟློག	mi kha dgra zlog \|
291	mikhai bumo	མི་ཁའི་བུ་མོ།	mi kha'i bu mo \|
292	mirgola	མིར་རྒུད་ལགས།	mir rgud lags \|
293	mitsim	མི་སིམ།	mi sim \|
294	Miyül	མི་ཡུལ།	Mi yul \|
295	mo	མོ།	mo \|
296	Molha	མོ་ལྷ།	Mo lha \|
297	Mon	མོན།	Mon \|
298	Mongar	མོང་སྒར།	Mong sgar \|
299	Monyul	མོན་ཡུལ།	Mon yul \|
300	mrang	སྨྲང་།	smrang \|
301	nachu	མནའ་ཆུ།	mna' chu \|
302	nachung	ན་ཆུང་།	na chung \|
303	nädho	མནའ་རྡོ།	mna' rdo \|
304	nama	མནའ་མ།	mna' ma \|
305	namkaling mentok	ནམ་ག་ལིང་མེ་ཏོག	nam ka ling me tog \|
306	namrimpa chusum	གནམ་རིམ་པ་བཅུ་གསུམ།	gnam rim pa bcu gsum \|
307	Namthotse	རྣམ་ཐོས་སྲས།	rNam thos sras \|
308	Nangkor	ནང་སྐོར།	Nang skor \|
309	nangpa	ནང་པ།	nang pa \|
310	nangpa sangaypai chö	ནང་པ་སངས་རྒྱས་པའི་ཆོས།	nang pa sangs rgyas pa'i chos \|
311	nangten	ནང་བསྟན།	nang bstan \|
312	nangtsang	ནང་ཚང་།	nang tshang \|
313	nawen	རྣ་འོན།	rna 'on \|
314	Nawoche	སྣ་བོ་ཆེ།	sNa bo che \|

Sl. No.	Local Term	Dzongkha Spelling	Wylie Transliteration
315	nejum	རྣལ་འབྱོར་མ།	rnal 'byor ma
316	neljorpa	རྣལ་འབྱོར་པ།	rnal 'byor pa
317	nepo	གནས་པོ།	gnas po
318	nerig chewa	ནད་རིགས་ཆེ་བ།	nad rigs che ba
319	nerig chungwa	ནད་རིགས་ཆུང་བ།	nad rigs chung ba
320	nga mo	རྔ་མོ།	rnga mo
321	ngag chu	སྔགས་ཆུ།	sngags chu
322	ngak mar	སྔགས་མར།	sngags mar
323	ngakpa	སྔགས་པ།	sngags pa
324	Ngalongpa	སྔ་ལུང་པ།	sNga lung pa
325	ngan	ངན།	ngan
326	Ngangla	ངང་ལ།	Ngang la
327	ngenlong	ངན་སློང་།	ngan slong
328	ngerpa	གཉེར་པ།	gnyer pa
329	Nor lha	ནོར་ལྷ།	Nor lha
330	norge yang	ནོར་གྱི་གཡང་།	nor gyi g.yang
331	Nubchogpa	ནུབ་ཕྱོགས་པ།	Nub phyogs pa
332	Nyakhar	ཉ་མཁར།	Nya mkhar
333	Nyakhar dung	ཉ་མཁར་གདུང་།	nya mkhar gdung
334	nyandar	གཉེན་དར།	gnyen dar
335	nyedung	སྨྱོས་གདུང་།	smyos gdung
336	Nyenkha	མཉེན་ཁ།	mnyen kha
337	Nyingma	རྙིང་མ།	rNying ma
338	nyipai jukreng	རྙི་པའི་མཇུག་རིང་།	rnyi pa'i mjug ring
339	Odé Gungyal	འོད་དེ་གུང་རྒྱལ།	'Od de gung rgyal
340	ogyaala	ཨོ་ངལ་ལ།	o ngal la
341	Olmo Lungring	འོལ་མོ་ལུང་རིང་།	'Ol mo lung ring
342	Padmasabhava	པདྨ་སམྦྷ་ཝ།	Pad ma sam bha va
343	Palden Lhamo	དཔལ་ལྡན་ལྷ་མོ།	dPal ldan lha mo

Sl. No.	Local Term	Dzongkha Spelling	Wylie Transliteration
344	pam	སྤམ།	spam \|
345	pamo	དཔའ་མོ།	dpa' mo \|
346	Pangrizampa	སྤང་རི་ཟམ་པ།	sPang ri zam pa \|
347	Pangtey pön	སྤང་བཏེག་དཔོན།	sPang bteg dpon \|
348	Pangzur	སྤང་ཟུར།	sPang zur \|
349	patang	དཔའ་རྟགས།	dpa' rtags \|
350	pawo	དཔའ་བོ།	dpa' bo \|
351	pecha	དཔེ་ཆ།	dpe cha \|
352	Peling	པད་གླིང་།	Pad gling \|
353	Pelripa	དཔལ་རི་པ།	dPal ri pa \|
354	Pema Karpo	པད་མ་དཀར་པོ།	Pad ma dar po \|
355	pema khabi	པདྨ་ཁ་འབུད།	pad ma kha 'bud \|
356	Pema Lingpa	པད་མ་གླིང་པ།	Pad ma gling pa \|
357	pha gyud	ཕ་རྒྱུད།	pha rgyud \|
358	phag lokar	ཕག་བློ་དཀར།	Phag blo dkar \|
359	Phagpa Pelzang	འཕགས་པ་དཔལ་བཟང་།	'Phags pa dpal bzang \|
360	phagyu bugyu	ཕ་རྒྱུད་བུ་རྒྱུད།	pha rgyud bu rgyud \|
361	phajo	ཕ་ཇོ།	pha jo \|
362	Phangkar	ཕངས་དཀར།	Phangs dkar \|
363	phrengba mo	ཕྲེང་བ་མོ།	phreng ba mo \|
364	phurkha	ཕུར་ཁ།	phur kha \|
365	Phyag chen	ཕྱག་ཆེན།	Phyag chen \|
366	phyiru shelni	ཕྱི་རུབ་བཤལ་ནི།	phyi rub bshal ni \|
367	Phywa Lha	ཕྱྭ་ལྷ།	Phywa lha \|
368	pirpön	སྤྱི་དཔོན།	spyi dpon \|
369	Polo Khenpo	སྤོ་ལུ་མཁན་པོ།	sPo lu mkhan po \|
370	ponmo	དཔོན་མོ།	dpon mo \|
371	ponpo	དཔོན་པོ།	dpon po \|
372	pöth	ཕུད།	phud \|

PHONETIC RENDERINGS OF LOCAL TERMS

Sl. No.	Local Term	Dzongkha Spelling	Wylie Transliteration
373	puta	སྤུ་བཏགས།	spu btags \|
374	Pyikor	ཕྱི་སྐོར།	Phyi skor \|
375	rabné	རབ་གནས།	rab gnas
376	Rakshong	རགས་གཤོང་།	rags gshong \|
377	raluk chusum	ར་ལུག་བཅུ་གསུམ།	ra lug bcu gsum \|
378	rangi lübpa	རང་གི་སློབ་པ།	rang gi slob pa \|
379	rDol bon	རྡོལ་བོན།	rDol bon \|
380	remè	རིས་མེད།	ris med \|
381	rignga	རིགས་ལྔ།	rigs lnga \|
382	Rinchen Jungné	རིན་ཆེན་འབྱུང་གནས།	Rin chen 'byung gnas \|
383	ru	རུས།	rus \|
384	rup (roop)	རུབ།	rub \|
385	sachak namchak	ས་ལྕགས་གནམ་ལྕགས།	sa lcags gnam lcags \|
386	sadag	ས་བདག	sa bdag \|
387	Sakya Özer	ཤཱཀྱ་འོད་ཟེར།	Shakya 'Od zer \|
388	Samkhar	བསམ་མཁར།	bSam mkhar \|
389	Samye	བསམ་ཡས།	bSam yas \|
390	Samye Gyalpo	བསམ་ཡས་རྒྱལ་པོ།	bSam yas rgyal po \|
391	sang rab	བསང་རབ།	bsang rab \|
392	sangja	གཙང་ཇ།	gtsang ja \|
393	sangku	གཙང་ཁུག	gtsang khug \|
394	Sarma	གསར་མ།	gSar ma \|
395	Sarpang	གསར་འབངས།	gSar 'bangs \|
396	semgi ing	སེམས་ཀྱི་དབྱིངས།	sems kyi dbyings \|
397	Senge	སེང་གེ	seng ge \|
398	Senge Dorji	སེང་གེ་རྡོ་རྗེ།	Seng ge rDo rje \|
399	shadag ridag	ས་བདག་རི་བདག	sa bdag ri bdag \|
400	Shalging Karpo	ཤེལ་གིང་དཀར་པོ།	Shel ging dkar po \|
401	Sharchogpa	ཤར་ཕྱོགས་པ།	Shar phyogs pa \|

Sl. No.	Local Term	Dzongkha Spelling	Wylie Transliteration	
402	shawa ragpa	ཤ་བ་རྭ་པ།	sha ba rwa pa	
403	shedra	བཤད་གྲྭ།	bshad grwa	
404	shen	གཤེན།	gshen	
405	shenpo	གཤེན་པོ།	gshen po	
406	shepa	བཤད་པ།	bshad pa	
407	shidag	གཞི་བདག	gzhi bdag	
408	shidib	ཤི་གྲིབ།	shi grib	
409	shindre	གཤིན་འདྲེ།	gshin 'dre	
410	shindre phoshin	གཤིན་འདྲེ་ཕོ་གཤིན།	gshin 'dre pho gshin	
411	shindri moshin	གཤིན་འདྲེ་མོ་གཤིན།	gshin 'dre mo gshin	
412	Shingkhar	ཤིང་མཁར།	Shing mkhar	
413	shingna gu	ཤིང་སྣ་དགུ།	shing sna dgu	
414	Shinje Chogyal	གཤིན་རྗེ་ཆོས་རྒྱལ།	gShin rje chos rgyal	
415	Shobleng	གཞོབ་གླིང་།	gZhob gling	
416	shomda mo	ཤོམ་འདབ་མོ།	shom 'dab mo	
417	shugpo shing	ཤུག་པོ་ཤིང་།	shug po shing	
418	shul chang	ཤུལ་ཆང་།	shul chang	
419	shuljab	ཤུལ་རྒྱགས།	shul rgyags	
420	Sidpai Gyalmo	སྲིད་པའི་རྒྱལ་མོ།	Srid pa'i rgyal mo	
421	Sidpai lha bon	སྲིད་པའི་ལྷ་བོན།	Srid pa'i lha bon	
422	Sidpai lha chö	སྲིད་པའི་ལྷ་ཆོས།	Srid pa'i lha chos	
423	Sidpai lhagan	སྲིད་པའི་ལྷ་རྒྱན།	Srid pa'i lha rgyan	
424	Sindhu Raja	སིནྡྷུ་རཱ་ཛ།	Sin dhu rā dza	
425	sinpo	སྲིན་པོ།	srin po	
426	sok	སྲོག	srog	
427	sok ched	སྲོག་གཅོད།	srog gcod	
428	sok dhar	སྲོག་དར།	srog dar	
429	sok gud	སྲོག་རྒུད།	srog rgud	
430	sokha	སོ་ཁ།	so kha	

Sl. No.	Local Term	Dzongkha Spelling	Wylie Transliteration	
431	sönam	བསོད་ནམས།	bsod nams	
432	sondre	གསོན་འདྲེ།	gson 'dre	
433	Srog lha	སྲོག་ལྷ།	Srog lha	
434	Subrang	བསུ་བྲང་།	bSu brang	
435	sungma	སྲུང་མ།	srung ma	
436	sur	གསུར།	gsur	
437	taak	སྟག	stag	
438	tachok	རྟ་མཆོག	rta mchog	
439	Tagma	ལྟག་མ།	lTag ma	
440	Tagma dung	ལྟག་མ་གདུང་།	lTag ma gdung	
441	Tagmachog	ལྟག་མ་མཆོག	lTag ma mchog	
442	Tala Mebar	སྟག་ལ་མེ་འབར།	sTag la me 'bar	
443	Tali	ཏ་ལི།	Ta li	
444	tän kar	སྟན་དཀར།	stan dkar	
445	Tashigang	བཀྲ་ཤིས་སྒང་།	bKra shis sgang	
446	Tashiyangtse	བཀྲ་ཤིས་གཡང་རྩེ།	bKra shis g.yang rtse	
447	tenchok lha	སྟེང་ཕྱོགས་ལྷ།	steng phyogs lha	
448	teng	སྟེང་།	steng	
449	terchö	གཏེར་ཆོས།	gter chos	
450	Terdag pawo	གཏེར་བདག་དཔའ་བོ།	gTer bdag dpa' bo	
451	terma	གཏེར་མ།	gter ma	
452	Tertongi Gyalpo	གཏེར་སྟོན་གྱི་རྒྱལ་པོ།	gTer ston gyi rgyal po	
453	thab	ཐབ།	thab	
454	Thab lha	ཐབ་ལྷ།	Thab lha	
455	thab tsang	ཐབ་ཚང་།	thab tshang	
456	thagpa ngennga	ཐག་པ་སྙེ་ལྔ།	thag pa sne lnga	
457	thamba	ཐམས་པ།	thams pa	
458	thegpa gu	ཐེག་པ་དགུ།	theg pa dgu	
459	Therchung	ཐེར་གཅུང་།	ther gcung	

Sl. No.	Local Term	Dzongkha Spelling	Wylie Transliteration
460	tho mo	ཐོ་མོ།	tho mo \|
461	thri	ཁྲི།	khri \|
462	thug mayeng	ཐུགས་མ་ཡེངས།	thugs ma yengs \|
463	Thuksey Dawa Gyaltshen	ཐུགས་སྲས་ཟླ་བ་རྒྱལ་མཚན།	Thugs sras zla ba rgyal mtshan \|
464	ting	ཏིང་།	ting \|
465	tingnge zingi zà	ཏིང་ངེ་འཛིན་གྱི་ཟས།	ting nge 'dzin gyi zas \|
466	Tingtibi	གཏིང་ཏིག་གཞིས།	gTing tig gzhis \|
467	Tonpa chidar	བསྟན་པ་ཕྱི་དར།	bsTan pa phyi dar \|
468	Tonpa ngadar	བསྟན་པ་སྔ་དར།	bsTan pa snga dar \|
469	Tonpa Shenrab Miwo	སྟོན་པ་གཤེན་རབ་མི་བོ།	sTon pa gshen rab mi bo \|
470	torma	གཏོར་མ།	gtor ma \|
471	Trisong Detsen	ཁྲི་སྲོང་ལྡེའུ་བཙན།	Khri srong lde'u btsan \|
472	trog lok	དཀྲོགས་ལོག	dkrogs log \|
473	Trong	ཀྲོང་།	Krong \|
474	Trongsa	ཀྲོང་གསར།	Krong gsar \|
475	Tsakaling Choje	ཚ་ཀ་གླིང་ཆོས་རྗེ།	Tsa ka gling chos rje \|
476	Tsalpa Kagyu	ཚལ་པ་བཀའ་བརྒྱུད།	Tshal pa bka' brgyud \|
477	tsam	མཚམས།	mtshams \|
478	tsang	གཙང་།	gTsang \|
479	Tsanglajong	ཚང་ལ་ལྗོངས།	Tshang la ljongs \|
480	Tsangma	གཙང་མ།	gTsang ma \|
481	tsawa	རྩ་བ།	rtsa ba \|
482	tsé drup	ཚེ་སྒྲུབ།	tshe sgrub \|
483	tsé yi bumpa	ཚེ་ཡི་བུམ་པ།	tshe yi bum pa \|
484	tsekpa	འཚེག་པ།	'tsheg pa \|
485	tsekpa rapa	འཚེག་པ་རག་པ།	'tsheg pa rag pa \|
486	tsen	བཙན།	btsan \|
487	tsen düd solkha	བཙན་བདུད་གསོལ་ཁ།	btsan bdud gsol kha \|

Sl. No.	Local Term	Dzongkha Spelling	Wylie Transliteration
488	Tsenchen Yeshi Norbu	བཙན་ཆེན་ཡིད་བཞིན་ནོར་བུ།	btsan chen yid bzhin nor bu \|
489	tsendhen lama	མཚན་ལྡན་བླ་མ།	mtshan ldan bla ma \|
490	tsenpo	བཙན་པོ།	btsan po \|
491	Tsepakmé	ཚེ་དཔག་མེད།	Tshe dpag med \|
492	Tsaidhang	ཚལ་དྭངས།	Tshal dwangs \|
493	tsheigyalpo & gyalmo	ཚེ་ཡི་རྒྱལ་པོ་དང་རྒྱལ་མོ།	tshe yi rgyal po dang rgyal mo \|
494	Tshong lha	ཚོང་ལྷ།	Tshong lha \|
495	tsipa	རྩིས་པ།	rtsis pa \|
496	Tsirang	སིལ་རངས།	Sil rangs \|
497	tsog	ཚོགས།	tshogs \|
498	tsogpa	ཚོགས་པ།	tshogs pa \|
499	tsomen	མཚོ་སྨན།	mtsho sman \|
500	tsongpon	ཚོང་དཔོན།	tshong dpon \|
501	Tsungmapa	སུམ་མ་པ།	Sum ma pa \|
502	tsuth	བཙོད།	btsod \|
503	tulku	སྤྲུལ་སྐུ།	sprul sku \|
504	Tunglabi	ལྟུང་ལ་སྦིས།	lTung la sbis \|
505	Üchogpa	དབུས་ཕྱོགས་པ།	dBus phyogs pa \|
506	umze	དབུ་མཛད།	dbu mdzad \|
507	Ura dung	ཨུ་ར་གདུང་།	U ra gdung \|
508	üsai sile	ཨུ་ཚའི་ཙི་ལི།	u tsha'i tsi li \|
509	wäm brangkhar	ཝམ་བྲང་དཀར།	wam brang dkar \|
510	Wamleng	ཝམ་གླིང་།	Wam gling \|
511	wang-ge bumpa	དབང་གི་བུམ་པ།	dbang gi bum pa \|
512	wangchen	དབང་ཆེན།	dbang chen \|
513	wangchen chenpo	དབང་ཆེན་ཆེན་པོ།	dbang chen chen po \|
514	wangchen pönpo	དབང་ཆེན་དཔོན་པོ།	dbang chen dpon po \|
515	Wangchuma	དབང་ཕྱུག་མ།	dBang phyug ma \|

PHONETIC RENDERINGS OF LOCAL TERMS 261

Sl. No.	Local Term	Dzongkha Spelling	Wylie Transliteration
516	Wangdiphodrang	དབང་འདུས་ཕོ་བྲང་།	dBang 'dus pho brang \|
517	Wanglingpa	དབང་གླིང་པ།	dBang gling pa \|
518	wangthang	དབང་ཐང་།	dbang thang \|
519	wangthang dhar	དབང་ཐང་དར།	dbang thang dar \|
520	wangthang gud	དབང་ཐང་རྒུད།	dbang thang rgud \|
521	wok	འོག	'og \|
522	yabma	གཡབ་མ།	g.yab ma \|
523	yang	གཡང་།	g.yang \|
524	yangbum	གཡང་བུམ།	g.yang bum \|
525	yangkhug	གཡང་ཁུག	g.yang khug \|
526	Yarlung	ཡར་ཀླུང་།	Yar klung \|
527	Yebilaptsa	ཡེ་སྦིས་ལབ་རྩ།	Ye sbis lab rtsa \|
528	Yéshupai chö	ཡེ་ཤུ་པའི་ཆོས།	Ye shu pa'i chos \|
529	yidam	ཡི་དམ།	yi dam \|
530	yongka	ཡོང་ལྒ།	yong lga \|
531	yoon mareng	ཡུན་མ་རིང་།	yun ma ring \|
532	Yudrakpa Tsondru Drakpa	གཡུ་བྲག་པ་བརྩོན་འགྲུས་གྲགས་པ།	g.Yu brag pa brtson 'grus grags pa \|
533	yugdib	གཡུག་གྲིབ།	g.yug grib \|
534	Yul-lha	ཡུལ་ལྷ།	Yul lha \|
535	Yungdrung Bon	གཡུང་དྲུང་བོན།	g.Yung drung bon \|
536	za'i japhor	འཛབ་ཀྱི་རྒྱ་ཕོར།	'dzab kyi rgya phor \|
537	Zalakha	ཛ་ལ་ཁ།	Dza la kha \|
538	zangchu	ཟངས་གཅུང་།	zangs gcung \|
539	Zangdokpelri	ཟངས་མདོག་དཔལ་རི།	Zangs mdog dpal ri \|
540	zapa	ཟ་པ།	za pa \|
541	Zas lha	ཟས་ལྷ།	Zas lha \|
542	zatsang	བཟའ་ཚང་།	bza' tshang \|
543	zey	ཟས།	zas \|
544	zey shimpo	ཟས་ཞིམ་པོ།	zas zhim po \|

Sl. No.	Local Term	Dzongkha Spelling	Wylie Transliteration	
545	Zhabdrung Ngawang Namgyal	ཞབས་དྲུང་ངག་དབང་རྣམ་རྒྱལ།	Zhabs drung ngag dbang rnam rgyal	
546	Zhang	ཞང་།	Zhang	
547	Zhangzhung	ཞང་ཞུང་།	Zhang zhung	
548	Zhemgang	གཞལ་སྒང་།	gZhal sgang	
549	Zhemgangpa	གཞལ་སྒང་པ།	gZhal sgang pa	
550	zhisar	གཞིས་གསར།	gzhis gsar	
551	zhiwa	ཞི་བ།	zhi ba	
552	Zhongar	གཞོང་སྒར།	gZhong sgar	
553	Zhung-gi bonpo	གཞུང་གི་བོན་པོ།	gZhung gi bon po	
554	zijid	གཟི་བརྗིད།	gzi brjid	
555	zurpa	ཟུར་པ།	zur pa	
556	Zurphel	ཟུར་འཕེལ།	Zur 'phel	

Notes

Chapter 1

1. The district capital is based in Zhemgang proper, which comprises Trong, Pam, and Dhangkhar villages.
2. Live-animal sacrifices and black magic are characteristic of Black Bon. Black magic is mostly performed in secret and involves sacrifice of effigies.
3. Prominent persons.
4. Buddhism was introduced during the reign of King Songtsen Gampo in the seventh century.
5. Langdarma (r. AD 838–42) succeeded Trisong Detsen, but due to his alleged pro-Bon campaign he was assassinated by a Buddhist monk, Lhalung Palgyi Dorji, in a dramatic black-hat ritual dance. This account has been, however, disputed by Karmay (2009 [1997]), who argues that Langdarma was not a supporter of Bon and did not persecute Buddhism.
6. *Grub mtha' shel gyi me long* by Chos kyi nyima (see Nyima 2009).
7. These differ from later Yungdrung Bon's three historical stages.
8. According to Tibetan legend, he was the first Tibetan king to be buried on earth. All of his predecessors were believed to have returned to heaven using a sky cord.
9. Renaissance of Tibetan Buddhism after the fall of the anti-Buddhist emperor Langdarma.
10. *A-ya, ku-shen, shenpo, lha-mi, drung*, etc.; see Huber (2015a, 2015b).
11. Torri (2020) has also recently suggested Hyolmo shamanism in Nepal as a form of popular Bon.
12. It must be noted that Tucci and Stein both used the term "Bon" to refer to "Yungdrung Bon."
13. The influence of Hinduism and Zoroastrianism on Bon has been demonstrated by several scholars.
14. They live in eastern Nepal, Sikkim, and Darjeeling.
15. Sherpas live mostly in eastern Nepal and parts of the Himalayas.
16. Bonpo is pronounced "bombo" among Gurungs in Nepal.
17. Shaman or spirit medium.
18. Hoffman (1979: 56–57) and Blezer (2008: 217) agree on the incorporation of familiar life stories of the historical Buddha and Padmasambhava.
19. A kind of Bon priest.

20. The oldest of the four main schools of Tibetan Buddhism.
21. According to Van Schaik (2013b), unlike the Dunhuang cave documents that employ the term *Bon*, these wooden slips are datable with some certainty.
22. Historical texts such as *chos byung* by Bu-ston and the famous *Padma bka thang*.
23. For Hoffman (1979) Bon designates magical formulas; for Stein (1988) Bon means rituals.
24. Areas spanning from eastern Bhutan to parts of Arunachal Pradesh.
25. The ancient Tibetan court rituals are nonexistent in Bhutan.
26. Various forms of sortileges; propitiation of local gods and deities; destructive rituals; death rituals.
27. Sutra level 1; sutra level 2; Tantra level 1 ; Tantra level 2; Bon Dzogchen. For more information see Snellgrove (1980 [1967]) and Samuel (2017).
28. The terms "oracle" and "medium" without the prefix "spirit" seem to be used primarily to refer to Buddhist mediumistic practices (see Berounský 2008; Bell 2021).
29. Songtsen Gampo (c. 605–50) was the thirty-second Tibetan emperor.
30. According to Phuntsho (2013), this legend is said to be recounted by Ugyen Zangpo. His identity, however, remains contested (Aris 1979). According to the biography of the hundred treasure revealers by the foremost Buddhist scholar of the nineteenth century, Jamgon Kongtrul Lodro Thaye the Great (1813–1899) (Thaye 1973), while Ugyen Zangpo is included in the list, there are no treasures or writings attributed to him, nor any information available on his exact birth and death year. He is believed to be a disciple of Dorji Lingpa (1346–1405) (cf. Aris 1979).
31. See Aris (1979) particularly, on the adaptation of the narratives about events surrounding the construction of the Nine-Storied Tower (Sekar Gutok) by Milarepa (1040–1123) in Tibet.
32. In Dzongkha "India" is known as Jagar (Wylie: *rgya gar*).
33. Phunsho (2013) mistakenly recorded that the Nabji temple is in Zhemgang.
34. *Lho Mon* literally means the southern land of darkness.
35. The absolute authority of this administrative system declined after the establishment of a hereditary monarchy in 1907.
36. The term *chö* as a modern equivalent of religion is also now employed to specify other religions: Yéshupai *chö* for Christianity, Hindui *chö*, etc. See also Van Schaik (2013b) for more information on *chö* in the Tibetan imperial period.
37. *Gomchen* literarily means Buddhist priest who has mastered the art of meditation, while *chöpa* seems to be a general term for Buddhist practitioners irrespective of their mastery. While it is common to refer lay Buddhists as *gomchen* and *chöpas* interchangeably in Goleng, the priests I worked with were not advanced practitioners (*ngakpas*). Hence, I prefer to use the general term *chöpa* to refer to these lay practitioners.
38. In Tibet, *pawo* is sometimes used to refer to the eighth-century Buddhist saint Guru Rinpoche.
39. Locally pronounced as "Lha Odé Gongjan" (also "Waden Gungden").
40. Central Bhutan constitutes Lhuntse, Bumthang, Trongsa, and Zhemgang districts.

Chapter 2

1. He was the fourth head of the Drukpa lineage.
2. Ethnologue recorded over fifty thousand speakers in 2013.
3. The book was dated to 1728 by Aris (1979) and 1668 by Ardussi (2007a).
4. The last king of the Tibetan empire. He was portrayed as a follower of Bon who persecuted Buddhists.
5. The chief disciple.
6. See Dorji (n.d).
7. One of the several hats of Guru Rinpoche.
8. Tawang is still known as "Mon" or "Mon Tawang."
9. Also see Aris (1979).
10. He is well known for assassinating King Langdarma in the mid-ninth century.
11. My translation.
12. The title applied to learned masters.
13. It was previously known as "Chameytang."
14. Changlochen is believed to be hallowed by Thuksey Dawa Gyaltshen (1499–1592?), who was the son of Pema Lingpa.
15. The replica of the Copper-Colored Mountain of Glory or the Pure Land of Guru Rinpoche.
16. Some claim Buyul or Beyul Lama is a reincarnation of Lama Sakya Özer, but there is no widely accepted evidence for this.
17. A replica of Guru Padmasambhava's pure land.
18. The present throne holder of Ganteng monastery in Wangdiphodrang.

Chapter 3

1. Barth and Wikan (2011: 34) call them five constituents or components of the normal person.
2. The five elements are fire, earth, iron, water, and wood.
3. The order of animal signs: rabbit, ox, tiger, rat, dragon, snake, horse, sheep, monkey, rooster, dog, and pig.
4. Buddha, dharma, and sangha.
5. Mythical birdlike creature of Hindu, Buddhist, Bon, and Jain.
6. A legendary warrior king (*dralha*) of Ling, Tibet.
7. The ritual of invoking the blessings of Buddhas, Bodhisattvas, and high masters.
8. The Goleng Bonpos were unaware of Yungdrung Bon's *lalu* ritual as described by Clerical Bonpo scholars.
9. Dorji (2004) has described a ritual in western Bhutan involving a sacrifice of a piglet in order to retrieve a soul in the form of a spider. A similar ritual in eastern Bhutan and the nearby regions was also described by Schrempf (2015a): a spider is collected on the wad of cotton before placing it on the victim's head.

10. A different classification is *düd, mamo, lu, ging, rahula, tsen, rakshasa, yaksha*. For more detail see Dudjom Rinpoche (1991: 158–159).
11. The act of foretelling the future by drawing lots.
12. Nebesky-Wojkowitz (1956: 464) makes a similar observation.

Chapter 4

1. Similar to what Turner (1969: 103) witnessed in the Ndembu ritual, these idioms and symbols have "ontological value" in the sense that a patient can recover from sickness when material and immaterial offerings are made to the evil spirit beings.
2. Both Day (1989: 141) and Mills (2013) have pointed out a similar practice among Ladakhi people.
3. For traditional medical system in Bhutan and Tibet, see Craig and Gerke (2016).
4. Also known as Gyalpo Pehar, he was bound by oath to protect the Samye monastery in Tibet.
5. According to a popular belief, quails have no tongue.
6. A hunting god.
7. Holmberg (2006) has rendered it as the "spirit of the harvest."
8. A container used as a measuring unit.
9. More recently, Taee (2017) described another method to treat the poison which causes *ja né*. In this method, the Bonpo, whom he calls "local healers, suck the poison out in the form of discharge from the genitals without employing any tools. The belief that bodily fluids, particularly genital discharge, are poison, causing unique discoloration and other symptoms, seems to be unique to Mongar in eastern Bhutan.

Chapter 5

1. A combined length of a thumb, palm, and middle finger.
2. One of the twelve zodiac animal signs.
3. One of twelve animal signs.
4. Refers to worldly dharma protectors.
5. Native Bhutanese treasure revealer.
6. One of the five Buddha families belonging to eastern cardinality.
7. One of the five Buddha families belonging to southern cardinality.
8. Consorts of Guru Rinpoche.
9. One of the eight manifestations of Guru Rinpoche.
10. Founder of the Bhutanese state.
11. One of the eight great Bodhisattvas.
12. One of the serpent kings.
13. It is probably the corruption of Gurlha of Mount Kailash, comprising thirteen gods (see Nebesky-Wojkowitz 1956: 223).

14. A two-headed ritual implement.
15. Berglie (1976) and Fürer-Haimendorf (1964) pointed out that the shamanic training among northern Nepalese involves Buddhist endorsement.
16. Shneiderman (2006: 249) has also pointed out the fluidity of religious identity in Mustang, Nepal.
17. People of southern Bhutan who mostly follow Hinduism.
18. "Diviner" here refers to a lay Buddhist, although he or she can also be a Bonpo.
19. From 1982 to 1994, the Yebilaptsa hospital was run by the Leprosy Mission of London at the behest of Royal Government of Bhutan. Golengpas still consider leprosy to be a disease caused by *lu* beings.
20. Menstrual blood can also weaken the powers of a Buddhist amulet; see McGranahan (2010).

Chapter 6

1. According to Dotson (2008: 43), Bon and *shen* priests served as ritual specialists for the early Yarlung kings. See also Karmay (1998 [1983]).
2. A unit of measurement for alcoholic beverages.
3. While Odé Gungyal blesses the villagers with a bountiful harvest and long life, the mythical hound blesses the hunters with a generous and quick catch. The *nawen* spirit was central to early Golengpas and was propitiated by almost all the farmers at one point in time. Although the number of hunters has reduced drastically over the years, many hunter-like farmers possess the *nawen* spirit, keeping the hunting god tradition alive.
4. A certain kind of migratory bird.
5. It is interesting to note that the Bonpo addresses the powerful animals by employing kinship terms to express the community's close affinity with nature. While most of the herbivores are labeled by describing their physical attributes, the faithful always apply kinship prefixes such as uncle, brother, grandfather, and monk to carnivores and omnivores.
6. See Durkheim (2001 [1912]) on group solidarity.
7. See Penjore (2004).
8. See Pelgen (2004).
9. The annual Bon rite (*shu*) of Tali in Nangkor county is now being performed by Buddhist *chöpas*.

Chapter 7

1. First Buddhist temple in Tibet, built in the eighth century.
2. Contracted form of *wangchen chenpo*.
3. A thin and flat, bamboo, woven basket.

4. Medicinal substances found in the high Himalayan mountains.
5. Nebesky-Wojkowitz (1956) and Ekvall (1959) list the thirteen Bon gods as follows:

 1. Phrag lha (shoulder god)
 2. Ma lha (mother goddess)
 3. Thab lha (hearth god)
 4. Khyim lha (house god)
 5. rNam Thos Sras (Vaisravana)
 6. Nor lha (wealth god)
 7. Tshong lha (trade god)
 8. mGron lha (feast god)
 9. Lam lha (road god)
 10. Jag lha (robber god)
 11. dGra lha (enemy god)
 12. Zas lha (food god)
 13. Srog lha (life god)

6. Flesh-eating malignant spirits.
7. Conversely, if it lands in a reverse position, the repeat, which in fact is the only remedy, is always initiated.
8. Most *chodpa* are celebrated between the eighth and tenth lunar months.
9. The Buddha of long life.
10. *Gada* is the main weapon of the Hindu god Hanuman.
11. The realm of gods, humans, and serpent beings.
12. The *gathpo* calls himself "penis" and his phallus *wangchen*.
13. The *gadpo*'s ritual seems to bring about fertility primarily among women through the use of the phallic symbols by the male actors somewhat as a means to reproduce or reinforce the dominant forms of masculinity in the matrilineal socialites. In actuality, the concept of infertility seems to apply only to women, for I did not come across any specific fertility ritual for men.

Chapter 8

1. See also Ortner (1989) on the Sherpa society. Wealthy and former noble families are dubbed "big" (*che*) people, the middle class "medium" (*ding*) people, and the poor "small" (*chung*) people.
2. *Karchod* is a Buddhist version of the propitiatory ritual of Shartsen deities.
3. A person can get multiple names from more than one monk.
4. In some villages in Bumthang, children receive names from a phallus-wielding *gadpo*.
5. Ganteng monastery is one of the important and biggest centers of the Nyingma school in Bhutan. It was founded by Pema Thinley (1564–1642), the grandson of Terton Pema Lingpa (1450–1521).
6. He was the Sixty-Ninth Je Khenpo (spiritual head) of Bhutan.
7. Karmay (2000) spelled his second name "Dulwa."
8. One of the twenty-five disciples of Guru Rinpoche.

Chapter 9

1. For information on Buddhist treasure literature, see Gyatso (1996).
2. Gellner (1999) describes three types of religion. The first is soteriology or salvation religion. The second is social or communal religion, while the third is instrumental religion referring to magic and healing rituals. The latter two are subtypes of this-worldly religion—the same category under which Bon falls.
3. Dzogchen, or the Great Perfection, is the highest teaching of the Nyingma school of Tibetan Buddhism. In the Bonpo version, it is claimed that treasure revealers, for instance, Ngodrup Drakpa discovered Yungdrung Bon Dzongchen teachings from a temple that is closely connected with the well-known Buddhist Dzongchen monastery in Kham in 1088 (see Karmay 1972; Kværne 1983).
4. According to Blezer (2011), Drenpa Namkha's life was elongated by the Yungdrung Bonpos. It is alleged that he was alive during the reign of both second and thirty-fourth Tibetan emperors.
5. The name of Bonpo Tonpa Shenrab appears throughout several rituals performed by the Shamanistic Bonpos.
6. *Lha Odé* Gungyal *la bö; yab* Tonpa Shenrab (བླ་འོད་དེ་གུང་རྒྱལ་ལ་འབོད། ཡབ་སྟོན་པ་གཤེན་རབས།).
7. See also Asad (1986) on different forms of Islam.
8. See Latour (2010) and Kohn (2013) on hybridity in relation to religious agency. See also Lopez (1999) on the production of Tibetan Buddhism.

Chapter 10

1. That is, Bhutan studies.
2. See also Samuel (1993) on Tibetan societies.

References

Adams, V. (1992). The production of self and body in Sherpa-Tibetan society. In M. Nichter (Ed.), *Anthropological Approaches to the Study of Ethnomedicine* (pp. 149–189). Amsterdam: Gordon and Breach Science Publishers.

Ardussi, J. (2004). The Gdung lineages of eastern and central Bhutan. In K. Ura and S. Kinga (Eds.), *The Spider and Piglet* (pp. 60–72). Thimphu: Centre for Bhutan Studies.

Ardussi, J. A. and Pommaret, F. (Eds.) (2007). *Bhutan: Traditions and Changes*. Vol. 5. Leiden: Brill.

Aris, M. (1976). The admonition of the thunderbolt cannon-ball and its place in the Bhutanese New Year festival. *Bulletin of the School of Oriental and African Studies*, 39 (3), 601–635.

Aris, M. (1979). *Bhutan: The Early History of a Himalayan Kingdom*. Warminster: Aris & Phillips.

Asad, T. (1986). *The Idea of an Anthropology of Islam*. Washington, DC: Georgetown University Press.

Asante, M. K. and Mazama, A. (Eds.) (2009). *Encyclopaedia of African Religion*. Vol. 1. Thousand Oaks, CA: Sage.

Aziz, B. N. (1978). *Tibetan Frontier Families*. New Delhi: Vikas.

Balikci, A. (2008). *Lamas, Shamans and Ancestors: Village Religion in Sikkim*. Vol. 17. Leiden: Brill.

Barth, F. (2018). Power and compliance in rural Bhutanese society. *Journal of Bhutan Studies*, 38, 46–64.

Barth, F. and Wikan, U. (2011). *Situation of Children in Bhutan: An Anthropological Perspective*. Thimphu: Centre for Bhutan Studies.

Bell, C. (2021). *The Dalai Lama and the Nechung Oracle*. New York: Oxford University Press.

Bellezza, J. V. (2005). *Spirit-Mediums, Sacred Mountains and Related Bon Textual Traditions in Upper Tibet: Calling Down the Gods*. Brill's Tibetan Studies Library 8. Leiden: Brill.

Berglie, P. A. (1976). Preliminary remarks on some Tibetan spirit mediums in Nepal. *Kailash* 4 (1), 87–108.

Berounský, D. (2008). Powerful hero (Dpa' rtsal): Protective deity from the 19th century Amdo and his mediums. *Mongolo-Tibetico Pragensia*, 8, 67–115.

Bjerken, Z. (2004). Exorcising the illusion of Bon shamans: A critical genealogy of shamanism in Tibetan religions. *Revue D'études Tibétaines*, 6, 4–59.

Blezer, H. (2008). Ston pa gshen rab: Six marriages and many more funerals. *Revue d'Etudes Tibétaines*, 15, 421–479.

Blezer, H. (2009). Greatly perfected, in space and time: Historicities of the Bon aural transmission from Zhang zhung. *Tibet Journal*, 34 (2–3), 71–160.

Blezer, H. (2011). The Bon of Bon: Forever old. In H. Blezer (Ed.), *Emerging Bon: The Formation of Bon Traditions in Tibet at the Turn of the First Millennium AD, PIATS 2006: Tibetan Studies: Proceedings of the Eleventh Seminar of the International Association for Tibetan Studies* (pp. 207-246). Andiast: International Institute for Tibetan and Buddhist Studies.

Blezer, H., Gurung, K. N., and Rath, S. (2013). Where to look for the origins of Zhang zhung-related scripts? *New Horizons in Bon Studies*, 3, 99-174.

Bourdieu, P. (1984). *Distinction: A Social Critique of the Judgment of Taste*. London: Routledge & Kegan Paul.

Chhoki, S. (1994). Religion in Bhutan I: The sacred and the obscene. In M. Aris and M. Hutt (Eds.), *Bhutan: Aspects of Culture and Development* (pp. 107-122). Kiscadale Asia Research Series No. 5. Gartmore, Scotland: Kiscadale.

Choden, T. (2004). Ha: The Bon festival of Gortshom village. In *Wayo, Wayo: Voices from the Past* (pp. 1-23). Monograph 11. Thimphu: Centre for Bhutan Studies.

Col, G. D. (2012). The poisoner and the parasite: Cosmoeconomics, fear, and hospitality among Dechen Tibetans. *Journal of the Royal Anthropological Institute*, 18, 175-195.

Craig, R. S. and Gerke, B. (2016). Naming and forgetting: Sowa Rigpa and the territory of Asian medical systems. *Medicine Anthropology Theory*, 3 (2), 87-122.

Day, S. (1989). "Embodying Spirits: Village Oracles and Possession in Ladakh, in North India." PhD dissertation, London School of Economics and Political Science.

Day, S. (1990). Ordering spirits: The initiation of village oracles in Ladakh. In L. Icke-Schwalbe and G. Meier (Eds.), *Wissenschaftsgeschichte und gegenwärtige Forschungen in Nordwest-Indien* (pp. 206-222). Dresden: Staatliches Museum für Völkerkunde Dresden, Forschungsstelle.

Descola, P. (2013 [2004]). *Beyond Nature and Culture*. Trans. J. Lloyd. Chicago: University of Chicago Press.

Desjarlais, R. (1992). *Body and Emotion: The Aesthetics of Illness and Healing in the Nepal Himalayas*. Philadelphia: University of Pennsylvania Press.

Desjarlais, R. (2016). *Subject to Death: Life and Loss in a Buddhist World*. Chicago: University of Chicago Press.

Dorji, J. (2011). Hen Kha: A dialect of Mangde Valley in Bhutan. *Journal of Bhutan Studies*, 24, 69-86.

Dorji, L. (2004). Goleng Roop: A cult of feast offering. In *Wayo, Wayo: Voices from the Past* (pp. 24-48). Monograph 11. Thimphu: Centre for Bhutan Studies.

Dorji, L. (2005). The historical anecdotes of Kheng nobilities. *Journal of Bhutan Studies*, (13), 31-59.

Dorji, S. (n.d.). *Rnam thar bzhi mdor bsdus su gsungs pa bzhugs so*. s.n.

Dorji, T. (2004). The spider, the piglet and the vital principle: A popular ritual for restoring the srog. In K. Ura and S. Kinga (Eds.), *The Spider and Piglet* (pp. 598-607). Thimphu: Centre for Bhutan Studies.

Dorji, T. (2007). Acquiring power: A modality of becoming a pawo (dpa 'bo). In J. A. Ardussi and F. Pommaret (Eds.), *Bhutan: Traditions and Changes. PIATS 2003: Tibetan Studies: Proceedings of the Tenth Seminar of the International Association for Tibetan Studies, Oxford, 2003* (pp. 121-134). Leiden: Brill.

Dorji, T. (2009). Ritualizing story: A way to prevent malicious spirits from causing malady. *Storytelling, Self, Society*, 6 (1), 58-65.

Dotson, B. (2008). Complementarity and opposition in early Tibetan ritual. *Journal of the American Oriental Society*, 128 (1), 41-67.

Droogers, A. (2015). Syncretism. In J. D. Wright (Ed.), *International Encyclopedia of the Social & Behavioural Sciences*, 2nd ed. (pp. 881–884). Oxford: Elsevier.

Dudjom Rinpoche, J. Y. D. (1991). *The Nyingma School of Tibetan Buddhism: Its Fundamentals and History*. Vol 2. Trans. and ed. G. Dorje and M. Kapstein. Boston: Wisdom Publications.

Dumont, L. and Pocock, D. F. (1957). Village studies. *Contributions to Indian Sociology*, 1, 23–41.

Durkheim, E. (2001 [1912]). *The Elementary Forms of Religious Life*. Trans. C. Cosman. New York: Oxford University Press.

Ekvall, B. R. (1959). Significance of thirteen as a symbolic number in Tibetan and Mongolian cultures. *Journal of the American Oriental Society*, 79(3), 188–192.

Eliade, M. (1964). *Shamanism: Archaic Techniques of Ecstasy*. Princeton, NJ: Princeton University Press.

Foucault, M. (1975). *Discipline and Punish: The Birth of the Prison*. Trans. A. Sheridan. New York: Random House.

Fürer-Haimendorf, C. (1955). Pre-Buddhist elements in Sherpa belief and ritual. *Man*, 55, 49–52.

Fürer-Haimendorf, C. (1964). *The Sherpas of Nepal*. London: John Murray.

Galay, K. (2004). Kharam—the cattle festival. In *Wayo, Wayo: Voices from the Past* (pp. 125–147). Monograph 11. Thimphu: Centre for Bhutan Studies.

Geertz, C. (1976). *The Religion of Java*. Rev. ed. Chicago: University of Chicago Press.

Gellner, D. (1999). Religion, politics and ritual: Remarks on Geertz and Bloch. *Social Anthropology*, 7, 135–54.

Germano, D. F. (2005). The funerary transformation of the Great Perfection (Rdzogs chen). *Journal of the International Association of Tibetan Studies*, 1, 1–54.

Glazier, S. (2006). Syncretism. In H. J. Birx (Ed.), *Encyclopedia of Anthropology* (pp. 2151–2152). Thousand Oaks, CA: Sage. https://dx.doi.org.10.4135/9781412952453.n849.

Goody, J. (1986). *The Logic of Writing and the Organization of Society*. Cambridge: Cambridge University Press.

Gorer, G. (1938). *Himalayan Village: An Ancient Account of Lepchas of Sikkim*. London: Michael Joseph.

Gyatso, J. (1996). Drawn from the Tibetan treasury: The gTer ma literature. In J. Cabezon and R. Jackson (Eds.), *Tibetan Literature: Studies in Genre* (pp. 147–169). Ithaca, NY: Snow Lion Press.

Hoffman, H. (1979). *The Religions of Tibet*. Westport, CT: Greenwood Press.

Hoffmann, H. (1944). Gšen, eine lexikographische-religionswissenschaftliche Untersuchung. *Zeitschrift der Deutschen Morgenländischen Gesellschaft*, 98, 340–58.

Holmberg, D. H. (1984). Ritual paradoxes in Nepal: Comparative perspectives on Tamang religion. *Journal of Asian Studies*, 43 (4), 697–722.

Holmberg, D. H. (1989). *Order in Paradox: Myth, Ritual and Exchange among Nepal's Tamang*. Ithaca, NY: Cornell University Press.

Holmberg, D. H. (2006). Transcendence, power and regeneration in Tamang shamanic practice. *Critique of Anthropology*, 26 (1), 87–101.

Huber, T. (2013). The iconography of gShen priests in the ethnographic context of the extended Eastern Himalayas, and reflections on the development of Bon religion. In F.-K. Ehrhard and P. Maurer (Eds.), *Nepalica-Tibetica: Festgabe for Christoph Cüppers*. Vol. 1 (pp. 263–294). Andiast: International Institute for Tibetan and Buddhist Studies.

Huber, T. (2015a). Descent, tutelaries and ancestors: Transmission among autonomous, Bon ritual specialists in eastern Bhutan and the Mon-yul Corridor. In H. Havnevik and C. Ramble (Eds.), *From Bhakti to Bon: Festschrift for Per Kværne* (pp. 271–289). Oslo: Novus Press.

Huber, T. (2015b). Hunting for the cure: A Bon healing narrative from eastern Bhutan. In C. Ramble and U. Rösler (Eds.), *Tibetan and Himalayan Healing: An Anthology for Anthony Aris* (pp. 371–382). Kathmandu: Vajra Books.

Huber. T. (2020). *Source of Life: Revitalisation Rites and Bon Shamans in Bhutan and the Eastern Himalayas*. Vol. 1. Vienna: Austrian Academy of Sciences Press.

Hyslop, G. (2013). On the internal phylogeny of East Bodish. *North East Indian Linguistics*, 5, 91–112.

Johnson, C. P. (2017). "Syncretism and Hybridization." In M. Stausberg and S. Engler (Eds.), *The Oxford Handbook of the Study of Religion* (pp. 755–72). Oxford: Oxford University Press.

Kapstein, M. (2006). *The Tibetans*. New York: Wiley-Blackwell.

Karmay, S. G. (1972). *The Treasury of Good Sayings: A Tibetan History of Bon*. London: Oxford University Press.

Karmay, S. G. (1998 [1983]). Early evidence for the existence of Bon as a religion in the Royal Period. In S. G. Karmay (Ed.), *The Arrow and the Spindle* (pp. 157–166). Kathmandu: Mandala.

Karmay, S. G. (2000). Dorje Lingpa and his rediscovery of the Gold Needle in Bhutan. *Journal of Bhutan Studies*, 2(2), 1–34.

Karmay, S. G. (2005). *The Arrow and the Spindle: Studies in History, Myths, Rituals and Beliefs in Tibet*. Vol. 2. Kathmandu: Mandala.

Karmay, S. G. (Ed.) (2009 [1997]). *The Arrow and the Spindle: Studies in History, Myths, Rituals and Beliefs in Tibet*. Vol. 1. Kathmandu: Mandala.

Karmay, S. G. (2014). *The Arrow and the Spindle: Studies in History, Myths, Rituals and Beliefs in Tibet*. Vol. 3. Kathmandu: Mandala.

Kehoe, Alice. (2000). *Shamans and Religion: An Anthropological Exploration in Critical Thinking*. Prospect Heights, IL: Waveland Press.

Kendall, Laurel. (2009). *Shamans, Nostalgias, and the IMF: South Korean Popular Religion in Motion*. Honolulu: University of Hawai'i Press.

Kinga, S. (2004). A brief history of Chendebji village and Lhabon celebration. In *Wayo, Wayo: Voices from the Past* (pp. 105–116). Monograph 11. Thimphu: Centre for Bhutan Studies.

Kohn, E. (2013). *How Forests Think: Toward an Anthropology Beyond the Human*. Berkeley: University of California Press.

Kvaerne, P. (1974). The canon of the Tibetan Bonpos. *Indo-Iranian Journal*, 16 (1), 18–56.

Kvaerne, P. (1983). The great perfection in the tradition of Bonpos. In W. Lai and L. R. Lancaster (Eds.), *Early Ch'an in China and Tibet* (pp. 367–392). Berkeley: Berkeley Buddhist Studies Series.

Kvaerne, P. (1995). *The Bon Religion of Tibet: The Iconography of a Living Tradition*. Boston: Shambala.

Kværne, P. and Thargyal, R. (1993). *Bon, Buddhism and Democracy: The Building of a Tibetan National Identity*. Copenhagen: Nordic Institute of Asian Studies.

Latour, B. (2010). *On the Modern Cult of the Factish Gods*. Durham, NC: Duke University Press.

Leach, E. R. (1964). *Political Systems of Highland Burma: A Study of Kachin Social Structure*. London: G. Bell and Sons, Ltd.
Leach, E. R. (1968). Introduction. In E. R. Leach (Ed.), *Dialectic in Practical Religion* (pp. 1–6). Cambridge: Cambridge University Press.
Lessing, F. D. (1951). Calling the soul: A Lamaist ritual. In W. J. Fischel (Ed.), *Semitic and Oriental Studies* (pp. 263–284). Berkeley: University of California Press.
Lévi-Strauss, C. (1963 [1949]). *Structural Anthropology*, trans. C. Jacobson and B. G. Schoepf. New York: Basic Books.
Lewis, I. M. (2003). *Ecstatic Religion: An Anthropological Study of Spirit Possession and Shamanism*. 3rd ed. New York: Routledge.
Lichter, D. and Epstein, L. (1983). Irony in Tibetan notions of the good life. In C. Keyes and E. V. Daniel (Eds.), *Karma: An Anthropological Inquiry* (pp. 223–259). Berkeley: University of California Press.
Lim, F. K. G. (2008). *Imagining the Good Life: Negotiating Culture and Development in Nepal Himalaya*. Leiden: Brill.
Lopez, S. D. (1999). *Prisoners of Shangri-La: Tibetan Buddhism and the West*. Chicago: University of Chicago Press.
Marriott, M. (1955). Little communities in an indigenous civilization. In M. Marriott (Ed.), *Village India: Studies in the Little Community* (pp. 171–222). Chicago: University of Chicago Press.
Martin, D. (2001). *Unearthing Bon Treasures: Life and Contested Legacy of a Tibetan Scripture Revealer*. Leiden: Brill.
Maspero, H. (1981). *Taoism and Chinese Religion*. Amherst: University of Massachusetts Press.
McGranahan, C. (2005). Truth, fear, and lies: Exile politics and arrested histories of the Tibetan resistance. *Cultural Anthropology*, 20 (4), 570–600.
McGranahan, C. (2010). Narrative dispossession, Tibet and the gendered logics of historical possibility. *Comparative Studies in Society and History*, 52 (4), 768–797.
Mills, M. A. (2013). *Identity, Ritual and State in Tibetan Buddhism: The Foundations of Authority in Gelukpa Monasticism*. London: Routledge.
Mumford, S. R. (1989). *Himalayan Dialogue: Tibetan Lamas and Gurung Shamans in Nepal*. Madison: University of Wisconsin Press.
Nebesky-Wojkowitz, R. de (1956). *Oracles and Demons in Tibet: The Cult and Iconography of the Tibetan Protective Deities*. The Hague: Mouton.
Nyima, C. L. T. (2009). *The Crystal Mirror of Philosophical Systems: A Tibetan Study of Asian Religious Thought*. Trans. L. Sopa and ed. R. R. Jackson. Boston: Wisdom Publications.
Obeyesekere, G. (1963). The great tradition and the little in the perspective of Sinhalese Buddhism. *Journal of Asian Studies*, 22 (2), 139–153.
Ortner, S. B. (1978). *Sherpas through Their Rituals*. Cambridge: Cambridge University Press.
Ortner, S. B. (1989). *High Religion: A Cultural and Political History of Sherpa Buddhism*. Princeton, NJ: Princeton University Press.
Ortner, S. B. (1995). The case of the disappearing shamans, or no individualism, no relationalism. *Ethos*, 23 (3), 355–390.
Pain, A. and Pema, D. (2004). The matrilineal inheritance of land in Bhutan. *Contemporary South Asia*, 13 (4), 421–435.

Pain, F. (2017). Local vs. trans-regional perspectives on Southeast Asian "Indianness." *Anthropological Forum*, 27 (2), 135–154.

Paul, R. (1976). Some observations on Sherpa shamanism. In J. T. Hitchcock and R. L. Jones (Eds.), *Spirit Possessions in the Nepal Himalayas* (pp. 141–51). Warminster: Aris and Phillips.

Pelgen, U. (2004). Khar Phud: A non-Buddhist Lha Sol festival of eastern Bhutan. In *Wayo, Wayo: Voices from the Past* (pp. 125–147). Monograph 11. Thimphu: Centre for Bhutan Studies.

Pelgen, U. (2007). Rituals and pilgrimage devoted to Aum Jomo Remati by the 'Brog pas of Me rag in eastern Bhutan. In J. A. Ardussi and F. Pommaret (Eds.), *Bhutan: Traditions and Changes* (pp. 121–134). PIATS 2003: Tibetan Studies: Proceedings of the Tenth Seminar of the International Association for Tibetan Studies, Oxford, 2003. Leiden: Brill.

Penjore, D. (2004). Wamling Kharpu: A vibrant ancient festival. In *Wayo, Wayo: Voices from the Past* (pp. 49–71). Monograph 11. Thimphu: Centre for Bhutan Studies.

Penjore, D. (2009). *Love, Courtship, and Marriage in Rural Bhutan: A Preliminary Ethnography of Wamling Village in Zhemgang*. Thimphu: Galing Printers and Publishers.

Phuntsho, K. (2013). *The History of Bhutan*. Haryana: Random House.

Pigg, S. L. (1996). The credible and the credulous: The question of "villagers' beliefs" in Nepal. *Cultural Anthropology*, 11 (2), 160–201.

Pommaret, F. (2009). Local community rituals in Bhutan: Documentation and tentative reading. In A. Terrone and S. Jacoby (Eds.), *Buddhism beyond the Monastery: Tantric Practices and Their Performers in Tibet and the Himalayas* (pp. 111–144). Leiden: Brill.

Pommaret, F. (2014). Bon in Bhutan: What is in the name? In K. Seiji (Ed.), *Bhutanese Buddhism and Its Culture* (pp. 113–126). Kathmandu: Vajra Publications.

Powers, J. (2007). *Introduction to Tibetan Buddhism*. Ithaca, NY: Snow Lion.

Ramble, C. (1998). The classification of territorial divinities in pagan and Buddhist rituals of South Mustang. In A.-M. Blondeau (Ed.), *Tibetan Mountain Deities, Their Cults and Representations* (pp. 123–143). Vienna: Verlag der Österreichischen Akademie der Wissenschaften.

Ramble, C. (2008). *The Navel of the Demoness: Tibetan Buddhism and Civil Religion in Highland Nepal*. New York: Oxford University Press.

Rapten, P. (2004). Goshing Chodpa. In *Wayo, Wayo: Voices from the Past* (pp. 72–105). Monograph 11. Thimphu: Centre for Bhutan Studies.

Redfield, R. (1956). *Peasant Society and Culture*. Chicago: University of Chicago Press.

Samuel, G. (1993). *Civilized Shamans: Buddhism in Tibetan Societies*. Washington, DC: Smithsonian Institution Press.

Samuel, G. (2013). Revisiting the problem of Bon identity: Bon priests and ritual practitioners in the Himalayas. *Journal of the International Association for Bon Research*, 1, 77–98.

Samuel, G. (2017). *Tantric Revisionings: New Understandings of Tibetan Buddhism and Indian Religion*. London: Routledge.

Sangren, P. S. (1984). Great tradition and little traditions reconsidered: The question of cultural integration in China. *Journal of Chinese Studies*, 1 (1), 1–24.

Sax, S. W. (2009). *God of Justice: Ritual Healing in the Central Himalayas*. New York: Oxford University Press.

Schrempf, M. (2015a). Spider, soul, and healing in eastern Bhutan. In H. Havnevik and C. Ramble (Eds.), *From Bhakti to Bon: Festschrift for Per Kværne* (pp. 481–497). Oslo: Institute for Comparative Research in Human Culture.

Schrempf, M. (2015b). Fighting illness with Gesar—a healing ritual from eastern Bhutan. In C. Ramble and U. Rösler (Eds.), *Tibetan and Himalayan Healing: An Anthology for Anthony Aris* (pp. 621–630). Kathmandu: Vajra Books.

Schrempf, M. (2015c). Becoming a female ritual healer in east Bhutan. In M. Schrempf and N. Schneider (Eds.), *Women as Visionaries, Healers and Agents of Social Transformation in the Himalayas, Tibet, and Mongolia*. Special issue of *Revue d'Etudes Tibétaines*, 34, 189–213.

Shakya, T. (1999). *The Dragon in the Land of Snows: A History of Modern Tibet since 1947*. New York: Columbia University Press.

Shaw, R., and Stewart, C. (Eds.) (2003). *Syncretism/Anti-syncretism: The Politics of Religious Synthesis*. New York: Routledge.

Shneiderman, S. (2006). Living practical Dharma: A tribute to Chomo Khandru and the Bonpo women of Lubra village, Mustang, Nepal. In M. Khandelwal and S. L. Hausner (Eds.), *Nuns, Yoginis, Saints and Singers: Women's Renunciation in South Asia* (pp. 91–122). Delhi: Zubaan.

Shneiderman, S. (2015). *Rituals of Ethnicity: Thangmi Identities between Nepal and India*. Philadelphia: University of Pennsylvania Press.

Singer, M. B. (1972). *When a Great Tradition Modernizes: An Anthropological Approach to Indian Civilization*. New York: Praeger Publishers.

Snellgrove, D. L. (1980 [1967]). *The Nine Ways of Bon: Excerpts from gZi-Brjid*. Oxford: Oxford University Press.

Snellgrove, D. L. (1987). *Indo-Tibetan Buddhism: Indian Buddhists and Their Tibetan Successors*. Boston: Shambhala.

Snellgrove, D. (1989 [1961]). *Himalayan Pilgrimage: A Study of Tibetan Religion by a Traveller through Western Nepal*. Boston: Shambala.

Snellgrove, D. L., and Richardson, H. E. (1968). *A Cultural History of Tibet*. New York: Frederick A. Praeger.

Spiro, M. E. (1982). *Buddhism and Society: A Great Tradition and Its Burmese Vicissitudes*. 2nd ed. Berkeley: University of California Press.

Srinivas, M. N. (1952). *Religion and Society among the Coorgs of South India*. Oxford: Clarendon Press.

Stein, M. A. (1921). *Serindia: Detailed Report of Explorations in Central Asia and Westernmost China*. Vol. 5. Oxford: Clarendon Press.

Stein, R. A. (1972). *Tibetan Civilization*. Stanford, CA: Stanford University Press.

Stein, R. A. (1988). Tibetica antiqua V: La religion indigène et les Bon-po dans les manuscrits de Touen houang. *Bulletin de l'Ecole Française d'Extrême Orient*, 77, 27–56.

Stein, R. A. (2010). *Rolf Stein's Tibetica Antiqua*. Trans. and ed. A. P. McKeown. Leiden: Brill.

Stewart, C. (1991). *Demons and the Devil: Moral Imagination in Modern Greek Culture*. Princeton, NJ: Princeton University Press.

Stewart, C. (2011) Creolization, hybridity, syncretism, mixture. *Portuguese Studies*, 27, 48–55.

Taee, J. (2017). *The Patient Multiple: An Ethnography of Healthcare and Decision-Making in Bhutan*. New York: Berghahn Books.

Tambiah, S. J. (1970). *Buddhism and the Spirit Cults in North-east Thailand*. Cambridge: Cambridge University Press.
Tashi, K. T. (2021). The (un)changing Karma: Pollution beliefs, social stratification and reincarnisation in Bhutan. *Asia Pacific Journal of Anthropology*, 22 (1), 41–47.
Tashi, K. T. (2022). Life on the porch: Marginality, women, and old age in rural Bhutan. *Journal of Anthropological Research*, 78 (1), 35–58.
Thaye, K. L. (1973). *gTer ston rgya rtsa'i rnam thar*. Tezu: Tibetan Nyingmapa Monastery.
Thondup, T. (2014). *Masters of Meditation and Miracles: Lives of the Great Buddhist Masters of India and Tibet*. Boston: Shambhala.
Torri, D. (2020). *Landscape, Ritual and Identity among the Hyolmo of Nepal*. London: Routledge.
Tucci, G. (1980). *The Religions of Tibet*. Trans. G. Samuel. London: Routledge and Kegan Paul.
Turner, V. (1969). *The Ritual Process: Structure and Anti-structure*. Chicago: Aldine Press.
Ura, K. (1994). Development and decentralization in medieval and modern Bhutan. In M. Aris and M. Hutt (Eds.), *Bhutan: Aspects of Culture and Development* (pp. 25–50). Gartmore, Scotland: Kiscadale.
van Driem, G. (1994). *Language Policy in Bhutan: Aspects of Culture and Development*. Gartmore, Scotland: Kiscadale.
van Schaik, S. (2011). *Tibet: A History*. New Haven: Yale University Press.
van Schaik, S. (2013a). Dating early Tibetan manuscripts: A paleographical method. In B. Dotson, K. Iwao, and T. Takeuchi (Eds.), *Scribes, Texts and Rituals in Early Tibet and Dunhuang* (pp. 119–135). Wiesbaden: Reichert Verlag.
van Schaik, S. (2013b). The naming of Tibetan religion: Bon and Chos in the Tibetan imperial period. *Journal of the International Association for Bon Research*, 1, 227–257.
Viveiros de Castro, E. (2014). *Cannibal Metaphysics*. Minneapolis: Univocal.
Webb, H. S. (2013). Expanding Western definitions of shamanism: A conversation with Stephan Beyer, Stanley Krippner, and Hillary S. Webb. *Anthropology of Consciousness*, 24 (1), 57–75.
Wikan, U. (2012). *Beyond the Words: The Power of Resonance*. Chicago: University of Chicago Press.
Winkelman, M. (2000). *Shamanism: The Neural Ecology of Consciousness and Healing*. Westport, CT: Bergin and Garvey.
Yangdon, T. (2015). "*Pchiru Shelni*: A Sexual Practice in Bhutan." PhD dissertation, University of Wollongong, NSW.

Index

For the benefit of digital users, indexed terms that span two pages (e.g., 52–53) may, on occasion, appear on only one of those pages.

Tables and figures are indicated by *t* and *f* following the page number

animal sacrifice, 3–4, 6, 7, 96, 127, 131, 136–38, 139, 234
animism, 11
antigossip ritual. See *kharam* ritual
Ap Chungdu, 20–21
Ardussi, John, 37
Aris, Michael, 35–36
atsara, 163–64, 181–82, 186–88
Aum Sangkharmeth, 72–73
autochthonous demons, 87–89

Balikci, A., 54, 55, 221
Barth, Fredrik, 204
basic health unit (BHU), 39–40, 79–80
beyul, 34
BHU. *See* basic health unit
Bhutan
 Bon in, 15–21, 36–37, 236
 Buddhism in, 15, 16, 236, 239–40
 Clerical Bon in, 210–11
 courtship in, 42–43
 dung nobilities in, 35–36, 38
 eastern, *tsen* in, 95
 Kheng in, 31
 languages and ethnolinguistic groups in, 29–30
 phallic symbols and objects in, 163–65, 188–89
 social stratification and taxation structure in, 43
 Zhabdrung in, 29–30
Black Bon *(bon nag)*, 3–4, 7, 20–21, 126–27
black Bonpos, 126–27, 133, 134, 135–36, 137
black magicians, 99–100
black magic rituals *(ngan)*, 3–4, 125, 126–28, 234
 lawsuits about, 130–33
 politics of, 133–40
Blezer, H., 8–10
body *(lü)*, 58–59, 60–63
Bon. *See also* Clerical Bon; Yungdrung Bon
 in Bhutan, 15–21, 36–37, 236
 cosmology, 171, 198
 divination techniques, 73–74
 on *düd* spirits, 87–88
 dung nobilities and, 35–36
 in Goleng, 51–52
 in Goleng, local divinities of pantheon, 67–75, 69t, 73f, 76–77, 82
 methods for treating poison attacks, 101–2
 Odé Gungyal in, 36–37, 198
 reformed, 6–7
 rites to nobilities of Zhemgang, 150–51
 shamanism and, 7
 Sid-pai lha Bon and, 11–12, 19–20
 soul in, 58–59
 surveillance of, 3–4, 221
 as term, changing usage, 10–11
Bon, Buddhism and, 1–3
 in Bhutan, 16, 236
 Bon rituals and practices and, 17–18, 19, 24, 26, 55–57, 105, 106–7, 108–9, 115, 139–40, 141–42, 197–98, 199–200, 225–26, 231, 233, 238–39
 Buddhist rituals, Bon deities and, 191–97, 217–18
 on child gods, 209
 chö, 17

Bon, Buddhism and (*cont.*)
 chodpa and, 175
 Clerical Bon, 210-11
 complementarity and influence between, 56
 dung and, 37
 five life elements and, 63
 gadpo and, 181-82, 189
 in Goleng, 22-23, 29, 54, 55, 67-68, 106, 203-4, 209-10, 220, 225-26, 227-29, 241-42
 great and little traditions in, 226-29
 history and relationship in Tibet, 4-14
 hoi-ya-hoi ritual and, 176
 iconographies of, 216
 influence through stages of life, 209
 lha chö and *mi chö* and, 22-23
 in naming patterns, 203-4
 Odé Gungyal ritual in, 197-98, 199-200, 202-3
 pantheons and deities of, 67-68, 74, 76, 139
 phallic rituals in, 163, 189-90
 pre-Buddhist Bon, 5-9, 10, 11, 12-13, 16, 20, 58-59
 rup and, 233
 shamanism and, 18-19
 syncretism, 229-35, 241
 tsen spirits in, 94-95
 Yungdrung Bon, 216-17, 223-24
bon kar (White Bon), 3-4, 7, 20-21, 127, 221-22
bon nag (Black Bon), 3-4, 7, 20-21, 126-27
Bonpo Chungla, 3-4, 47-48, 66-67, 88-89, 91, 127-28, 129, 138-39, 178-80, 207-8
Bonpo Dophu, 77-78, 107-15
Bonpo Drakpa, 127-28
Bonpo Karma, 3, 125, 126, 165-67, 168-69, 170-75
Bonpo Ngedup, 128, 131-33, 137
Bonpo Pemala, 4, 79-80, 88, 90-91, 92, 94, 127-30, 136-37, 202-3
 on Rematsen, 157
 on *rup*, 146, 148, 150-52, 153, 155, 156, 157, 158, 160-61
Bonpo Pila, 129-30

Bonpos. *See also* official Bonpo
 animal sacrifices by, 6
 anthropologists on, 7-8
 black, 126-27, 133, 134, 135-36, 137
 Buddhism and Buddhists on, 2-3, 5, 106-7, 115, 139-40, 218, 221-22, 228
 Buddhist rituals and, 20-21, 106-7, 108-9, 124-25, 139-40, 145
 clerical, 210, 223-25, 230-31, 232-33
 on *düd* spirits, 88-89
 on five life elements, 105
 in Goleng, lawsuits against, 130-33
 Golengpa, 3-4, 65, 79-80, 123, 126, 127-28, 136-38, 139, 221, 234
 on *gyalpos*, 82, 83-84, 87
 lay *chöpas* and, 124-25, 139, 141-42, 160, 192, 197, 217-18, 220-22, 228, 232-33, 234, 237-39, 242
 lu'i, 106-15
 on *mamo* spirits, 92-94
 shamans and, 126
 of Tibet, 5, 6, 13, 16
 treatment of poison attacks by, 101-2
 of Zhemgang district, 2-3
Bonpos, in Bon rituals, 17-18
 for deities and *lu*, 76-78, 79-81
 kharam, 166-67, 169-70
 rup rites, 142-43, 145, 146-48, 150-51, 152-53, 154, 155-56, 157-58, 160-61, 191, 233, 234
 Shartsen, 96-98
 for soul loss, 106
 texts for, 226-27
Bonpo Sangay, 82, 83, 85, 92, 95-97, 98, 136-38
Bonpo shaman, 88-89, 106-7
 Buddhist rituals and, 222
 Buddhists and, 140
 in Goleng, 116, 117
 lay *chöpas* and, 202
 as *pawo* and *pamo*, 18, 116-20, 121-25
 ritual for retrieval of lost souls, 120-25
 ways of becoming, 116-20, 222
Bonpo Tonpa Shenrab, 8-9, 18-19, 88-89, 115, 142-43, 150-51, 210-11, 214, 224-25
Bon rituals, 16-19, 20. *See also* black magic rituals; Bonpos, in Bon rituals;

INDEX 281

Goleng, Bon rituals in; *rup* and
 rup rites
 by Bonpo shamans, 120–25
 Buddhism and, 17–18, 19, 24, 26, 55–
 57, 105, 106–7, 108–9, 115, 139–40,
 141–42, 197–98, 199–200, 225–26,
 231, 233, 238–39
 consequences of noncompliance with
 rules, 145, 146t
 for *düd* spirits, 88–89
 five life elements and, 58, 63
 for *gyalpos*, 83–86, 87
 kharam, 166–75
 by *lu'i* Bonpos, 106–7, 108–15
 for *mamo* spirits, 92–94
 Odé Gungyal in, 197–98, 199–200
 protective and healing, 76–81
 for recapturing abducted soul, 65–
 67, 74
 for releasing trapped serpent
 spirits, 109–15
 for retrieval of lost souls, 120–25
 for Shartsen, 95–98
 for soul loss, 106
 by Tonpa Shenrab, 224
 in Zhemgang, 24
Bourdieu, Pierre, 125
Buddha Amitayus, 177, 178, 195
Buddhahood, 68
Buddhas of Three Times (*Düsum Sangay*),
 211, 216
Buddhism and Buddhists. *See also* Bon,
 Buddhism and; lay *chöpas*
 in Bhutan, 15, 16, 236, 239–40
 Bonpos and, 2–3, 5, 106–7, 115, 139–40,
 218, 221–22, 228
 Clerical, 14, 54
 Clerical Bon and, 210–11, 220, 223–
 24, 230–32
 dharma protectors in, 20, 55
 early diffusions of, 5
 enlightenment and, 225, 228, 237
 Four Noble Truths of, 227–28
 in Goleng, 29, 51, 52, 55–57, 161,
 203–4, 206–7, 221, 225, 227–28, 236–
 37, 241–42
 gyalpo and, 81, 103
 Hinduism and, 21–22

 local folk practices and, 22
 on *mikha*, 165
 naming patterns, 203–6
 nibbanic, 54
 philosophical, 54–55, 227, 236–37,
 238–39, 241
 schools and subschools of, 227
 Shamanic Bon and, 220, 224, 229–
 33, 235
 Tibetan, 29, 51, 81, 236–37
 Tibet and, 15, 16–17, 56, 165–66
 Vajrayana, 227
 village, 54, 56, 221, 231–32, 236–38
 Yungdrung Bon and, 216–17, 223–24
Buddhist festivals
 chodpa, 175
 phallic implements in, 163–64
Buddhist rituals
 Bonpos and, 20–21, 106–7, 108–9, 124–
 25, 139–40, 145
 Bonpo shaman and, 222
 chodpa, 175
 five life elements and, 63–64
 gadpo in, 181–83
 Goleng lineage deities in, 191–97
 Golengpas on, 55, 63, 64, 66
 lalu, 63–64, 65–66
 mikha dradog, 165–66
 Odé Gungyal in, 191, 197–203, 217–19
 phallic symbols in, 164, 181–82, 189–90
 phallic *tormas* in, 178–80
 rup and, 141–42, 159
 tsen düd solkha, 192–97
 wangchuma, 167
Buddhist temples
 in Goleng, 3, 51–57
 in Kumbu, 212–14, 216–17, 218–19
 protector gods of, 68–70
Bumthang, 44, 184
burnt offerings (*sur*), 3–4

Centre for Bhutan Studies, 11, 18–19
Chakhar Gyalpo, 15
Chakna Dorji, 115
child gods (*kyelha*), naming patterns
 and, 203–10
chimi and *magpa*, 46–47
chö, 17, 22–23

chodpa, 175–77, 180, 181–82
chod shampa, 186–88
chökyong (dharma), 5, 64
Chungdu, 206, 221
Clerical Bon, 26, 51, 115, 191, 205
 Buddhism and, 210–11, 220, 223–24, 230–32
 former temple, 210–19
 Shamanic Bon and, 224
clerical Bonpos, 210, 223–25, 230–31, 232–33
Clerical Buddhism, 14, 54
corvées, 44, 126–27

dakinis *(khandroma)*, 107–8
Dangling, 95–97
Dawa Bidha, 44, 47
Dechen, 101, 130–31, 137–38, 144–45
Dema, 131–33
demonesses and witches, 89–91
dham dham rite, 148, 150–56, 160, 161
dham lam rites, 148, 150, 156–58
dharma *(chökyong)*, 5, 64
dharma protectors, 20, 55
Dorji, T., 19, 84
Dorji Lingpa, 211–12
Dorjimo, 137–38
Dotson, B., 8–9
Dralha Karchung, 142
Drenpa Namkha, 223–24
Drigum Tsenpo, 5
Droogers, A., 229–30
Drukpa, 29–30
Drukpa Kagyu, 1–2, 16–17, 33, 51, 53, 164–65, 225–26, 241–42
Drukpa Kunley, 164–65, 188
drungpa, 45
düd spirits, 87–89, 157
duklha (poison god), 99–105
Dung House, 44, 47, 49–51, 143, 149–50, 155, 161, 193, 195–96
dung nobilities, 35–38, 44–45, 46–51
 Odé Gungyal and, 141, 143–44
 rup and, 141–44, 151, 156, 161–62, 240
 Yarlung kings and, 36–37, 143–44
 in Zhemgang, 37–38, 47
Düsum Sangay (Buddhas of Three Times), 211, 216

economy-generating spirits, 103–5
economy or prosperity *(wangthang)*, 58–59, 60–63
Eliade, M., 116
enlightenment, 225, 228, 237

female god *(molha)*, 119–20, 121, 122, 123–24
five life elements. See also *la*
 Bonpos on, 105
 Bon rituals and, 58, 63
 Buddhist rituals and, 63–64
 common rituals for strengthening, 61–64
 fluidity of, 58–61
 Golengpas on, 58–59, 60, 61–62, 63, 64, 74–75, 105, 239
 lü, 58–59, 60–63
 lungta, 58–60, 61–64
 sok, 58–59, 60–64, 65
 wangthang, 58–59, 60–63
Foucault, Michel, 139

gadpo, 180–90, 197–98
ganmo, 180, 185–87
Gedtongpa, 47
Gedun Rinchen, 211–12
Gellner, D., 54, 223
Genyen Jagpa Milen, 205
Geser, 63–64, 116, 118–20, 179–80
Geshe Pema Thinley, 51–53, 222, 232
Goleng, 1–4, 19–20, 39f
 BHU, 39–40, 79–80
 Bon and Buddhism in, 22–23, 29, 54, 55, 67–68, 106, 203–4, 209–10, 220, 225–26, 227–29, 241–42
 Bon in, 51–52
 Bon in, local divinities of pantheon, 67–75, 69t, 73f, 76–77, 82
 Bonpo shamans in, 116, 117
 Bonpos in court, 130–33
 Buddhism and Buddhists in, 29, 51, 52, 55–57, 161, 203–4, 221, 225, 227–28, 236–37, 241–42
 Buddhist protective deities in, 206–7
 Buddhist rituals in, 55, 63, 64, 66
 Buddhist rituals in, local deities and demons in, 191–97
 Buddhist temples in, 3, 51–57

child gods in, 203–4, 208–9
courtship in, 42–43
düd spirits in, 87–89
Dung House in, 44, 47, 49–51, 143, 149–50, 155, 161, 193, 195–96
dung in, 44–45, 46–51, 161
dung nobility, lineage deities and, 46–51
dung nobility, *rup* and, 141–44, 151, 156, 161–62
families and households in, 40–42, 48, 49–51, 82–83, 99
families and households in, *gyalpo* and, 86–87, 99, 103
fieldwork in, 24–26
five life elements in, 58–59, 60, 61–62, 63, 64, 74–75, 105, 239
Golengpas on purity and cleanliness, 99–101
goshé nyenshés, 127–28
great and little traditions in, 51, 225–29, 234–35
gyalpo beings in, 81–85, 86–87, 99, 103
hoi-ya-hoi ritual in, 176
Kudrung House in, 45, 49–50
lay *chöpas* in, 51, 52–54, 55–57, 74–75, 120, 124–25, 141–42, 159–60, 221, 231, 234, 236–38
lineage deities of, 71–72, 191–97, 194*f*
machim in, 48
magpa in, 46–47
Mamai House in, 45, 49–50, 196
mamo spirits in, 89, 90–93
map of neighboring villages and, 25*f*
matrilineality in, 40, 41, 42, 49, 99
migration to, 44
modernity and, 242
name of, 38
naming customs in, 203–4, 206–8, 209–10
Odé Gungyal worshiped in, 71, 161
official Bonpos in, 106–7, 126–30, 140, 234
Pirpön House in, 46, 49–50
poison gods in, 99, 100–3
Rematsen in, 196
rock phallus and, 178–79, 180
Shartsen in, 96, 98
sociality, 101

social organization in, 40–46, 161–62, 226
sondre spirits in, 89, 90, 91–92
subcounties, 39–40
syncretism in, 220, 230, 232
taxpayers in, 43–44
treatment for poison attacks in, 101–3
tsen in, 94–95
weather in, 39
women in, 40–43
yang in, 103–5
Goleng, Bon rituals in, 65–66, 73–74, 83–85, 86
black magic, 136
gyalpo, 83–85, 86
by *lu'i* Bonpos, 106–7, 108–9
Nine Ways of Yungdrung Bon, 223
protective and healing, 76–81
restriction on, 127, 129
rup rite, 129, 141–44, 145–46, 147–50, 152–53, 155–56, 159–62, 240–41
Shartsen, 96, 98
Goleng Dharmapalas, 82
gomde, 53
Gomphu, 33–35, 37–38, 180–81, 199–201
goshé nyenshé (village elite), 4, 38, 127–28, 146, 159–60, 197
gossip. See *kharam*; *mikha*
gossip pole *(kharam shing)*, 166–70, 168*f*, 174–75, 189
great and little traditions, 21–24, 51, 220, 225–29, 234–35
gung, 40–41
Guru Rinpoche, 81, 115, 142–43, 199–200
gyalpo beings
big, 81–83, 103
big, rituals for dispatching, 83–86
Buddhism and, 81, 103
düd spirits and, 87–89
small or familial, 86–87, 99, 103
sondre spirits and, 89, 103–5
gyalpo shul du, 83–86
Gyalrig (Ngawang), 31, 35–36

Hindu gods, 71
Hinduism, 21–22, 189
Hoffman, H., 8–9
hoi-ya-hoi ritual, 176–77, 180, 181
Holmberg, David, 18

Huber, Toni, 11–12, 19–20

Jampel Shinje, 206–7
jigtenpai chö (mundane religion), 225–29
Jomo, 95–97

Karmay, Samten, 7, 94–95, 211–12
Karma Yölek, 200
Kencho, 47–48
khandroma (dakinis), 107–8
kharam (gossip), 165–67, 168–69, 171
kharam (antigossip) ritual, 165–75, 189–90
 mikha and, 168–70, 171–75
kharam shing (gossip pole), 166–70, 168*f*, 172–73, 174–75, 189
Kheng, 31
Khengkha, 31
Khengpas, 31
Khraipa House, 148, 149–50, 151, 155, 156
khraipas, 43–44
kudrung, 45–46, 50
Kudrung House, 45, 49–50
Kumbu temple, 212–14, 216–17, 218–19
Kvaerne, P., 6, 7
kyelha (child gods), 203–10

la (soul), 58–60, 61–64, 65, 76, 105, 239
 Bon ritual for recapturing abducted, 65–67, 74
 lay *chöpas* and, 74–75
 loss, Bon rituals for, 106
 multiplicity of, 65
 shamanic retrieval of lost, 120–25
lalu rituals, 63–64, 65–66
Lama Sakya Özer, 199–200
Lama Zhang, 33, 34
Langdarma, 4–5, 16, 36–37
la prok ritual, 66
lay *chöpas*, 23–24, 76
 Bonpos and, 124–25, 139, 141–42, 146, 160, 192, 197, 217–18, 220–22, 228, 232–33, 234, 237–39, 242
 Bonpo shaman and, 202
 in *chodpa*, 175, 176
 Clerical Bon and, 210, 218–19
 gadpo and, 182, 183, 184, 185
 in Goleng, 51, 52–54, 55–57, 74–75, 120, 124–25, 141–42, 159–60, 221, 231, 234, 236–38
 on Goleng lineage deities, 191–92
 gyalpos and, 82
 in *hoi-ya-hoi* ritual, 176–77
 at Kumbu temple, 212
 in Odé Gungyal ritual, 197–200, 201–2, 203
 phallic symbols and, 163
 on phallic *torma*, 178
 rup rites and, 141–42, 146, 159–60, 198, 222, 232, 233, 234
 syncretism and, 235, 237–38
 treatment of poison attacks by, 101–2
 in *tsen düd solkha*, 192, 193, 195–96
 village Buddhism and, 237–38
Leach, E. R., 240–41
Lepchas, 7–8
Lévi-Strauss, Claude, 84
Lhalung Palgyi Dorji, 37
life essence (*sok*), 58–59, 60–64, 65
lineage deities
 in Buddhist rituals, 191–97
 Goleng *dung* nobility and, 46–51
 of Golengpas, 71–72, 191–97, 194*f*
Loden Nyingpo, 8
Lopön Pema Wangchuck, 4, 38, 52–53, 55–56, 64, 146, 159–60, 192, 195, 196–97, 221–22, 234
Lord Shiva, 167, 189
lü (body), 58–59, 60–63
lu (serpent spirits), 68–70, 72–73, 73*f*, 76–81
 lu'i Bonpos on, 106–15
 ritual of releasing trapped, 109–15
lud rituals, 63–64, 121
lu'i Bonpos, 106–15
lu nad, 108–9, 113–15
lungta (wish-fulfilling force), 58–60, 61–64
lu sadag, 111
lusang ritual, 80

machim, 48
magpa, 46–47, 130, 134, 197
Mamai House, 45, 49–50, 196
mamo-sondre class, of deities, 70–71, 89, 90–91, 92–93, 94, 99

mamo spirits, 89, 90–94, 120
man's religion *(mi chö)* and god's religion *(lha chö)*, 22–23
matrilineality, 40, 41, 42, 49, 99, 166
Merak-Sakteng, 95–96
mi chö (man's religion) and *lha chö* (god's religion), 22–23
mikha (gossip), 163, 165, 168–70, 171–75
 phallic symbols and, 163–64, 166, 188–89
mikha dradog ritual, 165–66
molha (female god), 119–20, 121, 122, 123–24
Mon, 15, 16
monthly outreach clinic (ORC), 79–80
mundane religion *(jigtenpai chö)*, 225–29
Mutok, 47–48

naming patterns, child gods and, 203–10
Namke Nyingpo, 217
nangpa sangaypai chö (supramundane or enlightened religion), 225–29
nangten (phallic relic), 207–8
Naro Bonchung, 142–43
nawen ritual, 84–85, 151–52
nawen spirit, 131–32, 137
Nebesky-Wojkowitz, R. de, 81
ngakmar, 114, 120
ngan. See black magic rituals
Ngawang, 31, 35–36
nibbanic Buddhism, 54
Nine Ways of Bon, The (Snellgrove), 5–6
Nine Ways of Yungdrung Bon, 13, 223
Nyatri Tsenpo, 143
Nyingma school, 51, 52, 223, 225–26, 234

Odé Gungyal, 18–20, 35–36, 145
 in Buddhist rituals, 191, 197–203, 217–19
 in Clerical Bon, 224–25
 in Goleng, 71, 161
 journey of, 201*f*
 lay *chöpas* in ritual, 197–200, 201–2, 203
 rup rites and, 141, 142, 143–44, 149–52, 153, 154, 159, 161–62, 197–98, 199, 240–41
official Bonpo *(zhung-gi bonpo)*, 3, 133, 221
 of Goleng, 106–7, 126–30, 140, 234
 of Zhemgang, 106, 125–26
ogyaala ritual, 180, 181

'ong force, 86–87
Ongma, 31
ORC. *See* monthly outreach clinic
Ortner, Sherry, 18

Padmasambhava, 4–5, 15, 20, 32, 34, 165–66, 223–24
Palden Lhamo, 216–17, 218–19
pamo Chozom, 179–80
pamo Karma, 117–20, 121–25
pawo and *pamo*, 18, 116–20, 121–25. *See also* Bonpo shaman
Peling traditions, 51
Pema Lingpa, 16–17, 34, 51–52
Pema Tashi, 179–80
Pema Wangchuck, 62–63
Penjore, D., 43–44
pernicious gossip. *See* gossip
Persia, 8
phallic relic *(nangten)*, 207–8
phallic rituals
 in Bon and Buddhism, 163, 189–90
 of *chodpa*, 175–77
 by *gadpo*, 180–90
phallic symbols, 163–66
 in Bhutan, 163–65, 188–89
 in Buddhist rituals, 164, 178–80, 181–82, 189–90
 in *chodpa*, 176
 in *kharam shing*, 166–69, 168*f*, 189
 mikha and, 163–64, 166, 188–89
 rock phallus, 178–80, 207–8
 in Shaivism, 167
 torma, 176, 178–80, 186–88
philosophical Buddhism, 54–55, 227, 236–37, 238–39, 241
phorgola rite, 145, 157, 161
phorgola ritual, 157
Phuntsho, K., 210
pirpön, 45–46, 50
Pirpön House, 46, 49–50
poison attacks, treating, 101–3
poison givers, 99–101, 102–3
poison god *(duklha)*, 99–105
Polu Khenpo, 52
Polu Khenpo Dorji, 52
pre-Buddhist Bon, 5–9, 10, 11, 12–13, 16, 20, 58–59

propitiatory ritual, of local deities and demons, 191–97

Redfield, R., 21, 22
reformed Bon, 6–7, 14
Rematsen, 48–50, 71–73, 94–95, 129–30, 150–51, 157, 193–94, 195–96
ritual cakes *(torma)*, 176, 178–80, 186–88, 192–96, 194f, 200, 201–2, 218
rock phallus, 178–80, 207–8
rup and *rup* rites, 129, 149t
 Bonpo Pemala on, 146, 148, 150–52, 153, 155, 156, 157, 158, 160–61
 Bonpos and, 142–43, 145, 146–48, 150–51, 152–53, 154, 155–56, 157–58, 160–61, 191, 233, 234
 Buddhist rituals and, 141–42, 159
 dham dham rite in, 148, 150–56, 160
 dham lam in, 148, 150, 156–58
 dung nobility and, 141–44, 151, 156, 161–62, 240
 of first, second, and third days, 156–59
 future of, 159–62
 in Goleng, 129, 141–44, 145–46, 147–50, 152–53, 155–56, 159–62, 240–41
 lay *chöpas* and, 141–42, 146, 159–60, 198, 222, 232, 233, 234
 lineage deities in, 191
 Odé Gungyal and, 141, 142, 143–44, 149–52, 153, 154, 159, 161–62, 197–98, 199, 240–41
 outline of, 146–50
 phorgola ritual in, 145, 157
 rules and consequences, 144–45
 in Shobleng, 148–50, 151–54, 155–56, 158, 160–61
 tsen düd solkha and, 192–93

Sakya Özer, 33–34
Samdrup Gyalmo, 49
Samuel, G., 6, 7–8, 10, 14, 54, 59, 223
Sangchu, 72–73
Senge Dorji, 33–34
serpent spirits. See *lu*
serpent spirits *(lu)*, 68–70, 72–73, 73f, 77–80
Shaivism, 167, 189
Shalging Karpo, 15–16

Shamanic Bon, 14, 17, 18–20. *See also* Bon; Bonpo shaman
 Buddhism and, 220, 224, 229–33, 235
 Clerical Bon and, 224
 cosmology of, 74
 as practical religion, 240–41
 shamanic retrieval of lost souls, 120–25
shamanism and shamans, 7–8, 11, 13–14, 18–19, 126
Shar Sergang, 206, 210, 212
Shartsen, 94–98, 136–37
shen, 8–9
Sherpas, 7–8
Shobleng, 2, 20
 Khraipa House, 148, 149–50, 151, 155, 156
 lay *chöpas* in, 237–38
 Rematsen in, 157
 rup rites, 148–50, 151–54, 155–56, 158, 159, 160–61
Siberia, 7, 13–14
Sid-pai Gyalmo, 205, 206, 210–11, 213–15, 216–17, 218–19
Sid-pai lha Bon, 11–12, 19–20
sid-pai lha chö (worldly or worldly god's religion), 225–26
Sindhu Raja, 15
Sithar Dondup, 199–200
Situation of Children in Bhutan (Barth and Wikan), 204
Snellgrove, D. L., 5–6, 7, 223
sok (life essence), 58–59, 60–64, 65
Sonam, 136–38
Sonam Rinchen, 58–59
sondre spirits, 89–90, 99
 discerning host of, 91–94
 in Goleng, 89, 90, 91–92
 gyalpo beings and, 89, 103–5
Songtsen Gampo, 32
soul. See *la*
Source of Life (Huber), 12
Spiro, M. E., 54
Stein, Aurel, 10, 17
Stein, Rolf, 10
supramundane or enlightened religion (*nangpa sangaypai chö*), 225–29
sur (burnt offerings), 3–4
syncretism, 2, 220, 221–22, 228, 229–35, 237–38, 239, 241

Tala Mebar, 15–16
Tali Zangdokpelri, 53
Tantra, 5, 14
taxpayers, 43–44
Terton Pema Lingpa, 175
Tibet
 Bonpos of, 5, 6, 13, 16
 Buddhism and, 15, 16–17, 56, 165–66
 Chinese occupation of, 52
 Clerical Bon of, 230–31
 history and relationship of Bon and Buddhism in, 4–14
 pre-Buddhist Bon in, 7–9
 religious and aristocratic families, 40
 Yungdrung Bonpos of, 223
Tibetan Buddhism, 29, 51, 81, 236–37
Tong Tongphai, 72–73
torma, 176, 178–80, 186–88, 192–96, 194f, 200, 201–2, 218
Trisong Detsen, 4–5, 16, 36–37
Trong county, Zhemgang, 24–25, 34–35
Tsangma, 16, 31, 36–37
tsekpa spirits, 99
Tsendhen Dewa, 210–12, 216, 217
tsen düd solkha, 192–97
tsen spirits, 77, 78, 94–98, 120–21, 124, 157
Tshering Wangdi, 52, 198–99, 200, 201–2
Tshewang, 134, 135–36
Tshewang Namgay, 47–48
Tsongtsongma, 95–97
Tsultrim Wangmo, 160–61
tsungmapa, 43–44, 45

Üchogpa, 29–30
Ugyen, 134–36
Ura *dung*, 35–36

Vajrayana Buddhism, 227
van Driem, G., 30
van Schaik, S., 9
village Buddhism, 54, 56, 221, 231–32, 236–38
village elite (*goshé nyenshé*), 4, 38, 127–28, 146, 159–60

wangchuma ritual, 167
wangthang (economy or prosperity), 58–59, 60–63
Wayo, Wayo—Voices from the Past, 18–19, 20
wealth and prosperity
 yang and, 103–5
White Bon (*bon kar*), 3–4, 7, 20–21, 127, 221–22
Wikan, Unni, 204
wish-fulfilling force (*lungta*), 58–60, 61–64
worldly or worldly god's religion (*sid-pai lha chö*), 225–26

Yamantaka, 206–8
yang, 59, 63, 79, 86–87, 103–5, 154, 156, 158, 174, 185
yangbum, 79
Yarlung kings, 36–37, 143–44
Yeshe Peldron, 47–48
yulha-dralha class, of deities, 68–70
Yungdrung Bon, 6, 7, 8–10, 11–13, 18–19, 206, 210–12, 214
 Buddhism and, 216–17, 223–24
 Nine Ways of, 13, 223
Yungdrung Bonpos, 223–24

Zhabdrung, 29–30, 37–38, 46–47, 142, 211–12, 217
Zhabdrung Ngawang Namgyal, 16–17
Zhang Yudrakpa Tsondru Drakpa, 33
Zhangzhung, 8–9
Zhemgang, 1–3, 24, 241
 Bon rites to nobilities of, 150–51
 conservation in, 32–33
 dung nobilities in, 37–38, 47
 gadpo in, 184
 Kheng in, 31–32
 as "land of nobility," 35
 official Bonpos of, 106, 125–26
 religious pluralism in, 34–35
 Sakya Özer in, 33–34
 three ridges of, 29–38
zhung-gi bonpo. *See* official Bonpo
Zijid (Loden Nyingpo), 8